Van Gogh's Letters

The Mind of the Artist in Paintings, Drawings, and Words, 1875-1890

Van Gogh's Letters

The Mind of the Artist in Paintings, Drawings, and Words, 1875-1890

Edited by H. Anna Suh

Translated by Alayne Pullen, Alastair Weir, and Cora Weir

Copyright © 2006 by Black Dog & Leventhal Publshers

All rights reserved. No part of this book, either text or illustration, may be used or reproduced in any form without prior written permission from the publisher.

Originally published in hardcover as Vincent Van Gogh: A Self-Portrait in Art and Letters

Published by Black Dog & Leventhal Publishers, Inc. 151 West 19th Street New York, NY 10011

Distributed by Workman Publishing Company 225 Varick Street New York, NY 10014

Manufactured in China

Cover design by Elizabeth Driesbach Interior design by Toshiya Masuda

Cover photograph/illustration © The Bridgeman Art Library

ISBN-13: 978-1-57912-859-3

hgfedcba

Library of Congress Cataloging-in-Publication Data available on file.

CONTENTS

- 6 Introduction
- 8 Part I 1875 1881
- 30 Part II 1882
- 74 Part III 1883
- 112 Part IV 1884-1887
- 176 Part V 1888
- 240 Part VI 1889
- 282 PART VII 1890
- 314 Bibliography
- 318 Index
- 320 Art credits

Introduction

or many, Vincent van Gogh (1853–1890) epitomizes the concept of the artist as mad genius. His mental instability, which at one point drove him to mutilate his own ear, is the stuff of legend, and feeds into the common view of van Gogh as a lone voice in the wilderness, propelled by primitive urges and haunted by unspeakable demons.

In truth, van Gogh did have a difficult life. The same antipathy toward convention that helped him develop his inimitable (though much-imitated) artistic language also alienated many friends and acquaintances. Frequent breakdowns plagued him in later years. Although they had their emotional components, it is most likely that they were actually epileptic seizures, perhaps exacerbated by the lingering effects of a venereal disease contracted in his youth. Unlucky in love, he displayed fantastically poor judgment in several romantic entanglements before resigning himself to a bachelor's life. At the age of thirty-seven, and on the brink of the recognition and success that had eluded him for so long, he died of a self-inflicted gunshot wound.

Yet van Gogh was a thoughtful, intelligent man who expressed himself eloquently and poignantly in three languages. We know this because of a remarkably complete correspondence, which survives thanks to his brother, Theo van Gogh, and Theo's wife, Johanna. Comprising more than seven hundred letters, it casts a revealing light on an artist whose work, while almost completely disregarded during his lifetime, is considered virtually priceless today.

The significance of van Gogh's relationship with his brother comes through clearly in the letters, the vast majority of which are addressed to Theo, an art dealer in Paris. Despite never actually selling any paintings by his older brother, the younger van Gogh did help the socially awkward Vincent meet other artists. Moreover, Theo's financial support kept Vincent in paints and canvas. Indeed, nearly every letter to Theo contains either a request for more money or an acknowledgement of a recent remittance. Theo's unflagging moral

support was also a lifeline for his troubled brother. But Vincent was no passive dependent. Rather, his letters demonstrate that he served as a lively interlocutor for his brother in matters both personal and intellectual.

Although van Gogh was well versed in literature and art history, as an artist, he was largely self-taught, and, to judge from his early works, hardly a natural-born draftsman. The creative outpouring of his last few years, during which his many famous paintings were created, is best understood in the context of the many struggles that preceded them. These struggles are documented in excruciating detail in his letters, which testify to his dogged pursuit of technical skills such as figure modeling and perspective.

At the same time, the letters show the evolution of his theoretical principles. Van Gogh's astute observations about such artistic role models as Millet and Delacroix certainly do not sound like a lunatic's ravings. Yet this sophistication is always juxtaposed against a strong work ethic inspired by the humbler occupations. "A painter really ought to work as hard as, say, a shoemaker"; "I plow my canvases as [the peasants] do their fields."

This selection of excerpts from his letters, by turns contemplative and ornery, passionate and elegiac, aims to convey a fuller sense of this iconic artist's odyssey. Van Gogh's own words, illustrated by his own hand, belie his reputation as a maniac and do greater justice to his exuberant and joyous artwork than the caricature that has dominated popular opinion for so long.

EDITOR'S NOTE

Unless otherwise indicated, the letters from which the excerpts in this book are drawn are addressed to Theo. Most of the letters were undated; estimated dates appear in brackets. The numbering system follows the one established by Johanna Bonger-van Gogh in her edition of her brother-in-law's correspondence (see the bibliography). Images of the letters themselves, or of drawings included with a letter, are labeled with the number of the letter. Numbers with a dagger mark (†) indicate images that are referred to in the text of the letter.

Part I 1875–1881

vincent van Gogh didn't find his calling as an artist until his mid-twenties. Before then, he dabbled in art dealership, teaching, and various permutations of religious service. Yet even during these early years, his letters reveal certain characteristics that were to remain consistent throughout his life.

Foremost among these is his ability to find solace and inspiration in landscapes and nature. His letters from London, The Hague, and other locales throughout northern Europe contain many lyrical descriptions of his surroundings. Such pastoral elements of his thought combined in these early days with his deeply felt piety (his father was a minister). Although Vincent was eventually to renounce his religious beliefs, his love of nature was to prove more long lived.

Another perennial interest that manifested in his youth was his fascination with rural life and manual laborers. In an awkward and brief stint as a missionary in the Belgian coal region of the Borinage, Vincent sketched scenes from the miners' daily life; these drawings complement his poignant descriptions of their hard lot. Indeed, it was during this time that his interest in the ministry gave way to his new ambition to be an artist.

Van Gogh remained remarkably devoted to the same artistic influences throughout his career, despite changes in his own work. In particular, his admiration for the French artist Jean-Francois Millet emerges in his early letters and sketches as well as in his most accomplished works in the last years of his life. Millet's affectionate yet dignified portrayal of peasant life appealed greatly to van Gogh.

Finally, we see in his earliest letters the mutual fondness between Vincent and his younger brother, Theo, an art dealer. After he declared himself an artist, Vincent depended almost exclusively on Theo's faithful support. This fraternal bond was the most significant relationship in Vincent's life, and sustained him emotionally, intellectually, and financially to an extent that is difficult to overstate.

类

Londen April 1875

Waarde Theo,

Heerby stuur ik et eene kleines

Leekening. Ik maakte die verhe

Zondag, den morgen naarops

eene oloch tertje (13 pair) voor myne

londlady stierf.

1 Is een gezicht op Streathourn

enmon, eene groote wlatete

met eikeboomen i brem.

1 Hood s'noichts geregend & de grond

was hier & olaar olocofig & I jange

len legtas frische groen.

Zovals ge ziet is het gekrabbelos.

op het tetilblad voor de Toesies

d'Edmond Roche.
Boaat zyn movie by gernstig.

LONDON, 18 APRIL, 1875

25

Enclosed I am sending you a small drawing. I made it last Sunday, the morning my landlady's little daughter died (she was thirteen years old). It is a view of Streatham Common, a large grassed-over area with oak trees and broom. It had been raining during the night and the ground was soggy here and there, and the young spring grass fresh and green.

RAMSGATE, 21 APRIL, 1876

62

I really wish you could have a look through the school window. The house is situated on a square (all the houses around it are the same, as is often the case here). In the middle of the square is a large stretch of grass, enclosed by an iron fence and surrounded by lilac bushes; the boys play there in the midday break. The house where I have my room is in the same square.

Hærtelyk gegroet i het beste ti toegenerischt. Aview

Vincent

25

RAMSGATE, 31 MAY, 1876

67

Here is a small drawing of the view from the school window, from which the boys watch their parents leave when they have visited them and are going back to the station. Many of them will probably never forget the view from that window. You should have seen it this week, when we had some rainy days, particularly at dusk when the streetlights are lit and their light is reflected in the wet roads.

On those days Mr. Stokes was sometimes not in a good temper, and if the boys made too much noise to his liking, it could happen that they did not get their bread and tea that evening.

You should have seen them then, standing there, looking out of that window; there was something very melancholy about it. They have so little other than their food and drink to look forward to and to help them get from one day to the next. I would also like you to see them go down the dark stairs and through the passage to the table. However, that is where the friendly sun shines.

Another peculiar place is the room with the rotten floor, where there are six bowls where they have to wash themselves, and where a faint light falls onto the washstand through a window with broken panes; that is also rather a melancholy sight. I would really like to spend a winter with them, or have spent one with them, to know what it is like. The boys have made an oil stain on your drawing; please forgive them.

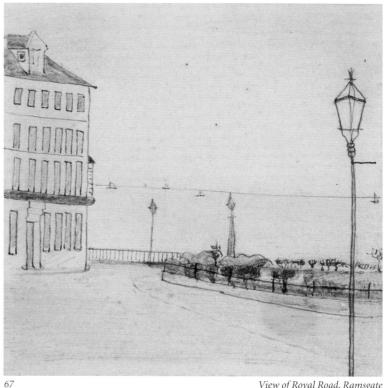

View of Royal Road, Ramsgate

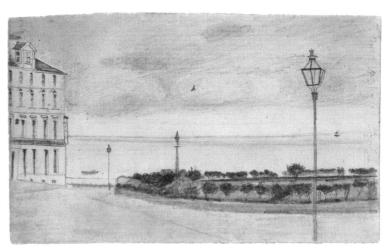

View of Royal Road, Ramsgate

Joleworll 15 Nov. 1876 het hom licht geleuren Dut Gij ook nog eens le War De Theo. Pary komt. o'avand half is was it weer hier Dank voor two loodster, brief dienet ontwing keyeligh berug, ih gong ged cellelijk met De un da grund met een wil Ellen . Gig zigt das weer in Doe lij wal time hum venot um te duen met Evilway Lewy . - Gelukkey has ih was get limen al une hwelt en de regen ap werken en bissen getregen vod du Jones. Ben berigaan 70.42:1 tol niet achter bligen .- Wat has it grang seen bookt man het Heike en nam Sprend et nyee Tre Pelersham zei ch 101 de gemeente dat zij slecht Engelsch enwen huren, maan dat als ite oprak ht in Deserberneum - Man vinik ik dacht aan den mun in de gelijkenis die dei .. heb gedeld met my en ih zah te alles betalen" God helpe mig - oflieren schelo By Mr. Obach zorg il het scheldery van verder y a ochriftik sen paar verzen aver die hij wel movi well vinden The journey of life This lovers by a made grown spring Two lovers by a made grown spring The parameter of the last of the Boughton: the pelgremoprogres . - Als by will sens kunt krijgen Bunyanio Pelgrimopro. o Budding time The word of from the portal steps
The two still out to getter there
The two still out to get the three
The curves soft was faming wings
While petals on the pathways lept
to price eyes blise
to tender price

O tender price greef het is vego de mueile wound om dat te leven. Throw mij houd er tieloveel va Flet is inden macht ik eit may wat te werken ever de Gladerelle. tedensishe le ochriquen en z, men muet het yzer omed en oils Two forces o'er accords bent Thered light showe upon the floor two hands above the kear were belied In more the space between them wide The sine and the sharing sings. They are their ghair up stocky side These watches also after while they sake Their pale checks journed, and said wises these watches after whether the theorem at character to past that is. Let keet is en het hart Des menschen als het is bromberde en ous .- Morgen wen naar Londyn van M. Janes. Onder Dut vers vom Thejournepul life en the stree little chairs zong men mag muchen ochraven: Om en de bedeeling, van de vollers Der The three lettle chairs tyden wederom alles tol cer te very as christino, beed of at in olen Hemel is en Jos op auron to . - Zou 2 y het . - een hand ruth in yeduchten growt so their deur. Terrhey own my en allem by Roys on Hunnelch en v Stockenney deanne, . Dien ens They sat alone by the bight implies

They sat alone by the bight implies

They are hard some will be agained for I look at them own I forget.

They are hard some by

The hard supplies mainteed theck

The buy's come back, and only thang.

They both sor thoughts thout begand on speak with he agreem on of excelered blue.

And south heart uttend a right.

And soit here every day. Ind sit here every day.

Johnny still whittles a hips hall mas I in Wittle his haden helles cars to white they have palehouse some of the evening time three hildsoh prayer of exply that no one knows.

Johnny comes back from the billowy day witted water from the billowy day to the the tree water from the billowy day to the tree water from the billowy day of the some interest of the tree water from the billowy day of the some interest of the tree water from the billowy day of the some interest of the some o And couch heart where a right for the lettle chairs places so lyste Again Again the chairs places so lyste Again the chairs places so lyste Again their thing warmen all to be particularly and their plays by their scales of Higgs, and their plays by with their back or shaight and ball their he site should this large frag. And with hem bling you ce to by wolf you with hem bling you ce to groutly said, a too flow that only a heart of the start of the said of th gelouf my bufh. bever Vincent. 田田 And comes lovest on my knee.

82

ISLEWORTH, 25 NOVEMBER, 1876

82

Last Sunday evening I was in a village on the Thames, Petersham. I had been to the Sunday school in Turnham Green in the morning, and from there went to Richmond at sundown and then on to Petersham. It soon got dark, and I did not know the road well. It was an amazingly muddy road, across a kind of dyke or rise, its slope covered with knotted elm trees and shrubs. At last I saw below the rise a light in a cottage and scrambled and wadcd towards it, and there they showed me the way. But, oh boy, there was a pretty little wooden church with

a friendly light at the end of that dark road. I read Acts v:14–16, Acts xII:5–17, Peter in prison, and then I told them the story of John and Theagenes again. There was a harmonium in the church, which was played by a young lady from a boarding school, whose pupils were all there.

In the morning it was so beautiful on the way to Turnham Green, the chestnut trees and the bright blue sky and the morning sun were reflected in the water of the Thames, the grass was such a magnificent green, and everywhere around me was the sound of church bells. [ETTEN,] 16 APRIL, 1877

92

It is already late. This afternoon I went for a walk because I felt such a need for it, first round the *Groote Kerk* [Great Church] and then the *Nieuwe Kerk* [New Church], and then up onto the dyke, where all those windmills are, which you can see in the distance if you walk near the railway line. There is so much in that strange landscape and its surroundings that seems to speak to you and say, "Keep your spirits up, don't be afraid."

ETTEN, 22 JULY, 1878

123

This morning Cor,* who is on holiday, and I went to the heathland and the pinewood again, some way beyond the mill, and went to collect heather for his rabbits, who are apparently very fond of it, and a few things to fill a flower basket with. We sat in the pinewood for some time and together drew a small map of Etten and surroundings with the Bremberg, Sprundel, 't Heike, and De Hoeve.

I often think of you and am so pleased that all is well with you and that you find things there that cheer you up and, as it were, supply you with sound sustenance for real life. Because that is the real art, and those are the works of those who work with their heart and soul and with their minds, like so many you know and possibly also meet personally, for whom words and works are their life and soul.

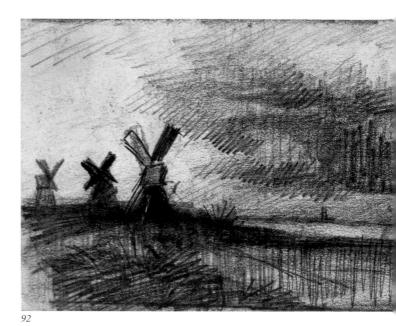

LAEKEN, 15 NOVEMBER, 1878

126

I enclose the little sketch I mentioned of *Au Charbonnage* [*At the Coal Merchants*].

I would really like to start making rough sketches of one or another aspect of so many things that I happen to come across, but as it might possibly keep me from my real work, it is better not to start on it. As soon as I came home I began a sermon about the "barren fig tree," Luke XIII:6–9.

That little drawing, *Au Charbonnage*, is not really anything special, but the reason why I felt compelled to make it is that you see so many of these people here, who work in coal and are really quite peculiar folk. This cottage is not far from the carriage road; it is really a small tavern attached to the big works, where the workers come and eat their bread and drink a glass of beer during their meal break.

^{*}Vincent's youngest brother, Cornelius, born 1867.

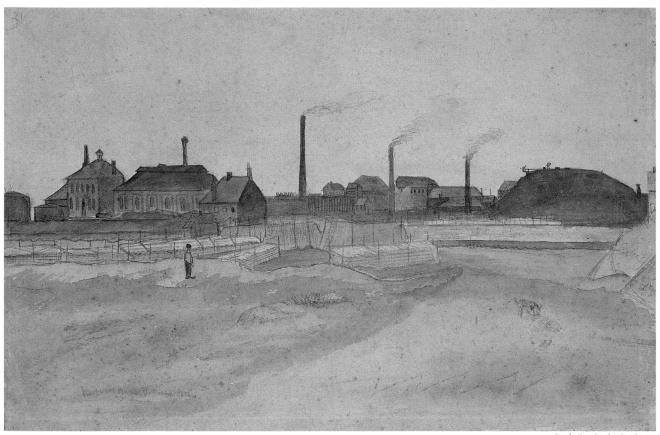

Coalmine in the Borinage

CUESMES, 5 AUGUST, 1879

131

If you have time to come and stay here, for a day or a longer or shorter spell, I would be really happy if that should happen.

I would be able to show you a few more drawings, of local characters, not that those in themselves would be worth the effort of getting off the train, but you would probably find in the scenery and quaintness all kinds of things that would attract you, as everything in this area shows such a picturesque character.

I have recently been to a studio, at Dominie Pietersen's, who paints in the style of Schelfhout or Hoppen-brouwers and has quite a good understanding of art.

He asked me for one of my sketches, that of a typical miner.

Am often sketching till late at night, to record some souvenirs and strengthen my thoughts, which are spontaneously aroused when I see things.

IULY 1880

133

What the molt is for birds, the time when they change their plumage, is what adversity or misfortune is for us humans, a difficult time. You can stay in this molting period, you can also come out of it like a new man, but nevertheless this is not something to be done in public, it is hardly a laughing matter, which is why you need to hide away. Well, so be it.

If now you can forgive a man for devoting himself to a thorough study of pictures, you must admit that a love of books is as sacred as a love of Rembrandt, and I even think that the two complement each other.

So what do you want? Does what happens inside show on the outside? There is such a great fire in one's soul, and yet nobody ever comes to warm themselves there, and passersby see nothing but a little smoke coming from the top of the chimney, and go on their way.

So then, what to do? Stoke up that fire inside, have salt in yourself, wait patiently, yet with how much impatience, wait for the hour, when someone might want to come and sit down by it—and to stay there, how should I know? Let anyone who believes in God wait for the hour that will come sooner or later.

Now for the moment everything seems to be going wrong for me, and this has been the case for some considerable time, and may well stay like this for some time in the future, but it is also possible that after

everything appears to be going awry, things will improve later. I am not counting on it, perhaps it will not happen, but if there should be some change for the better, I would count that as so much gain, I would be pleased, I would say, "At last! So there was something there after all."

I am writing to you rather at random just what comes to my pen.

I would be very pleased if you could see me as something other than a kind of idler.

Because there are quite different kinds of idler. There is the man who is idle from laziness and lack of character, from the baseness of his nature. You can, if you like, take me for one of these.

Then there is the other kind of idler, who is idle despite himself, who is consumed inwardly by a great desire for action, but who does nothing, because it is impossible to do anything, because it is as if he were imprisoned in some way, because he lacks what he needs to be productive, because inevitable circumstances have reduced him to this. Such a man does not always know himself what he could do, but he feels instinctively: nevertheless I am good at something, I can sense a reason for my existence! I know that I could be quite a different man! How could I be useful, what could I do? There is something within me, but what is it?

That is quite a different kind of idler. You can, if you like, take me for one of these.

A bird in a cage in spring knows quite well that there is something he would be good at, he feels strongly that there is something to be done, but he can't do it. What is it? He can't quite remember, then he gets some vague ideas, and says to himself, "The others are building their nests and producing their young, and raising their brood." Then he bangs his head against the bars of his cage. And the cage is still there, and the bird is mad with grief.

"There's a lazybones," says another bird who is passing. "He's comfortably off." However, the prisoner lives and does not die, nothing shows on the outside of what is going on inside him. He is in good health, he is more or less cheerful while the sun shines. Then the migration season comes, and a bout of melancholy. "But," say the children who look after him in his cage, "he has everything he needs." Yet for him it means looking out at the swollen, stormy skies and feeling the revolt against his fate within himself. "I am in a cage, I am in a cage, and so I lack nothing, fools! I have everything I need! Oh, for pity's sake, give me freedom, to be a bird like other birds."

That idle fellow is like that idle bird.

And men are often faced with the impossibility of doing anything, imprisoned in some kind of horrible, horrible, very horrible cage.

There is also, I know, deliverance, eventual deliverance. A reputation ruined rightly or wrongly, embarrassment, circumstance, misfortune, all these make people

prisoners. You can't always say what it is that shuts you up, what walls you in, what seems to bury you alive, but you still feel some kind of bars, some kind of cage, some kind of walls.

Is all this imagination, fantasy? I don't think so; and then I ask myself: My God, is it for long, is it forever, is it for eternity?

Do you know what makes the prison disappear? It is every deep, genuine affection. To be friends, brothers, to love, that opens the prison by its sovereign power, its powerful charm. Someone who does not have that remains bereft of life.

But where sympathy is reborn, life is reborn.

Sometimes the prison is called prejudice, misunderstanding, fatal ignorance of this or that, distrust, false shame. CUESMES, 20 AUGUST, 1880

134

I have done a rough sketch showing mine workers, men and women, going to the pit in the morning in the snow, along a path beside a thorny hedge, shadows that pass hazily visible in the half light. In the background the blurred outlines of the colliery buildings and the pithead wheel stand out against the sky.

I am sending you the sketch so that you can get an idea of it. But I feel the need to study the drawing of figures by masters such as Millet, Breton, Brion, or Boughton, or others. What do you think of the sketch, does the idea seem a good one?

I would very much like to have done the drawing in question better than I have done. In the one I did, as it is, the figures may be about ten cm high. Its pendant shows the coalminers returning, but such as it is, it is less successful; it is very difficult, since it involves the effect of brown silhouettes, edged by light against a streaked, sunset sky.

CUESMES, 7 SEPTEMBER, 1880

135

For some time I have been scribbling drawings without making much progress, but recently it seems to me that it has been getting better, and I have good hopes that it will get better still. Particularly because of the way Mr. Tersteeg,* and you too, have helped me with good models. I think it is much better at present to copy some good things than just to work without this foundation.

However, I have not been able to resist sketching, on a fairly large scale, the drawing of the mine workers going to the pit, of which I sent you the rough sketch, changing

the arrangement of the figures a little. I have good hopes that after copying Bargue's other two sets, I will be able to draw a coalminer, or a woman pannier carrier, more or less reasonably when I see a chance of getting a model with some character and, for that matter, there are some here.

If you still have the book of etchings after Michel, will you lend that to me too, when it is convenient; there is no hurry. For the moment I have enough work, but I would like to look at those country scenes again, because now I look at things differently from the time before I started drawing.

I hope you will not be too dissatisfied with the drawings after Millet when you see them; those little woodcuts are admirable.

So my very best thanks for having sent them, and remember that anything you can find by that particular artist can only be most useful to me. As for *The Sower*, I have now drawn it five times, twice small size, three times large, and I will do it again, that figure interests me so much.

^{*}Hermanns Gijsbertus Tersteeg (1845–1927), a manager at the art dealership in The Hague where Vincent briefly worked.

CUESMES, SEPTEMBER 24, 1880

136

So you see I am madly at work, but for the moment it is not producing any very satisfactory results. But I hope that these thorns will produce white blossoms in their day, and that this apparently sterile struggle is nothing but the labor of giving birth. First the pain, but afterwards the joy.

I can't tell you how much, in spite of the difficulties that crop up each day and the new ones that keep appearing, I can't tell you how happy I am to have started drawing again. I have been worrying about it for a long time, but I always thought it was impossible and beyond my reach. But now, even though aware of my weakness and my painful dependence on many things, I have recovered my peace of mind and my energy revives from day to day.

BRUSSELS, 15 OCTOBER, 1880

137

I don't entirely reject the idea of the Ecôle des Beaux-Arts, in as much that I could, for example, take evening classes there while I am here, if they are free or not too expensive.

But at least for the moment my object must still be to learn as soon as possible to make presentable and saleable drawings, so that I may straightaway start to earn some kind of living from my work. Because that is in fact the necessity imposed on me.

Once master of my pencil, or of watercolor, or of etching, I will be able to return to the realm of coalminers or weavers to do better from life than I have been able to up to now. But first I must gather a little know-how.

BRUSSELS, 1 NOVEMBER, [1880]
72 BOULEVARD DU MIDI

138

I have recently drawn something that gave me a great deal of work, but I am still pleased to have done it: I have made a pen drawing of a skeleton and done this rather large, on 5 sheets of Ingres paper.

I did this using a guide by John Marshall: *Anatomy for Artists*. And there are a number of other illustrations in it which seem to be very efficient and clear, of a hand, foot, etc., etc.

And what I will do now is finish the drawing of the muscles totally, to be precise, those of the trunk and legs, which with those already done will form the entire human body. After that the body seen from behind and the side will follow.

So you see that I am pursuing this with some energy; these things are not so very easy and demand time and, moreover, a great deal of patience.

It is my intention to get hold of the anatomical illustrations of, for instance, a horse, cow or sheep from the veterinary school here, and to draw them in the same way as I did the human anatomy. There are laws of proportion, of light and shade, of perspective, which one has to know to draw anything at all; if you lack that knowledge than it will always remain a sterile attempt and will never bear fruit.

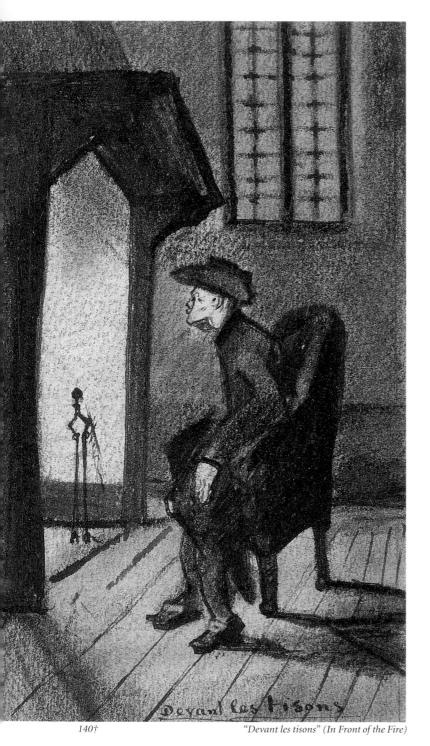

JANUARY 1881

140

I want you to know that in the last few days there has been a change for the better. I have just finished at least a dozen drawings, or rather sketches in pencil or pen and ink, which are, it seems to me, already a little better. They look vaguely like some drawings by Lançon or some English woodcuts, but still more clumsy and more awkward. Among other things, they are of a porter, a miner, a man sweeping snow, a walk in the snow, old women, a type of old man ("Ferragus" from Balzac's *L'histoire des Treize*), etc. I am sending you two small ones, *En Route and Devant les Tisons* [In Front of the Fire]. I can see that they are not good yet, but it is beginning to work out.

I feel and know for sure, I will make more progress. And I shall probably reach the stage of knowing how to make portraits.

But it is only by working hard; "not a day without a line," as Gavarni said.

[JUNE 1881]

146

I have made a pen drawing of another spot in the marshes, where many water lilies grow (near the road to Rozendaal).

Until today I have been drawing exclusively with a pencil, worked up or emphasized with a pen and, if necessary, with a reed pen, which makes a wider line.

The drawings I have made lately also entailed this way of working, as they involved subjects that called for a great deal of *drawing*, also in perspective.

[ETTEN, JULY 1881]

148

It would not be right if in drawing from life I lapsed into too much detail and overlooked important things. And I found this far too much the case in my recent drawings. That is why I want to study Bargue's method again (who works with strong lines and shapes, and simple, delicate contours). And if I leave off drawing outside for the moment, then when I come back to it after a short while, I will have a better eye for things than before.

I also hope I will be successful in finding a good model, for instance, Piet Kaufman, the laborer, though I think it will be better not to have him sit for me at home, but either at the yard, or in his own home, or in the field, with a spade or a plow or some other thing. But what a job it is get people to understand what is meant by posing. Town and country people are all desperately convinced of one thing they will not give up on; they will not pose in anything other than their Sunday suit, with impossible folds in which neither knee, nor elbow, nor shoulder blades, nor any other part of the body has marked its characteristic dents or bulges. That is truly one of the little trials in the life of a draftsman.

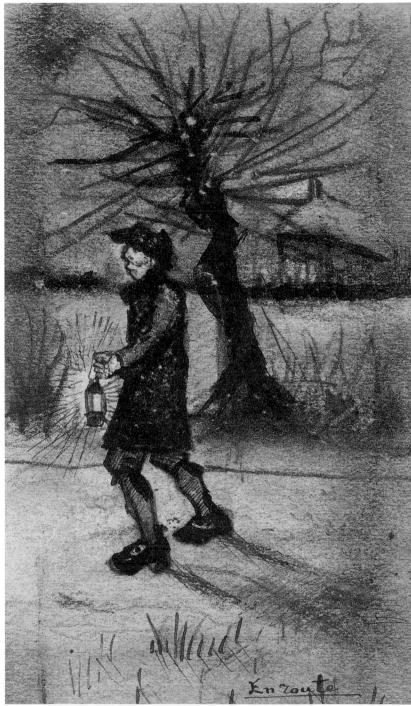

140† "En Route"

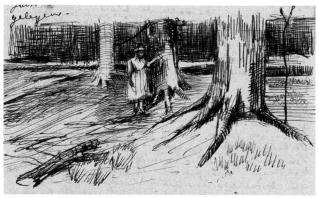

150

[SEPTEMBER 1881]

150

There has been a change in my drawing, both in my way of doing it and in its result. Also as a result of some things Mauve* said to me, I have started to work with a live model again. I have fortunately been able to persuade several people to do this, among them Piet Kaufman, the laborer. The careful study, the persistent and repeated drawing of Bargue's *Exercises au Fusain*, has given me a better insight into drawing figures. I have learned to measure and observe and to look for main lines, so that what once seemed desperately impossible to me is slowly beginning to be possible. Thank God.

I have some five times drawn a peasant with a spade—in short, a digger—in all kinds of poses, twice a sower, and twice a girl with a broom. Also a woman with a white bonnet, peeling potatoes, and a shepherd leaning on his crook, and finally, an old, sick peasant, sitting in a chair by the fire with his head in his hands and his elbows on his knees. And, of course, that will not be the end; once there are a few sheep over the bridge, the whole flock will follow. Diggers, sowers, plowmen, men and women, I have to draw them ceaselessly. Study and draw all that is part of life in the country. As so many others have done and still do. I now no longer feel so powerless as I used to be when confronted by nature.

*Anton Mauve (1838–1888), a painter and the Van Goghs' cousin by marriage.

I brought some crayon in wood back with me from The Hague (as well as pencils), and I work with it a lot.
I have also started to work ... with a brush and a stump, with some sepia or india ink, and every now and then with color. What is quite certain is that the drawings I have made lately bear very little resemblance to what I have made until now. The size of the figures is more or less that of an *Exercise au Fusain*.

As far as landscape is concerned, I am of the opinion that it need not suffer in any way; to the contrary, it will gain by it.

I need not tell you that I only send you these sketches to give you some idea of the poses; I have dashed them off today in a very short time and notice that the proportions leave much to be desired, at least, certainly more than in the actual drawings.

This is a field, or a stubble field, where people are plowing and sowing; I have made a fairly large sketch of it with an approaching storm. The two other sketches are poses of diggers. I hope to make several more of these. The other sower has a basket.

I would be enormously pleased if I could get a woman to pose with a seed basket, to retrieve the small figure I showed you in the spring and which you can see in the foreground on the first sketch.

In short, as Mauve says: "The factory is in full operation."

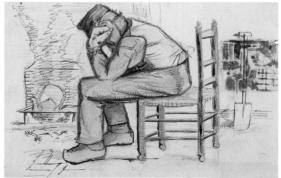

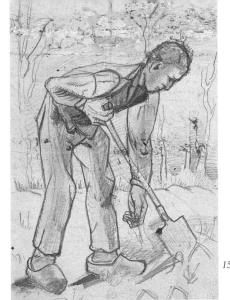

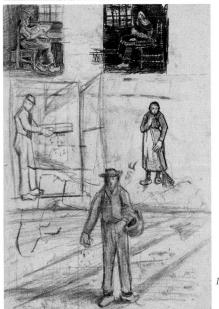

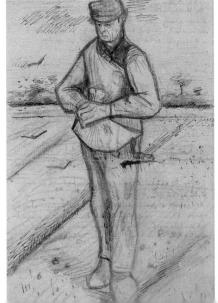

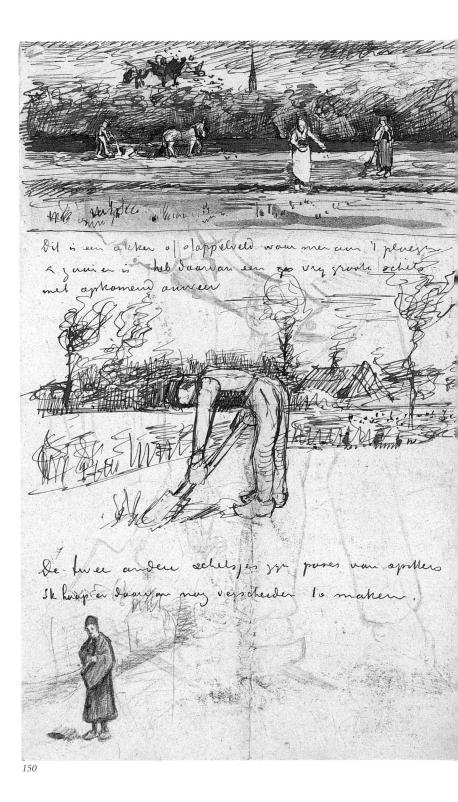

1875 - 1881

150

Dras er weder een brief naar te toegaat zoo sluct ik een woordje in Van harte hoop ite olat gij het goest maaket geens een haef eurstje 3 ult kunnen v molen am my weer eens te schry een.

Ik wil te nu nog zeggen wat it het untgevoord sedert it a her laatst geschreven he 8.

Rnot wilgen Spo ongever als understand, petetsje.

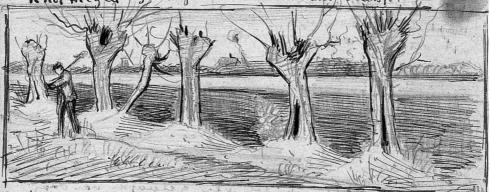

Verder sen ditte maan mede hoogte van de lemsche way Dan het ih weer een paar heer model gehad speller om mande maken.

En dan hel it van oan Eent verleweek een verfdaas gebrege die vrij gail is zeter goed genaeg an mee te begennien (Agverf is van Pauland): Eis daar het it zen beleg mede.

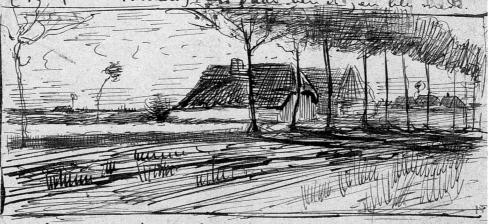

Nu habit dadelyt seus leproses em, ant aquarel la maker a als levenslaar motief.

[CA. 12 OCTOBER, 1881]

151

First of all, two large drawings (crayon and a little sepia) of pollard willows—more or less like the sketch below. Next a similar one, but oblong, of the road to Leur. After that I had a model again a few times, a digger and a basket maker. And then I was given a box of paints by Uncle in Prinsenhage last week, which is quite good, certainly good enough to start with (the paint is Paillard's). And I am very pleased with that.

Well, I have immediately attempted to make a kind of watercolor.

I count myself very lucky to be able to get a model. I am also having a go at drawing a horse and a donkey.

Especially for watercolor, that particular thick Ingres paper is very good and a good deal cheaper than any other. Even so, I am not in a particular hurry with it, because I brought back some stock from The Hague, but unfortunately it is plain white.

Well, you can see I am hard at work.

And now goodbye, I have walked a long way today and am incredibly tired, but I did not want to let the letter go off without enclosing something.

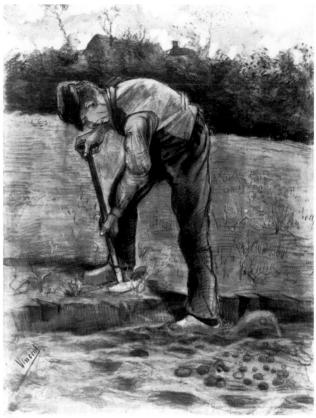

151

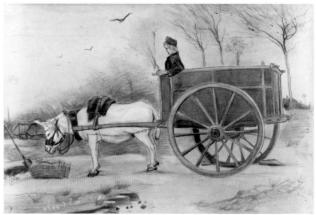

151† Donkey Cart

[12-15 OCTOBER, 1881] 152

Nature always starts by resisting the artist, but if you take her really seriously, you will not let yourself be upset by this resistance; on the contrary, it is an extra stimulus to conquer her, and at heart nature and a true artist are in tune with each other. However, nature is certainly "intangible," yet she needs to be tackled, and that with a firm hand. And having wrestled and battled with nature for some time, she starts to be a little more cooperative and submissive. Not that I have reached that stage, no one is further from it than I believe myself to be, but I am beginning to make headway.

The battle with nature sometimes has something of what Shakespeare calls the "taming of the shrew" (that is, conquering the resisting party by perseverance, *bon gré et* *mal gré* [willingly or unwillingly]). In many things, but certainly in drawing, I believe that holding on tight is better than giving up.

More and more I feel that drawing figures in particular is good, and indirectly also has a beneficial influence on landscape drawing. If you draw a pollard willow as if it were a living being—and that is surely the case—then the environment follows relatively smoothly of its own accord, as long as you have concentrated all your attention on that particular tree and don't rest until it shows some life.

Enclosed are a few sketches. I am often busy on the road to Leur these days, occasionally working with watercolor and sepia, but that is not so easily done.

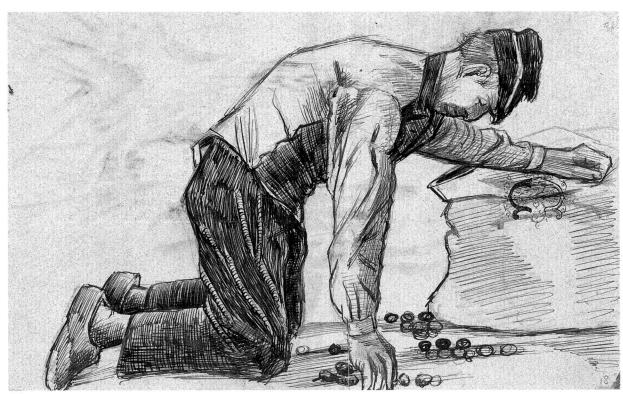

152

150 waarde Theo. Regt veel genergen clock het my zoo even un breef le ontvangen en van wege ile beh zoe de dejer deger tooznemens was om ale schique oloe de het nu oumed dely to naur danleed ing van un ochnyven. Dal gy her Papeer Songer hell af gezonden vend it hearly te its he bonoy wel was man met meer van de hewerte beleur Dat de Hi Terriery to wintered myn leekeningen heeft gegend wat by gezer I heeft werkengt my in seen jeken miet munder dat 37 seef led de gezondern schehejer vindt er vorzulgung is moten die aanvangt te toomen zeen zeleer hoop it verdeez le western zoo dad noch zig nach de the the geneen gunsleye aprimie behaven lernig le nemen, it & 3 ve myn her down is on dezen met le beoliègen. De natuur begunt altyd met den lectionaan le greentaan maan zou wie het waarachtig ernsteg opneemt land gich Door Dien Legenhand miet g van streek brengen integendeel I is prelikelte meer om le werwinnen en en den grond zijn de nætuur han te volune i jenjetter pirstangeble "fort mod han han anhysikken en tot med vark hand en een opreyt bestemder het eens. En næ me eeniger by 3 met de nestum gewordeld en gestreden le hebben begint die met men meegevend en gedwere leworden niet det it er at hen numered is en verder van I aan dan it geef dat le ren man I begint beler te vlotten. Met denotes Shakespeare normt of aming the shrew on Jeel Junger man Repartelyh in I leekener meen it hat Serrer de près sant meux que lacher. Hoe langer hoe meen gevoel ik dut bepauldelyk het fignurtecken I goed is, ook inducted len goede werlet op I landschapleckenen Als men een knotvely teekend als ware to een levend wegen I an dat is lack eigently h go. mad an doubt dan volgt de onywing sangel beheldeligh men at zyn aandacht geconcentreed heeft It op dien bewusten boom en met gerant heeft voor dut en to cels van het leven on terrain. Heartry ven pour schels jes it hen may al dekunt of he Leurschen was bezig beginn wordig. Werk and . a from met water a segion menen dut lutt por in carri met we now treate he of prout me him it had you in corn inc who is may say the of prout much him it man he got the or is my say the more majorum he mad you may see a buy to mountage. Do Fad which to Rotherd. going it my jun op my last, on I that my player had one he last illestry owner je very on it got

[12 OCTOBER, 1881]

RAPPARD R1

Recently I have done a great deal of drawing from life, since I have found several models who are willing enough. And I have all kinds of studies of both men and women, digging and sowing, and so on. I work a lot with charcoal and conté crayon these days, and I have also experimented with sepia and watercolor. Well, whether you will see any improvement in my drawings I would not be able to say, but you would most certainly see a change.

Do you know what is so very beautiful these days?—that road to the station and to the Leur with the old pollard willows. You actually have a sepia of it. I can't tell you how lovely the trees are now. I have made about seven large studies of some of them.

18 NOVEMBER, 1881

158

Have my drawings arrived? I made another one yesterday, of a peasant boy who every morning lights the fire in the hearth, over which the kettle hangs. Another one is of an old man putting dry faggots on the fire. To my regret there is still something hard and severe in my drawings.

19 NOVEMBER, 1881

160

I have started on another digger, working in a field, lifting potatoes. And here the environment has been dealt with a little more. Clumps of trees in the background and a strip of sky.

Oh, boy, how beautiful that field is! When I am earning more and can spend more on models, you can be sure I will make some entirely different things!

152

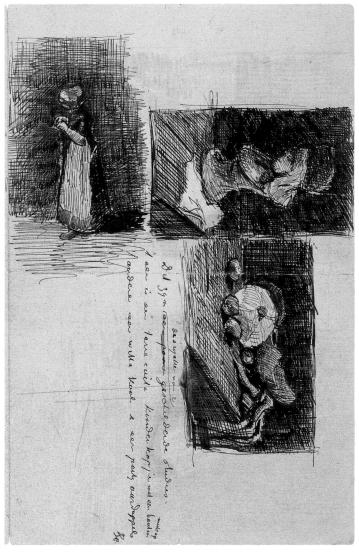

163

[CA. 18 DECEMBER, 1882]

163

I am still spending every day at Mauve's, in the daytime to paint, in the evening to draw. I have now painted five studies and two watercolors, and obviously a few sketches, too.

In any case, Theo, Mauve has thrown a little light on the mysteries of the palette and the use of watercolor. And that should compensate for the ninety guilders it cost to travel. Mauve says that the sun is beginning to shine for me, but is still hidden in the mists. Well, I have nothing against that. I will tell you more about Mauve some time, how warm hearted and good he is.

I am sending you some scribbles after the two watercolors I did. I have every hope that I will be able to make something saleable relatively soon, in fact, *I believe that if necessary these two could be sold.* Particularly one in which Mauve has added some brushstrokes. But I would prefer to hang on to them for a little while, to remind me of various things about the execution process.

What a wonderful thing watercolor is to express space and light, so that the figure is part of the atmosphere and the whole thing comes to life. Now, do you want me to make a few watercolors for you here? There is nothing I would rather do, but staying here and the models, paint and paper, etc., etc., all cost money, and I have none left. So write to me in any case a brief word by return, and if you want me to stay here, then please send me some money if possible. I truly believe that I can make better progress now, the more so because I have for once had some practical advice about color and brushwork.

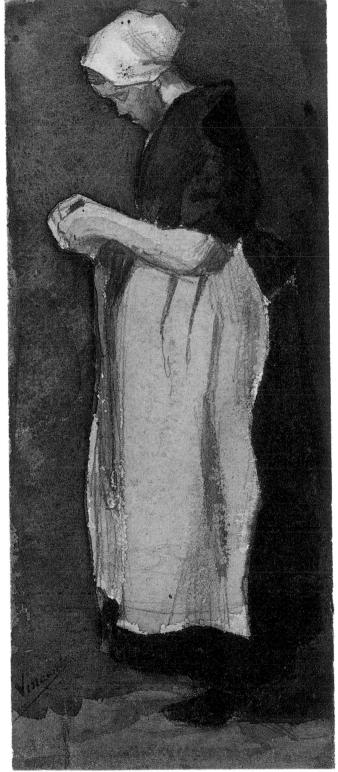

Scheveningen Woman Knitting

[22-24 DECEMBER 1881]

165

As Pa and Ma are writing, I am adding a brief word, but I hope to write to you in more detail soon, that is, when Mauve has been. He will be coming to Prinsenhage shortly, and here, too. You should know, Theo, that Mauve has sent me an artist's box with paint, brushes, palette, palette knife, oil, turpentine, in short, with all essentials. This means that I will also start painting in oils, and I am pleased to have reached this stage.

I have in fact done a great deal of drawing lately, particularly figure studies. If you saw these now, you would realize what I am aiming for.

I have also recently drawn some children and I found that very enjoyable.

Lately the colors and tones outside have been magnificent. Now that I am beginning to see some light where painting is concerned, I should be able to reach a point where I can express some of it, but I will have to stick to my guns, and now that I am concentrating on drawing figures I will have to persevere with that until I have reached a more advanced stage. When I work outside, that will be to make studies of trees, but actually regarding the trees as if they are figures. I mean, particularly looking at them with an eye for their outline, their proportions and how they are structured. That is the first thing to deal with. After that the modeling, and the color and environment, and that in particular is a problem I want to talk about with Mauve.

But Theo, I am so pleased with my artist's box, and it is better, I think, that I have got it only now, having spent at least a year exclusively on drawing, than if I had started painting in the beginning. I think you will agree with me on that.

Because, Theo, with painting my career will get off to a start. Don't you think it right to see it like that?

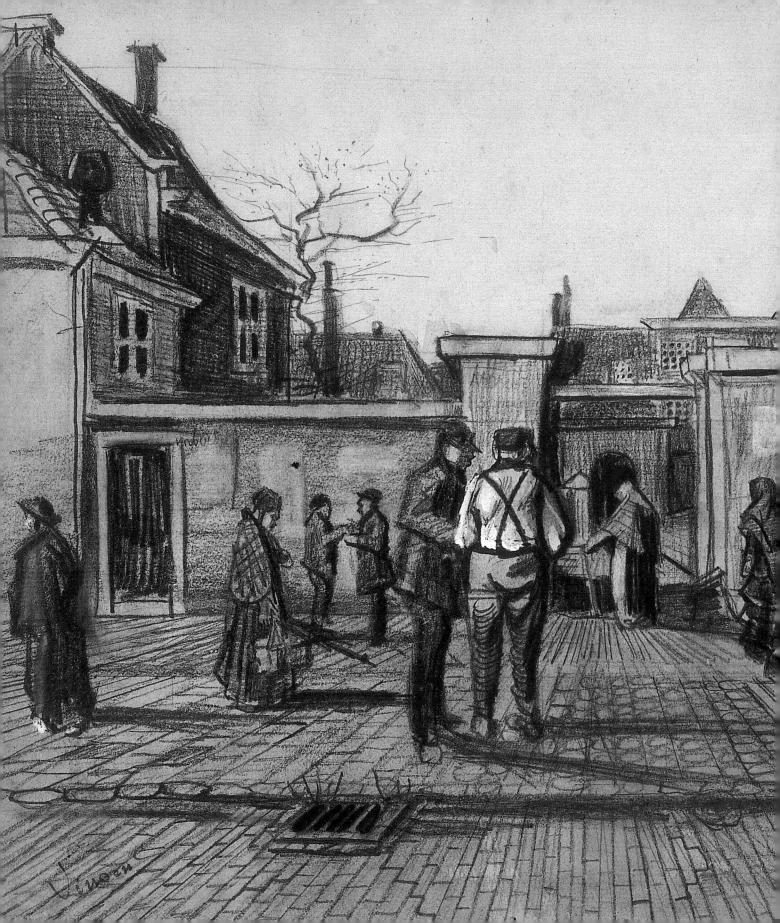

Part II 1882

In the winter of 1881, van Gogh had a falling out with his parents, with whom he had been living since that spring, over his unrequited interest in a recently widowed cousin. In the wake of their argument, he moved to The Hague in January of 1882. There, he rented a studio and continued his intensive studies in drawing and sketching. He was assisted in these endeavors by various acquaintances in the art world.

However, soon after the move, van Gogh became involved with an unmarried woman who had one young child and another on the way. This ill-advised entanglement not only earned him a stay in a venereal-disease ward, but it also alienated him from his more respectable companions. Shortly after his release from the hospital, the woman, Clasina Hoornik (called Sien) gave birth, and he set up housekeeping with her in a large, well-lit studio.

The relationship was only a simulacrum of the domestic bliss van Gogh dreamed of; in reality his time with Sien was tumultuous. Their difficulties were exacerbated by poverty and Sien's mother, who apparently pressed her to return to the more lucrative prostitution that had supported her before she met van Gogh. He briefly considered marrying her, but Theo seemed to have convinced him otherwise.

During this time, van Gogh the artist was preoccupied with the technical aspects of different media, as well as questions of perspective, color, and light and shade. Despite the social isolation, he continued to work at a brisk pace, producing many drawings in his new studio, as well as his first watercolor and oil paintings. In these early attempts, he felt that he was finally reaping the rewards of his commitment to the elemental medium of pencil and paper. A stubbornly independent streak emerged at this time: he formed firm opinions on the importance of drawing as a fundamental skill and seemed to feel little need for more formal training.

Ik hen bowley to behove e een pour kleine out seen groots aquarel begannen y syn munt zur grunt als een van die fegneurstudent du de Ellen machte Nu aprecht het van jelf dat dat jew maan met in eins goed a gry van slapel loupt. houve jelf jegt me dod it up syn ment een sluh of co beekeningen verknoeien jal voor it goow at helpenseel weel to hunteren Na maar downachter 3 of sen beleve luckon I us werk it door met jour se Roelbloedykeed als it veryamelen kom en with down myn feuli at afockrekken Gyzulih zoch naar toon een kappe of een handye das glocil en waar leven u jet en dat uitkomt om legen cen dammelenden achtergrond schemerend en don hubare down legen and see don 6 20/2

ochoonsleen en kergelet yzer « leen. en een planken vloer. He et de leekening naar

must 3/4 from en groene geep styl maken en

myn zan kon krygen dom zon ih en up zu

[CA. 12–16 JANUARY, 1882]

So although I meant to write to you in more detail about what happened at home, and to try and explain matters as they appear to me, and although I would also like to talk to you about a few other subjects, I have no time for it now, and I think it would be better if I write to you about drawing again.

Mauve tells me that I will spoil at least some ten drawings before I learn how to wield a brush well. But beyond that point is a better future, so I carry on working with as much *sang-froid* as I can gather together and will not let myself be put off, even by my mistakes.

It goes without saying that one can't master the technique in a day.

This is the subject of the large drawing, but I am doing it in a hurry and the small sketch is atrocious.

I am planning to make a string of small pen drawings in between other dribs and drabs, but in a different style from that large one last summer. A little more caustic and angrier.

Iam alleen dat dat hvelye maar dat kendje zet heur eur zocht en met sentiment behandelen. Moron gy begrypt ik kan dat alles nog met zav medrukken zwo als ih hel wel maan de zoak is meur dunkt me de moeselykheden aungrypen en het groenezeep gedeelte es muy met groenez sepaethy genvey en de heerheed door legenver met leer genag. troion ent in & de schels is en loch opgedonderd en de aprolling is en. Nu sprieht hil van jelf deil men de lechnich met den eersten doeg meester is Nu delis I sujel van de grade lishering maar it due het on hours en hel a chels, e is afochewely 12. Evennel magelsh jeef het heen gedrell en hels lauter Ik hvor drider vandaag remaind voor me geweest is in dent de le versley. Sol won it wel wans by heeft me belough dut by Jou komen opdokken Jew it wan hem wel leens eprehits aver een en amber. dly jou morgen ochland lerny humen. Theo in heb veel gercharrel met de moderen it joet je en al et je vind deur eo het een loer om je up toteleer le kryzen en deur laten je me demo in den steet Net als van morgen sen smids jongen de kon med kamen amodat zign vader jei dat h of sen gulden per um hetalen muest mu dom had it malaurtyt geen tiek in. Morgan het it wan't model van het oud vrouwt je maar & dagen actheren kom je met komen. Na dom alschudger zet ih nog al. seens in de redhøgmarhenken af in de waeltkamer 3ª kluste of dergelijke lacaliteiten le Krabbelen. Man hister is het you verdamed havind murue war my sie may mist son vlag bethen als men genefanden en myn schiefe eigentech men utwon

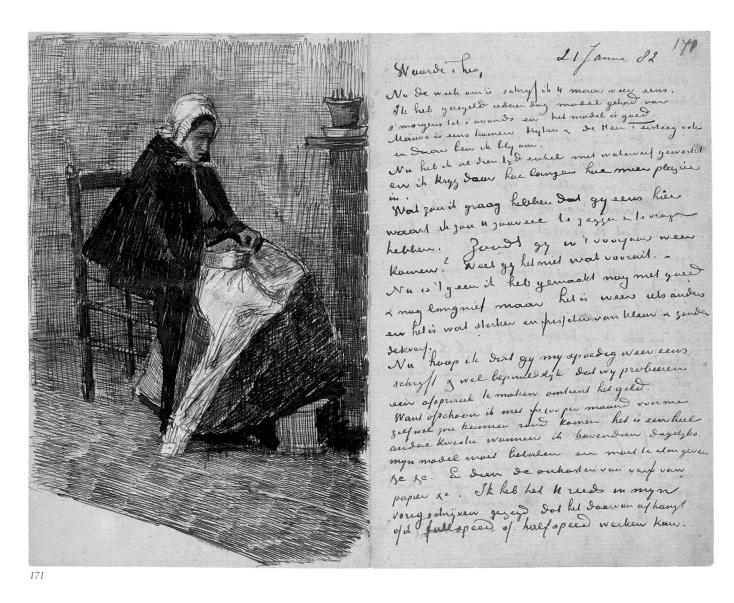

[THE HAGUE, 21 JANUARY, 1882]

171

As far as the size of the drawings is concerned or the various subjects, I will gladly pay attention to what Mr. Tersteeg or Mauve have to say. I have recently started on some large ones, because I must at all costs overcome the dryness of last summer's studies. And Mauve said, last night, although he obviously also had criticisms, "It is beginning to be a watercolor." Well, if I have gained that

much, then I figure I have wasted neither time nor money. And now that I have endeavored to try out the brush techniques and the strength of the colors on a larger scale, I can turn my hand to smaller ones again. As a matter of fact, I have two small ones in hand already, but because I had problems with them and partly sponged them out again, I have started a very large one, of which I am sending you a small sketch.

FRIDAY, 3 MARCH, [1882]

178

The model I have now is a new one, although I have made a superficial drawing of her before. Or rather, there is more than one model, because from the same house I have already had three people, a woman of about forty-five, who is just like a character from Ed. Frère, and then her daughter, about thirty years old, and a younger child of ten or twelve. They are poor people whose willingness, I must say, is invaluable.

The young woman's face is not beautiful because she has had smallpox, but she is very graceful, and I find her charming. They also have good clothes. Black merino and nicely fashioned bonnets, and a beautiful shawl, etc.

But I must try to sell some of [these pictures]. If I could, I would keep all I am currently making of them for myself, because even if I keep these studies for only a year, I am certain I will then get more for them than now.

The reason why I would so much like to keep them is simply this. When I draw individual characters, it is always with a view to a composition of more figures, for instance, a third-class waiting room, a pawnshop, or an interior. But those larger compositions have to ripen gradually, and for a drawing with, for instance, three seamstresses, you may have to draw some ninety seamstresses. And there you have it.

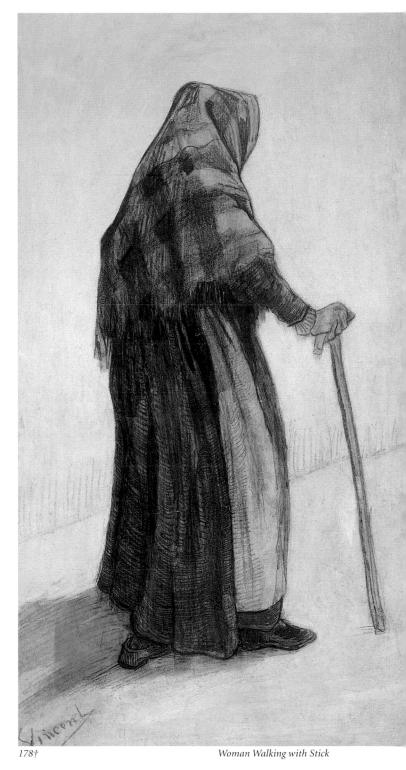

1882

[CA. 14-18 MARCH, 1882]

182

I am decidedly no landscape painter. When I make landscapes there will always be something figurative in them.

And when summer comes and the cold is no longer a problem, I will in some way or another inevitably have to make some nude studies. Not exactly in academic poses. But I would so very much like to have a nude model, for instance for a digger or seamstress. Seen from the front, from behind, from the side. So that I can learn to see and sense the shapes through their clothes, to make the action clear to me. I figure that about twelve studies, six men, six women, would be very illuminating for me. Each study is a day's work. However, the difficulty lies very much in finding models for this purpose, and if I can, I would want to avoid having a nude model at the studio, so as not to frighten off other models.

[24 MARCH, 1882]

183

I have recently been hard at work, and I am busy from morning till night.

I carry on drawing these small town views almost daily, and I am beginning to get the hang of it.

I have not sent you any more sketches recently, I am waiting until you come here yourself, that will be better. I am working on figures and also a few landscapes, including a nursery garden on the Schenkweg here.

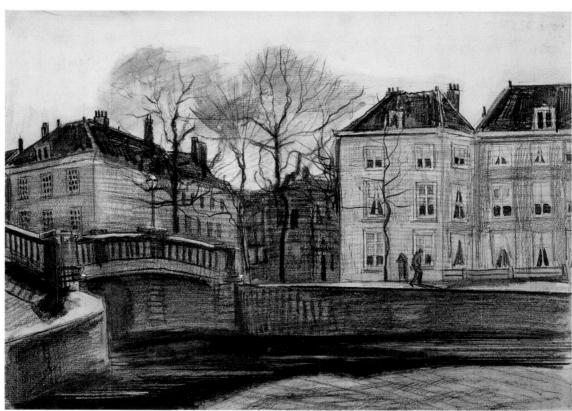

183†

View of Scheveningen

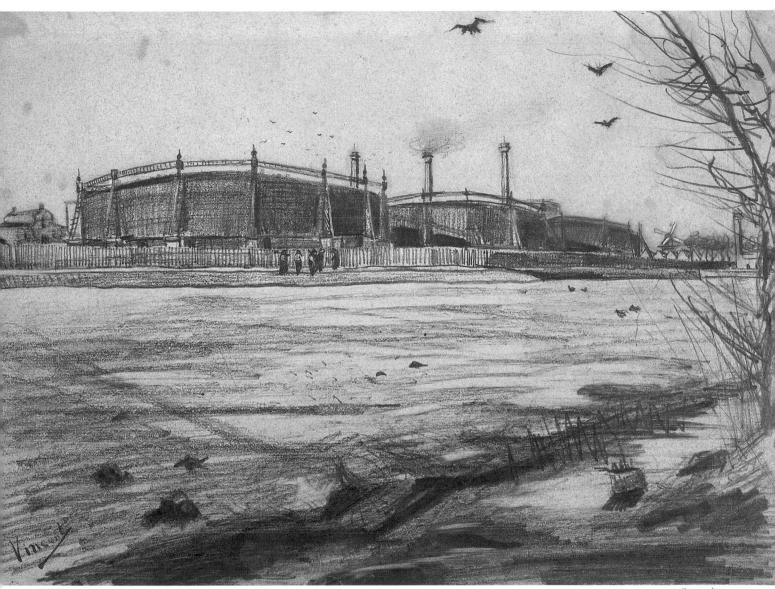

183† Gasworks

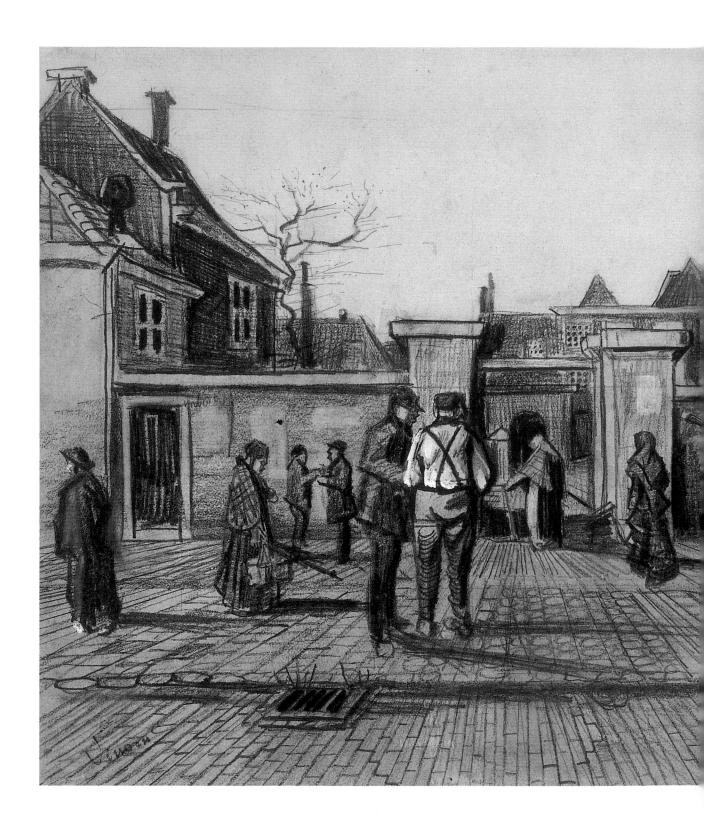

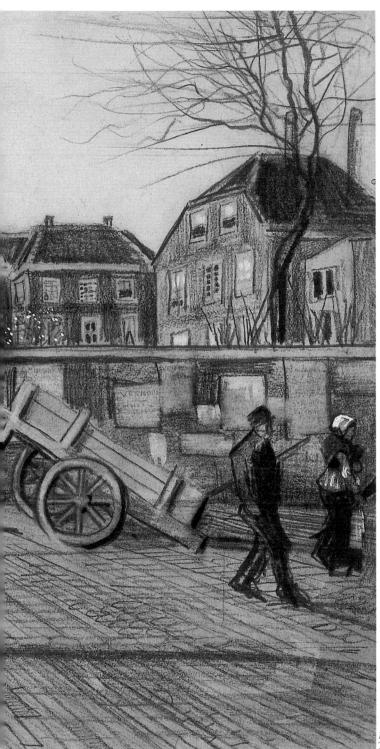

183† The Entrance to the Pawn Bank, The Hague

[LATE MARCH 1882]

184

One day, when people begin to say that I can draw a little, but can't paint, I will perhaps surprise them by coming up with a painting when they are not expecting it. But as long as it looks as if I *should* do it, and that *I* ought to do nothing else, then I certainly will not do it.

There are two ways of reasoning about painting: how to do it and how not to do it; *how to do it* with a great deal of drawing and not much color, *how not to do it* with a great deal of color and not much drawing.

[EARLY APRIL 1882]

185

What lovely weather it is, there are signs of spring in everything. I can't abandon figures, for that is my top priority, but sometimes I can't restrain myself from going outdoors. But I am working on some difficult things, which I must not let slip.

Lately I have made many studies of parts of the figure: head, neck, chest, shoulders. Enclosed is a rough sketch. I would very much like to make a lot more nude studies. As you know I have drawn the *Exercises au Fusain*, several times in fact, but they do not include any female figures.

Working from life is quite different, of course. A little drawing like the one enclosed is simple enough in line. But when you are sitting in front of a model, it is hard enough to capture those simple, characteristic lines. These lines are so simple that you can draw their outline with a pen, but I repeat, the problem is to find those main lines, so that a couple of strokes or scratches can express the essence.

To choose your lines in such a way that they, as it were, *speak for themselves*, that *they have to run like that*, that is something that does not happen *automatically*.

The little drawing enclosed is a rough sketch of a larger study in which the expression is more somber. I think there is a poem by Tom Hood, in which he tells of a great lady who can't sleep at night, because that day, when she went out to buy a dress, she saw the poor seamstresses, pale, consumptive, emaciated, working in an airless room. And now she has pangs of conscience about her wealth and lies awake at night. In short, it is a slender, fair, female figure, restless in the dark night.

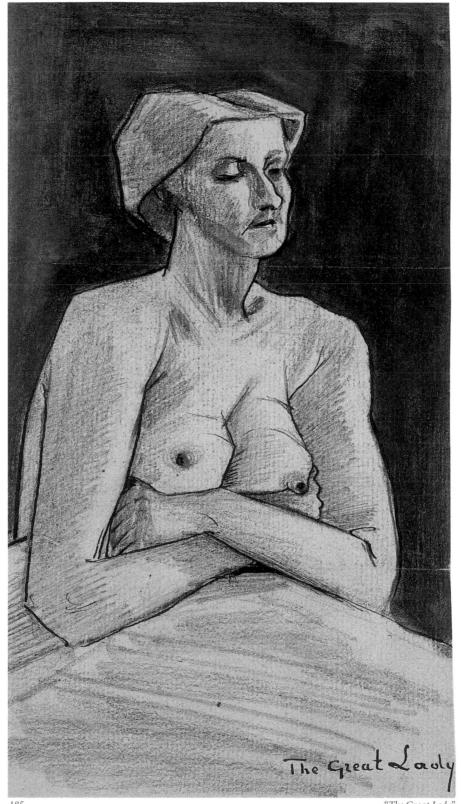

"The Great Lady"

[CA. 15-27 APRIL, 1882]

190

Enclosed is a small sketch of diggers. I will explain why I am sending it.

Tersteeg tells me: "Things were not going well with you before, and you failed, and now exactly the same is happening again." Stop—no, it is quite different from before, and this argument is actually a fallacy.

That I was not suited to commerce or academic study in no way proves that I should also be unfit to be a painter. On the contrary, if I had been fit to be a minister, or to sell the work of others, then I would perhaps not have been any good at painting and drawing, and I would not so readily have taken my leave from those jobs, or been given it.

It is just because I have a draftsman's fist that I cannot keep away from drawing, and I ask you, from the day I first started to draw, have I ever doubted, or hesitated, or faltered? I think you know very well that I have soldiered on, and of course, the battle has gradually become hotter.

Now I come to this little sketch—that was made in the Geest, in drizzling rain, in a street where I stood in the mud among all that racket and noise, and I am sending it to show you that my sketchbook proves that I am trying to capture things as they happen.

For instance, imagine Tersteeg himself in front of a trench in the Geest, where workmen are at work laying a water main or gas pipes; I would just like to see his face, and what sort of sketch he would make of it. To potter around workshops, in streets and alleys, and inside houses, waiting rooms, even bars, that is not a pleasant job unless you are an artist. If you are, you would rather be in the

shabbiest places, provided there is something there to draw, than at a polite tea party with attractive ladies. Unless he is painting the ladies, then even an artist will enjoy a tea party.

All I want to say is, that looking for subjects, moving among laborers, dealing with models and worrying about them, drawing from nature and in the place itself, is rough work, sometimes even messy work, and really, the manner and dress of a salesclerk are not exactly right for me or any other person who does not have to talk to beautiful ladies and rich gentlemen and sell them expensive items, and earn money but, for example, has to draw diggers working in a pit in the Geest.

If I could do what Tersteeg can do, if I were suited to it, I would not be right for my profession, and for my profession it is better that I am as I am, than that I forced myself to adopt a style that would not suit me.

I, who did not feel comfortable in a reasonably respectable coat in a respectable shop, and particularly not now any more, and would very likely be bored and be a nuisance, am an entirely different person when I am working somewhere like the Geest or on the heath or the dunes. There my ugly face and my weather-beaten coat fit perfectly into my environment, and I am myself, and I work with pleasure.

As far as the "how to do it" is concerned, I hope to fight my way through it. If I wear a respectable coat, then the workmen I need as a model are devilishly afraid and suspicious of me, or they will want a lot of money from me.

Now I bumble along as I usually do, and I don't think you will find me among those who complain: "There are no models in The Hague." So if anyone comments on my

manners, my dress sense, appearance, manner of speech, what should I say to that—that such talk bores me?

Am I then a man without manners in a different sense, boorish, or without sensitivity?

Look here, in my view good manners are entirely based on consideration for everyone, based on the need felt by everyone who has his heart in the right place, to mean something to others, and to be useful for something, in the ultimate need we have to live together and not alone. This is why I do my best, I don't draw to annoy people, but to amuse them or draw their attention to matters that need to be noticed and not everyone knows about.

I can't accept, Theo, that I am such a monster of boorishness and bad manners, that I would deserve being excluded from society, or rather, according to Tersteeg, "would not be able to live in The Hague." Do I lower myself by living with the people I draw, do I cheapen myself if I go into the houses of laborers and the poor, and receive them in my studio?

I think this is part of my profession and would only be commented on by those who don't understand anything about painting or drawing.

I would ask this: where do the illustrators for the *Graphic*, *Punch*, etc., get their models from? Do they dig them up themselves in the poorest alleyways of London, yes or no?

And their knowledge of people, were they born to it—or have they made themselves familiar with it at a later stage of life by living among the people and noticing things many others just walk past, by remembering what many forget?

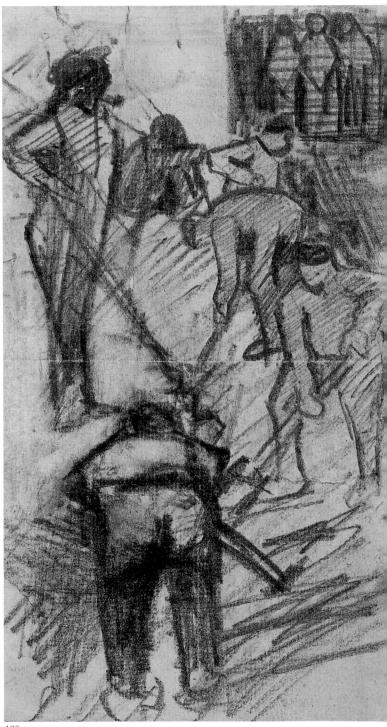

190

[1 MAY, 1882]

195

As far as the carpenter's pencil is concerned my reasoning is as follows. What would the old masters have used to draw with? Certainly not with Faber B, BB, BBB, etc., but with a rough piece of graphite. The tool Michelangelo and Dürer used was probably very much like a carpenter's pencil. But I wasn't there and don't know, but this I do know, that you can achieve much stronger effects with a carpenter's pencil than with all those fine Fabers and so on.

I prefer to have the graphite in its natural form than honed so finely in the expensive Fabers. And the shiny effect disappears when you fix it with milk. If you are working outside with a conté crayon, the bright light prevents you from seeing what you are doing and you soon realize that it has become too black. But graphite is gray rather than black, and you can always add a few "octaves" by going over it again with a pen, so that the strongest shades of graphite become lighter again as the ink pen provides a foil for it.

Charcoal is fine, but if you work it too hard it loses its freshness, and to preserve its finesse, it has to be fixed at once. For landscape too, I see that draftsmen such as Ruysdael, Van Goyen, and Calamé, and Roelofs too, among the moderns, have made a great deal of use of it. But if anyone would invent a good pen for using outside, complete with a container for the ink, there would perhaps be more pen drawings in the world.

With charcoal that has been soaked in oil you can do fabulous things, as Weissenbruch's work shows. The oil fixes it and the black becomes warmer and deeper. [JUNE 1882]

208

This is the first time in several days that I have been sitting up again, and writing like this I am beginning to feel some life reawakening in me. If only I were well again. If I could organize myself properly, I would love to make some studies here in the wards. I am now in a different ward, with beds or cots without curtains, and particularly in the evening or at night there are peculiar effects. The doctor is just as I would like him to be, he looks rather like some of the heads by Rembrandt: a magnificent forehead and a very sympathetic expression. I hope I have learned something from him, in the sense that I hope I will be able to deal with my models more or less in the same way he deals with his patients, that is, to be firm with them and to put them in the required position without further ado. It is marvelous with how much patience this man treats his patients himself by massaging, applying ointments, and handling them in all kinds of ways, infinitely more firmly than an attendant, and how he has the knack of removing their scruples and getting people in the position he needs them to be. There is an old man who would be superb as a St. Jerome: a thin, tall, wiry, brown and wrinkled body, with joints so fabulously clear and expressive that it makes me melancholy not to have him as a model.

[JUNE 1882]

RAPPARD R9

Art is jealous and demands all our time and all our strength, and then when we dedicate these to it, it leaves rather a bitter taste to be taken for some kind of impractical person and I don't know what else.

Well, we just have to try and battle on.

[21 JULY, 1882]

218

Today I have done a study of the cradle, with a few streaks of color in it. I am also doing a repeat of those meadows, which I sent to you last time.

My hands have become rather too white to my liking, but what can I do about it?

I will also work out of doors again, I am less concerned that I may regret it than about staying off work any longer. Art is jealous, she does not accept that an indisposition should be counted more important than her. So I let her have her way. You should therefore, I hope, soon have a few reasonable drawings sent to you.

People like me should not really be allowed to get ill.

You really have to understand how I consider art. To reach the essence of it, you have to work long and hard. What I want and what I am aiming for is infernally difficult, and yet I believe I am not aiming too high.

I want to make drawings that will touch people. Either in a figure, or in landscape, I would like to express, not something sentimentally melancholy, but sincere sorrow.

In short, I want to get to a stage where it is said of my work: this man feels deeply, and this man is sensitive. Despite my so-called roughness, you understand, or perhaps just because of it.

It seems rather pretentious to talk like this, but that is the reason why I want to devote all my efforts to it.

What am I in the eyes of most people? A nonentity or an eccentric, or a disagreeable fellow—someone who has no position in society or will ever have one, in short, the lowest of the low.

218†

Well, assuming that everything were exactly so, then I would like to show through my work what is in the heart of such an eccentric, such a nonentity.

That is my ambition, which in spite of everything is based less on anger than on love, based more on a feeling of serenity than on passion. Although I am often in trouble, there is inside me a serene, pure harmony and music. In the poorest hovel, in the grubbiest corner, I can see paintings or drawings. And as if compelled by an irresistible urge, my soul goes out in that direction.

More and more, other things are pushed out aside, and the more this happens, the sooner my eye can discern the picturesque. Art demands a tenacious effort, an effort in spite of everything, and continuous observation. By tenacious effort I mean in the first place constant labor, but also not abandoning your views at someone else's say-so.

Because I now have such a broad, such a liberal feeling for art and life itself, of which art is also the essence, it seems to me so glaring and false when there are people who only want to rush me. Personally I feel that many modern paintings have a peculiar charm that the old ones don't have.

I hope that apart from the one I did today, I will draw the cradle a hundred times more, with *tenacity*.

[23 JULY 1882]

219

When you come here now, brother, I will have a few watercolors for you.

They are landscapes with complicated perspective, very difficult to draw, but precisely for that reason they show some real Dutch character and sentiment. They resemble the ones I sent last; their drawing is no less conscientious, but now they have color, too—the soft green of the meadow contrasting with the red tiled roof, the light in the sky showing more strongly against the muted tones in the foreground, a yard full of earth and damp wood.

So you will have to picture me sitting in front of my attic window at about four o'clock in the morning, busy studying the meadows and the carpenter's yard with my perspective frame, when the fires in the cottages are being started to make coffee and the first laborer strolls into the yard. Across the red tiled roofs a flock of white pigeons comes sailing in between the black, smoking

chimneys. But beyond that there is an infinity of tender, soft green, miles and miles of flat meadowland, and a gray sky, so still, so peaceful, like a Corot or a Van Goyen.

That view across the ridges of the roofs and the gutters with grass growing in them, very early in the morning, and those first signs of life and awakening, the birds flying, the chimneys smoking, the small figure far below strolling slowly along, is then the subject of my watercolor. I hope you will like it.

Whether things will go well for me in the future depends, I think, more on my work than anything else. As long as I keep going, well, I will fight my battle silently in this way and no other, by looking with enjoyment out of my small window at aspects of nature and drawing them faithfully and lovingly, only taking a defensive attitude in the case of possible molestation. For the rest, I love drawing too much to want to be deflected from it by anything. The peculiar effects of perspective intrigue me more than human intrigues.

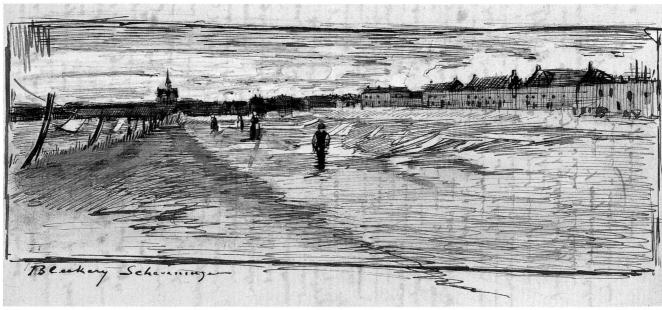

[26 JULY, 1882]

220

I now have three [watercolors] of Scheveningen, again of the fish-drying shed—drawn in as much detail—only this time it has color. You know quite well, Theo, that it is no more difficult to work with color than in black and white: perhaps the reverse, only as far as I can see it depends seventy-five percent on the original sketch, and almost the whole watercolor depends on the quality of that.

It is not enough to do a job more or less well, and it has been and still is my aim to take it to the top.

When you come, I know a few beautiful paths through the meadows where it is so quiet and peaceful that you are sure to enjoy it. I have discovered some old and new laborers' cottages and other dwellings there, quite characteristic, with small gardens on the waterside, very attractive. I am going to draw there early tomorrow. The road runs through the meadows of the Schenkweg to the Enthoven factory or the Zieke.

I have seen the trunk of a dead pollard willow there; it hung over a pool covered with reeds, quite alone and melancholy, and its bark was scaly and mossy, and flecked and marbled in several tones, rather like a snakeskin, greenish, yellowish, mostly dull black, with white patches peeling off and stunted branches. I am going to tackle it tomorrow.

I have also done a bleaching field in Scheveningen in situ, washed entirely at one go, almost without preparation, on a piece of very coarse torchon [unbleached linen]. Here are a few rough sketches of it.

If you work with love and intelligence, you develop a kind of armor against people's opinions, just because of the sincerity of your love for nature and art. Nature is also severe and, to put it that way, hard, but never deceives and always helps you to move forward.

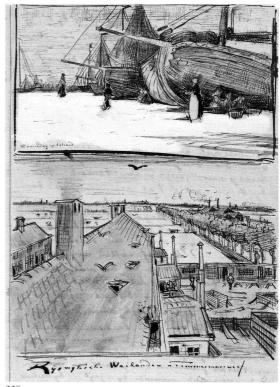

220

All these things make me feel more and more refreshed inside—you will also see that I am not frightened of using a fresh green or a soft blue and the thousands of different shades of gray, because there is almost no color that is not a kind of gray, red-gray, yellow-gray, green-gray, blue-gray. All color mixing comes down to it.

When I went back to that fish-drying shed, I saw that a lush and indescribably fresh green of wild turnip or oilseed had sprouted in the baskets full of sand in the foreground, those things that serve to prevent the dune sands from blowing away. Two months ago everything was bare, all but a little grass in the small garden, and now this rough, wild, luxuriant growth of green provides a most attractive effect as a contrast to the barrenness of the rest.

I hope that you will like this drawing. The wide prospect, the view over the village rooftops with the church steeple and the dunes, was so delightful. I can't tell you how much pleasure it gave me to make it.

[31 JULY, 1882]

2.21

As far as I understand, we are, of course, fully in agreement about black in nature. Absolute black does not really occur. However, like white, it is present in almost all colors and forms the infinite variety of *grays*—in different tones and strengths. So that in nature you do not really see anything except those tones and strengths.

There are only three primary colors—red, yellow, and blue; "composite" colors are orange, green, and purple. From these, by adding black and a little white, the endless variations of gray are derived: *red*-gray, *yellow*-gray, *blue*-gray, *green*-gray, *orange*-gray, *violet*-gray.

It is impossible to say, for instance, how many different green-grays there are; it varies infinitely. But the whole chemistry of colors is no more complicated than those few simple primaries. And a good understanding of them is worth more than seventy different strengths of paint—as you can make more than seventy tones and strengths with the three primary colors and black and white. The man who can calmly analyze a color when he sees it in nature and say, for example, that green-gray is yellow with black and very little blue, is a colorist. In short, one who can create the grays of nature on his palette.

However, to make notes outside, or to make a small rough sketch, a strongly developed feeling for contours is an absolute requirement, and also for working it up later. I don't think that you achieve this automatically, but firstly by observation, and then particularly by tenacious work and research, and in addition, an intensive study of anatomy and perspective is necessary. Beside me hangs a landscape study by Roelofs, a pen sketch, but I can't tell you how expressive its simple contour is. It has everything.

But you will see when you come to the studio that apart from this search for contour I also quite definitely have a feeling for the *strengths* of color, just like everybody else.

I have tackled that old giant of a pollard willow and believe that it has turned out to be the best of the watercolors. An austere landscape—that dead tree with a view beyond it of a stagnant pool covered in duckweed; a depot of the Rhine Railway Company, where the lines cross each other; black, smoky buildings, then green meadows, a cinder track, and a sky where clouds chase each other, gray with an occasional bright, white edge, and a depth of blue where the clouds briefly part. In short, I wanted to make it in the way I think the signalman in his smock and with his little red flag must see and feel it, and say to himself, "What a miserable day it is today."

Of the drawings I will show you now, I think only this: that they, I hope, will prove to you that I am not just staying at the same level, but progressing in a reasonable direction. As far as the commercial value of my work is concerned, I have no other pretensions about that other

than that I would be very surprised if in due course my work would not be just as saleable as that of others. Whether that will happen *now* or *later*, well, I leave that open. Only to work faithfully from nature and with perseverance is, I think, a sure way, which *cannot* come to nothing.

Sooner or later the feeling and love for nature will always find a response in people who are interested in art. It is a painter's duty to immerse himself totally in nature and use all his intelligence and express his feelings in his work, so that it can be understood by others. But to work for the sake of selling is in my view not exactly the right way, but would rather put off the art lovers.

When I see how several painters I know here are struggling with their watercolors and paintings so that they can't see a solution any more, I sometimes think: Friend, the fault is in your drawing. I don't regret for a moment that I did not go in for watercolor and oil painting straightaway. I am sure I will catch up if only I struggle on, so that my hand does not waver in drawing and perspective.

I don't think that you suspect me of *obstinacy*, but it seems to me that the painters here reason in this way. They say, "You must do this and that," and if you don't do it, at least not immediately or not precisely so, or if you argue against it, they follow it up with, "So you think you know better than I do?" In this way you find yourself, sometimes within five minutes, opposing each

other and in such a position that neither of you can move forwards or backwards, nor sideways. In that case the least hateful outcome is that both parties have the presence of mind to be silent and somehow, at the first available excuse, make a hasty retreat. And I would be inclined to say, "Bless my soul, painters are just like a family." In other words, a disastrous amalgamation of persons with conflicting interests, each of whom disagrees with the others, and only a few [of whom] are of the same mind if they find it expedient to join forces to annoy another member. This definition of the word family, dear brother, I hope does not always hold good, particularly where painters or our own family are concerned. That peace may continue to reign in our own family I wish with all my heart.

This is more or less the effect of the pollard willow, but in the watercolor itself there is no black, except in broken tones. Where in this sketch the black is darkest, the greatest strengths in the watercolor can be found: dark green, brown, and gray.

Now adieu, and believe me that sometimes I have to laugh at the people who suspect me (who am actually no more than a friend of nature, of study, of work, and, particularly, of people) of all kinds of malice and absurdities that I would not dream of.

nemen moet. Det is zoowet i effekt var du knotweg maar in de aquaret jeef is geen zwart fan in gebroken toesland.

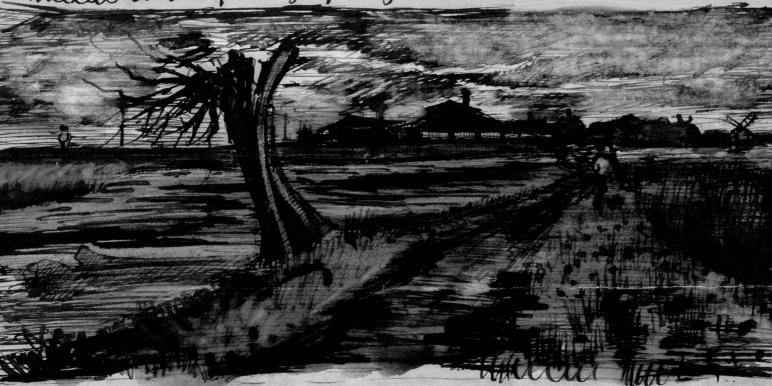

Waar op del robelsje het zwar I donkers is zetten de greats
krocken in de aquarel. _ donker groen breisin
jraciew. Nu adieu, en geloof me dat sommy len
The en hartely hom lock dat de lui my blie eigenlyh
mets anders hen dan een vriend van de matuur van
studie, van werh _ ook vour menschen vooral / verde.
8 an diverse kwaadaardryheden en alsurpitenten
yeen hoar op myn hoof dentt. Enfu - lot zeus

[AUGUST 1882]

222

It stands to reason that many people are unable to carry on because of expenses, and I cannot express how grateful I am that I can work regularly. To catch up on the time I lost by starting later than others, I will have to try twice as hard, but even with the best will in the world I would have to stop if I did not have you.

I will tell you what kind of things I have bought.

First, a large moist-color box for twelve tubes of watercolor, with a double-hinged lid, which serves as a palette when open and at the same time has space for some six brushes. That is a valuable piece of equipment for working outside, and is in fact absolutely essential. However, it is very expensive, and in my mind I had put it off to some later date and meanwhile worked with loose bits on saucers, which are difficult to take with me, particularly when I have other luggage. So that is a wonderful thing, which now that I have got it will last a long time. At the same time I have bought a stock of

watercolor paints and replaced and supplemented my brushes. And I now have everything I absolutely need for actual oil painting. And also paint in stock, large tubes (which are much cheaper than small ones), but as you will understand, for both watercolor and oil paints I have limited myself to simple colors: ochre (red-, yellow-, brown-), cobalt and Prussian blue, Naples yellow, sienna, black and white, supplemented with some carmine, sepia, vermilion, ultramarine, and gamboge in smaller tubes. But I refrained from buying colors I can mix myself. This is, I believe, a practical palette with sound colors. Ultramarine, carmine, or other colors can be added if it is absolutely necessary.

I shall start with small things, but I do hope that this summer I can still practice with charcoal for larger sketches, with a view to painting them later in a rather larger size.

What we saw together in Scheveningen—sand, sea, and sky—is something I would most certainly hope to express sometime during my lifetime.

[AUGUST 1882]

224

I now have three painted studies. One is of a row of pollard willows in the meadow (behind the Geest bridge), then a study of the nearby cinder track, and today I was in the vegetable gardens in the Laan van Meerdervoort again, and there found a potato field by a canal. A man in a blue jacket and a woman were busy lifting potatoes, and I included those figures.

The field was of white, sandy soil, partly turned, partly still covered in rows of dried stems, with green weeds between them. In the distance, dark green and a few roofs.

I took great pleasure in making this last study. I have to tell you that painting does not seem as foreign to me as you might think. Quite the reverse, it appeals to me very much because it is a powerful means of expression. And at the same time you can express tenderness by introducing a soft green in the middle of the rugged terrain.

These studies are of medium size, a little larger than the lid of an ordinary artist's box, because I don't work in the lid, but fix the paper for the study with drawing pins to a frame on which canvas is stretched, which is easily carried by hand.

That the studies will have to become better stands to reason, and also that there is certainly still something lacking, but I believe that you would in these first efforts already see that there is something there from the world outside, something that proves that I have a feeling for nature and that there is a painter's heart in me. I add a little scribble of the Laan van Meerdervoort. Those vegetable gardens there have a kind of old-Dutch cachet that appeals to me.

I marched to the beach this morning and have just come back from it with a fairly large painted study of sand, sea, and sky; a few fishing smacks; and two men on the beach.

There is still some dune sand in it, and I assure you that this will not be the last one. I thought you might be pleased to hear that I have tackled this.

These scribbles have been made in a tearing hurry, as you can see. Now that things are going more smoothly, I will try to strike while the iron is hot and carry on a little with painting.

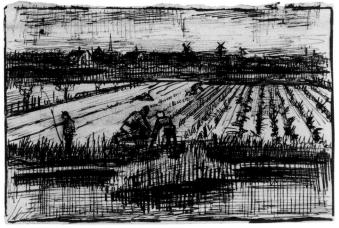

toen ih de en breef gescher en had kwam het my voor dat en iels ovan montkeerle c'k dacht - ih mort zorgen dat ih kem 6 chry ven kom dort ih sens zoo'n brok Zand 2 se lucht het aangepakt 3 voals we'l zamen le Schevening 3 orgen. I ver held it myn brod op en marcheerde dezen morgen ham 18 kand en ben daan an zoveren terug yekomen med sen tamelyk grante geschelder de studie nan sand see a lucht on con pour R zil nog dungand in en A zil nog dungand in en ih verzeher le dat I met by deze bly ver dal! he dacht het h pleasur you down to got sernemer aangepakt olal in del eens have 3 vools gez as in wel zongen dat legen dat ge lerughand I sy over em hue jour of 1 24 aver een und grante hand semanded somes & see knowledge 39 min gol it man traction I gjer le smeden lange l'heet is en nog word doorschilderen. V. I gy legen der to ste-Let gewone juden kund zue is en geen kwestie van dat ik met nag ein hijbje uitsluitend en my men bezig kan henden. Ingeleag dat rend not een maand bezig kan henden. Ingeleag dat rend not een maand bezig geregeld schilderen het oderin een goursch ander wan sen zu son leblen. Hopsinde dat dit it geneegen zal wan sen zich ik it nogmaals de hern , en weursch is van harte voorspaal in alle lingen

Wande I her, Gedurende de dougen verloog en vedert hu vertrek het ik met het ichelderen een poon proeven genomen. En dacht dat gy mistehien wel nieuwygerig joudt wegen hoe I my gegovan is. I'k wenschle wet doch it to gy nog maan eens een nurtie op I aleber kondt zyn - alle dol was de heste weg own to la jasge. here I won untgevollen. Aange en zuehs natuurly hervy. met how wil it it offer man zeggen dol the 3 girchedorde studies hat. Ear som earn ry knotwelgen in I weeloud - (achter de geerbry) dan een studie van den kolenweg vlak by my in Debunt - en heden was it weer in he moestuinen op de locan v. meerdervoort. en font town een aurdappel land met een I loot. En mannelje met blaauwen kreel en een vrount je woven begig de aardapyrees op le rogen en sie feguert es hel her gryebrough. He's land was een wet will en jundgrand half omyesped - holy noy bedell met de ry en verdrouge dlengtes - met groen ontraid er landeli In Iversched downter grown & sen pour doken. Die laatste studie vooral held met bysonder vel plusser gemacht. I'k moet to Jessen dat het schilderen me met zoo vreenn voorhand als ge mes Jehren denten zoudt. Untegendere is het my byponder sympathiet wagers am Beden het en krachtig wildruhhungs model is

224

Is incharan das I geen it van niger eager work jug met als of the reeds are coulent wors his begender a novar - bock od geloof the dat genomen is don't houselearn als als my treft in de nochum meer middle lot myn des positie het dan vroeger am her met men krocest met le drukken. En h vind het met onorangenous doct me viortaan I geen it maak en wat makelyher Joe ulzien. of the gelanfook met dat het me henderen zou als myn examples by ly den eens van struk was. Ever jawee In Kom nagoion zyn het de dechtste schilders met Det mu en dan een week of en dagen hebten dat ze met werken kunnen. Doch keeft wel eens jon oursaak dat zij junt dægener zign gui gmellent lear peau" zoo des Milles zegt. Dat hindert niet en men moet negers enjeens zich met sparen als het en ap aonikant, is het dat men een tydje eelyputi bot kant weer levegt en men heeft gewammen Lut men zyn sludis binnen heeftnetals de baen zon koangha. Nu denh it vove my vorlaag og mag met aan rust houden deen it het gesteren, zendag. wering gedown - all hours ned by hard namy but in givent. O'k wil jorgen dat ich Kwowind ge reed dy en winder ge het Som Roppart omburg it gesteren en bruef - by is man Dreuch geween en ut twee kraklelye In vardelen ein by my stande heeft by niet I tel gezelen. Hy ochynt zen hand le werken set ook, growel aan figuren als aun Nu a den ih moet er ap uit, met een hul handdruh that is no met organical house form getter both to the bornogs began to full own retitas lettras

15 augustus d2 Wastron chis, Ge most het my met kwalyk nemen datih i wen eens chief - het is om te le zeggen dat it in het rehelderen zoo by zunder pleizeer het. Verl Jahrenday would hel it seen dring aangeported wan it it tokujes van gedraamd had -Het is een gezigt in de vlakke groene weelande met hoopen have Een kolenweg met een sloot er large loops dwars in how. In our den houson medden en I schelder I'k Rom Teffekt ommøgelyk god en de haart Tekenem dock ziehen de compride Mason I was getwee een kwerlie van klein a lam le schattereny van de gomma kleuren van de lucks versteen blas nevel waaren de roade zon haef bedekt Down sen donker poursele welk met schelleren con /y a cange; by de zour reflecties van vermily our, moon daarbie een strock gut Door groen weed en knoger blaamachig Ceruleon blue en daar her adaar blaauwachig below a granuwe weeken du reflecties De grand in was seen soul lapy I weepel van graen - grys - bruin mower vil schaleuring en wemeling - bet water van tolastje schekert m dien toonigen grond. Hel is iels was Eine Breton 6.v. zourchied ades you. I want to have side and

[15 AUGUST, 1882]

225

Last Saturday night I tackled something I have often dreamt about.

It is a view of flat, green fields with haycocks. A cinder track with a canal alongside it runs straight across it. And on the horizon, in the middle of the painting, the sun sets in a fiery red glow. I cannot possibly draw the effect in a hurry, but you can see the composition here. But it was altogether a question of color and tone, the hues of a spectrum of colors of the sky, first a violet haze—in which the red sun was half hidden by a dark purple cloud with a thin, brilliantly red border; near the sun were reflections of vermilion, but above it a band of yellow that turned into green, and higher up a shade of blue, the so-called *cerulean blue*, and then here and there lilac and gray clouds, catching reflections from the sun.

The ground was a kind of tapestry of green, gray, and brown, but full of patterning and bristling with movement—the water in the ditch sparkles in that multihued ground.

I have also painted a large piece of duneland—pasted on and painted thickly.

Of these two, of the small seascape and the potato field, *I* am convinced that no one would think that these were my first painted studies.

To tell you the truth, it surprises me a little; I thought my first efforts would look like nothing on earth and might improve later, but although I say so myself, they definitely look like something, and that surprises me a little.

I believe it is because I have spent so much time drawing and studying the perspective before I started painting that I was able to put what I saw together.

I have literally been unable to stop myself, I could not let go or take a rest.

There is some sense of color emerging in me that I never had before, something that is wide-ranging and powerful. [19 AUGUST, 1882]

226

During the whole of last week we have had a lot of wind, storms, and heavy rain here, and I have been to Scheveningen many times to look at it. I came back with two small seascapes.

In one of them there is a lot of sand—but the second one, made when there was in fact a gale and the sea came very close to the dunes, I twice had to scrape off completely, because it was covered in a thick layer of sand. There was so much wind that I could hardly keep upright and could barely see anything because of the blowing sands.

But I still attempted to retrieve it by going to a small tavern behind the dunes and, after scraping it off, putting it back again at once, and from there going back to have another look. So I still have a few souvenirs of it after all.

It has been so beautiful in Scheveningen recently. The sea was almost more imposing before the storm than when it became a real gale. During the gale you could see less of the waves, and there was less the effect of the furrows of a ploughed field. The waves followed each other so fast that one would push away another, and the collision of the masses of water caused a kind of foam like drifting sand, which veiled the foreground of the sea in a kind of mist. But otherwise it was a furious little storm, even more so—and the longer you looked at it the more impressive it was—because it made so little noise. The sea was the color of dirty soapsuds. There was on that spot a little fishing smack, the last one of a row, and some dark figures.

There is something infinite about painting—I can't quite explain it to you—but particularly for the expression of moods it is so wonderful. In colors there are hidden aspects of harmony or contrasts that cooperate automatically and don't take sides.

I hope I can go out again tomorrow.

[20 AUGUST, 1882]

227

This week I painted a few fairly large studies in the woods, which I tried to bring up to a higher level and develop more than the first.

The one I think has come out best is no more than a stretch of turned-over ground—white, black, and brown soil after a rainstorm, so that clumps of earth catch the light here and there and have a more pronounced relief.

The other woodland study is of large, green beech trunks on a piece of ground with dry sticks and the figure of a girl in white. Here the main difficulty was to keep it bright and bring light in between the trunks, which were at various distances, and the place and relative thickness of the trunks changed in perspective—to make it so that you can breathe in it and walk around it, and smell the wood.

I made these two with a great deal of pleasure. As much pleasure as I had from something I saw in Scheveningen: a large plain in the dunes on the morning after the rain; the grass was relatively very green, and black nets were spread out on it in enormous circles, creating tones on the ground of a deep, reddish black and green-gray. On that somber ground, women with white bonnets and men sat or stood or walked about like strange, dark shadows, spreading nets or repairing them.

I am looking forward to autumn. By that time I will definitely have to make sure to have more paint and various things in stock. I am particularly fond of the effect of yellow foliage, which provides such a wonderful foil for the green trunks of beech trees, and also for figures.

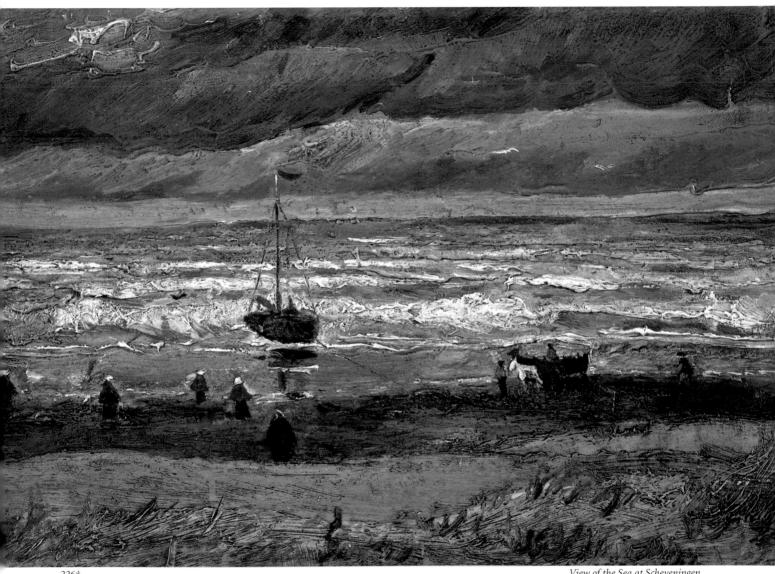

View of the Sea at Scheveningen 226†

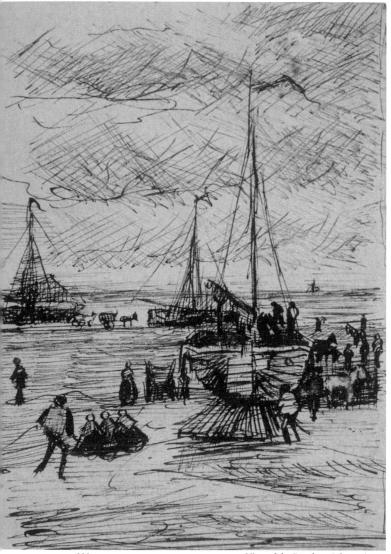

View of the Beach at Scheveningen

[3 SEPTEMBER, 1882]

This week I have painted something that would give you, I believe, a little of the impression of Scheveningen as we saw it when we walked there together. A large study of sand, sea, and sky—a vast sky of delicate gray and warm white, with a single spot of soft blue shimmering through it—the sand and the sea light—so that the whole becomes golden, but animated by the cheeky and oddly colorful little figures and the fishing smacks, which add tones. The subject of the sketch I made there is a fishing smack where an anchor is being weighed. The horses are waiting to be harnessed to pull the smack into the sea.

I am enclosing a rough sketch of it. It took me a great deal of trouble; I wish that I had painted it on a panel or on canvas. I have tried to get more color in it—that is, depth, firmness of color.

The woods are beginning to look distinctly autumnal—there are color effects that I have rarely seen in Dutch paintings.

Last night I was working on a slightly sloping stretch of woodland covered in decayed and withered leaves. The ground there consisted of lighter and darker shades of reddish brown, made more so by shadows from the trees, which threw stripes across it, fainter or stronger, partly blotted out. The problem was—and I found it to be very difficult—to get the depth of color, the enormous power and solidity of that terrain, and yet while I was painting I

noticed how much light there still was in that darkness; to keep the light, and yet to maintain the glow, the depth of that rich color. For there is no tapestry imaginable as magnificent as that deep brown-red in the glow of an autumn evening's sun, tempered by the trees.

From that ground young beeches have sprouted, which catch the light from one side and are a brilliant green there, and on the shadow side of their trunks a warm, strong black-green.

Behind those slender trunks, behind that brown-red ground, is a sky, very delicate, blue-gray, warm, barely blue, tingling.

And against it is a hazy border of green and a network of small trees and yellowish leaves. A few figures of people gathering wood move around there like dark shapes of mysterious shadows.

The white bonnet of a woman bending down to reach for a withered branch suddenly stands out against the deep reddish brown of the ground. A skirt catches the light—a shadow falls—a dark silhouette of a man appears above the undergrowth. A white bonnet, a cap, shoulder, a woman's breast molds itself against the sky. These figures are great and full of poetry—in the half-light of the deep shadow tone they look like enormous terra-cotta figures being modeled in a studio.

To paint it was a hard job. I used a large tube and a half of white for the ground—and yet that ground is very

dark—also red, yellow, brown ochre, black, terra sienna, bister, and the result is a reddish brown, but that varies from bistre to a deep wine-red and to a pale shade, golden, almost reddish. And then there are mosses and an edge of fresh grass, which catches the light and shines brightly and is very difficult to get right.

However, as this effect does not last, I had to paint fast. The figures have been put on with a few powerful strokes of a firm brush, in one go. It struck me how firmly those small trunks were rooted in the soil; I started to do them with a brush, but because the ground was already heavily pasted on, a brushstroke sank away to nothing, so then I squeezed some roots and trunks onto it straight from the tube and modeled them a little with the brush.

How I paint *I don't know myself*; I come and sit with a white board in front of a scene that catches my eye, I look at what is in front of me, and I tell myself: That white board will have to become something.

As you see I am totally absorbed by my painting. I am engrossed in the color—I have refrained from using it until now and don't regret it.

As you see from the scribble of the seascape, there is a golden, soft effect and in the woods a more sober, serious mood. I am pleased that both exist in life.

Wound Theo, Met en entre words we it h may getakwanschen met w l'epr. . . de het yerchieven dat it aen hug hit out unger van tree der my heel auroy du nation van Nueven berchieft. Het ochynt das bet down lender movi is. On hel hour may een en andere meesting ambent de wevers gerrage de me hyponder interesperen. It het dat ender egd m'i l'as de Colour gezun unherchryfiegh Doch whytohen had it may geen wevers he rebelderen of schoon vroezer of eater the hoop or seems van Komen zue ih zueles seus due. mi er het heift in rborch - I hen dans vol vans. Er zyn u den haft I war dengen de my begande aanhekken. En soms en goethe gelemperde leid in de was years von de dinge Dan every en hom he same den meer staeren ruwen kant - von die storke lietteffahlen 6. Jap joan spotter de m de midday jan staat Justen. Hierby en paar krobbelys und Justen, die de der werk maakle. In Montmarke die gegen in laakten brief bescheven hebt het lay my by dat er innen was die die byjonder gued gemaakt heeft. Ik heral A Langun - ih keek nog eens de hoodsneden na die hour hew heb - was is die kerel to ch knap - it jag er by een Rendez vous sto chifformies een destribution de vouge - Novement de neur de it prostby vend. En by is pro producted - I is als of by het we you mount schude.

Jam wan it die aurdoppilmans jog is het jas aurdig.

al tet arme volk van de Jeert van het dedig erf
en at die hoffes daar in de huurt komt dun aurdoppen
fleeds zijn daar derglighe rienes mit is I een soluid met
ting - dair weer een met verch da met sleinhaut fles and,
O'k het eene menigte schels in ran Engelsche arteilen
uit O'erland - my dreicht dree haurt woarven
it is robert must vere van een iersche slad hebten.
It due at myn hed en kracht achter te zellen det
want it verlang er zoo dah naar maare droppen te
maken - maar maare droppen kanter my een
an belaanstelling en voekraden. Kahen my een
allegen het vere van der gegen, hue pracht,
diet effekt in de notuen was
kun it het bruns van het grain
and het bruns van het grain
and het bruns van het grain
het daan.
The wan dot geg en darands
wan het bruns van het grain
and het bruns van het grain
and het bruns van het grain
het daan.
The wan dot geg en darands
wan het bruns van het grain
and het bruns van het grain
het daan.
The wan dot geg en darands

here - Helgeen ha del gran and levery jul brenger is may mean ear schnalen veget end me took hury he ear paan denight and later here lange have me paan denight del ger and you was hered to ger and later human god. In all you was much a new man med a may make the act of mark! - Jour 1e scheder gast me van wegt I with - I hel to en lock at ordings smay had van moen moun average human and he hurger may loopen a journe camplement Noon the ranger may loopen a journe camplement Noon the ranger wall down west hypey or am le jeen that here he locked in dopply sien in heart. A longer word weet had it dopply sien in heart. a order mut een handruk for I

[9 SEPTEMBER, 1882]

229

Now it is autumn in the woods—I am full of it.

There are two things in autumn that particularly appeal to me. Sometimes there is a mild melancholy in the falling leaves, in the muted light, in the haziness of things, in the elegance of the slender tree trunks.

Then I love the more sturdy, rugged side just as much; those strong light effects, for instance, on a man digging, perspiring in the midday sun.

I believe that through painting I will reach a point where I will get a better sense of light, which will add a completely different dimension to my drawings.

I feel such a creative force in me; I am convinced that there will be a time when, let us say, I will make something good *every day*, on a regular basis.

[For instance, I did] a rough sketch of the potato market in the Noordwal—the bustle of laborers and women with baskets that are being unloaded from a boat is fun to see. These are things that I would like to paint or draw in a *powerful way*—the life and movement of such a scene, and the types of people.

I am doing my very best to make every effort, because I am longing so much to make beautiful things. But beautiful things mean painstaking work, disappointment, and perseverance.

Here is another woodland scene done in the evening after rain. I can't tell you how magnificent the effect was in nature, with the bronze of the green and here and there the fallen leaves.

[11 SEPTEMBER, 1882]

230

You will remember, as I wrote to you in my last letter, that I went to that potato market. I came home with many sketches, it was exceptionally attractive—but here is a sample of the behavior of The Hague locals towards painters: a chap behind me, or probably from a window, spat a wad of tobacco onto my paper—you have a lot of bother sometimes. Oh well, it's not worth getting upset about it; those people don't mean badly, but they just don't understand it at all and probably think I am mad, when they see me draw with large lines and scratches that don't mean anything to them.

I have been very busy recently drawing horses in the street. I would like to have a horse as a model some time. For instance, yesterday I heard somebody behind me say, "Now, what kind of a painter is that, he draws the horse's behind instead of his front." I was rather amused by that.

I enjoy doing that, making sketches in the street, and as I said in my last letter, I would like to bring that up to a certain level.

I am so covered in paint that some has even got onto this letter.

[17 SEPTEMBER, 1882]

231

I have spent quite a lot of time in Scheveningen recently and one evening very fortuitously came across the arrival of a fishing smack. Near the monument is a wooden hut where a man is on the lookout. As soon as the smack was clearly in sight, the man came out with a large, blue flag, followed by a clutch of small children who barely reached up to his knees. It was obviously a great pleasure for them to stand near the man with the flag, and by doing so they clearly imagined they were helping the smack to come in. A few minutes after the man had waved his flag, another fellow on an old horse came along, who had to bring in the anchor.

After that the group was joined by various men and women—mothers with children too—to meet the crew.

When the smack was near enough, the man on horseback went into the sea and came back with the anchor. After that the men were brought to the beach on the backs of men wearing waders, and there was a noisy welcome for each new arrival. When they were all in, the whole lot marched home like a flock of sheep or like a caravan, with the chap on the camel—I mean on the horse—towering above everyone else like a tall specter.

Obviously all my attention was focused on trying to sketch the various incidents. I have also painted some of it, for instance, the group I have shown in this scribble.

But how hard it is to get life and movement in them, and get the figures in their place and yet as individuals. It is that big problem of *moutonner*, groups of figures that, although forming a whole, from above show up with heads and shoulders, one above the other, while in the

foreground the legs of the first figures stand out clearly, and higher up the skirts and trouser legs turn into a kind of muddle, which yet shows some line.

Then to the right and left, according to the viewpoint, the further extension or shortening of the sides. As for the composition, all kinds of possible scenes with figures are based on that same principle of the flock of sheep [moutons], from which surely the word moutonner comes. Everything boils down to the same issues of light and brown and perspective, whether they are in a market, at the arrival of a boat, a group of people at the soup kitchen, in a waiting room, hospital, the pawnshop, or groups walking or talking in the streets.

[18 SEPTEMBER, 1882]

232

It is with drawing more or less as with writing. When you learn to write as a child, you have a feeling that it is quite impossible that you will ever understand it, and it seems a miracle when you see the schoolmaster writing so fast. Nevertheless you get the hang of it in time. And I really believe that this is the way to learn to draw, that it will become just as easy as writing something down, and you need to have the proportions in your head and learn to see them in such a way that you can reproduce something you see at will, in a larger or smaller size.

We are having very beautiful bad weather these days—rain, wind, thunderstorms, but with wonderful effects, which is why I think it beautiful, but otherwise it feels very chilly. The time that I can go and sit outside is getting considerably shorter, and I need to make the most of it before the winter comes

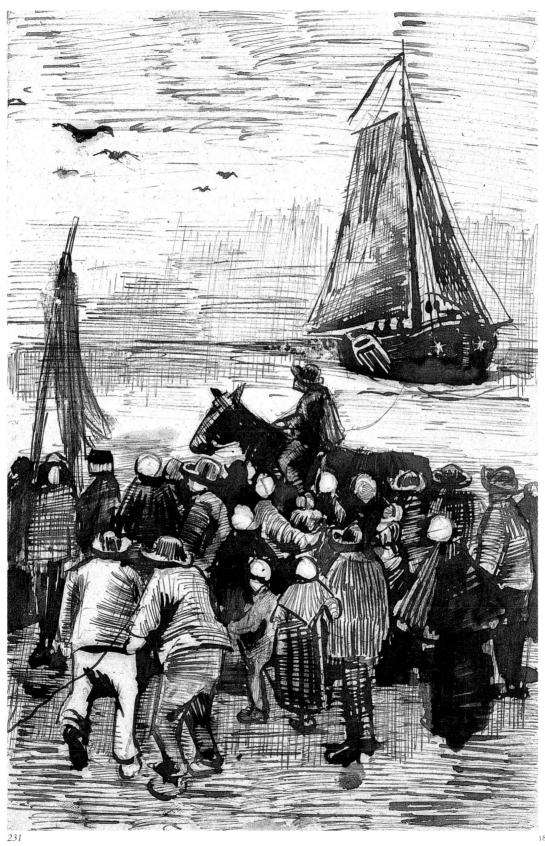

[CA. 1 OCTOBER, 1882]

235

Do you remember Moorman's National Lottery Office at the beginning of the Spuistraat? I came past it one rainy morning, when people were waiting outside to collect lottery tickets. They were mostly old women and the sort of people of whom you can't say what they do or how they live, but who obviously have a lot to do and worry about, and who get on with life.

Looking at it superficially, such a group of people, who clearly take a lot of interest in "today's draw," is obviously something you and I would almost laugh at, as the lottery leaves both of us completely cold.

But the little group of people—and their expression of waiting—touched me, and while I drew it, it began to get a greater, deeper meaning for me than at first.

It becomes more meaningful when you see it in terms of the poor and the money. This actually applies to almost all groups of figures. You sometimes have to think it through before you recognize what it means; the curiosity and illusion about the lottery seems a little childish to us—but it becomes serious when you think that in a revolt against misery and in an effort to forget,

the poor souls will buy a lottery ticket, paid for with money for which they have stinted themselves, which they imagine might possibly rescue them.

Anyhow, I have set up a large watercolor of it. And moreover, I am working on one of a church pew I saw in a small church in the Geest, where the almshouse men go (here they have a very expressive name for them: *orphan men* and *orphan women*).

Once I am busy drawing, I sometimes think that there is nothing as pleasant as drawing.

This is part of those pews—in addition there are men's heads in the background.

It is obvious that in that group of figures, of which I am sending a scribble in black, there were splendid examples of color: blue smocks and brown jackets; white, black, and yellowish workers' trousers; faded shawls; an overcoat turning a greenish color; white bonnets and black toppers; muddy street cobbles and boots, as a contrast for pale or weather-beaten faces. That is where oil painting or watercolor comes in. Anyhow, I will work on it.

Wat heer woh wan zy it he er een groote equine van op toew. In ben bovendren bezig aans een van eens kerke ap er kerkbank die it zag in een keen kertye ap er geet wan de and drakome mannelye goan (men noemt je heer zeer cepressiet Welsmanmen) en weed vrouwen. — dat wen eens druk aan v heehenen zynde it domo dent er is lock need zoo prellig als leekenen.

andre tapper of ten achtergrand can mannen. en 34 may andre tapper of ten achtergrand can mannen. 3 mike dengen 34 n echter mountly hen jullen soom seens met lukken. Het getakken van van Verndrevelaal van seen heile verie meslakkange San Skeel mannen geoproken — ih serd in I schryken can bezer gestoore door de Romet van myn model. En ik het tot den donker met fleur gewerkt. En ik het tot den donker met fleur gewerkt. En ik het tot den donker met fleur gewerkt. En ik het tot den donker met fleur gewerkt. En ik het tot den donker met fleur gewerkt. En ik het tot den donker met fleur gewerkt. En ik het tot den verfas aan en gewerkt. En ik het tot den prode onen han zondago x werkpek. Edlechte weedmannen in hun zondago x werkpek. Form porkte it hem oak nag eens zellende met een pij pe. Hy hull ern aarbijen kalen kop - groote ooren hull en sichte tekhebeardy

235

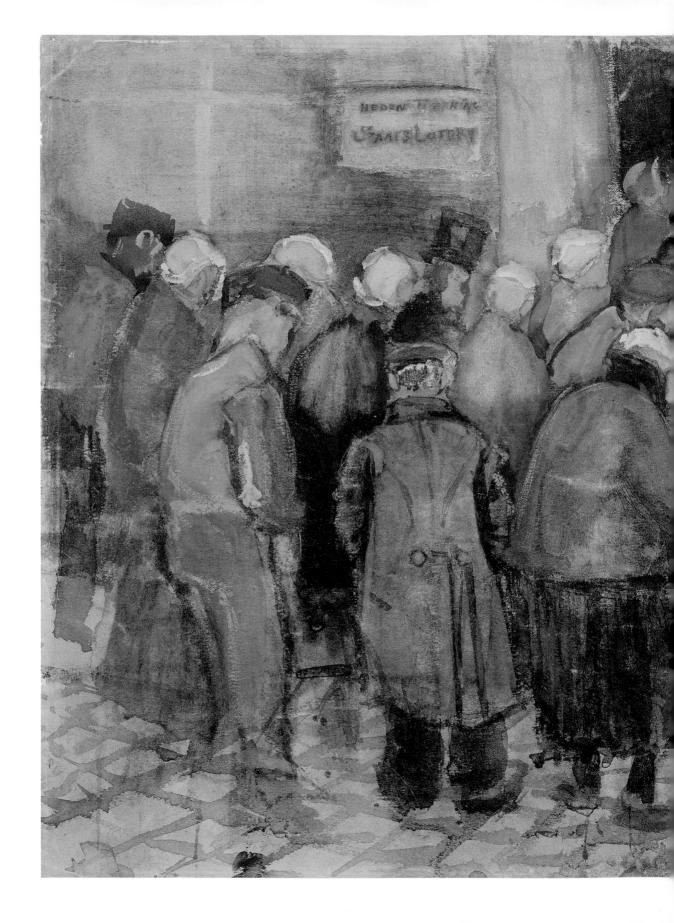

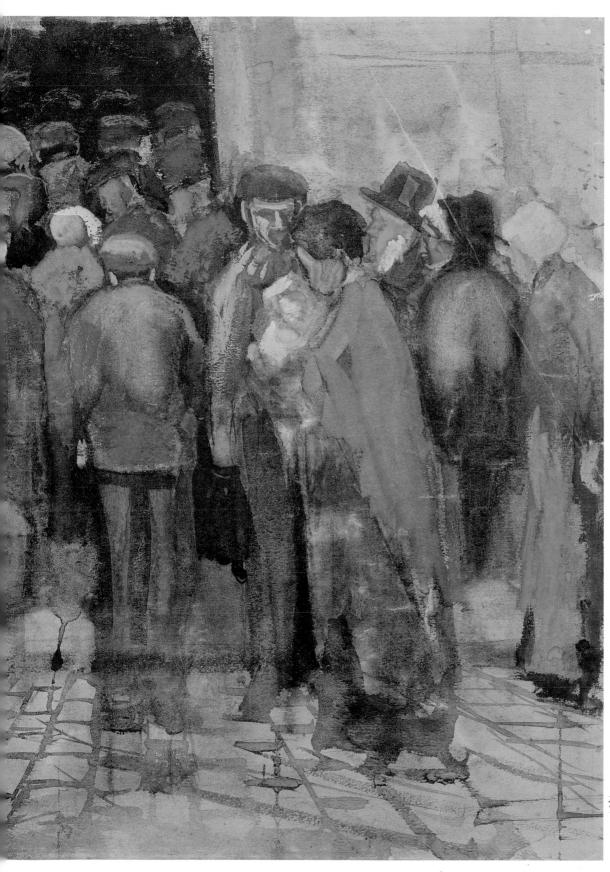

235† The Poor and Money

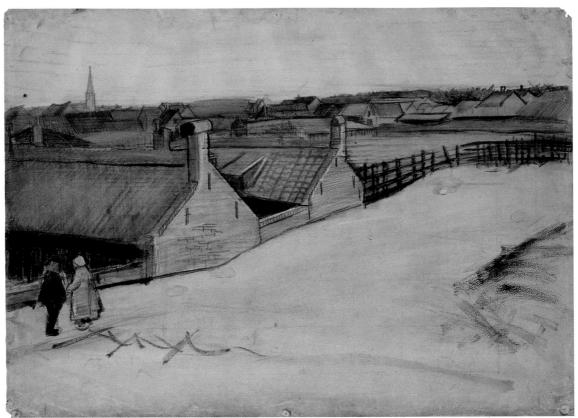

View of Scheveningen

[22 OCTOBER, 1882]

237

We keep having true autumn weather, rainy and cold, full of mood, particularly wonderful for figures, which stand out in tone in the wet streets and roads that reflect the sky.

Because of it, I have been able to do a little more on the big watercolor of the people in front of the lottery office, and I have just now also started another one of the beach.

I fully agree with what you say about the times we sometimes have, in which we seem to be less perceptive towards the things of nature, or where nature no longer seems to speak to us.

From the studio window I get a splendid prospect at the moment. The town with its spires and roofs and smoking chimneys stands out as a dark, somber silhouette against a horizon of light. This light is, however, only a single broad stripe; above it hangs a heavy shower, more concentrated at the bottom; at the top it is torn by the autumn wind into great tufts and solid masses that float away from it. But that strip of light causes the wet roofs to glisten here and there in the gloomy mass of the town (in a drawing a brushstroke of body paint would bring it out), and this means that although the mass has one tone, the difference between red tiles and slates is still visible.

The Schenkweg runs through the foreground like a glistening stripe through the wet, the poplars have yellow leaves, the banks of the canals and the meadow are a deep green, the figures black.

[CA. 10 OCTOBER, 1882]

238

Work out of doors has now stopped—that is to say, work that involves sitting still, because it is too cold—so we will have to occupy our winter quarters.

I think I quite like winter; it is a wonderful season if you can keep on working regularly. I have some hope that it will work out.

[EARLY NOVEMBER 1882]

242

How good it is to walk along an empty beach and look at the gray-green sea with its long, white streaks of waves, when you are feeling depressed. But if you have a need for something great, something infinite, something in which you can see God, you don't have to look far: I think I have seen something deeper, more infinite, more eternal than an ocean, expressed in the eyes of an infant when it wakes in the morning and crows with pleasure, or laughs because it can see the sun shine in its cradle. If there is a *rayon d'en haut*, a "ray from heaven," perhaps it can be found there.

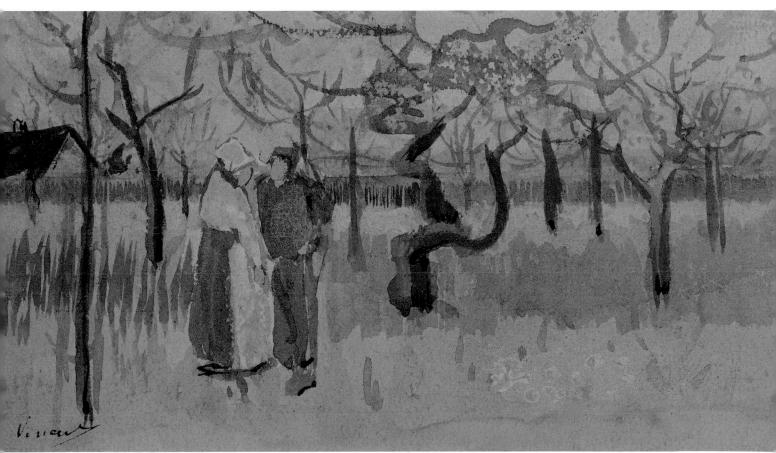

Orchard in Blossom with Couple: Spring

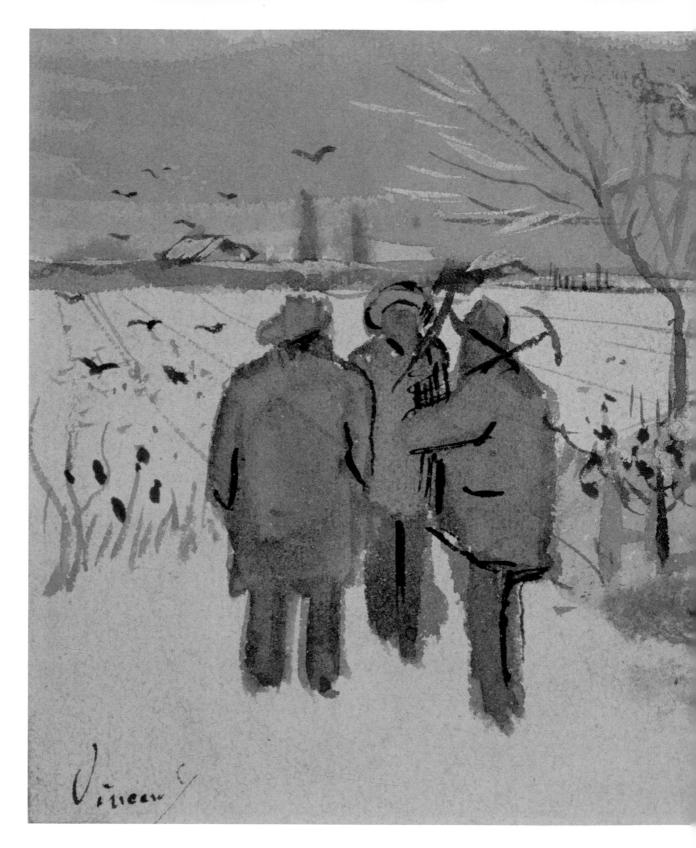

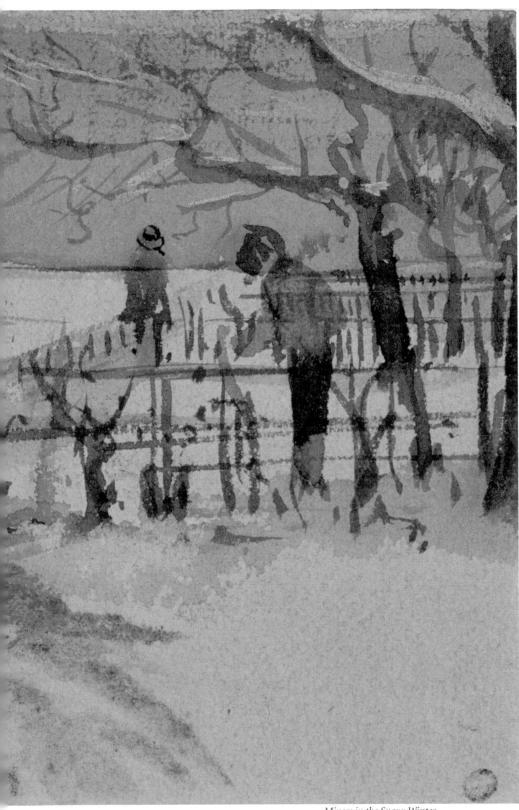

Miners in the Snow: Winter

[CA. 3-5 DECEMBER, 1882]

251

I told myself that what I had to do was obvious: to do my very best with the drawings. Hence, in the time between my letter about this subject and now, I have made some new ones.

First of all, a sower. A large, elderly fellow, a tall, dark silhouette against a dark background. In the far distance, a heathland cottage with a moss-covered roof and a patch of sky with a lark. The man is a kind of cock-like figure, a clean-shaven face, a rather sharp nose and chin, small eyes, and a drawn-in mouth. Long legs with boots on.

Next, a second sower with a pale brown bombazine jacket and trousers, so his figure stands out pale against the black field, [which is] bordered by a row of pollard willows at the end.

This is quite a different character, with a fringe of beard, broad shoulders; a little squat, a little like an ox, in that his whole appearance has been determined by working on the land. If you like, more an Eskimo type, with thick lips and a broad nose.

Then a mower with a large scythe in a meadow. The head, with a brown woolen cap, is outlined against the clear sky.

Next, one of those little old men with a short jacket and a large topper, such as you might well meet in the dunes. He is carrying home a basketful of peat.

These characters are all doing something, and that trend in particular must be maintained generally in the choice of subjects, I think. You know yourself how beautiful the numerous figures at rest are, which are so very, very often shown. They are done more often than figures at work.

It is always very tempting to draw a figure at rest; it is very hard to express action, and in the eyes of many the effect of the former is more "attractive" than anything else.

But this "attractiveness" should not hide the truth, and the truth is that there is more toil than rest in life. So you see, my opinion about it all is particularly that I personally try to work on the truth.

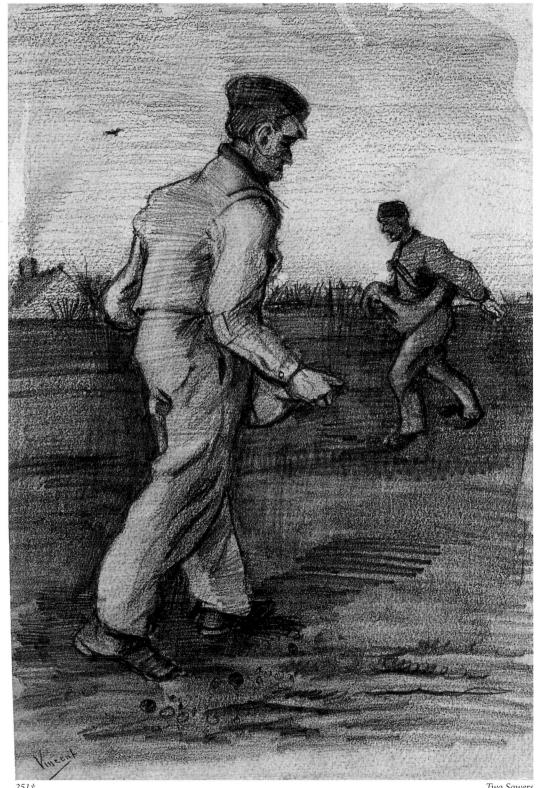

251† Two Sowers

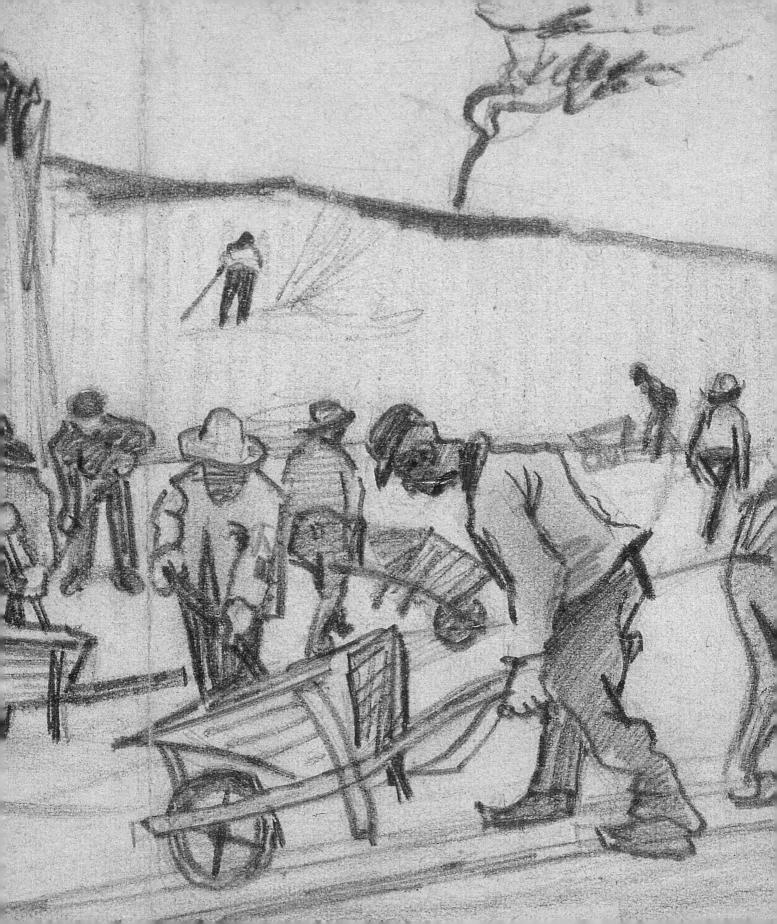

Part III 1883

an Gogh continued to produce many drawings throughout 1883. They included figures studies and street scenes from The Hague that testify to his continued fascination with humble subjects. That summer, he was much occupied with studies of peat diggers and potato diggers. Although he produced the occasional watercolor or oil composition, his focus on drawing remained strong, not least because of the higher cost of painting.

His forays into the countryside surrounding The Hague sparked a longing for rural life. Moreover, the higher cost of an urban lifestyle was much on his mind, and his home life was also deteriorating rapidly. These factors all contributed to a growing restlessness.

A maudlin letter from August (Letter #309) hints at his state of mind: he muses on an untimely death and resolves to maintain his relentless pace of work, even to his own detriment. This letter foreshadows the emotional instability that troubled him in later years, as well as the intensity of his commitment to his art.

That fall, he broke with Sien and left The Hague for the remote province of Drenthe, where he hoped to establish a kind of artistic colony. Although inspired by the stark landscape of the region, van Gogh failed to achieve his utopian vision. He instead endured several months of loneliness and deprivation, the latter exacerbated by delays in Theo's remittances. After briefly considering the idea of joining his brother in Paris, where the younger van Gogh was making his name as an art dealer, he decided instead to move back in with his parents, who were now living in the small town of Nuenen.

Tensions ran high when van Gogh first joined his parents, mostly because of lingering rancor over the Sien affair. Despite the chilly reception, van Gogh was to stay on for nearly two years.

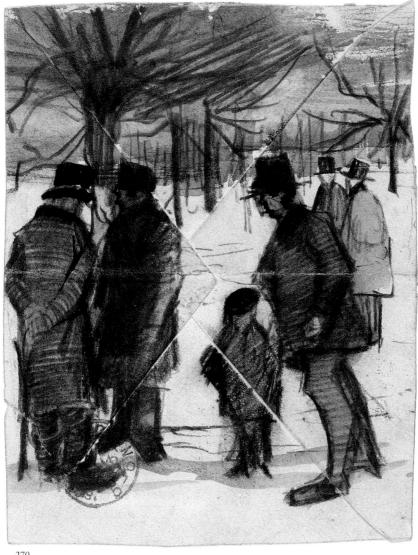

5 FEBRUARY, 1883

264

In the evening at sundown, there are effects of dark clouds with silver linings that are magnificent, for instance, when you walk along the Bezuidenhout [in The Hague] or the edge of the woods. You will remember that from past times. From the window of the studio it is also beautiful, or in the meadows—you feel the spring far off, and now and then there is already something balmy in the air.

[CA. 2 MARCH, 1883]

270

However unfinished and imperfect, you see here a chunk of street life as I want to represent the Geest [in The Hague], etc., or the Jewish quarter [in Amsterdam]. This sketch is not a chance occurrence; I can get all kinds of scenes I see to this level and this relatively expressive color and tone. If you now compare this sheet with the lithographs and drawings of heads I sent you this winter, then you will clearly see from those various failures what I am trying to achieve.

The large studies of heads, for example, of which I still have plenty of others, with sou'westers, or shawls and white bonnets, and top hats and caps, will have to serve for compositions like the ones I am sending you now.

In watercolors a good deal depends on great skill and fast work. You have to work in semi-wet conditions to get a harmonious effect, and there is not much time for reflection. So it does not depend on finishing it little by little, no, you have to set up those twenty or thirty heads almost at once and one after the other. Here are a few interesting things said about watercolors: "L'aquarelle est quelque chose de diabolique" ["Watercolors are something diabolical"], and the other by Whistler who said: "Yes, I did that in two hours, but I worked for many years to accomplish something like this in two hours."

Enough about that then—I love watercolor too much ever to drop it entirely, I keep beavering away at it again and again. But the foundation of all things is knowledge of the human figure, so that you can quickly draw men, women, and children in all possible activities. I concentrate mostly on that, because I don't believe that there is any other way of achieving what I want.

And I am trying to work myself up to a higher standard of knowledge and skill in general, rather than worrying about finishing any particular sketch. If I have spent a month drawing, I make a few watercolors, for instance, by way of testing the water; I then see time and again that I have indeed solved a thing or two, but that new difficulties have arisen. I then start to struggle anew to conquer those.

As far as paint is concerned, that has really all been used, and not only that, but because of one or two fairly large expenses I am totally broke rather than just short of cash. Spring is on the way, and I would like to do some painting again, too. So that is certainly partly the reason why I don't paint in watercolor at the moment.

However, indirectly I am working on it all the time, and because the changes in the studio mean that I will now be able to study the effects of chiaroscuro better, I will also be able to work more and more with a brush in black and white drawings, and wash any shadows in plain shades in them with neutral tint, sepia, india ink, Cassel earth, and bring out light effects with Chinese white.

Do you remember last summer you brought me pieces of mountain crayon? I tried to work with it then, but didn't succeed. As a result, some pieces remained, which I picked up again one day. I enclose a rough sketch done with it: as you see it is a strange, warm black. I would be very pleased if you could bring me some more of it this summer. It has a great advantage—the solid pieces are much nicer to hold in your hand when sketching than a stick of conté crayon, which is difficult to keep hold of and keeps breaking. So it is excellent to sketch with outside.

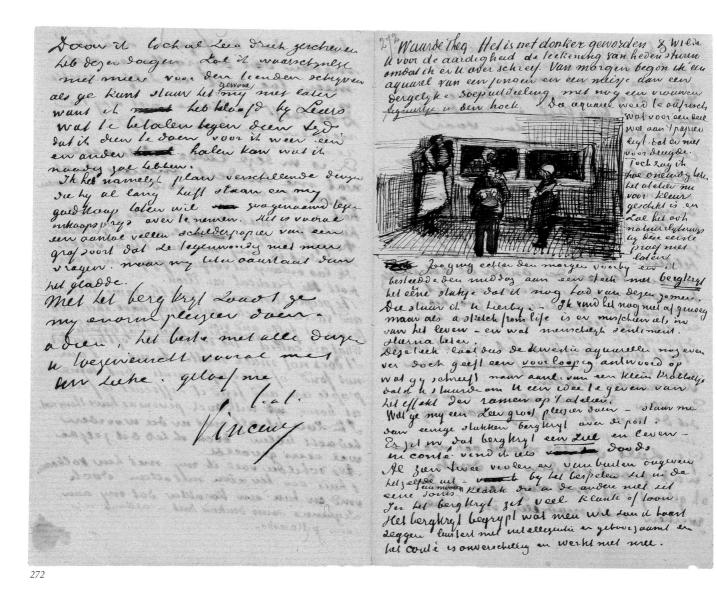

[CA. 4 MARCH, 1883]

272

It has just got dark, and just for fun I wanted to send you today's drawing, because I have written about it to you. This morning I started on a watercolor of a boy and a girl at a soup kitchen like the one I told you about, with another figure, a woman, in the corner. That watercolor turned out too dingy, which is partly because the paper was not right for the purpose.

Yet I could see how infinitely more suitable the studio is now for color, and I will obviously not leave it at this first attempt. However, this is how I passed the time in the morning, and I spent the afternoon doing a drawing in *mountain crayon*, the one little piece I had left from this summer. I am enclosing this drawing now. I don't think it is sufficiently finished, but, as a sketch from life, there is perhaps something there of life and of some human sentiment. I'll do better next time.

[11 MARCH, 1883]

274

In my view I am often *immensely rich*, not in money, but (although just now perhaps not all the time) rich because I have found my métier, something I can devote myself to heart and soul and that gives inspiration and meaning to my life.

My moods vary, of course, but nevertheless I have on average acquired a certain serenity. I have a strong *belief* in art, a certain *faith* that it is a powerful current that carries a man to a haven, although he himself has to put in an effort too. I think in any case that it is such a blessing when a man has found his métier, that I don't count myself among the unfortunates.

I mean that even if I were in some considerable difficulties, and if there were dark days in my life, I would not wish to be taken for one of the unfortunates, nor would it be right.

[CA. 21 MARCH. 1883]

275

The scribble overleaf is from a drawing I started early this morning and toiled on all day. It is perhaps the best I have done so far, at least in the use of light and brown. I am sending you this scribble, although I can't possibly work on this paper in such a way that the same strengths show up—this is out of proportion and the drawing has more foreground—because I think that you will be able to see from it what I have gained by the change of lighting in the studio. The figure is posed against the light, and to represent this it needs something more than an outline; because the light falls from a single source, the modeling gains in character and the strong points are in harmony with each other and reach a mutual rapport. In the first place this conception brings with it the difficulties of representing what you can see, but also something else, which means you have to work hard at it: that is the problem of placing a figure in such a way and getting the light to fall just so, [so] that the character stands out best and most complete. Whatever you see outside or inside has to be analyzed in relation to the light to such an extent that it can be retraced.

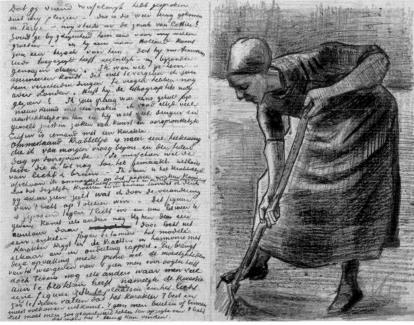

1883

6 Man in Village Inn

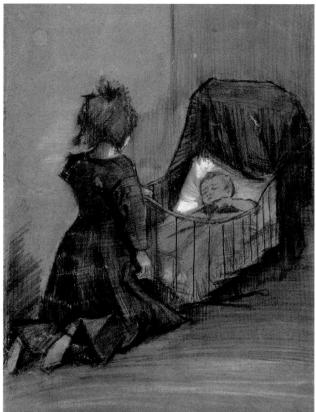

[CA. 21-28 MARCH, 1883]

276

The cold days we had last week have in my view been the most "real" part of this winter. It was incredibly beautiful with the snow and the curious skies. The melting snow today was almost even more beautiful.

But it was *typical* winter weather, if I can call it that; it was the kind of weather that brings back old memories, and the most ordinary things look so different that it makes you automatically think up stories from the time of stagecoaches and mail coaches.

Here, for instance, is a scribble I did in such a reverie. It represents a gentleman who has had to spend a night in a village inn because of the delayed arrival of a stagecoach or similar. Now he has got up early, and while he imbibes a glass of brandy against the cold, he pays the landlady (a little woman with a peasant bonnet). It is, however, still very early in the morning, at break of day; he still has to catch the mail coach. The moon is still shining, and through the window of the public room you can see the snow flicker, and things have curious, fanciful shadows.

This story in fact means nothing at all, and the scribble is also nothing, but perhaps one thing and another will make you understand what I mean: that everything in those days had a *je ne sais quoi* that made you want to put it on paper.

In short, when we have these snow effects, the whole of nature is an indescribably beautiful black and white exhibition.

276 Girl Kneeling by a Cradle

As I am so busy doing scribbles, I add another very superficial one of a drawing in mountain crayon: a little girl by a cradle, done in a similar way to the drawing of a woman and child, about which you wrote. Really, this mountain crayon is a curious medium. The other scribble of a skipper is from a drawing in which there has been much use of washing with neutral tint and sepia.

APRIL 1883

278

Thank you for your good wishes on my birthday. As it happened, I had a very nice day as I had an excellent model for a digger.

I can reassure you on one thing: the work is becoming more and more enjoyable, and I feel—if I can put it that way—more of an inner warmth because of it. It makes me think of you, as it is because of you that I can work. Without fatal obstacles, that is, without any direct ties. Sometimes difficulties can be stimulating. Now the time has to come to find still more energy to put behind it.

My ideal is to work with more and more models, a whole herd of poor souls for whom the studio could be a kind of haven of refuge in cold days, or when they are without work, or are in need. Where they know that a fire, food, drink, and a few quarters can be earned. That is still on a very small scale now, but I hope it will increase.

Here we have lovely spring weather now. The evenings are indescribably beautiful.

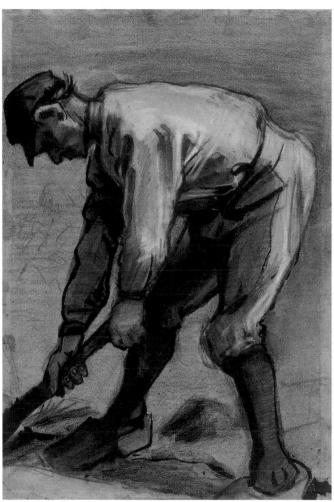

278†

Man Breaking up the Soil

[CA. 26 MAY, 1883]

RAPPARD R36

What a lot of wonderful things we come across, don't we? The drawing of the Peat Cutters I have now sketched with charcoal and with autographic ink. I have not yet used the strongest forms of printing ink. As a result, the prospect is not as powerful as I suppose it could have been. My only objection to charcoal is that it wipes away so easily that you can lose things you have done, if you are not careful. And I would rather not have to be too careful.

[CA. 30 MAY, 1883]

287

This week I have been busy working on a large drawing, of which I send you a rough sketch.

These are the peat cutters in the dunes—the actual drawing has now turned out to be about one meter by half a meter.

The natural scenery is fabulously beautiful, from which an infinite number of subjects can be drawn. I spent much time on it these last few weeks and made various studies. Rappard saw some of the studies, but when he was here we did not quite know yet how to bring it all together. But this composition was created later. And by the time I had got it more or less together, it really took off, and I was already at work in the attic by four o'clock in the morning.

When you see the drawing, I don't think you will find it too large.

The proportions the figures have acquired in this way are such that you can put some power into them, and each one demands a separate study. I have made studies of all the figures that appear in it. I have made this drawing with charcoal, mountain crayon, and printing ink.

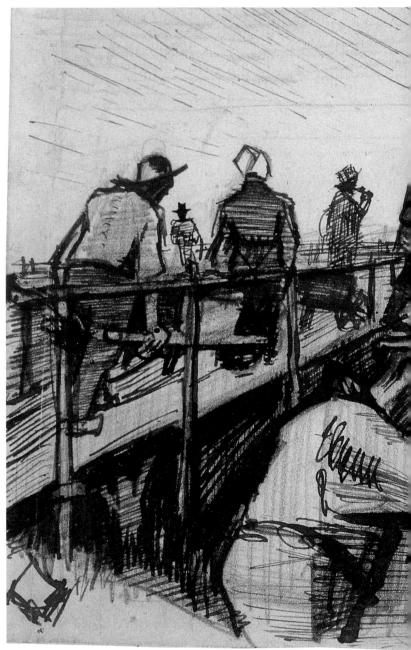

287†

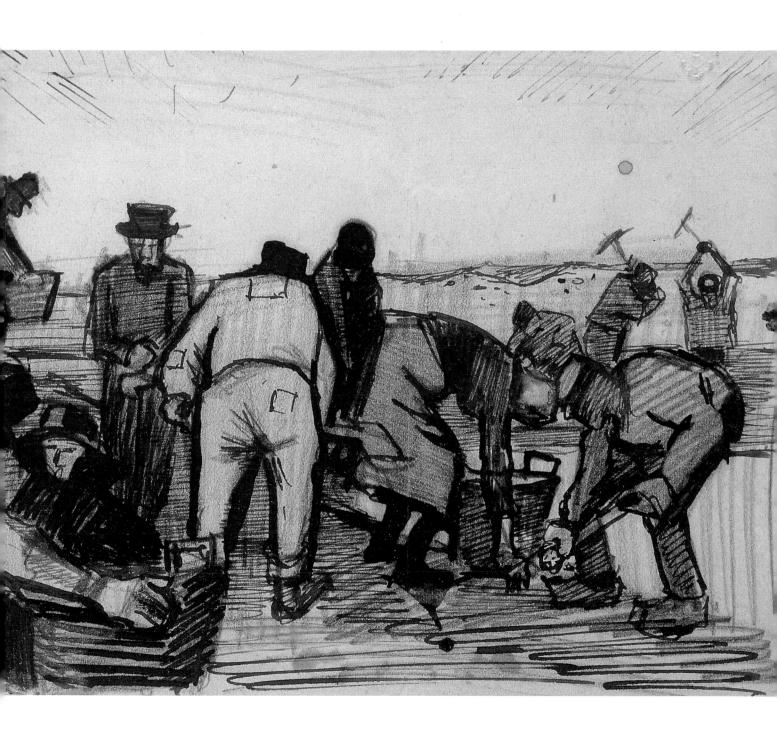

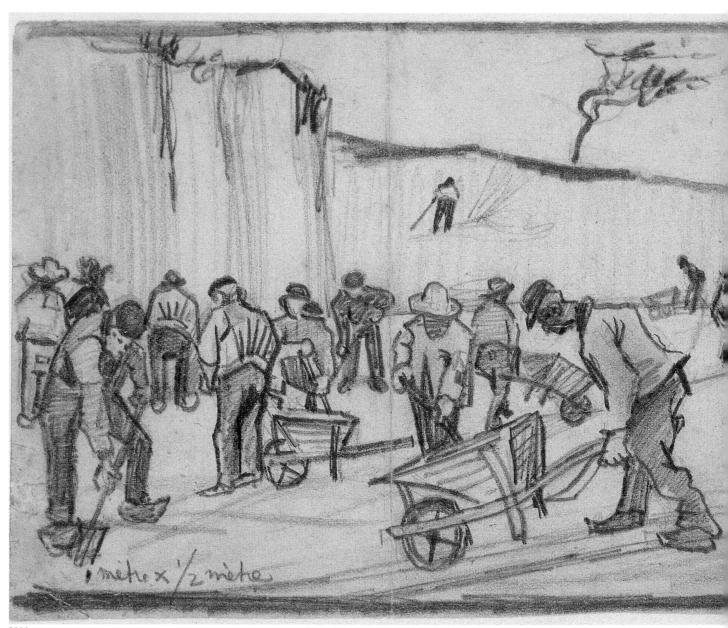

288†

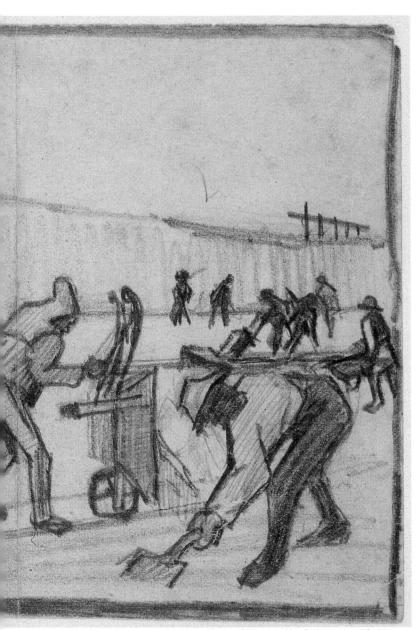

The Sand-Pit at Dekkers's Dune Near The Hague

[3 JUNE, 1883]

I was in Dekkersduin with Van der Weele, and we came across that sand quarry. I have been there since and was busy with models day in, day out, and so the second drawing has been set up. It shows men with wheelbarrows and diggers. I will try and make a sketch of this, too, but it is a complicated composition and in a sketch it may be difficult to see some of the details. The figures have been drawn from comprehensive studies.

I have got myself organized to do some more larger compositions and now have stretchers for two more new ones. I would also like to do woodcutters in the wood, and the garbage dump with garbage men, and people lifting potatoes in the dunes.

[4 OR 5 JUNE, 1883]

289

This morning I was already out of doors at four o'clock; it was my plan to attack the garbage men, or rather, the attack has already started. This drawing also entails making studies of horses, and today I made two in the Rhine railway stables, and I will probably also get an old horse at the garbage dump.

The situation at the dump is marvelous, but very complicated and difficult, and it will involve quite a struggle. Very early on I made some plans; one where there is a view through to a very small, beautiful spot of fresh green will probably be the definitive plan.

It is a little like the rough sketch above. Everything, including the women in the foreground and the white horse in the background, will have to be in chiaroscuro against the spot of green with a strip of sky above it, so that you get the contrast of all those bleak sheds, slipping behind each other in perspective, and all that dirt and those gray figures against something clean and fresh.

In the toning of the chiaroscuro the group of women and the horse create lighter passages, and the garbage men and piles of manure darker areas.

In the foreground are all kinds of broken and discarded objects, parts of old baskets, a rusty street lantern, broken pots, etc.

While making these first two drawings, so many thoughts came into my mind and so much appetite for making yet others, that I don't know what to start on first, but for now I am concentrating on the dump.

[CA. 4-9 JUNE, 1883]

29

I have progressed so well with the garbage dump that I have more or less captured the sheepfold effect of the interior against the outside and the light under the bleak sheds, and the group of women emptying their waste bins is starting to develop and take shape. Well, the wheelbarrows going backwards and forwards and the garbage men with their muckrakes, which bustle below the sheds, still need to be expressed without losing the effect of light and brown of the whole. Quite the reverse, it has to be reinforced by it.

[CA. 10 JUNE, 1883]

292

This is now the composition of the garbage dump. I don't know if you can make anything of it. In front are women emptying waste bins, behind them are the sheds where the garbage is kept, and the men working with wheelbarrows, etc.

The first sketch I made of this was rather different; there were two fellows in the foreground with sou'westers, which they often wear in bad weather, and the group of women was more shaded.

But that light effect is really there, as the light from above falls on the figures that are on the paths between the sheds. It would be a splendid thing to paint. I think you will understand it all. I wish I could talk to Mauve about it. But perhaps it would be better not to, because it does not always help to get advice from someone else, however clever he is. The cleverest people are not always equally clever at explaining things clearly.

[CA. 14-15 JUNE, 1883] RAPPARD R37

Once I get the feel of a subject—or get to know it—then I usually make three or more variations of it. Whether it be a figure or a landscape, I always introduce nature into each one. And I even do my best not to give any detail—because that takes the dream element out of it. When Tersteeg and my brother and others say, "What is that? Grass or cabbage?"—I say, "I am glad that you can't identify it."

And yet they are still sufficiently true to nature for the respectable native citizens of this region to recognize details, which I, for instance, have barely noticed myself, saying, for example, "Yes, that is Mrs. Renesse's hedge and those are De Louw's beanpoles."

maur per gecomple a cloud in er hart vous jauders en gal veel , haranden de lech in de viveyla mualite pleas wude co was onge op em hel blem schiller (must se de cregues mes eens pleke fresch heed van graen gat wat he Vriend West clary laten Ryken definitieve worden duch Lem Horehen er over dat ih ge gued jouden zon voor In how week good worden Animeer hem in elle yera ast latolos le Romen als was van margen flet is iels as bovenslaand krabbellije an alles outs de souwen op den svorgrand en ker suite pour ay den aestergrow most in clair obser her legen het rakte groen met een get ge lu zeeds legamon Loven Looder men de oppositie krygt van al die somlen loodson en al vat vul en die I Mudie, ven pacer der maken mars graauwe feguren legen tot e cels reinsen pen en it mobile en fiver van dag en des Un den town vom het clair obscur Veroor jaken de groep Mal van de Ryssopvor en Kryg och wourchgalish can and praced aun grouven en het paard watt lichtere party en en De chillonners en de hougen men donkorde De aschvoialt y lakken

[13 OR 14 JUNE, 1883]

293

I am beginning to get a plan for a much larger drawing, one of the potato harvest, and it so fills my thoughts that you may well see something in it.

For the landscape I would want some flat ground and a line of dunes. The figures about a foot high, the composition to be across the width, about one by two.

In the forefront in a corner, kneeling figures of women, lifting potatoes, as a repoussoir.

As a background to them, a row of diggers, men and women.

And the perspective of the area should be arranged so that I have the place where the wheelbarrows will be in the opposite corner of the drawing from where the women are lifting the potatoes.

Well, apart from the kneeling figures of the women, I would already be able to let you see all the other figures in large-size studies.

Yes, I would like to start on this drawing one of these days; I have also got the plots more or less in my head, and will take my time to search for a nice potato field and make studies for the lines of the landscape.

By the autumn, when the potato harvest takes place, the drawing should be finished, at least as a completed sketch, and then I shall only have the shading and the finishing off to do.

The row of diggers would have to be a row of dark shapes, seen only at first sight, or from a distance, but very finished and varied in their movement and type. For example, a young, plainly dressed chap contrasted with one of those real old-Scheveningen types in a brown and white overlapping coat and old-fashioned top hat, such a dull black one that they pull down to their neck; and a short, sturdy female figure, sober in black, contrasted with a tall, itinerant day laborer in white trousers, light blue smock, and straw hat, a bald head next to a young woman.

These thoughts come to my mind, just from setting off the studies I have already done against each other.

[CA. 23-28 JUNE, 1883]

296

I was looking for something that would be quite a different subject from those [of Butin and Legros], i.e., the potato pickers, kneeling on the ground, working with their short forks, about which I recently wrote to you that I was making some studies. I now have on the easel one sketch of them with four figures: three men and a woman. I would like to do something wide and bold in silhouette and design. I keep on searching for it.

Here is a rough sketch of potato pickers, but on the drawing they are rather further apart.

Ih v mid hem year op regt in deget, he to he had by schynbaar an en snel averbeingtlager is by met minder rossonable an just in you bettering is get lev on agris land by is een van de marmen vie it met persoonlyk him en toch wes ih eels van hem zee han it me how voorstellen have by & gemochs nuft gy I schy van Blommers van der dalan sond mot movi it sond het net als als of I van Bulun reproduction it vind het net als als of I van Bulun reproduction it vind het net als als of I van Bulun reproduction it vind het net als als of I van contest was en meer prosser er en dan B. genvonlich by det vogenbur he d met minder dan 4.10 Itako teehenengen under hunder van i meter savang dat it sus lot are de voien in of meling in I wesh got quel ge a wel kummen denkun Maon it has zoon hoop furt door dezen tod Jao byvoorheed begins den trygenzen de st had om met houlehout te werken met den dag meer veg te gaan fat lyt och doaroun dat it er selvy gevonde, hel am de houtshoot se fix ceres en dan met als anders the 6 v druhenhi er over heen

Licher sen krabbeltje vun aardaggelnraeters maan ze zeklen wels verder uet een up de lechening Nu goo beruge is a relief deat it aan vien avont - ge kerement y is may cheen oppersoon 1 / aren geleden is - dat gy - of jamen ein avant doodraghen by house been by noy monde by de Kagerne en may mot dem photographie maan een beekening van dem kregen een placy -Wenny dock to low for by be it jelf joude techemen werny back of law law you woh dat as er moeulyhteren jouden kumen hisfelen livanes Ik they betrekkelyt me vermonideren das Imes I erest komt le men amout en engentlyt als onen I regt in den grand zun magaan ambiery zur gard als mets verschie van mysten behavir. lang geleden houvers dat it tegenwoordig myn opgernimeter wen larny begun lækrysen walld werk helreft en een verhouwen In her lock gown me It has dat at vrouger ook wel getal andauts alles made men racht lock van streek omvellekeurg & haft een melanholich geral als Julhe personen het afkens of I geen men dael en slectier weg noemen. schuff ge spoedig! hu huef sal weer sen welkom sen figuer) so van een voet grootle valstrekt niel gemakkelyter le beckenen is dan sen klene opaan - en om het op die groote loch nous propositio oven kroeley la krysen als keene bymen no somo seen erge spouwery. avecu perel hel quele Dagen en der maar / weck juhen met eer hune 1. a 6 // Incens

296, 293†

I ch must be may vertaleer dut de floch seus by me is severed - may at prelling the severe by Breedner severed med in I much server at the amount by moder 1,5 I select the severe of get when I sheller known gotheren accusellen. Das I seed my pleis eer amder om der 132 - in rhey in van dat it her was heel pressy was on mee to loop en. Ik hevael somen end to gran met noor buden maar en de stad jeef an figuren le goan sochen en aardye gevaleen. En sagen een hen en der thoog woon it mee en de Mad self dat and hel gedraan de meesten venden de stad leetzh en gaar alles versky En 14 m slat locker h v. me gen mone met waar. Gesteren gag it . v. on I Novelende werken begy am 1 oft reher von sod gedreet e legenaren 1 pollis welle Perces gehre wit vom 1 sluven vom de kalle med Ramer & pourd m. 1 von Perce winderig weer de Cucht grander en ar was voer karakter in die pleh. 9. I Velden goig it vert juan eens - by ar Noch of en wond out we by be to chen gegeen kellen The school a reeds over term dot by them up my een Jen gunsliger mo ent machte efection by weing sprach jen gunsliger mo ent machte efection by weing sprach and the said med and the said med and the said med and the said med and the said of me mouth one by deed of me mouth was did I seen solice easter solither is jobale I of seen verstands on you keep the said brushads on the process of mediants on the process of the proce Eres els mannely les en prispents in herr och at jegt by mile of at overly meso by sonders
It loop wet out it seems met tern nader in contact
jal komen merspetien door I Weeke Was U Jordy by I Weste die aun een Schevery van de Voeren it de bayt les y was manwood to seize plunke slaves heeft. Hy goal me vos een by lay nour buden.

deb degre dagen voor de verandering ween sens en paur agnarellen buten gemaakt een kovenvelege en een souhet aanderges land in mag een paar landergy es get extend who am een howard be kebben von levremen our eye nour / your beheninger sie it sochende ben Del zyn de plannen em die frynantickenergen. I havente antroduchande in I had appearlakinge aurouppelland hamen. It dent a sterk ever sen aantal figuristadies he schilderen las ville vom I hooger eproceser van de techenangen voral

299

[CA. 11 JULY, 1883]

299

For a change I have recently done a few watercolors outside: a small wheat field and part of a potato field. And I also drew a few small landscapes, to have a setting for some figure drawings which I am planning.

These are my plans for those figure drawings, done very superficially. At the top is one of people burning weeds, with below people leaving the potato fields.

I am seriously thinking of painting a number of figure studies, mainly to raise the standard of the drawings.

Something that I would very much like to have and that I also feel that I can do, subject to certain conditions of him posing patiently, is the figure of Pa on a heathland path, the figure drawn strongly and with character, and, as I said, a patch of brown heath with a narrow, white, sandy path through it and the sky done with some passion and lightly expressed.

Then perhaps Pa and Ma arm in arm—in an autumn setting or with a beech hedge with withered leaves. I

would also like to have Pa's figure when I do a peasant funeral, which I am actually planning to do, although I will find it very difficult. Apart from the less important differences in religious convictions, the figure of a poor village parson is to me, as a type and character, one of the most sympathetic there is, and I would not be me if I did not attempt it.

[JULY 1883]

300

I was in the almshouse once on a visiting day. That is when I saw the little gardener and drew him from the window.

Well, I did not want to let that go, and it now exists in this form more or less as I can remember from memory.

Last night I received a present that gave me enormous pleasure (from the two surveyors, because a second one now comes too): a very genuine Scheveningen jacket, with a high collar, picturesque, faded, and patched.

I khel nee met to serve 3 ocole le bespreten du hoop it of your zuel vender. In vongrehnyven some dalso ih to myne lyvalde menny med del het anvarante undelpto source you als we can best met orders to profeturen ven de nells project van Deverf inplants van mean met of er mels aun be toen was den particularen proje le belorten Verlegende algod 33 1/3 a/o. - Arch ander go vert, June her mes up entermored so. Inclide a magely to movely their en mayber gyn an ap der num van Sce" ees to haler bestent tot men privat gebruch en Van myn Hand deed of demunde die it vrueger west apper which gentamen had am sonder out gy en engineng & yol hegelpe to vertigen en it huy moun dad your s'hemels mean met twy telen jues of del is problisch. Se weed it guf les aun een land meter. Nu dingvaler her is I rayed in handes in verticaren is depost house van Tullard er level sia aun Mouve. Your dat les gever our den joon heb it would uts getail mune wel veil belong origen van I construleizheed van Dere naver En Dawry lot it mour sem Dovey egown en 1 vo Cyande lot tengging). Doil it mal luylelde of hy had onder syn waverend sen lanelyte acculat on mel courante takes Dul dege door my evenime hand in worden gebrucht en ih die van hem jouds over menen legen metto pry, Poullard of voorwaarde by my ook De currante lule en vervolg ven 15 d'y legel de conditas per leveren. Earl had by by wear, man love heeft by sy is voorioned. sens naggeur en het ih eurschokking gemaaht mit hem at havenstaand. It neem van hem aven to by na 300 hubes waarender 1. v. verscheden Eurmyn en alhamen waarender 1. v. verscheden Eurmyn en alhamen. hegen mender (f 10 ga party så lynnet på latend and og nette pry, Pailland Portande als dans my die 140. - Wennende daarvaar hoveroun hed regt voodown at water wanty profiteerende again 33% so - En met allen het it dat rated van 37 % of or aleevery duch barender of de watervery.

Wound This. the Een our de dengen warran in er wet sens over hes gredacht am te verhungen zum ook op een andere wege be verklepen 39 a. Gesteren a eingoteen het in cent de bewel van doordrumen conditioners - line o. a. van I dary noon ju gogman on hit an loting to knowned in ger ander well ned you man air de Brahamtrele maan lock moet men daar Jewes certain agreement to habeter on an van de dans to prove the second of the second Nu dom daar kustchen 1. Doep en de jee stour structure van een deep brown acter grown verwaard van der gewend en gewieet dat men van men dan een Senth: . Od is me de Buesfor van skay, sael & Men Ran daar me met der door ham hem en dus is het la beseiteen ook als men bassage huft of nother The last beginned and a general of the wand teny.

The law plat meet of 98 3 will have more even you clear the discussion of a combine to work the second of et jan Dal sen Danbigny sen Corol Hernmity of weld mus much verder of gown waar in grond byen very is ven de voelsluppen der badge

[29-30 JULY, 1883]

307

Yesterday and the day before I went for a walk near Loosduinen. I went from the village towards the sea and discovered a lot of wheat fields there, not really as pretty as those in Brabant, but they should still have people harvesting, sowing, gleaning, all those things I missed this year and why at times I felt a need for something else.

I painted another study on the beach there. There are some sea defenses or groynes—piers, jetties—and very good ones, too, of weathered stone and woven branches. I sat down on one to paint the incoming tide, until it came so close that I had to pack up all my belongings. Now, between the village and the sea there are shrubs of a deep bronze-green, blown in the wind and so real that one might think of several of them: oh, this is clearly Ruysdael's actual *Bush*. You can now go there by steam tram, so it is quite easy to reach even if you have things to carry or have wet studies to bring home.

Here you see a rough sketch of the lane to the sea.

I especially thought of you on my walk. I have no doubt that you will agree with me that in the last ten years the dunes in the vicinity of the town and Scheveningen have lost a great deal of their naturalness; and there is something else, year by year they have acquired a more frivolous character.

Scheveningen is undoubtedly very beautiful, but has not been virgin territory for a long time; on the walk I described to you that untouched quality of nature struck me enormously.

It has lately been rare for silence, for nature alone, to speak to me in such a way. Sometimes it is just in places like this that you are no longer aware of what is known as the civilized world and leave all that decidedly behind you; sometimes you need just those places to calm yourself down. Only I would have wished to have you with me, because I think you would have shared my impression of finding myself in an environment just as I imagine Scheveningen to have been in the days when the first Daubignys appeared, and I found that this environment had a strong power, stimulating me to take on some real man's work.

[CA. 4-8 AUGUST, 1883] 309

I have high hopes of making good progress with the color in this way [by painting several studies]. It seems to me that the last painted studies are firmer and sounder of color. As, for instance, a few I made in the rain recently, of a man on a wet, muddy road, I believe that I have expressed the mood better.

They are mostly landscape impressions. I don't mean to say as good as they sometimes appear in your letters, because I often run up against technical difficulties, but there is still something in them—for example, a silhouette of a town in the evening as the sun goes down, and a towpath with windmills.

A definite feeling for color is beginning to stir in me these days when I am painting, stronger and different from what I have felt about it until now.

I have often tried to work less dryly, but every time it turned out more or less the same. But it is just as if these days, now that some weakness prevents me from working in my usual way, that this is helping me more than it hinders; as if by letting myself go a little and instead of looking intently at joints and analyzing how things are put together, I am looking more through my eyelashes, bringing me more directly to see things as patches of color against each other.

I am rather curious how this will go on and how it will develop. I have at times wondered why I was not more of a colorist, because my temperament would make you expect this—and yet it had developed very little so far.

At times I was very worried that I was not making any progress with color, but now I have some hope again. We will see how it develops further.

What I want to say is that I in fact believe that in these studies there is, for example, something of that mystery you get by looking at nature through your eyelashes, so that the shapes are simplified to areas of color. Time will have to show, but for the time being I see in various studies something different in color and tone.

[POSTSCRIPT]

On a whim and for no particular reason I want to add a word about a thought that just occurred to me.

Not only did I start drawing at a late stage, but added to that it may be that I may not be able to count on so very many years of life.

If I think of it with level-headed reasoning for the purpose of estimation or planning, it is, of course, in the nature of things that I can't possibly have any certainty of this.

But by comparison with various people whose lives we have known, or with whom we have something in common, we can surely make certain suppositions that are not totally without foundation. About the time span I have ahead of me in which I can still work, I believe I can accept the fact, without being too premature, that my physical body will last out, all being well, for a certain number of years—a certain number being, say, between six and ten. I dare to accept this, moreover, because at the moment there is not yet an immediate "all being well."

That is the period I firmly count on; beyond that I would consider it all too much airy speculation to determine for myself, as it will, for instance, particularly depend on these first ten years whether there will be anything after that time or not.

If you wear yourself out too much in those years, then you don't get beyond forty. If you conserve yourself sufficiently to withstand certain shocks that tend to befall people and overcome more or less complicated physical difficulties, then you move from forty to fifty into new, fairly normal waters.

But calculations about this are *at present* not on the agenda, although plans for a period of five to ten years are, as I said before. My plan is *not* to save myself, not to spare emotions or difficulties too much—it is relatively

indifferent to me whether I live longer or shorter. I am, moreover, not competent to guide myself physically in the way that, for instance, a doctor can do to some extent.

So I carry on *in my ignorance*, but knowing this one thing: I must accomplish certain work within a space of a few years; I need not rush, because there is no future in that—but serenely and with composure I must carry on working with as much regulation and concentration as possible, and as much to the point as possible. The world concerns me only in so far as I have a certain debt and duty to it, because I have lived in it for thirty years and owe to it to leave behind some souvenir in the shape of drawings and paintings—not done to please any particular movement, but within which a genuine human sentiment is expressed. This work is therefore my objective—and by concentrating on this thought, it simplifies what I do or don't do in so far that it does not lead to chaos, but that all I do has one and the same aspiration.

[CA. 4 SEPTEMBER, 1883]

319

I just received your letter when I came home from the dunes beyond Loosduinen, soaking wet, because I had been sitting in the rain for some three hours, on a spot where everything was Ruysdael, Daubigny, or Jules Dupré. I came back with a study of small, bent, windblown trees, and a second one of a farm after the rain stopped. Everything has already turned a bronze color, everything is what you can see outside only at this moment of the year, or if you are standing in front of one of those paintings by Dupré, so beautiful that it always stays in your imagination.

[EARLY SEPTEMBER 1883]

323

I have just arrived here [in Hoogeveen].

From the train I saw beautiful parts of the country in the Veluwe, but by the time we came to these regions everything was dark. So I still don't know anything about it.

But I am in a large public room in a tavern, like those in Brabant, where a woman is peeling potatoes, quite a pleasant little figure.

I have only brought very little paint with me, but have some, and I hope soon to make a start. I found the colors of the Veluwe rich.

[CA. 15 SEPTEMBER, 1883]

324

Now that I have been here some days and have walked around in various directions, I can tell you more about the area I have ended up in.

I add to this a rough sketch of my first painted study in this area, of a hut on the heath, constructed completely of turf and stakes. I have seen the inside of some six of this kind of hut, and there will be more studies of them later.

What they look like from outside in twilight or even after sundown I can't explain more accurately than to remind you of a painting by Jules Dupré, which I think belongs to Mesdag, of two huts, whose moss-covered roofs contrast with an amazing depth of tone against a hazy, dusty night sky. *That is here.*

I saw some superb figures while I was out—striking by their expressions of austerity. A female breast, for instance, has that movement of toil that is the direct opposite of voluptuousness, and sometimes, if the poor creature is old or ill, arouses pity, and at other times respect. And the melancholy aspects of things generally are of a healthy kind, as in Millet's drawings. Fortunately men wear short trousers here, which show the shape of their legs and make their movements more expressive.

[CA. 17 SEPTEMBER, 1883]

325

Yesterday I found one of the most peculiar churchyards I have ever seen; imagine a patch of heath with a hedge of closely planted pine trees round it, so that you would think it was an ordinary pinewood. However, there is an entrance—a short path, and then you come to a number of graves overgrown with bent and heather, many of them marked by white posts on which there are names. I am sending you a sketch of the study I painted of it.

Liebermann had it reeds als ran gehourd Joch an beschryving Van zy n Jachen Vooral geeft my men licht amhent tem. Jyn | Se zegt het het goed " lee blevery met overgangen le! gry, seel e gryp breuen ! The begryp het er volkomen uit. Dot die manier van schilderen het it is seen herset Dong als men on active is in dat it veel verlang le retilderen is gant wegens it in myn factuur us vasts en o/schoon homenegeen hande seggen je mait geer systeen teller - loch heel group cels of lemaleset welde helben. Was ky en men anderen hel ben. Wit um berdry very see it and by declarmann , val van de maner van Herhamer moet heblen soonal wegens consequent dourvers en dat le analyseren du pletjes betten donter verois and door don nerhalen donter verois and many ong of duyes It may looked de grade graver not Herkomer the last mas for gy lebt da Jeher ook gez an - wat een mannety kheed " De Jules Breton felle d'un minen zand et ers song jeen - ee is le coarrières nog seen steentes les rugne loen der up een regendag kwam gruger juit de arbeiders lerag soon den modder een kuravaan al van reloonteen reges een met een vanden 12 apol pas oon de vrouw, eeller druggen green mannen kleenen pao als u de Normage waar de, logues de forfe vooraller Treefor you en vonerel temps affection

real on sever to yourselfel year eighteen my man

No Rece hu Free 2al Weer weekom wegen schaff on elk det lea minde wy met reedo her gedaan met een autel war neus P. U dalil allen her un Arenthe nu ben en als van dr plannen Dock andwood by law med up law hel James me avergegeven worden. Dank Youral an bemueyinger Hely dejen morgen fyn yry, weder redered her her geen son en dat sal

mous syn das et ga er up wit. De lu wan of a de hart her sign Leel best. It man is aun de spoor vou de guederen sen kere du uls de Broux acties heft en yezest dat romes en loon van voos kaal heeft een eelle spouwe De vrouw hell weeksaan en nelyes. I kund eren It ling , wave sely neg to see action solder vous wertylands aben been betere led Vincens sulven have trul

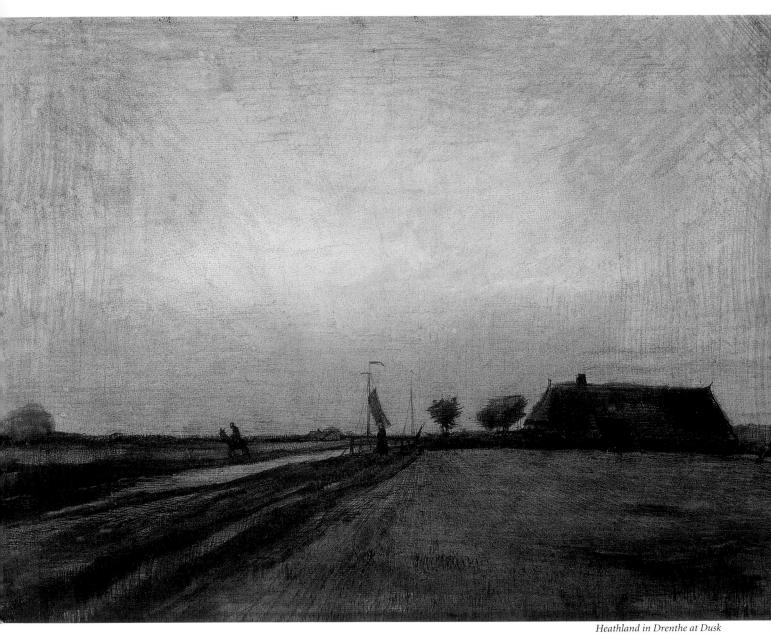

[HOOGEVEEN, 2 SEPTEMBER, 1883]

327

In the past week I have been further into the peat moors—wonderful subjects; the longer I am here, the more beautiful I find it, and from the start I have wanted to work on staying in this district. For it is so beautiful here that it requires a great deal of study, and only well-thought-out work can give a more correct understanding of things as they really are in their serious, austere character. I have come across superb figures, but still, a nature that has so much noblesse, so much dignity and gravity, should be treated with maturity and patience and protracted work.

[CA. 3 OCTOBER, 1883]

330

This time I am writing to you from a remote corner of Drenthe, where I have arrived after an endless voyage on a barge towed through the heathland.

I see no way of describing the country to you as it deserves, as words fail me, but imagine the banks of the canal as miles and miles of paintings by Michel, or Th. Rousseau, Van Goyen, or Ph. De Koninck.

Flat expanses or strips of different colors, becoming ever narrower as they approach the horizon, here and there accentuated by a turf hut or small farm, or a few meager little birches, poplars, or oaks—everywhere peat stacks, and time and again we sail past barges piled with peat or irises from the bogs.

Here and there lean cows of a delicate color, often sheep or pigs. The figures that appear now and then in this flat expanse are mostly large in character; sometimes they have a wonderful charm. I drew a little woman in the barge with crepe round her cap brooches because she was in mourning, and later on a mother with her child; she wore a purple head scarf. There are a whole crowd of Ostade characters among them, faces reminiscent of pigs or crows, but now and then a figure like a lily among the thorns.

So I am very happy about this trip, since I am full of what I have seen. This evening the heath was extraordinarily lovely. In one of Boetzel's albums there is a Daubigny that expresses precisely that effect. The sky was an indescribably delicate lavender-white, no fleecy clouds, as they all tended to run together and covered the whole of the sky, but patches of more or less toning lilac, gray, and white, with odd gaps where the blue shone through. Then on the horizon a brilliant stripe of red, with under it the surprisingly dark expanse of brown heather, and against the luminous, red strip a number of low roofs of small cottages. In the evening this heath often has effects for which the English would have descriptions such as "weird" or "quaint." Don Quixote--type windmills or the strange shapes of drawbridges outline their fanciful silhouettes against the everchanging pattern of the evening sky. In the evening a village like this, with the reflections of lighted windows on the water, or on mud and ponds, is sometimes tremendously enjoyable.

But what peace, what space, what calm there is in nature here.

Similar methy of saint by the Chapter like had able the header han becomes and the property of the saint in the saint in the saint in a part of the saint in the

[6–7 OCTOBER, 1883] NIEUW AMSTERDAM

331

Here everything is so wholly what I consider beautiful. In other words, there is peace here.

There is something else I consider beautiful—that is the drama—but that is everywhere, and here they are not only Van Goyen effects. Yesterday I drew decayed oak roots, so-called bog oak (oak trees that may have been buried under the peat for a century and from which new peat has formed—when that is dug up this bog oak is exposed).

The roots lay in a pool, in black mud. Some black roots lay in the water in which they were reflected, some lay bleached on the black surface. A white path led past

them, behind it was more peat, pitch black. And a stormy sky above it. That pool in the mud with those decayed roots, it was absolutely melancholy and dramatic, like Ruysdael or like Jules Dupré.

Here is a scribble from the peat area.

Often there are curious contrasts of black and white here. For instance, a canal with white sandy banks crossing a pitch-dark plain. You see it above, too; black figures against a white sky, and in the foreground again variations of black and white in the soil.

I believe I have found my patch here.

Coming events cast their shadows before, says an English proverb.

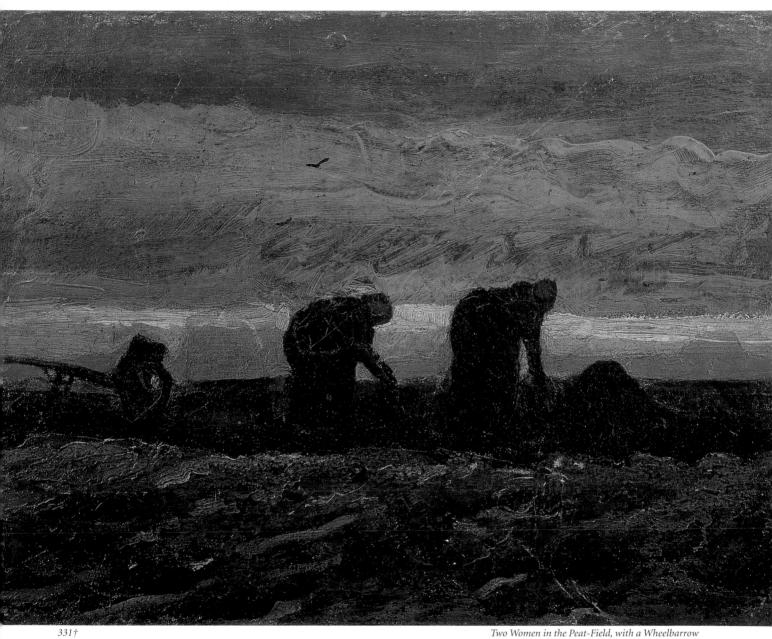

Two Women in the Peat-Field, with a Wheelbarrow

Yest on war proton every in over proton I is as men I justile said You to july onder namen hat lauk may must I was a like on in Ness dal ge un jurgen mes mough hiblen ja wee I just van jeef med man he mad zyn en voelen ad van wat my Termontyd belyd - at wet med med unwindy is ga it wey van - it were de dad met men - it wit now buten . welen as en effaire we is het degree la oneuros vije man de gedaction mes besterfung en up eigt en -No in Se testimot he or my juin als schedus ko me ar bernerd led you ar hywaren lock his que her eigen weath at jun Een brok nature sanky ken - I auten dad wie it schelderen - Personney he is averger in aan dat will the schelder worden -In sens word on de lue galfo un heste vuenden als vicend en min of men - \$771 eigens andres m - Just - In seus sen voelen bleksem d steam I her up een verkeerden veg. Waar is myn akaleer we es mys peusel Gevaellen aes deze als men je roeel zzn zeer deep men jest soon normalylen po need of wany new & zue servery of my you as over was to make meet meet and a geven det is een dovarop his brenzen das men met legenwerkt integendal waar men gueden me quely in moved voor heeft. It jeg net dat men van het quelque close la tout ver weetten must dat he precus ales Jul doen men maar bet Greegere chare a hour es or boch len mante at better en en jelwy de gg det notwerte I'm must e des helles er in jelest de 99 hern down not verticewan day by metsuft as by west val but w was. Who men may soon wet sends down I when Judy of the allen set het lever services and are exploration was met de moerelyt bedien wegneemt aan de activering verhandle en après lous y even serieus is en men y possé serieus mais aproallen dut men you had duet am you leven to up to voeren lat uto d'eyelyho en das on gwal van een dangingegen nondjuhelyhled van veranderen hetregt over zwander may tollen dats was de lucer our jessen to a majoring.

Water van gezegd is in der lyd line later mes man gevraagt worden en en minder op aan te Jether pry ups wir his may be all to may continue to the his best to may continue to be by according to mage in the same and part to _ may be ann great must good to _ may be ann great must good to _ may be ann great must go as yet of when the work of the man must go the hundred by a hundred with the same and the same and when the same but he was get great good to the same and good to world men schelder. Wit men scheld en word in help men wordt men schelder. Rund vseld onen vad sy veel dom Keen men meen det Kennen gad gys oon met moerke zo zen teleursteller h der van metenskeler van ommont en diet allers - Dor de vid er av ver the veel det zie en de veel de ver en koeldele je vid er av ver the veel det zie de de veel de vee sen krubbelly a muest me tourbain dat det wet son vell of sigten seen me alle er bevord som servende averda Denaham zous by zomeer onde so det zig gref dan der gang handt gam i zour seen mounts sen seed fresch worden met de I organ Ios or rett muzelyt. Teyeraver de wereld jouden me met são val guiden moed zoovell energie zoovell leuther his muelen apone met zwaar bilen hoor - at helden we seneme zonzen als vivolyto helber als de Jwelen van wu ze vertaldet ato se auden on Sentyson that grows flent build aproblem. met Ingleton outlen of versions shak to hange syn - In all plan south me I have gevalen on sen ander plan allyd vell vell number I have. It tryfee donoch geen augenalit of gy jours en un t no aver denten dut als des gedram words his me de meens mugelyke leuklew more andernamen word an. In schryf And expelligh men om a to leveren et de publica och leb.
Nam myn kant gelvafel in to als orbitler als artest ex-experter
to also questionis.

333

[CA. 13 OCTOBER, 1883]

333

Today I walked behind the men plowing a potato field, with the women walking behind to pick up any potatoes left behind.

This was quite a different field from the one I sketched for you yesterday, but there is something curious here: it is always exactly the same and yet it varies in the same way as paintings of the same subjects by masters who work in the same genre and yet differ. Oh, it is so special here and so quiet, so peaceful. I can think of no better word than *peace*. Talk about it a lot or a little, it is all the same, there is nothing to add or take away.

It is a question of wanting something completely new, undertaking a kind of recreation of yourself, coolly getting rid of the *idée fixe*; *ça ira*—we'll manage it!

Ind in it must us you even mere er us van ken in I leg in nee au men to glie of over vegenery komet verver pas die absolute entendigled van sig elf gigen lettend e ten it morfelien een goed e komerood at. py inteletel to to blen helt they got tel geens juw verwoodware us mitteletel to to blen helt they got tel geens juw verwoodware us sommet denger die my alleen zonde lang apezelweiden hellen ein ent te venden. Bland er mei op den wy telpen. No world niet precentive willes gesteld is dal voet as housens and med loe del jou ets) vo meun o you dat het en munder ap aun kwam bu sen sander stoud betrekkeligh -Dad was of yes is veranderen zuel ze hough waarschruse lock to a homen much on er al june I hast vonden gy an same Gerandering door a door van machtel ben sher greyst in de horono. ben steer fatalelet du onzallen miserabel un melunkolet jou maker at Ity house is brown wan wy souther worstelmy nut burys kunner yn wat well y welle - orde hondwerk kunst goed ga mit den kunstlandel wordt scheder - Het jou mertehen te westelwe za moun ge eu voer wat nu neg was wat & e e ge cu vous wat nu noy was was ge c' is servers af loop an ben it met metters gierest oneen in eigentlyt deut it gy ook met - Maron hard ar von hellem joo al, I mu is dat kang ge net just ament gy av land voor grant helder at Vanders men. En me dot surber - In dat als held met en het met be doen you you am our een by I workey weather her levery eheren - muel gg valander aunvallen Naturet hosp it rois inable my to schikken man I sen of noun Yunder des let jus moest. Doch it jey als plan wour it me thus on Viel eln Lander was it je that is ein almaylie wang such nock sy nuches syn bany am alo la duran Denh er das serio o var en Segrent kerel school speed of on alle geral. met een homodruk in jevaakle lee te was gy over most? hait is to de taisas -· o al que l'on voil se tance un cog sur la bragère les her kung je med som

It his me an mound helect ingladend, it his order on the obsoluted mandy - it hang aun jetter by au bear lay our mes en weg en noust - It sprach kalen it some teat me me - tel a her book so my en auns was grochemen beef my vertrouwen - varaum ny meg eur heef a meer

of leever need my mour vertroum gy in tot get the wan it in vertroum in dot men his meet wagen am net be wereld and lequan en het te jacker in sen steller leven mes sen hand werk - Nes amous of Y kg g amous ge I self ook jou jelooft most je I doon - Nee dan bet of a ook niet be jegen dut go me de also an en leuns wegen gy jeef my " joeten begrypt als squite regt she I met my jan juan en gevue zy genes hesteuten junet schelder le word en weel et meet. Me er een weg was too my he large me out dan notweelft mour matter en anders ; us) va d met l'a 1 maêtres juen le schyppera sal of Jaw and er Dak Kewam in a Brahand in by guar werhen debur och it must averklaren d dat me ned seus mote gewoellen heb at het myn mementeel werh en gestacten en verder 1 plan voork. Sy syl een Revel met een wil en met een goeden denhenden helderen Rup med sen eerlyk land me word sy served relieve m de gegerenen des vois en 1, dje ge le bien erken muds Kunnen. En nog seus min werk jou er gideed send sen shoot door leggen It het van doog acts er der players gelongen du een aurdrup palveld ump weed in an vouwer actionen legen om entelle

Del was an hut andervield and it is protein knowled in man lit is as anymomous van her Isthum precess of selfer en toch an net precise thereties de pet for molecular at scholley en van meeden de myselfer gene vertien an loch verschillen ohd is her pro expensated of - en 3. It I so' very - It kan an seen and ar woord voor ventan dan dan verde -

[CA. 22 OCTOBER, 1883]

335

I have sketched a few more subjects from around here. The country is so lovely that I cannot describe it to you. *When* I can paint a little better—then!

Arrange things that concern me as suits best, I would learn here and learn there too, I think.

These were some people I saw on the peat moor; they were sitting behind a stack of peat, with a bonfire in the foreground, and eating. [The second drawing is of] peat loaders, though I am afraid it is impossible to decipher my scribbles.

[28 OCTOBER, 1883]

336

Zola says: "Moi artiste je veux vivre tout haut" — "As an artist, I want to live life to the full" — "want to live life" without mental reservation, naïve like a child; no, not like a child, like an artist—with goodwill; as life turns out, so I will find something in it, so I will give of my best.

Now, come along with all those assumed mannerisms, with what is conventional; how enormously pedantic it is really, how absurd, a man who thinks that he knows it all and that it will be as he thinks, as if there were not always in all things in life a *je ne sais quoi* of great good, and also an element of bad, from which we feel that there is something infinite above us, infinitely greater, mightier than we are.

A man who does not feel himself small, who does not realize that he is just a speck, how wrong he is basically.

Do we lose anything if we abandon some of the concepts that were imprinted into us as children, such as keeping up appearances and considering certain forms of behavior to be of prime importance? Personally, whether I lose by it or not, I don't even think about it. I only know that in my experience these forms and concepts have no validity and are often even disastrous. I arrive at the conclusion that I know nothing, but that at the same time the life we live is such a mystery that certainly the system of "respectability" is too cramping. So for me, it has lost all credit.

om en half fan moedelrasheid be visaisaken In Julsty & burgeten nderen bedheu mender stryd doch her by soudd wh un shleet such och chen they a ketten en it say west ran her seef out gy he gwaar am door en die zonoer loggel mages beste intenties hebben Yanstreeh le worden gebragt. Nes we in a gelf zigt " If It gean rehilder den just Kerel en die dem bedoort ook mour we are hy val vorel good now stechlo vaarvoor -Vriender en yn now kloup you manneighted als van het herte wat in hem is Un vuenden kun neu slechts zign dezuehen die Jul Jamegen veelden door eigen voorbield van the active in a op weather

[NOVEMBER 1883]

338

I have myself sometimes pondered about being a thinker, but I have increasingly realized that I was not born to be one. Now unfortunately, because of the prejudice that anyone who feels the need to think things through is *not* practical and is classed as only a dreamer, and because this prejudice is widely respected in society, I have often been rebuffed just because I did not keep things sufficiently to myself.

I say that I have nothing against thinking, provided I can at the same time draw and paint.

And *my* plan for *my* life is to make as many good drawings and paintings as I can, then when my life is over, I hope to leave in no other way than by looking back wistfully and with love and thinking: oh, the paintings that I might have made! But this does not, if you please, exclude doing all that is possible. Have you anything against this, either on my behalf or for yourself?

Theo, I declare that I would rather think about how arms, legs, and heads fit onto the body then whether I myself am an artist or not, or more or less of one.

I think of you, that you would rather think of a sky with gray clouds and their brilliant edges above a muddy countryside than bury yourself in the question of your own self. [CA. 29 OCTOBER, 1883]

339

Now there is, so to speak, not a day that I don't make something or other. Just by learning as I go along, it cannot be otherwise than that I must move forward; every drawing made, every study painted, means a step forward. It is like walking along a road; you can see a spire at the end of it, but because the country is not flat, when you think you can see the end there is always a stretch that you could not see at first, and it adds to the journey. However, you get nearer. Sooner or later, I don't know how soon, I will reach the stage when I can start selling my work.

I will quickly sketch those landscapes for you that I have on the easel. There you see the kind of studies that I would wish to make a direct impact on you. To learn to look at the landscape at large in its simple lines and contrasts of light and dark. I saw the top one today: it was altogether Michel. The natural scenery set off that foreground superbly. My study is not yet mature enough for me, but the effect moved me, and as far as light and dark goes, it was as I draw it for you here.

The bottom one has a little wheat field of delicate green in the foreground and withered grasses; behind the cottage are two peat stacks, again a vista onto the heath, and the sky very light. The war my Towal als gy her want zone get men in men of Jegun me concenheren sh joe he even he landschopp in up krabbelen tre it of I exec he

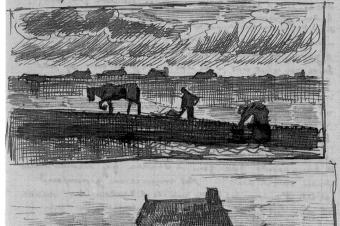

diedaan I jeme van omdies dee it jewde verlangen gy derekt dangreept. Hat lands ohap groot laran aantegleen in zijn eenvrandige lig nen en tegenstellingen van beht zi bruin. I Bovenste zog it heden was gehal ne michel . Die groon vords Supperhe in de natuur. Myn ohadie is my may niet zijp genaeg maan het effett greep my aan en vras wel gran leett Ltruir zoo as it het in her teetur

of the supplement with the ward war a

Het onderste is mit een 1 een graen kovenveldze op den noorpand i verweekte grasjen achten I hunge z hougen hung wer een koorkrykge op de beide an de lacht het licht. Ohe waar it op kamen wiel is on dat genne zweidt geg musten hegen nen en zweidt dankt my wiel daen van I kegen of aan volkreks met uitduitend I e leekenen. Q' K mean on vollen vallen arms at world in her schryf oh bet en al justany over gestacht En zun er mit eren gesproken bellen als alles goed jehlene was met & C' soch mu on de gegevenen ligt het alleen aan onga eigen miserable / munhes das it viel oney week herberter zey kom derekt mour her men woorden san sat zon shanders met gel nuchen stel land is superhe superhe alles ruept to line scholder! Jus east en zus gevarrend -Le keree hoe I ook loope zyn er met allyd overal forunteele begwaren en maun 39 m 20mender groot dan leer en waar of hue las wereld kan een tod van olyd las las forfunkeren Grede lewen. od graden vrede dre geen mennet meer verdoren kan. It voor my kan met meer jeggen dun dat ih al myn ergen studies in pund for waarborg wil geven lot beruggeve van helgeen me vour de cerde twee jan ahoulant novy taken. Bovenden det get tehhen my ones alles in seems moving. My dundet let mues kunnen gevanden worden Ih okel hel minimum andal en zy en it zeer jumy y zouden sunleggen. No my aungoands it his sen bull planner maur of wow out wel soon my zelf dat it may eens een ungoof van een handerd gulden kan daen aan myn gereedschap to verheteren En et ever ih soart wert sat ih her 6.0 twee Jum quand même gan skumen zon It his me may suo weeny sashykend van dulekomen zon weenschie ih das zehen wert dat it meet ween way you muchen aver een byoje

Farmhouse with Peat-Stacks

1883

[CA. 16 NOVEMBER, 1883]

340

The area round Zweeloo is at the moment all under young wheat—vast stretches sometimes, of the very tenderest green I know. With above it a sky of delicate lilac-white, which gives an effect—I don't believe I can paint it—but which for me is a basic color you have to know if you are to understand what the basis of other effects is.

A plain of black earth—infinite—a light sky of delicate lilac-white. From that earth sprouts the young wheat, and with that wheat the earth appears to be covered in mold. The good fertile soils of Drenthe are basically that; it is all in a damp atmosphere. Think of Brion's *Le Dernier Jour de la Creation [The Last Day of Creation]*; it seemed to me that only yesterday I understood the meaning of that painting.

The poor soil of Drenthe is the same—only the black earth is even blacker, like soot, not lilac-black like the furrows, and with a melancholy growth of ever-decaying heather and peat.

I see that everywhere, the incidentals on that endless background, in the peat, the turf huts, in the fertile areas, very primitive hulks of farms and sheepfolds with low, very low walls and enormous turf roofs. And oaks around them.

If you travel for hours and hours through the area, you feel as if there is actually nothing but this earth—endless—that mold of wheat or heather, and the endless sky. Horses, people seem as small as fleas. You sense nothing, even if in itself it is quite large; you only know there is earth and sky. However, in its quality of a spot observing other spots—leaving infinity aside—you find that each spot is in fact a Millet.

I came past a little old church, exactly—yes, exactly—like *l'Eglise de Gréville* [the church of Gréville] of Millet's painting in the Luxemburg. Here, instead of the peasant with a spade in that painting, there is a shepherd with a couple of sheep beside a hedge. In the background you could see not the view through to the sea, but only the sea of young wheat, a sea of furrows instead of a sea of waves. The effect it produces is the same. I saw plowmen—very busy—a sand cart, shepherds, road menders, manure carts. In an inn by the roadside I drew an little old woman with a spinning wheel, a dark silhouette as if from a fairy tale—a dark silhouette against a light window, through which you saw the light sky and a path through the delicate green, and a few geese pecking at the grass.

And when the evening twilight fell—imagine the silence, the peace then! Picture a lane with tall poplars in their autumn foliage *then*; picture a wide and muddy road, all black mud with endless heather on the right and endless

heather on the left; a few black triangular silhouettes of turf huts, with the red light of their fires shining through the windows; with a few pools of dirty, yellowish water, which reflect the sky, with bog oak decaying in them; just picture all that mud in the evening twilight with a whitish sky above it; everything a contrast of black and white. And in the middle of all that mud a shaggy figure—the shepherd—and a bunch of egg-shaped lumps half wool, half mud, bumping into each other, crowding each other—his flock. You can see them coming—you are surrounded by them—you turn round and follow them. With difficulty and unwillingly, they progress along the muddy road. However, there is the farm in the distance—some turf roofs and piles of straw and peat between the poplars.

The sheepfold is again like a triangular silhouette—dark. The door is wide open, like the entrance to a dark cavern. Through the cracks in the planks at the back shines the light of the sky behind it.

The whole caravan of lumps of wool and mud disappears into this cave—the shepherd and a little woman with a lantern close the doors behind them.

That return home of the flock at dusk was the finale of the symphony I heard yesterday. [THE HAGUE, DECEMBER 1883]

Just a word to let you know that as a result of the arrangement with Pa and Ma to let me use the room, which until today served as a laundry room, as a studio and storeroom for this and that, I have been to The Hague to pack up and dispatch my studies, prints, etc., which I need to arrange myself.

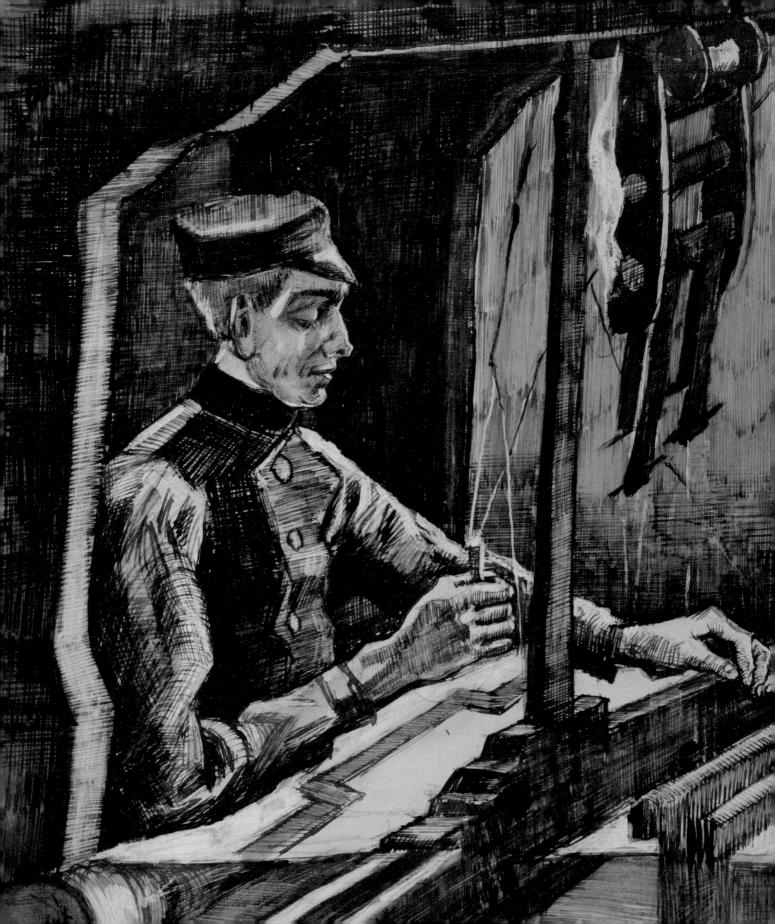

Part IV 1884–1887

arly in 1884, van Gogh's mother broke her leg; his helpfulness during her convalescence led to a rapprochement of sorts with his parents. After setting up a studio in an unused laundry room, van Gogh embarked on numerous studies of the local weavers. Captivated by the artistic possibilities of the rural area of Nuenen, he also produced many landscapes and pastoral scenes of peasant life.

Although Vincent's relationship with his younger brother became strained at this time, largely owing to his discomfort at the extent of his dependence on Theo, they maintained their usual conversation about art. Indeed, Theo seems to have been the first to mention to Vincent a group of artists called the Impressionists, whose bright palettes and revolutionary techniques were gaining popularity in Paris.

In 1885, shortly after the sudden death of his father in the spring, van Gogh completed his first major painting, *The Potato Eaters*, a distillation of his preoccupations and largely self-taught technical accomplishments over the previous years. Later that year, after one of his models, an unmarried girl, became pregnant, suspicion fell on him, although he seems to have been uninvolved in the matter. Nevertheless, local opinion turned against the eccentric painter, and he relocated to Antwerp.

In Antwerp, he studied the old masters at the new Rijksmuseum and even enrolled in the Antwerp Academy in 1886. But his rough ways and autodidactic habits were incompatible with the strict classical curriculum, and he abruptly quit the program, showing up unannounced in Paris in March of 1886.

From that time until early in 1888, van Gogh's usual torrent of letters slowed to a trickle, as he was living with his main correspondent. But we do know, from others' accounts and from the changes in his artwork at the time, that he made the acquaintance of a core group of Impressionists that included Henri de Toulouse-Lautrec, Émile Bernard, and Georges Seurat. The latter's use of stippled color was particularly influential in the development of van Gogh's mature brush style.

Just och andal gy in un vak lock allyd buten muel zyn. Hel gaat my hur in Brahant nog at met fen murste it vond de naturn hur erg aj, welken. Nu het it deze laverte weten 4 ag nærellen pum Krabbels er van.

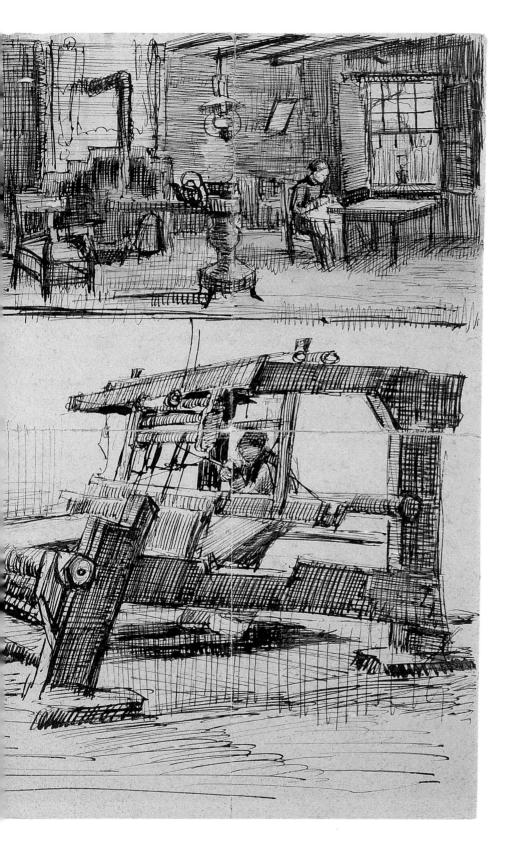

[3–16 JANUARY, 1884]

351

For my part, I often find it more pleasant to be among people who are *not in fact familiar* with the word in question [*isolation*], that is to say, peasants or weavers, then I am in politer circles. That is fortunate for me. For instance, while I have been here I have gotten very interested in the weavers.

Have you seen many drawings of weavers? I have seen only very few. At the moment I am making three watercolors of them.

These people are difficult to draw because in their small rooms you can't get far enough away to draw the looms. I believe that is the reason why they often go wrong. I have, however, found a room with two looms in it where I can manage it.

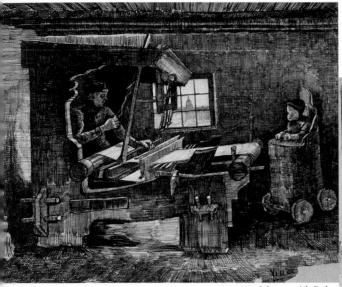

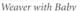

Weaver Facing Left

[CA. 24 JANUARY, 1884]

355

Taking account of her difficulties, Mother's mood is fortunately very even and contented. And she keeps herself amused with small things. I have recently painted the little church with the hedge and the trees for her, this sort of thing.

You will certainly be able to appreciate that I greatly enjoy the natural environment here. If you ever come, I will take you to the weavers' cottages some time. You will certainly find the figures of the weavers and the women who wind the wool striking.

The last study I made is the figure of a man sitting at his weaving loom, by himself, the bust and hands. I am painting a weaving loom of old greenish oak turned brown, on which the date 1730 is carved. By that loom, at a window through which you can see green fields, is a baby chair, and the small child sits there for hours looking at the shuttle going to and fro.

I have tackled that subject as it is in real life, the loom with the weaver, the window, and the child's chair in the impoverished room with a clay floor.

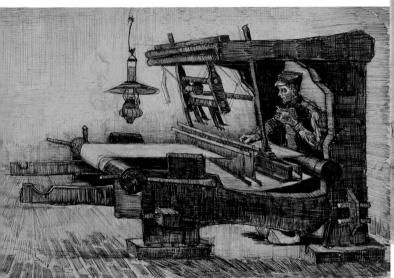

Weaver at His Loom

Weaver

[CA. 18-23 FEBRUARY, 1884]

357

I wanted to send you a brief word—also in reply to your letter in which you commented on my pen drawings—to say that I have five weavers for you, which I did from my painted studies and which are a little different in execution—and I believe more lively—than the pen drawings you have seen by me up to now.

I am working from early to late, because apart from the painted studies and the pen drawings I have also started on some new watercolors of them.

[FEBRUARY 1884]

359

One of these days I will send you yet another pen drawing of a weaver—larger than the other five; the loom seen from the front—which will make this series of drawings more complete. I believe that if you mount them on gray Ingres paper they will look their best.

I would be a bit disappointed if these little weavers were sent back. And if there is no one else you know who wants them. I would think this is something you might like to take yourself, as the first items of a collection of pen drawings of Brabant craftsmen, which I would gladly undertake and, assuming that I will be in Brabant a lot, would very much like to do.

[MARCH 1884]

363

You said something about my drawings, that if they were so good that you could put them next to a Millet or a Daumier, you would be willing to handle them.

On my part I would, of course, believe that, but I also know something else, that there are plenty more people to whom I can turn. And if you make it appear that the house of G & Co [Goupil & Co.] indeed trades mainly in that sort of art (Millet and Daumier), I will add that the house of G & Co decidedly *did not* at that time, before the big Millet sales, occupy themselves with Millet—nor with Daumier. Then, in Millet and Daumier's early days, G & Co were surely very busy with Julien Brochart and Monsieur Paul Delaroche (not a genuine *Monsieur* Delaroche to me), weren't they? So much for the house of G & Co.

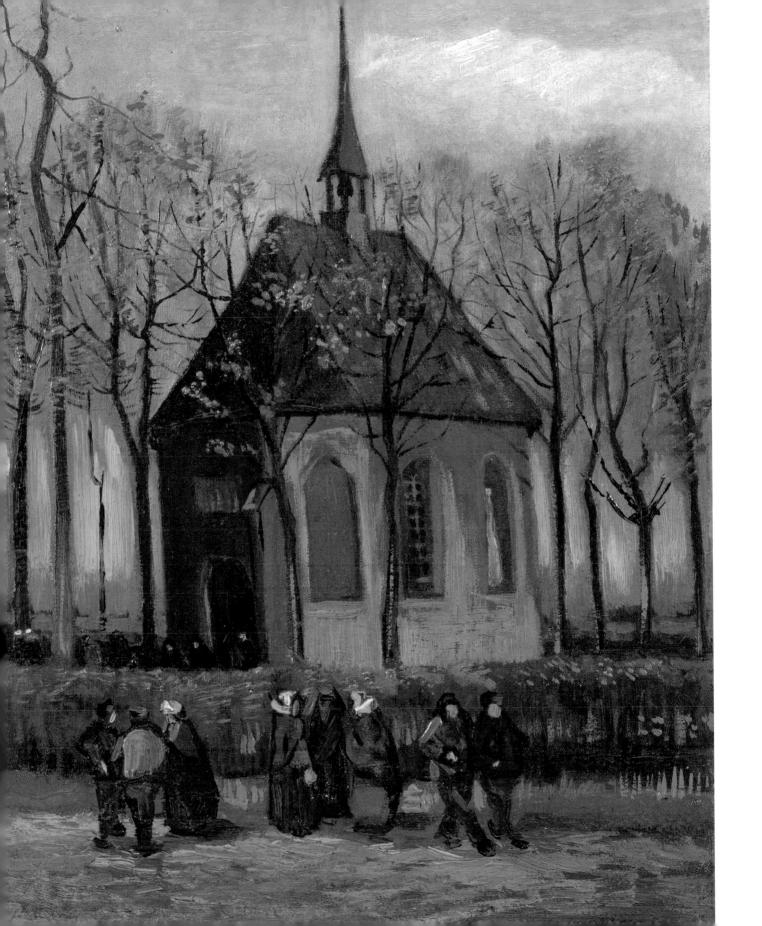

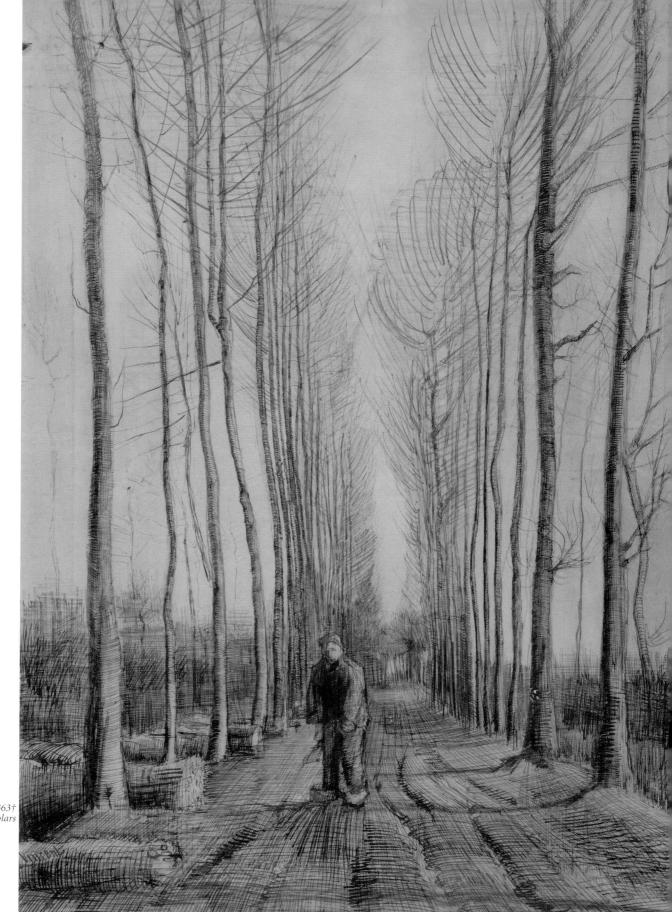

363† Avenue of Poplars

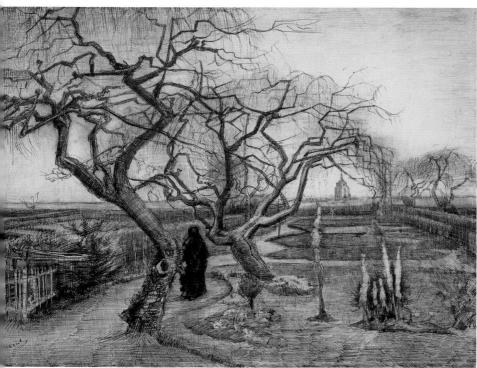

[EARLY APRIL 1884]

363A

For the current month I have already got the following drawings, which I would otherwise have sent you in April: Winter garden—pollard birches—lane of poplars—the kingfisher.

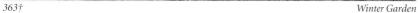

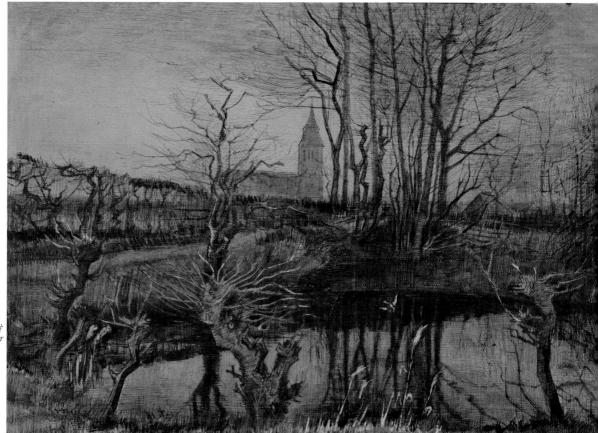

363† The Kingfisher

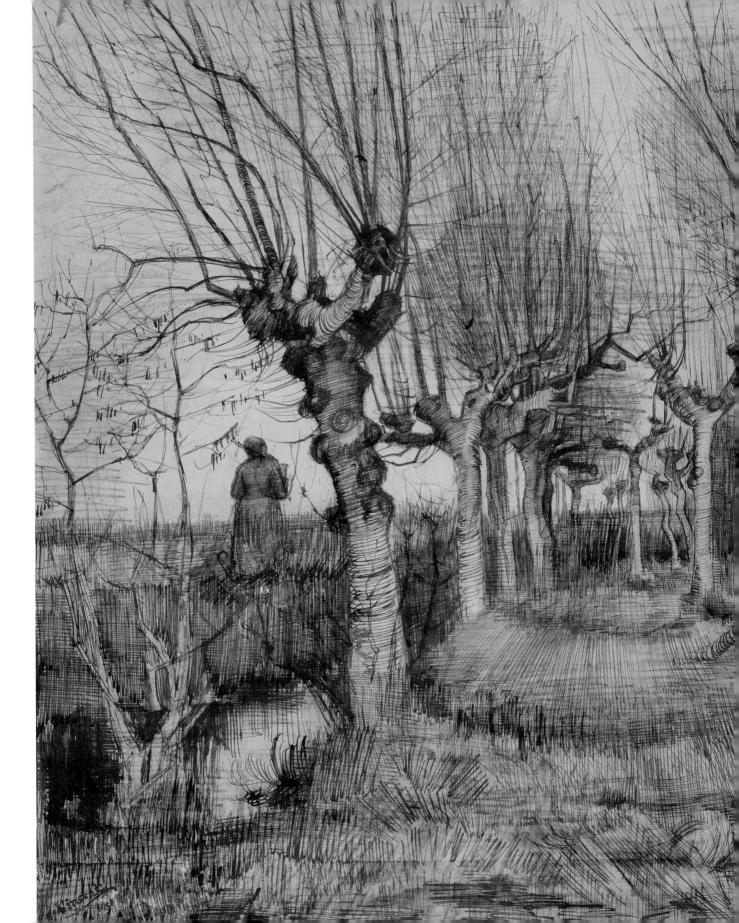

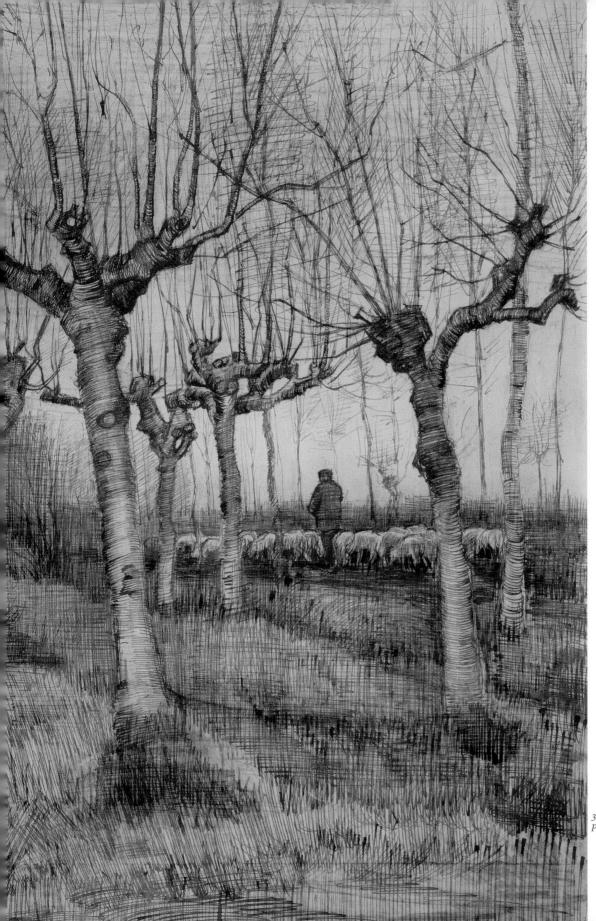

363† Pollard Birches

Muenen 185 Warrow Theo, Heerby obnur it a croques ven een scheldery but it met mer underen under hander het - det is een effekt van bloeunde boarmen to in den achtermeddag - By de lækeningen die ge Krygen jult jewore Roppand her kanns son er & see van I zelfde geval genomen zin Not my truf in de natuur was het verbusend had mirrored but rusten kanden En dal is neur Izelfor hactije behalve dat it en verscheeden studies our markle die il vermelyde tol skeer hu sen pentakenny markle was just amount it welde you an Interester of in sening sulceme delails die met makkely to of van jeef of locually and be trubben you -As it was my seeing geef vertrouwen het in my wients is helook dawronis ametal bet me Is veel marite kost dan dat it goo! mour gelos of men down mets soon women you of het le very ests do en - En may eens voor de algemeenheden waaren de meeste Kunstkenners wel schynen te vervallen men it have en myn schouders vove up.

[APRIL 1884] 366

Enclosed I send you a sketch of a painting that I have in hand along with some others. This shows the effect of flowering trees in the late afternoon. Among the drawings, which you will get as soon as Rappard comes here, there are three made of the same subject. What struck me in the scenery was the astonishingly real, half old-fashioned, half rustic character of that garden. And that I made a pen drawing of it as many as three times from the same angle—apart from several studies of it that I destroyed—was because I wanted to reproduce its character in some intimate detail, which could not be expressed easily or automatically or by accident.

If I have any self-confidence about my work, it is because too much effort is spent on it to believe that nothing could be gained by it, or that it would be in vain. And again, I just shrug off the generalities most art critics increasingly appear to lapse into.

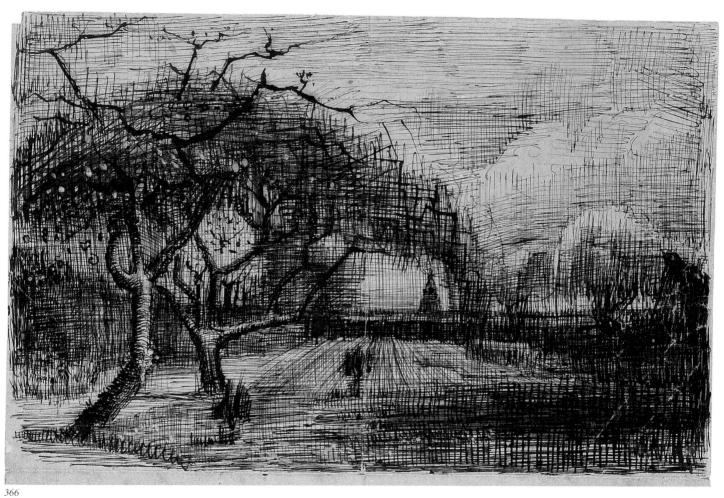

[CA. 30 APRIL, 1884]

367

As regards work, I am engaged on a rather large painting of a weaver, with the loom seen straight from the front—the figure a dark silhouette against the white wall. And at the same time also the one that I began in the winter, a loom on which a red piece of cloth is being woven; it shows the loom from one side. I have also set up another two of effects on the heath. And one with pollarded birches.

I will still have a great deal of hard work on the weaving looms, but there are such wonderfully beautiful things in nature, all that old oak against a grayish wall, that I am sure it is right it should be painted sometime. We should, however, see that we produce them in such a way that they fit well with other Dutch paintings in their color and tone. I hope soon to start on two others of weavers, where the figure will come in quite differently, with the weaver not sitting behind the loom, but arranging the threads of the piece. I have seen them weaving in the evening by lamplight; that gives a very Rembrandtesque effect.

I recently also saw some colored pieces being woven one evening. I will take you with me sometime, if you ever come here. When I saw it, the men were just standing there, arranging the threads, so their figures were bent forwards, showing dark against the light and contrasting with the color of the cloth. Large shadows on the white walls from the planks and beams of the loom.

[EARLY JUNE 1884]

37

In my last letter I already wrote you that as well as the woman spinning, I wanted to start on a large male figure. Here is a scribble of it. Perhaps you remember the two studies that I had in the studio when you were here, of the same little corner.

The *laws* of colors are indescribably wonderful, particularly because they are in *no way accidental*. Just as these days we no longer believe in arbitrary *miracles*, no longer believe in a God who capriciously and despotically skips at random from one thing to another, but in fact are beginning to acquire more respect and admiration and belief in nature, even so and for the same reasons I think that we should in art no longer ignore the old-fashioned ideas of innate genius, inspiration, etc., but thoroughly consider, verify and ... change them very considerably. However, I do not deny the existence of genius and even the innate nature of it. But the conclusions from this, that by the nature of things theory and education are always useless, that I deny.

The same thing that I did in the little woman spinning and the old man winding thread, I hope, or rather, I shall try, to do much better in the future.

But in these two studies from life I have been a *little more myself* than up to now in most of my other studies—unless I was successful in being so in some of my drawings.

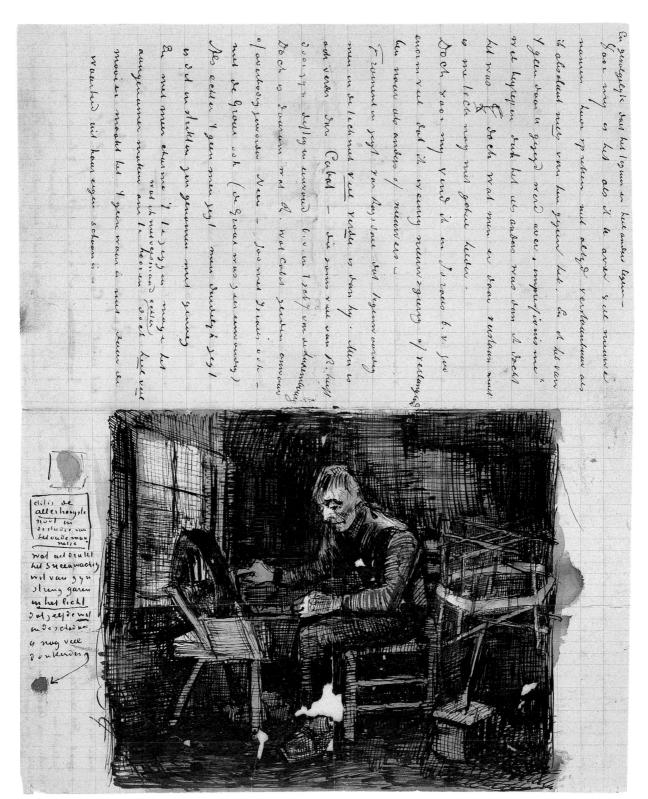

[EARLY JULY 1884]

372

But what has struck me most in the natural scenery recently, I have not yet started, because of the lack of a good model. The half-ripe wheat fields now have a dark, golden-blonde tone, reddish or golden bronze. This is brought to a maximum effect by the opposition of the broken cobalt tone of the sky.

Imagine against such a background female figures, very rough, very energetic, their faces, arms, and feet bronzed by the sun, with dusty, coarse, indigo clothing and black, beret-shaped caps on their cropped hair, while they go to work along a dusty path of reddish violet with some green weeds, through the corn, with weed scrapers on their shoulder or a loaf of rye bread under their arm—a jar or a copper coffee pot.

I have recently seen the same subject repeatedly in all its variations. And I assure you that it was very real. Very rich and yet very austere, very selectively artistic. And it preoccupies me enormously.

My paint account, however, is such that I must be a little economical with putting new things in hand in a larger size and the more so, as it will cost me a lot on models, always providing I can get models of the type I have in mind (rough, flat faces with low foreheads and thick lips, not sharp, but full and Millet-like) and with the right clothing.

For that is a very important point here; you have no freedom to depart from the colors of the costume, where

the effect lies in the analogy of the broken indigo tone with the broken cobalt tone, enhanced by the secret elements of orange and reddish bronze of the wheat.

It will be something that expresses *summer* well. To my mind it is not easy to express summer, as mostly, or at least often, a summer effect is either impossible or ugly; at least that is what I feel. On the other hand, however, there are the twilight evenings.

But I mean, it is not easy to find a summer effect that is as rich and as simple and as good to look at as the characteristic effects of other seasons. Spring is delicate, green young wheat and pink apple blossom. Autumn is the contrast of yellow foliage against violet tones. Winter is the snow with black silhouettes.

So if summer is the contrast of blues against an element of orange in the gold-bronze of the wheat, it should similarly be possible to paint a picture that expresses the mood of each season well, by using in each case the contrasts of the complementary colors (red and green, blue and orange, yellow and violet, white and black).

[EARLY AUGUST 1884]

374

When you come here, you will find all the peasants busy plowing and sowing spurry, or that may just be coming to an end.

I have seen fine sunsets on the fields of stubble.

Verleden wach hen it dagely hoch op Voud by den Korenwagst geweest waarv und may een earrywoodingemaaks het

Dit maalile it voor amand on Einsteven

Die eene alzaal weestel le Decomacus. Hy webe

JI Jan met compendes van Jeverse heelegen

Jli gaf hem on bedenking of een blat voorstellingen

met het boerenleven van de leeg erg - levers de

4 jaarget, den 37 morteseernde - wet toere

met meen den appet 1 den brave menschen die

pedaan aan lafet meeten loomen tellen kon

ap wakteen dan de mystelze personages herhaven

genoemd - Nu o de man daar warm op geworder

per een bezoch op 't at eleer
Maar hy wet jelf du valeten schelderen au

late dat lechtem ! (doct it zen in reductie de compositie onwerpen)

Late dat lechtem ! (doct it zen in reductie de compositie onwerpen)

Late dat lechtem ! (doct it zen in reductie de compositie onwerpen)

Late dat lechtem ! (doct it zen in reductie de compositie onwerpen)

Land en - een gewegen goud, med die lat

Janaal loe eene leer aangevelyte cultestie

3 maal loe eene leer aangevelyte cultestie

antygudelen heeft vergamet & verkocht
Nu zyk is en een huis heeft gezet dat

by weer vol antiquiteden heeft en meubleest met sommege hel movie erkenhauten harten re. De plafonds en muren decoreur by self met en werkely to goed do mo hour de set, val wil by heground schelderevert hebben on is beginnen # 12 parcelon met blaemen le schelderen Algren aver 6 valetumende breedte en daarvoor gofil hem voorlaapige plans van Laover - ploeger - herder - Kurenauget andippelangel - Osfellar in de meeur Man of I als geven got weet it met want een varle af prach hel I miet van hem. Allen met det eenste vale is by injuramen als mede met my m ochetyes voor de andere sujellen. Ik verlang gen nam un 120 mml -Het begit me her wee her aleen - by by den mus it wel som muge dangen doch het weit also whent my genery No - grand der the black over me als ge hum legen i leg laagel. Als ge kumt , wet ge alle bueren aan 1 plager under - to en parrie Jamen . / - I d jol van net ey) yn end lugi en sk het prochlije dows andergangen ses un eg. or stoppelveeden. Tol years 1. Kincenty

[SEPTEMBER/OCTOBER 1884]

381

I have bought a very beautiful book on anatomy, Anatomy for Artists by John Marshall, which was quite expensive, but which I shall also find very useful for the rest of my life, because it is very good. Besides, I also have what they use at the Ecôle des Beaux-Arts and what they use in Antwerp.

The key to *many* things is the basic knowledge of the human body, but it also *costs quite a lot of money* to learn it. And I also think that *color, chiaroscuro, perspective, tone,* and *draftsmanship,* in fact everything, has similar definite fixed laws too, which should and can be studied just like chemistry or algebra. This is not by any means the easiest view of things, and anyone who says, "Oh, everything should come naturally" makes too little of it. If only that were enough! But it is not enough, because even if you know quite a lot *instinctively*, that is exactly why you have to do your best three times as much in my opinion, to move from instinct to *reasoning*.

[OCTOBER 1884]

383

The last thing I did is a rather large study of a lane of poplars with their yellow autumn foliage, where the sun makes occasional bright patches on the fallen leaves on the ground, alternating with the long shadows cast by the trunks. At the end of the road, a little farmhouse with the blue sky above shining through the autumn leaves.

I believe that in a year spent painting a great deal and continuously, I will change my style of painting and of color quite a lot, and that I shall become more somber rather than lighter.

[NOVEMBER 1884]

38

I can safely claim that since your visit I have made progress in the technique of painting and in color—and that this will improve still further. It is the first steps that count in painting; later on it is more compliant, and I have some trumps still in my hand. And I believe that I can play my trumps.

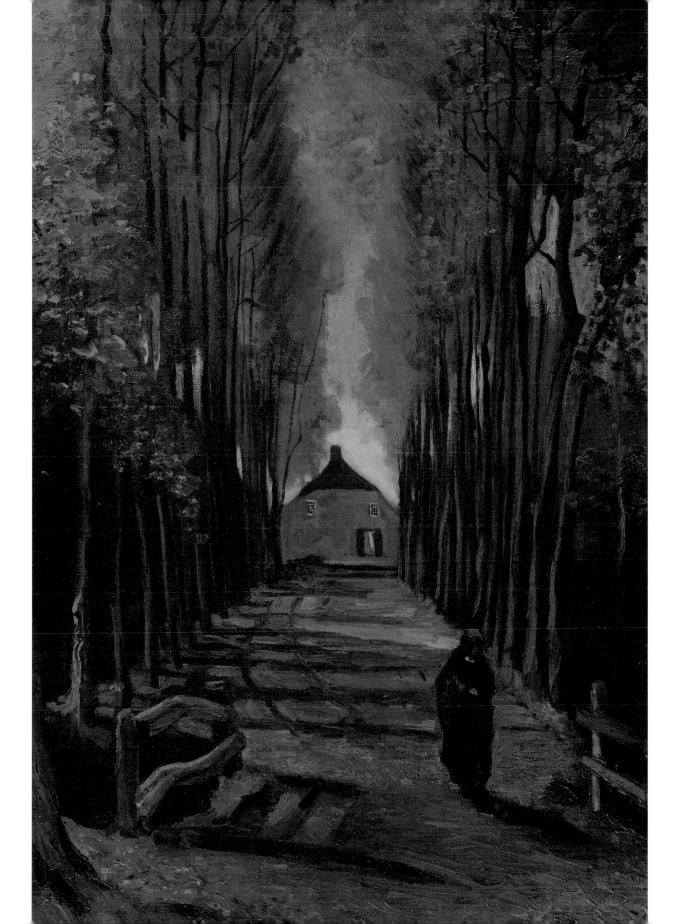

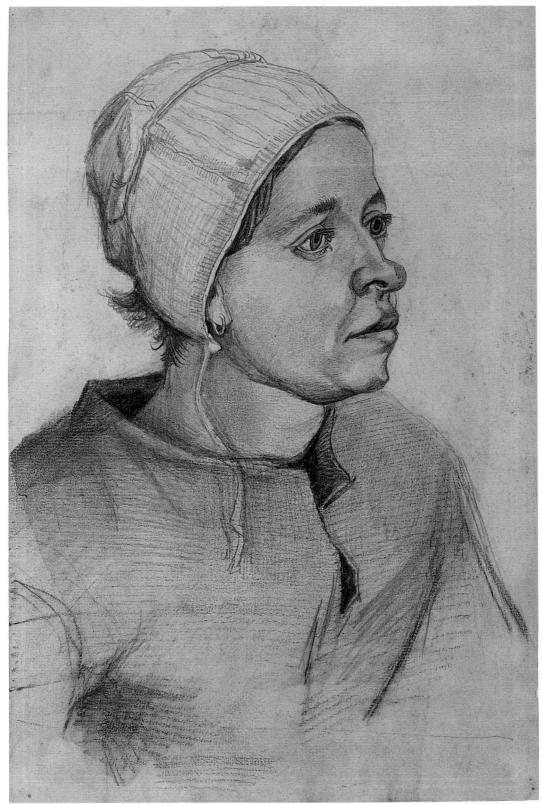

Head of a Peasant Woman with White Cap

[FEBRUARY 1885]

394

Painting these heads has kept me very busy. I paint in the daytime and draw in the evening. In this way I have managed to paint some thirty already and draw as many, with the result that I see a chance, I hope, of soon doing

things quite differently. I think that this will help me in general with figures.

Today I did one in black and white against flesh color. And I am always searching for blue. The figures of peasants here are blue, as a rule. That color in the ripe wheat or against the withered leaves of a birch hedge, so that the faded shades of darker and lighter blue bring them to life again and make them more expressive by the contrast with golden tones or red-brown, is very beautiful and has struck me here from

the beginning. The people here all instinctively wear the loveliest blue I have ever seen.

It is coarse linen, which they weave themselves; the warp black, the weft blue, so that it produces a black and blue striped pattern. When that is faded and has lost a little color from wind and weather, it is an infinitely quiet, delicate tone, which brings out the flesh colors very well. In short, there is enough blue to liven all other colors, in which elements of orange are hidden, and it is sufficiently faded not to be discordant.

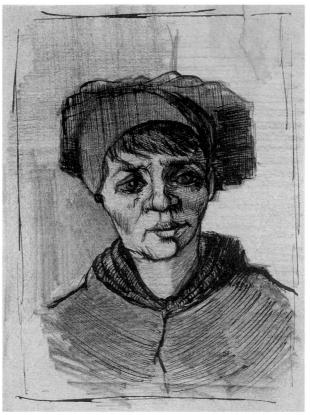

Head of a Woman

But this is a question of color, and it is the question of form that matters to me even more at the point I am now. To express form, I believe, an almost monochrome color palette is best, with the tones varying mainly in intensity and value. For instance, Jules Breton's La Source was painted in almost a single color. But you have to study each color in itself, together with its opposite, before you can be quite sure to achieve a harmonious result.

When there was snow, I painted a few studies of

our garden. Since then the landscape has changed a great deal; we now have splendid evening skies of lilac with gold above toning silhouettes of the houses between the masses of reddish-colored brushwood, above which the slender black poplars rise. The foreground is a faded and bleached green, varied with streaks of black earth and by pale, withered reeds on the sides of the canal.

en gekerheid scheppen en composeeren doch 8002 je julks deden On croil que j'imagine - ce n'est pas vrai. Je me souvieus - jei sen die mederlyte composeeren kom-Walny nu belieft ih kan nog geen entre I children later seen des moods may geen enkele beekening Maar studies mout it well en juist douron Kan ih me heel bed roorstellen de mogelykkeed er een by home det chook grif weg composeren Runnen. En trouvers I is morelyk le zeggen want studie ophoudl en schilderg begint Ik denk aver sen paar grootere doorwerkte dengen en als het seus was dat it it helderheid kreeg bestragt die dog toog leb weer legwen - m dat geval zou ih die studies en kwestie mag her houden want dan zon it ze er zehen voor noudy hebben - helis box (00 cers -

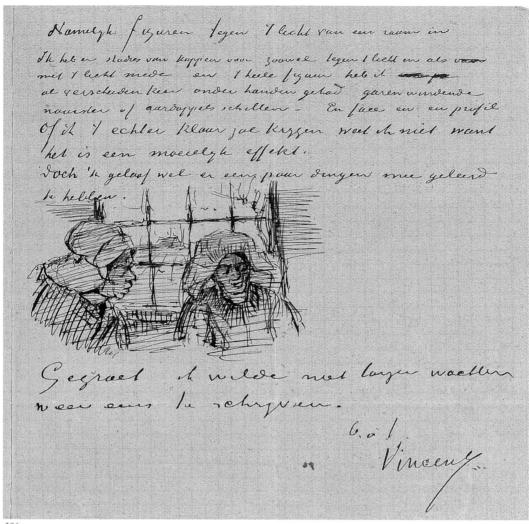

396

[MID MARCH 1885]

396

As for me now, I can still not show you a single *painting*, not even a single drawing.

But I am doing *studies*, and that is why I can well envisage a time ahead when I will be able to compose readily. And after all, it is difficult to say where studies end and painting begins.

I am thinking about some larger, more developed things, and once I am clear how to reproduce the effect

I have in mind, I would still need to keep the relevant studies here, because I would certainly need them. It would, for instance, be something like this.

That is to say, figures against the light of a window. I have made studies of heads for it, both against the light and with the light in front, and several times I have worked on the whole figure: winding threads, sewing, or peeling potatoes. Full face and in profile, it is a difficult effect. But I think I have, in fact, learned a few more things.

Two Peasant Women Working in the Fields

[CA. 5 APRIL, 1885]

398

I am still very much affected by what has just happened [the death of Theo and Vincent's father] —and so I have simply gone on painting throughout these two Sundays.

Here is another scribble of a man's head and of a still life with honesty flowers in the same style as the one you took with you. In the foreground is one of Pa's pipes and his tobacco pouch. If you would like to have it, you can of course have it with pleasure.

[9 APRIL, 1885]

39

Enclosed are two scribbles of a few studies I have made, while I have also been working again on those peasants around a dish of potatoes. I have just come home from that and have worked on it some more by lamplight, although I started it by day this time.

You can see here how the composition has now turned out. I have painted it on a fairly large canvas, and as the sketch is now, I think there is some life in it.

[21 APRIL, 1885]

402

There is a school—I believe—of impressionists. But I don't know much about it. I do know, however, who the original individuals are around whom—as if around an axis—painters of peasant life and landscapes will turn:

Delacroix, Millet, Corot, and the rest. That is my own impression, expressed rather badly. I mean that (rather than persons) there are rules and principles, or fundamental truths, for both drawing and color, which you appear to come upon when you have found the genuine thing.

For drawing there is, for instance, the question of drawing figures in a circle, e.g., basing yourself on oval areas of ground, which is something the ancient Greeks were already conscious of and which will remain so until the end of the world. For color, the eternal question, which, for instance, was the first question Corot put to Français, when Français (who already had a name) asked Corot (who still had no name other than a negative or very bad one) when he (F.) came to Corot to ask him things:

"Qu'est-ce que c'est qu'un ton rompu? Qu'est-ce que c'est qu'un ton neutre?" ["What is a broken tone? What is a neutral tone?"]

Which can be better shown on a palette than explained in words.

And also where, for example, the painting I am doing now is different from lamplight scenes such as those by Dou or Van Schendel, it is perhaps not superfluous to point out how one of the most wonderful achievements of the painters of this century has been painting *darkness* that yet is *color*. In short, read again what I have written, and you will see that it is not unintelligible, and that there is *something* in it and that *something* is a question that came into my thoughts as I was painting.

I hope that the painting of the potato eaters will go smoothly. Apart from that, I am also working on a red sunset. To paint peasant life you have to be master of such an enormous amount of detail. But on the other hand, I don't know where you can work in such peace, in the sense of *peace of mind*, even when material matters are such a struggle.

Two Peasants Planting Potatoes

Sketch of a Peasant Family at Table

[APRIL 1885]

403

I wanted to let you know that I am hard at work on the *Potato Eaters* and have again painted studies of the heads. The hands in particular have been changed a great deal.

Above all I am doing my best to bring life into it.

I will not send the *Potato Eaters*, unless I am sure that there is *something* in it. But it is progressing, and I think that there is something quite different about it from anything you have ever seen by me. At least so clearly.

I specifically mean the *life*. I am painting this *from memory into the actual painting*. But you know how many times I have painted those heads! And moreover, I go round every evening, to draw things actually on the spot.

But in the painting I let my own head assist me in the sense of *thought* or imagination, which is not the case so much with my *studies*, where no creative process should take place, but where you find nourishment for your imagination from the reality, so that this turns out to be right.

[CA. 30 APRIL, 1885]

404

When the weavers weave that cloth that, I believe, is called cheviot, or the distinctive Scottish tartan weaves, then it is their custom, as you know, to achieve peculiar broken colors and grays in their cheviots or in the tartans by putting the brightest colors of all next to each other to get a balance, so that instead of the cloth lacking cohesion, the final effect of the pattern from a distance is harmonious.

A gray that is woven from red, blue, yellow, off-white, and black threads all mixed up, a blue that is *broken* by a green and orange-red or yellow thread, are quite different from *plain* colors; they are more alive, and plain colors become *hard* and quite lifeless beside them. However, for the weaver, or rather for the designer of the pattern or the color combination, it is not always easy to calculate the number of threads and their direction; nor is it easy to weave brushstrokes together until a harmonious effect is achieved.

If you saw them together—the first painted studies that I did on coming here to Nuenen—and today's canvas, I believe you would realize that as regards color, things are beginning to look up.

As far as the *Potato Eaters* is concerned, it is a painting that would *look well framed in gold*, I am sure of that. But it would look just as well on a wall hung with a paper of a deep shade of ripe wheat. However, it is *simply not possible to picture it* without that kind of finish. It would not show up against a dark background and particularly not in a drab setting. And that is because it is a view of a very gray interior.

In *reality* it is, as it were, already framed in gilt, which would be more around the observer and reflect from the hearth and the fire onto the white walls and onto the

painting from outside it, but in the nature of it throw the whole thing back. So again, it must be surrounded by a deep gold or copper color to *finish it off*.

If you want to see for yourself how it should be seen, then please remember that. Linking it to a golden tone also brightens *areas you would not suspect* and takes away the *marbled* aspect that you would get if it had the misfortune to be placed against a drab or black background. The shadows have been painted with blue, and a golden color has an effect on that.

I have deliberately tried to work on creating the impression that these people, who, by the light of a little lamp, eat their potatoes with those hands that they put in the dish, [that] have themselves dug the earth, and so it is *their own manual labor* by which they have honorably *earned* what they are eating.

I wanted to make people think of a totally different way of living from that which we, educated people, live. I would absolutely not want anyone to find it beautiful or good without a thought.

For the whole winter I have had the threads of this weave in my hands and looked for the definitive pattern, and if it should now be a weave with a rough and coarse aspect, the threads have been chosen with no less care and following certain rules. And it could well turn out to be a real *peasant painting*. *I know that it is*. But if anyone prefers namby-pamby peasants, it is up to them. For my part, I am convinced that in the long run it gives better results to paint them in their roughness than to introduce conventional prettiness.

A peasant girl is more beautiful than a lady in my eyes, in her blue, patched and dusty jacket and skirt, which is given the most delicate shades by sun, wind, and weather. But if she puts on a lady's dress, than the reality

404†, R57†

Four Peasants at a Meal

is gone. A peasant in his fustian clothes in the fields looks better than when he goes to church on Sundays in some kind of gentleman's suit.

And likewise, I think you would be wrong to give some kind of conventional smoothness to a peasant painting. If a peasant painting smells of bacon, smoke, steaming potatoes, fine, that is not unhealthy; if a stable smells of manure, fine, it is a stable. If a field has a smell of ripe wheat or potatoes, or guano and manure, that is simply healthy, particularly for townspeople. They can derive some benefit from such paintings. But a peasant painting should not be delicately scented.

[AUGUST 1885]

RAPPARD R57

As far as my work goes, the subject of the potato eaters, of which you saw the lithograph, is one that I tried to paint, having been carried away by the exceptional

lighting of the grimy hut. It is in such a low spectrum that the light colors smeared on white paper would look like ink blots, and on the canvas they look like lights because of the great contrasts confronting them—for instance, the Prussian blue put on straight without mixing. My own criticism of it is that because of my attention to that I had failed to keep my eye on the shape of the torsos. However, the heads and hands were done with great care, and because they were, the most important features and the whole of the rest was almost in darkness (therefore giving a quite different effect from the lithograph). I may perhaps be excused more than you think for having painted this the way I did. And in fact, the actual painting is also different in composition from either the rough sketch of it (which I still have and which I made in the hut in the evening by the light of a small lamp) or from the lithograph.

I am still having trouble with putting action—being busy, doing things—in my figures.

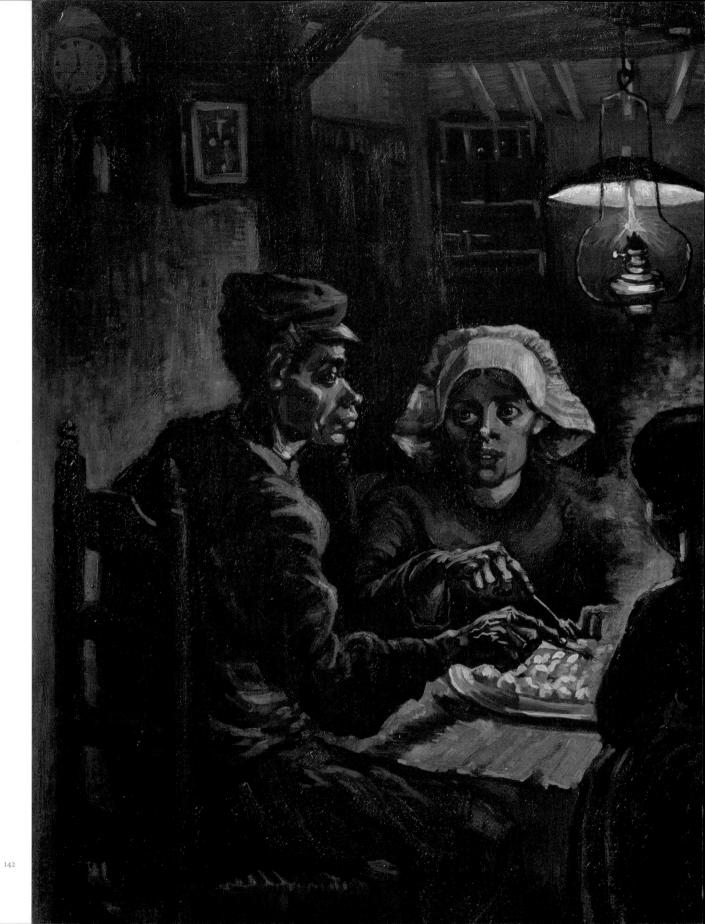

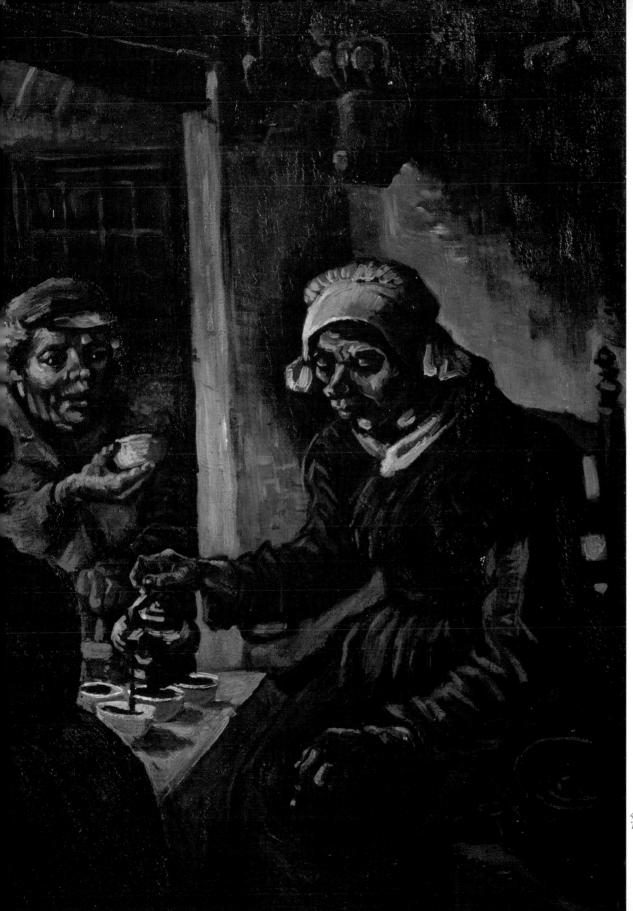

404†, R57†, 405† The Potato Eaters

[EARLY MAY 1885]

The painting of the potato eaters is very dark; for instance, hardly any white has been used in the white, but simply the neutral color you get when you mix red, blue, and yellow together, e.g., vermilion, Paris blue, and Naples yellow. That color is in itself a fairly dark gray, but comes across as white in the painting.

I will tell you why I have done that. Here the subject is a gray interior, lit by a small lamp. The gray linen tablecloth, smoke-stained walls, the dusty bonnets in which the women have been working on the land, all that, when you look at it through your eyelashes, seems in the light of the lamp to be a much darker gray, and the lamp, although it is a reddish-yellow light, seems still lighter—and very much so—than the white in question.

And now the flesh colors: I know that at a superficial glance—when you don't think it through—they look rather like what people *call* flesh colors. However, when I started painting this, I painted them, for instance, with some yellow ochre, red ochre, and white. But that was *much too light* and was certainly not right at all So what to do? I had finished the heads and done them with great care, but I promptly painted them over without mercy, and the color they are now painted with is rather like the *color of a good, dusty potato, unpeeled, of course.*

While I did that, I thought of what was so rightly said of Millet's peasants: "Ses paysants semblent peints avec la terre

qu'ils ensemencent" ["His peasants look as if they were painted with the earth they were sowing"]. Words that automatically come to my mind when I see them working, outside as well as inside.

I am, however, quite sure that if you were to ask Millet, Daubigny, or Corot to paint a snowy landscape without using white, they would be able to do so, and the *snow* would look white in their paintings.

As regards *bright* contemporary paintings, I have in recent years seen very few. But I have thought about the question a great deal. Corot, Millet, Daubigny, Israëls, Dupré, and others *painted bright paintings as well*, ones in which you can see into every corner and depth, however deep their range.

But those I have named are none of them people who paint the local tone literally; they follow the spectrum they have started with, carry through their own thoughts in color and tone and drawing. And that *their lights are mostly fairly dark grays* in themselves, which in a painting *seem* light by contrast, that is a truth which you will probably have the opportunity to observe every day.

You will understand that I *don't* say that Millet uses no white when he paints snow, but I claim that he and other colorists, if they want to and set themselves to do it, would deliver it in the same way that Delacroix says of Paolo Veronese, that he painted pale, fair, nude women in a color that in itself is reminiscent of sludge.

Nu de fleesch Bleuren -I weel wel dat die by appenlaktige beschouwing n. l. als men met er by Door Dentil det ly Renew wat men nound vleerchileen Joch ik hal je by I hegen van I och 300 eins geschilderd - was seel oher wood oher en wel 6.v. Morar dot was seel le liebt en Leagde bejoald met - al de koppen had chaf en nog al met seel jong afsenweld maar ek het se gref avergesdeldere sander genade en de Reeur waar ze nu mee geschelderd 37 n is sooned de Kleur van een goed stoflegen aardappel ony chew no wardy h Terry like dat deed daelt ch er nag van dat het goo jeurs gegegd s van de boeren van hullet -Oses paysans Sembled peints " aveclaterre qu'ils ensemenceng" Een woord war in Isthers omvileetiense aun denken als it je aan I wert Bre barlen jourel als burnen.

Jk hvad het dan och voor jeken vot
als men Melet Daabegry Corol 3000 gragen sen Inseuw landschap 1. schilderen 3 onder wil te gebrucken - 34 het doen jonden en de sneum jou Willy kenen in hun schildery.

Helyeen gy jegle sande leth dat het effekt wolling is sind et jest och en is in jouverne myn eigen schuld met down de lethograaf sig Lewserde dat andal it houst nergens wit op den steen had gelaten het met said drakker jou Ih hed lower up 33 n aun weder to lecht a probables ud gebelen als it I servoudez ged with how Jos als de leekening was som het algemeen donkertegeweest zzn men met gerann met helpen. en er jou al mosfeer tusteten de plans 324 Doch was much it does met het soly het as you grad als die spusser van verl. jaar -It hat het me weer in de hut om ke nour de natuur mag dengen aan le daen It geles feeller in het af joe krigsen at you out by wy , e van spreken - want ough eigen werk sold eigenslyt mount of of blown venden jelf. Ik kan er een Pleiner van maken of en lækenny seller als ge de lever helt want it voel het ding goo dat Rund ge 4 mes begrypen / geval Id it has near krafe peachly was -Your ch Yan arow road et de luisjes aun het schoften by i lecht van I raangge ur plast, van Jonder de lump

okt was verkes end mavi. de kleur was
ook ergenaardy - het here ze hermmert te die kapp en
legen leuren uit geocheldend - ap de mannen was her
elleht doch nog southerden.

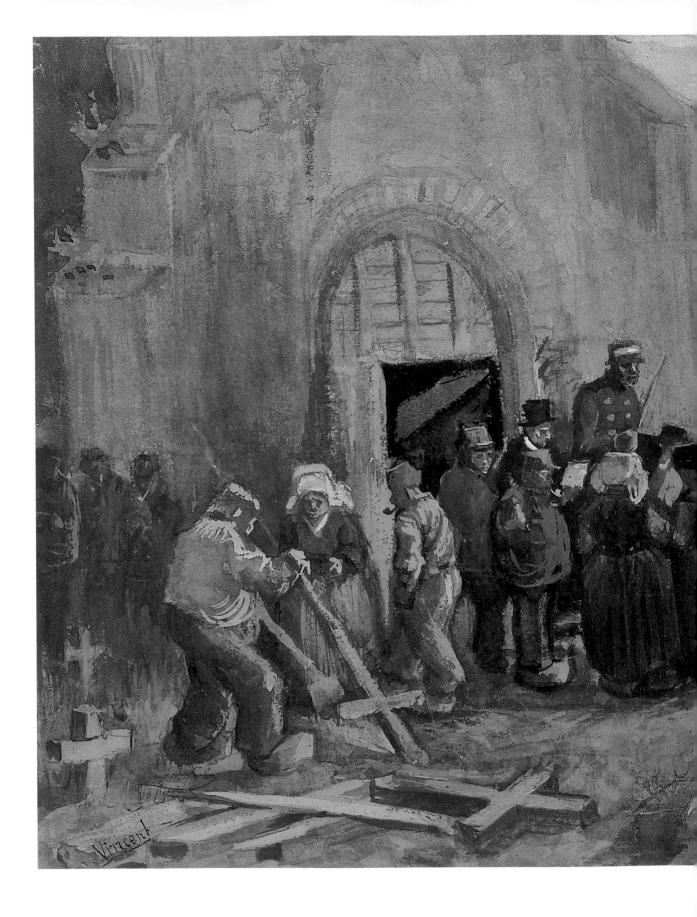

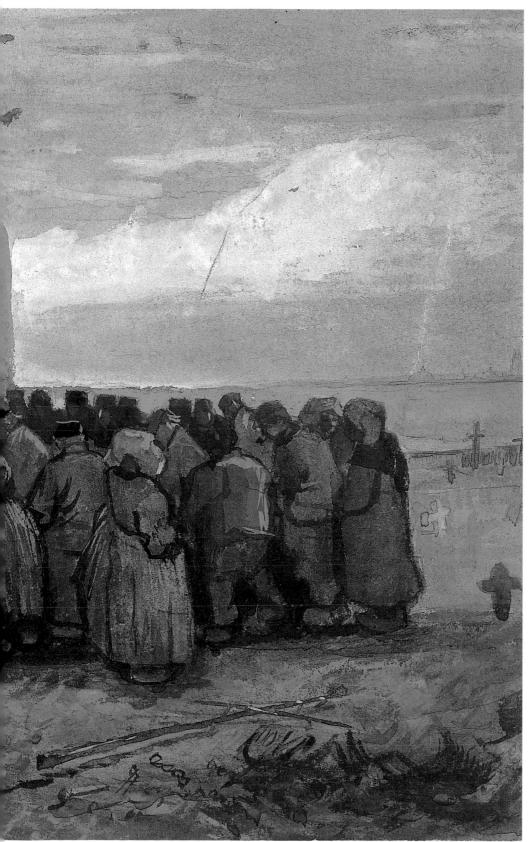

Public Sale of Crosses from Nuenen Cemetery

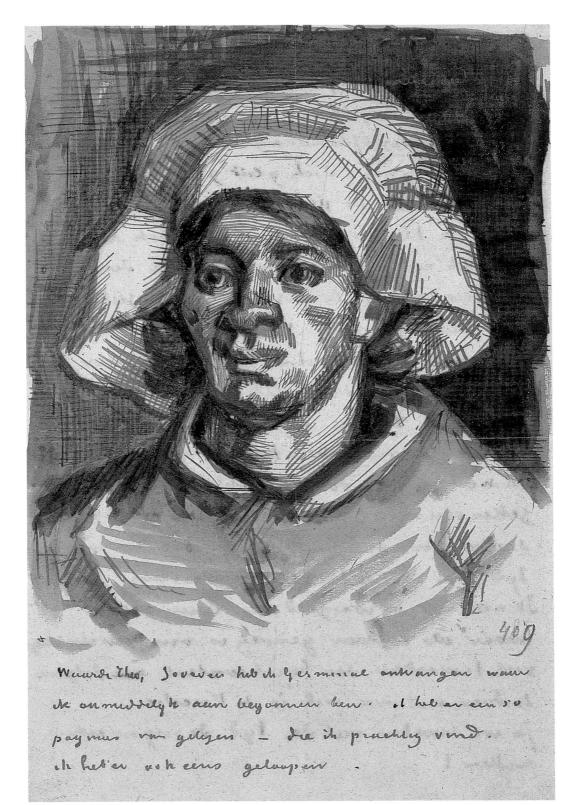

409

[CA. 15 MAY, 1885]

409

Here is a sketch of a head, which I have just done. You have received the same one in the last set of studies I sent; it was the largest of them. But painted smoothly. I have not spread out the brushstrokes this time, and the color is in fact quite different.

I have not made a head before that is quite as much "peint avec de la terre" ["painted with the earth"], and more will certainly follow. If all goes well—if I can earn a little more, so that I can travel more—then I hope to go and paint mineworker's heads as well some time.

However, I carry on working until I am completely sure of what I am doing, so that I can work still faster than now, and in a month's time, for instance, I will also produce some thirty studies.

[IULY 1885]

417

The last time I wrote to you it was in such great haste. I need the whole day these days, as I am working a good two hours away from here. I want to do some lovely cottages in the middle of the heath. I now have four as large as the two I last sent you, and several smaller ones. They are not dry yet, and I will want to add something to them at home. But then I would like to send them to you with some figure studies.

However, now I want to tell you that as I have some six fairly large canvases, I intend to make only small ones for the time being.

Sketch of a Thatched Cottage

[JULY 1885]

418

You may laugh at Courbet, who says, "Peindre des anges! Qui est-ce qui a vu des anges?" ["Paint angels! Who has seen angels?"] But I would like to add more to that, e.g.:

"Des justices au harem [the judges of the harem], qui est-ce qui a vu des justices au harem? Des combats de taureaux [fighting bulls], qui est-ce qui en a vu?" And so many other Moorish, Spanish subjects, cardinals, and then all those history paintings, which still go on being produced, meters high by meters wide! What use are they all and what do they want with them? They are mostly stuffy and dull when a few years have gone by, and become more and more boring.

Peasant Woman Digging

Anyway, perhaps they have been beautifully painted, that may be so; these days when connoisseurs stand in front of a painting such as that by Benjamin Constant [Judges of the Harem], or a reception of a cardinal by some Spaniard or other, it is customary to say something profound like "good technique." But as soon as these same connoisseurs are confronted with a scene of peasant life or a drawing by, for instance, Raffaelli, they would with the same profound air start criticizing the technique.

You may think that I am making an unfair comment here, but I am so full of the fact that all these exotic paintings were painted in the *studio*. Just go out and paint out of doors, on the spot! Then all kinds of things

will happen. For example, from the four canvases that you are about to receive, I must have removed at least a hundred or more flies, to say nothing of dust and sand, etc., and not forgetting that if you carry them across heath and hedges for an hour or two, you will get the odd scratch on them from a branch or so.

Nor should it be forgotten that when you reach the moors in this weather after a few hours walk, you are tired and hot. Nor do the figures stand still, like professional

models, and the effect you want to capture will be different as the day progresses.

I don't know how it strikes you, but as far as I am concerned, the more I work on it, the more the peasant life absorbs me.

I would be *desperate if my figures were good*; I don't want them to be academically correct. I mean that if you *photograph* a digger then he would *certainly not be* digging. I find Michelangelo's figures wonderful, though they are a little too long in the legs, and the hips and buttocks too wide. In my eyes, therefore, Millet and Lhermitte are true painters, because they do not paint things as they are, after dry analytical investigation, but as they, Millet, Lhermitte, Michelangelo, feel they are. My great desire is to learn to make such inaccuracies, such deviations, revisions, changes to the reality, that they will become, yes, lies, if you will, but more valid than the literal truth.

And now I must draw to an end; but I wanted to talk to you about how those who paint peasant life or popular life, although they may not be classed as men of the world, in the long run will perhaps last better than the producers of exotic harems or cardinals' receptions, all painted in Paris.

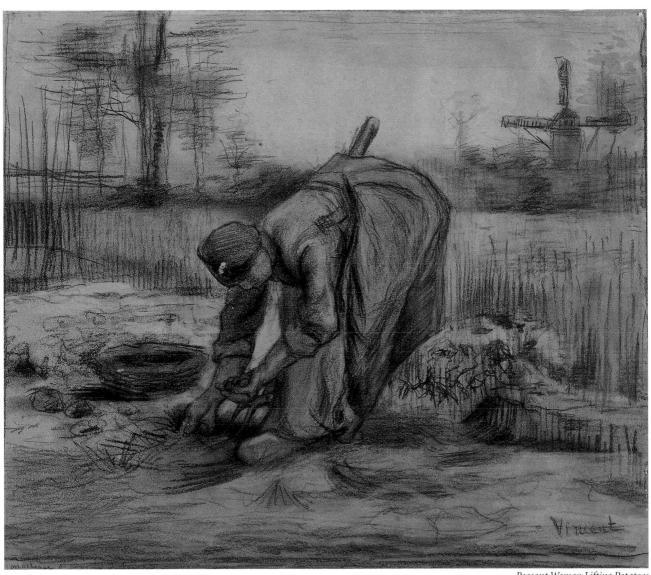

Peasant Woman Lifting Potatoes

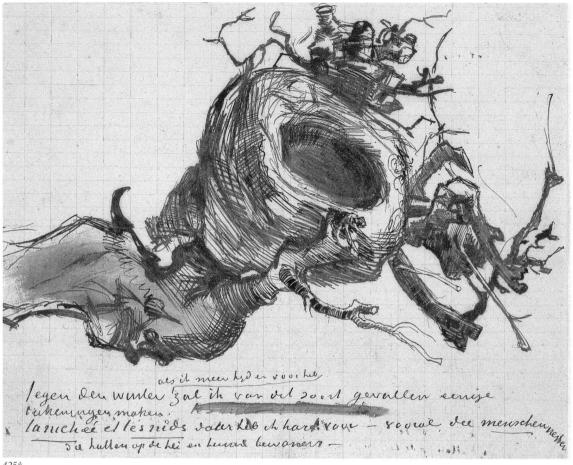

425†

[CA. 4 SEPTEMBER, 1885]

As regards work, as I already wrote to you, I have recently been very busy painting still lifes that have turned out excellently. I will send you some.

I know that they are difficult to sell, but it is devilish useful, and I will go on doing a lot of it in the winter.

You will receive a large still life of potatoes, in which I have tried to incorporate the substance; I intend to

express the subject matter in such a way that it turns into heavy, solid lumps, which you would feel if your were pelted with them, for instance.

I am now working on still lifes of my bird's nests, of which I have four ready; I believe that because of the colors of the moss, withered leaves and grasses, clay, etc., they could well suit some people who are familiar with nature.

Basket of Potatoes

The De Ruijterkade in Amsterdam

[OCTOBER 1885]

428

These things that are relevant to complementary colors, to the simultaneous contrasting and the mutual devaluation of complementary colors, are the first and the most important issue; the second is the mutual influence of two *similar* colors, such as a carmine and a vermilion, or a pink-lilac and a blue-lilac.

The third issue is a light blue against the same dark blue, a pink against a brownish red, a lemon yellow against a chamois yellow, etc. But the first issue is the most important.

If you can find some book that is good on color questions, please send it to me, particularly because there is still a lot I don't know about it and I am continually trying to find out.

[OCTOBER 1885]

429

It is surely by studying the laws of colors that you can come from an instinctive belief in the great masters to an awareness of why people think something beautiful—what they think beautiful—and that is very necessary today, when you consider how terribly arbitrarily and superficially judgments are made.

You will have to put up with my pessimism about the contemporary art market, because it certainly does not include despondency. I reason with myself like this: suppose that I am right in looking at it more and more as something like the tulip trade, in its peculiar dealings with the prices of paintings. Suppose, say I, that like the tulip trade in the past, the art market with other branches of speculation will by the end of this century disappear as it came, that is, relatively quickly.

The tulip trade died—the flower-growing industry flourishes. And I for my part am content, for better or worse, to be a gardener, who cares for his planting.

Today my palette has begun to thaw, and the barrenness of the first beginnings has gone.

I still sometimes get it wrong when I undertake something, but the colors follow each other on

automatically, and if I take one color as my starting point, it is clear in my mind what it will lead to and how to get life in it.

A man's head or a woman's head is divinely beautiful, isn't it, if you look at it leisurely? Well, the *general effect of beauty* of colors in nature may be lost in painfully literal imitation; it may be maintained by recreating a parallel spectrum of colors, but of necessity not precisely, or by no means the same, as the original.

Always making intelligent use of the beautiful tones that the paints form automatically when they are spread on the palette; again—to start from the palette, from a knowledge of the harmony of colors, is very different from mechanically and slavishly copying nature.

Here is another example: suppose I have to paint an autumn landscape, trees with yellow foliage. Well, if I conceive it as a symphony in yellow, would it matter whether my primary basic color is or is not the same as that of the leaves; it would add or detract *little*.

Much, *everything*, depends on my feeling for the infinite variety of tones of the *same family*.

Flying Fox

[4 NOVEMBER, 1885]

430

Don't let it worry you if in my studies I lay on the paint with brushstrokes that leave smaller or larger bits of paint sticking up. This means nothing; if you leave them for a year (or six months is enough) and then quickly scrape over them with a razor, you will soon get rather more fixity of color than would be the case if it were painted lightly. If you want a painting to go on looking good and keep its colors, it is a good thing for the light parts in particular to be firmly painted. And this scraping off has been done by the old masters as well as today's French painters.

I believe that the glaze of a transparent color often completely fades and disappears with time if you apply it before the painting is completely dry from its preparation, but if applied *later*, it should certainly survive.

You have yourself remarked that my studies in the studio improve rather than lose their color with time. I believe that this is because the paint is applied firmly, without my using any oil. When they are a year old, the little oil that is always in the paint has sweated out, and you get down to the sound, solid paste. This is crucial in my opinion—how to paint so that it hardens well—that is always rather important. It is a pity that some durable paints, like cobalt, are so expensive.

[NOVEMBER 1885]

437

Anyway, Antwerp is certainly a very strange and beautiful place for a painter.

My studio is quite bearable, particularly because I have pinned a set of Japanese prints on the wall, which I find very amusing. You know, the ones of female figures in gardens, or on the beach, horsemen, flowers, and knotted thorn bushes.

[8-15 DECEMBER, 1885]

439

I have persevered with models. I have done two fairly large heads, as a trial for a portrait.

First that old man, about whom I have already written to you. A kind of head like that of Victor Hugo, and I have also done a study of a woman. In the woman's portrait I put lighter tones in the flesh, *white*, tinted with carmine, vermilion, yellow, and a pale yellow-gray background, from which her face is only distinguished by her black hair. Lilac tones in the clothes.

Ah, a painting has to be painted—and why not simply? If I now look at life itself, I have a similar impression. I see people in the street, fine, but I find the servant girls often much more interesting and more beautiful than their mistresses, the working men more interesting than the gentlemen. And in ordinary young men and girls I find a vigor and life that should be painted with a firm brushstroke with a simple technique to express their individual character.

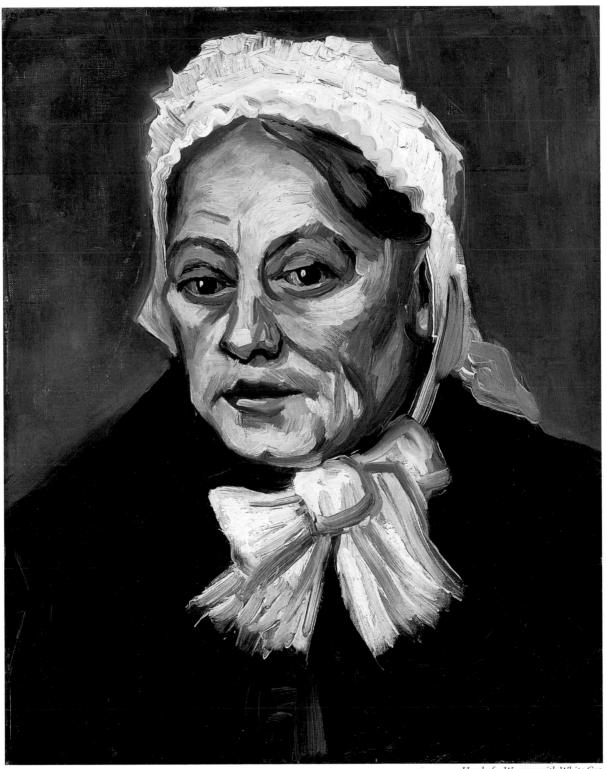

Head of a Woman with White Cap

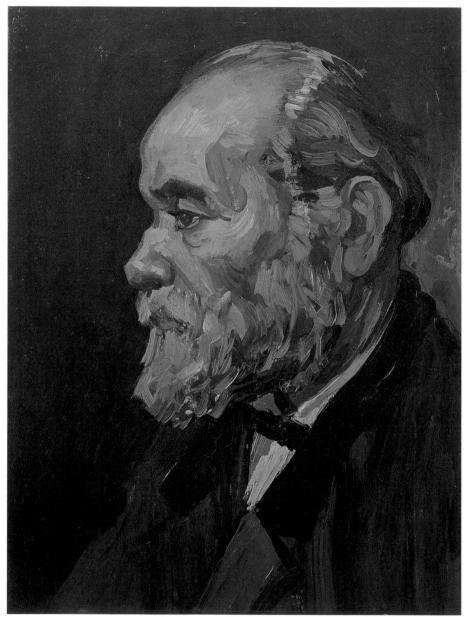

439†

Head of an Old Man

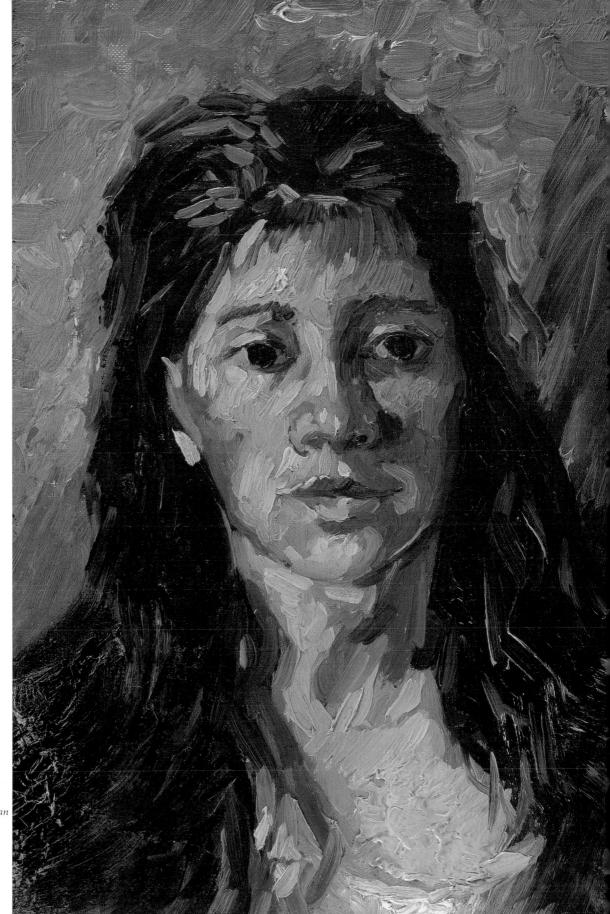

439†, Head of a Woman

441†

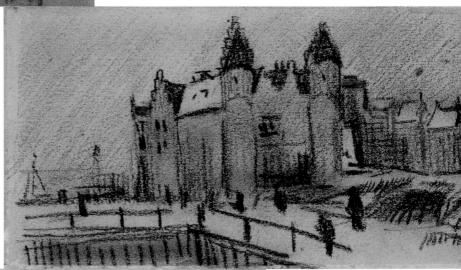

View of Het Steen

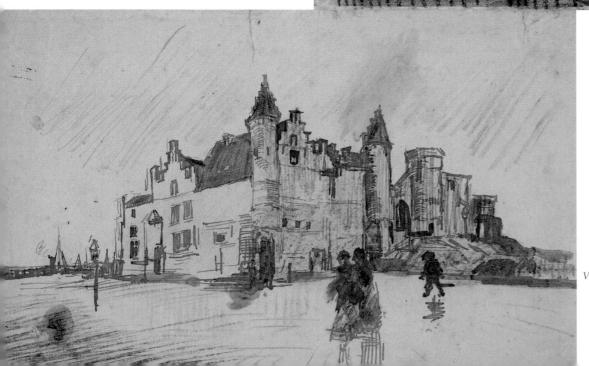

View of Het Steen

[18 DECEMBER, 1885]

441

I took my view of the Steen to another dealer, who thought it good in tone and color, but happened to be in the middle of stocktaking and has only small premises. However, I can go back to him after New Year's. It is a useful item in case there are foreigners who want to have a souvenir of Antwerp, and for that reason I will make some more views of the city of the same kind.

So yesterday I painted a few studies for a view in which you can see the cathedral. And I have a little one of the park.

However, I would rather paint the eyes of people than cathedrals, because there is something in their eyes that is not in the cathedral, solemn and imposing as it is — the soul of a human being, whether that of a poor beggar or a street girl, is in my view more interesting.

That there is something to do here, I am quite sure. There appear to be many beautiful women in the city, and it seems certain that there is money to be made with either women's portraits or women's heads and figures painted from imagination.

[28 DECEMBER, 1885]

442

Cobalt is a divine color, and there is nothing so fine for putting sky round things. Carmine is wine-red, and it is as warm and spirited as wine.

So is emerald green. It is no economy to deprive oneself of these colors. Cadmium, too.

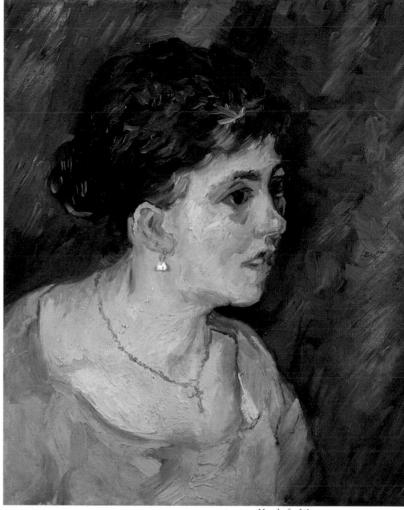

Head of a Woman

[JANUARY 1886]

447

It is odd that when I compare a study of mine with those of other people, they have very little in common.

Theirs have almost the *same color as flesh*, and so it seems very exact when seen from close up—but if you go a little further away it looks painfully flat—all that pink and delicate yellow, etc., etc., although soft in itself, gives a hard effect in practice. The way I do it, it looks from close up a greenish pink, yellow-gray, white, black, and a great deal of neutral, and mostly colors that you can't identify. But it becomes right outside the paint; when you stand back a little there is air around it and a kind of fluctuating light falls on it. At the same time the smallest spot of color with which you may eventually glaze it shows up in it.

But what is lacking is practice. I should paint fifty like that; I believe that I would then have *something*. Putting on paint now takes too much *effort*, because I have not yet got into a routine of it, spend too much time searching and work it to death. But that is a question of

persevering with painting, so that the more it is in your mind, the more the touch becomes right instantly.

There are a few people who have seen my drawings. One of them, who attends the nude class [at the academy where Vincent was taking a painting class] and was inspired by my peasant figures, started at once to draw the model with more powerful modeling, putting the shadows in strongly. He let me see that drawing, and we discussed it; it was full of life, and it was the best drawing I have seen by the people here. What do you suppose they thought of it? Sibert, the teacher, called him out specially and told him that if he dared do anything like that again in this way, it would be assumed that he was making fun of his teacher. And I tell you, it was the only drawing that was grassement fait [boldly done], in the manner of Tassaert or Gavarni. So you see how it is. But that is, however, not serious, and it does not do to get upset about it, and you have to feign ignorance, as if you were very keen to unlearn this bad method, but unfortunately always fall back into it. The figures they draw are almost all top heavy and would fall head over heels, not one of them is standing on its feet.

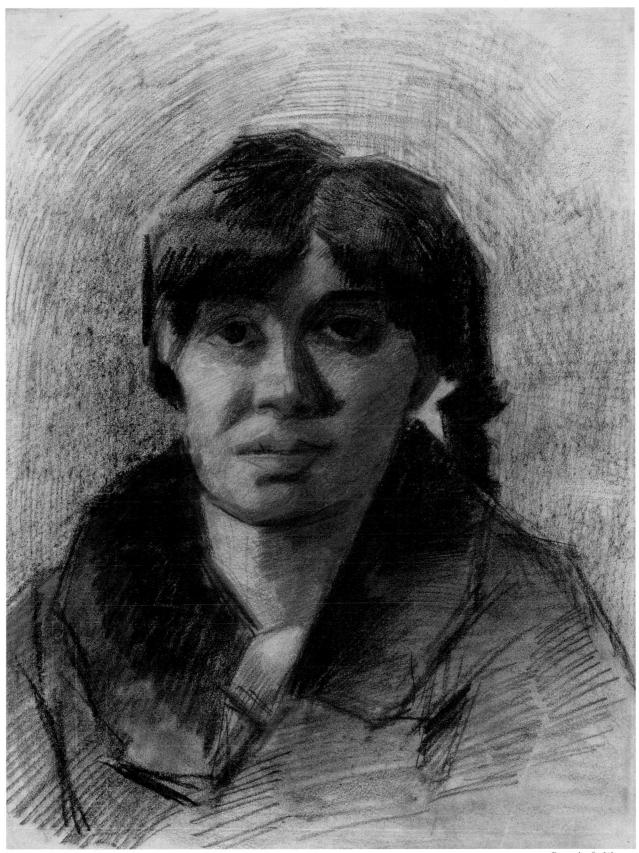

Portrait of a Woman

[FEBRUARY 1886]

448

Now I am drawing in the daytime, too, and the teacher there [at the academy], who nowadays makes portraits and gets high prices for them, has repeatedly asked whether I have ever drawn classical models before, or whether I have taught myself to draw.

He concluded: "I can see that you have been working very hard" and "it will not be long before you make progress, you will gain a great deal by it—it will take a year, but that does not matter, does it?"

As regards portraits, I will certainly not have much time left for them if I want to keep up with everything. And that is how things are here, too.

However, it strikes me very forcibly that there are still other things that I absolutely need to change. If I compare myself to other people, there is something very wooden about me, as if I had spent *ten years in solitary confinement*. And the cause of this lies precisely in the fact that I had a difficult and disturbed time some ten years ago, with worry and distress and no friends.

However, that will change as my work improves, and I can do more and know more. And as I say, we are on track to get something sound going. Have no doubt about it, the way to succeed is to keep my spirits up and be patient, and keep on working steadily. And ultimately it is important that I improve my image.

Plaster Figure of a Female

The Discus Thrower

[FEBRUARY 1886]

452

I feel the need to tell you that I would be very much easier, if you would agree that I should, if need be, come to Paris much earlier than in June or July. The more I think about it, the more desirable it seems to me.

I must also tell you that, although I carry on with it, the nitpicking by the people at the academy is often unbearable to me, since they keep on being decidedly spiteful. However, I try systematically to avoid any quarrel and go my own way. I imagine I am getting on the track of what I am looking for, and perhaps I would find it sooner if I could study the classical models on my own. Even so, I am pleased to have gone to the academy, precisely because I get to see so much of the results of prendre par le contour [sticking to the outline].

Because they do that systematically and then they try to quibble with me: "Faites d'abord un contour, votre contour n'est pas juste, je ne corrigerai pas ça, si vous modelez avant d'avoir sérieusement arrêté votre contour" ["First make an outline, your outline is wrong, I won't correct this if you start modeling before you have seriously fixed your outline"]. You see, everything depends on that. And then you should see it!!! How flat, how dead and how lousy the results of that system are. Oh, I tell you, I am very glad to have seen it from close up.

[FEBRUARY 1886]

454

You can't forecast infallibly over such a large area. So best leave it alone. But if you analyze it closely, you see that the greatest and most dynamic people of the century always worked *against the stream*, and that they were always working on their own initiative. You see it both in painting and in literature (I know nothing about music, but I assume that the same holds good there). To start something in a small way, persevere in spite of everything, produce a lot from small beginnings, have character rather than money, more audacity than credit; there you have Millet and Sensier, Balzac, Zola, de Goncourt, and Delacroix.

Yet actually setting up a studio in Paris at once would perhaps not be such a good idea as doing it *after another year's study*, both by you and me.

If I come to Paris the most sensible way would be for us to wait and see how it goes for a year; in that year we would both learn to know each other more closely, which can change a lot, and then we can expand with less anxiety, because we will in that time have reinforced all the weak points.

Head of a Man (Possibly Theo Van Gogh)

[MARCH 1886]

459

Don't be cross with me for arriving so suddenly; I've been thinking about it a lot, and I believe that we can save time this way. I'll be at the Louvre from midday or earlier if you like.

Figures in a Park

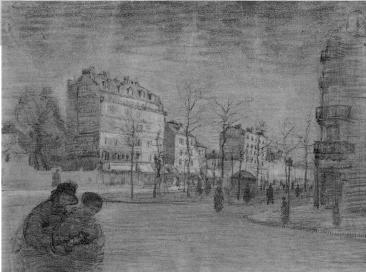

Boulevard de Clichy

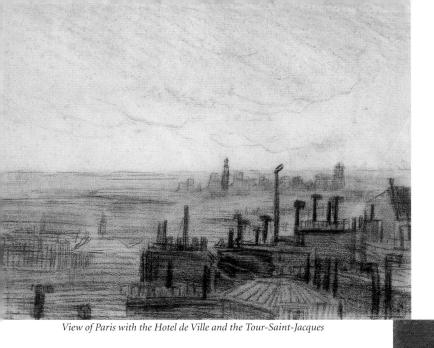

The Hill of Montmartre with Stone Quarry

Self-Portrait with Felt Hat

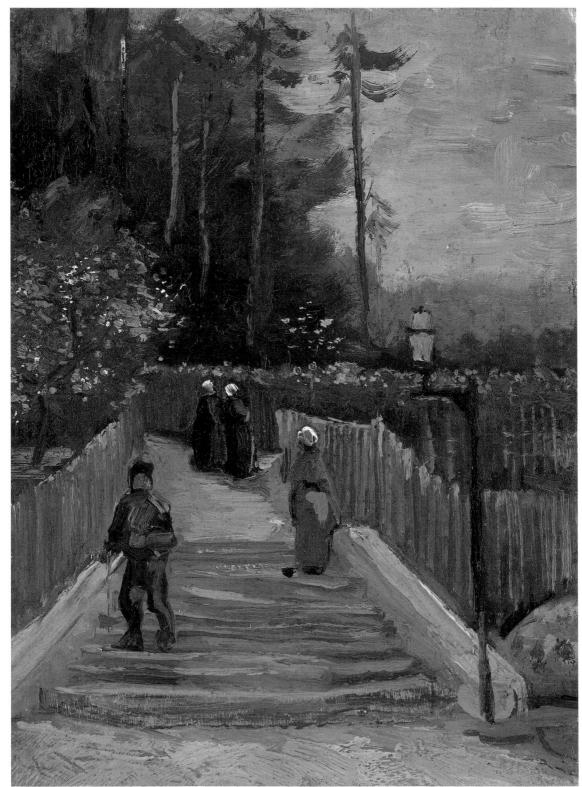

Path in Montmartre

Bridge in the Rain (after Hiroshige)

Couples in the Voyer d'Argenson Park

SUMMER 1887

462

As for me—I can feel the desire for marriage and children slipping away, and sometimes I'm saddened about feeling like this at the age of thirty-five, when I ought to feel quite differently.

And there are times when I already feel old and broken, and yet still not sufficiently in love not to feel enthusiastic about painting. To succeed you need ambition, and ambition seems absurd to me. What will come of this I don't know, but above all I'd like to be less of a burden to you—and in the future that's not impossible—for I hope to progress to the point where you can show what I do confidently without having to compromise yourself. And then I'll move away somewhere down in the South so that I can get away from all these painters who disgust me as men.

[SUMMER/AUTUMN 1887]

SISTER W1

What I think of my own work is that the painting of the peasants eating potatoes, which I made in Nuenen, is after all the best thing I have done. Only since then I have not had the opportunity to find models, but on the other hand I had the opportunity of studying the question of color.

And if later on I can find models again for my figures, then I hope to show that I am still after something more than green landscapes and flowers. Last year I painted hardly anything except flowers to accustom myself to some other color than gray, i.e. pink, soft or bright green, pale blue, violet yellow, orange, a beautiful red.

Exterior of a Restaurant

Part V 1888

In the fall of 1887, van Gogh, weary of the Parisian social scene and the inevitable tensions that arose from his living with Theo, was thinking of moving to the south of France. He arrived in the Provencal town of Arles in late February of 1888, and was so taken with the picturesque scenery and colorful locals that he immediately began agitating for his fellow artists Émile Bernard and Paul Gauguin to join him there.

Van Gogh dove into work, despite the discomforts of the mistral wind that was to bedevil him for the next few years. Inspired, as always, by rural living, he embarked on a remarkably prolific period that was to last, with only a few interruptions, until his death.

That spring, he painted a series of blossoming trees that showcased the brighter palette that he had picked up during his time in Paris. In June, he spent some time on the Mediterranean cost, painting seascapes and views of fishing villages. He even made a few friends among the citizens of Arles, including a postman's family, a café owner, and a Zouave* soldier, all of whom appear in his portraits.

By the summer, van Gogh expressed more confidence in his methods, which he called "crude, even garish." He still sought to strip his art down to the essentials, in both composition and color (yellow was a favorite of his that summer), and spoke admiringly of Japanese prints as models in this endeavor. Millet's painting *The Sower* was also much on his mind, as were the beginnings of a composition that would become *Starry Night*.

That fall, his frenetic output lessened somewhat during a bout of nervous exhaustion. Still insistent upon painting only from life, he made the best of his enforced rest and produced some pictures of his bedroom. In late October, Gauguin, himself not in the best of health, finally arrived in Arles after much coaxing from van Gogh and others.

Gauguin's stay lasted only nine weeks, during which, despite many comradely exchanges, the two men argued terribly. Their final dispute, just before Christmas, led to a fit of pique in which van Gogh severed part of his own earlobe. As a result, he was hospitalized, and a traumatized Gauguin fled Arles.

^{*}The Zouaves were a specialized regiment of the French army that originated in Algeria and were distinguished by their flamboyant uniforms.

[21 FEBRUARY, 1888]

463

Now, to begin with, I must tell you that there is at least two feet of snow everywhere, and it's still falling. Arles does not appear to me to be any larger than Breda or Mons.

Before arriving at Tarascon I noticed a magnificent landscape with strange tumbled piles of huge, yellow rocks in most impressive forms.

In the little valleys created by these rocks were lines of small, round trees with olive green and gray-green foliage, which could well be lemon trees.

But here in Arles the countryside appears flat. I've noticed some magnificent areas of red soil planted with vines against a backdrop of mountains in the most subtle lilac. And the landscapes in the snow, with peaks white against a sky as luminous as the snow itself, were just like the winter landscapes painted by the Japanese.

[CA. 25 FEBRUARY, 1888]

464

The studies I have are: an old woman from Arles, a landscape with snow, and a view of a stretch of pavement with a pork butcher's shop. The women here are really beautiful—I'm not joking; but the Arles Museum, on the other hand, is appalling and a complete joke—it ought really to be in Tarascon. There's also a museum of antiquities, and these are genuine.

[CA. 9 MARCH, 1888]

467

At long last, this morning the weather has changed and become milder—and I've also already had a chance to discover what the mistral is like. I've been out for a number of walks around here, but with this wind it was impossible to do anything.

The sky was a hard blue with a large, bright sun that has melted almost all that quantity of snow, but the wind was so cold and dry that it gave you goose bumps.

All the same, I've seen some very beautiful things—a ruined abbey on a hill covered in holly, pines, and gray olive trees.

I hope to have a go at that quite soon.

Right now I have just finished a study like that one of mine Lucien Pissaro has, but this time it's of oranges.

That makes eight studies so far. But it doesn't really count as I haven't yet been able to work comfortably and in the warmth.

[30 MARCH, 1888]

472

I'd been working on a size 20 canvas in the open air in an orchard, a piece of lilac-colored, plowed soil with a reed fence and two pink peach trees against a glorious blue and white sky. Probably the best landscape I've done.

I'm having a lot of trouble painting because of the wind, but I fasten my easel down with pegs knocked into the ground and carry on working; it's too beautiful not to.

The Pink Orchard

[CA. 14 MARCH, 1888]

469

As far as work is concerned, I came back today with a size 15 canvas; it's of a lift bridge with a small cart crossing, outlined against a blue sky—the river's blue too, the banks orange colored with green vegetation, and a group of women in smocks and colorful bonnets washing clothes.

There's another landscape with a small, rustic bridge, also with women washing clothes.

And lastly, an avenue of plane trees near the station. In all, twelve studies since I've been here.

The weather is variable, often windy with cloudy skies, but the almond trees are beginning to come into blossom in most places.

[18 MARCH, 1888]

BERNARD B2

The countryside here seems to me to be as beautiful as Japan in terms of the limpidity of the atmosphere and the brightness of the colors. Water makes patches of fine emerald green and rich blue in the landscape, such as we see in Japanese prints. There are pale orange sunsets that bring out the blue of the soil. And the sun is a splendid yellow. And yet I have still to see the area in its customary summer splendor. The women here dress prettily, and on Sundays especially, out on the boulevards, you see very simple yet well-chosen combinations of color. And I imagine it will become more vibrant still in the summer.

At the beginning of this letter I'm sending you a small sketch of a study that I've been thinking a lot about making something of: sailors walking back into town with their girlfriends, with the strange outline of the liftbridge against an enormous yellow sun. I have another study of the same bridge with a group of washerwomen.

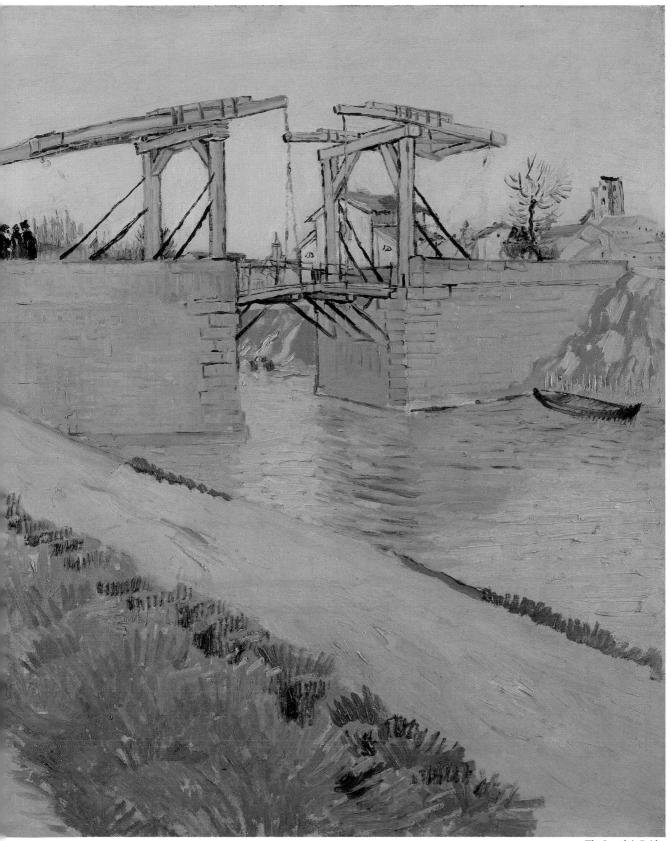

The Langlois Bridge

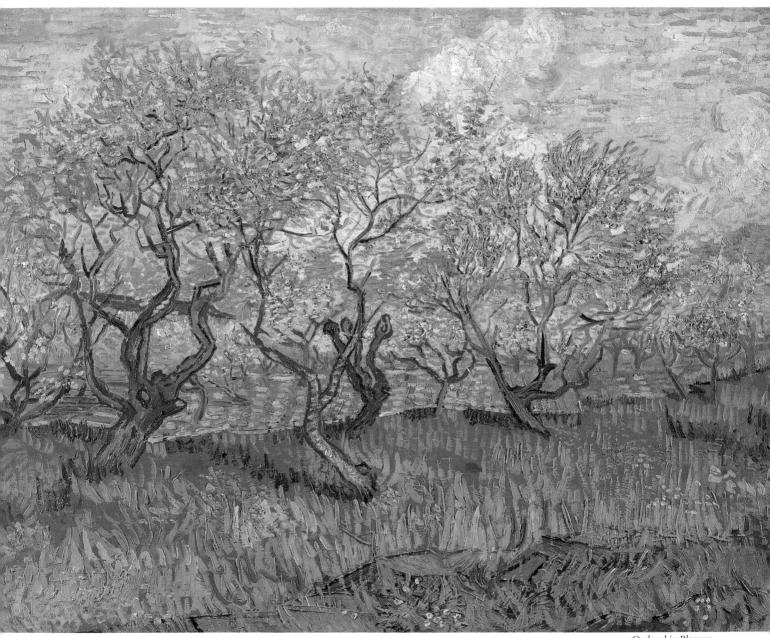

Orchard in Blossom

[9 APRIL, 1888]

474

The air here is most definitely doing me good; I only wish you could fill your lungs with it too. One of the effects it has on me is quite amusing: a single small glass of cognac is enough to make me tipsy here, and since I don't have to rely on stimulants to help my circulation, it's easier on my constitution.

The month will be hard for you and for me, yet, if you can manage it, it will be to our advantage to make the most of orchards in blossom. I'm already well under way, but I think I still need to do another ten on the same subject.

You know how changeable I can be about my work, and that this passion for painting orchards will not last forever. After this it could be bullrings. Then I have a tremendous amount of drawing to do, as I'd like to make drawings in the style of Japanese crepon prints. I've no choice but to strike while the iron is hot.

I must also do a starry night with cypress trees or perhaps over a field of ripe wheat; the nights here can be very beautiful. I'm in a continual fever of work. [9 APRIL, 1888]

BERNARD B3

At the moment I'm captivated by the fruit trees in blossom: pink peach trees, white-yellow pear trees. There's no system to my brushstrokes. I strike the canvas with uneven touches and leave them just as they are.

Patches of thickly applied color, some areas where the canvas is left uncovered, others left completely unfinished, some retouching, some brusqueness; in fact, I'm inclined to believe that the result may be rather disturbing and irritating and not at all pleasing to people with preconceived and fixed ideas about technique.

While still working directly on site, I try to capture the essential in my drawing—then I fill in the spaces, defining them with outlines, some expressed, some not, but in every case felt; I fill these with tones that are also simplified, so that everything that is soil will share the same violet tone, the whole of the sky will have a blue tonality, and the vegetation will be either green-blue or else green-yellow, purposely exaggerating the yellow or blue qualities in this case.

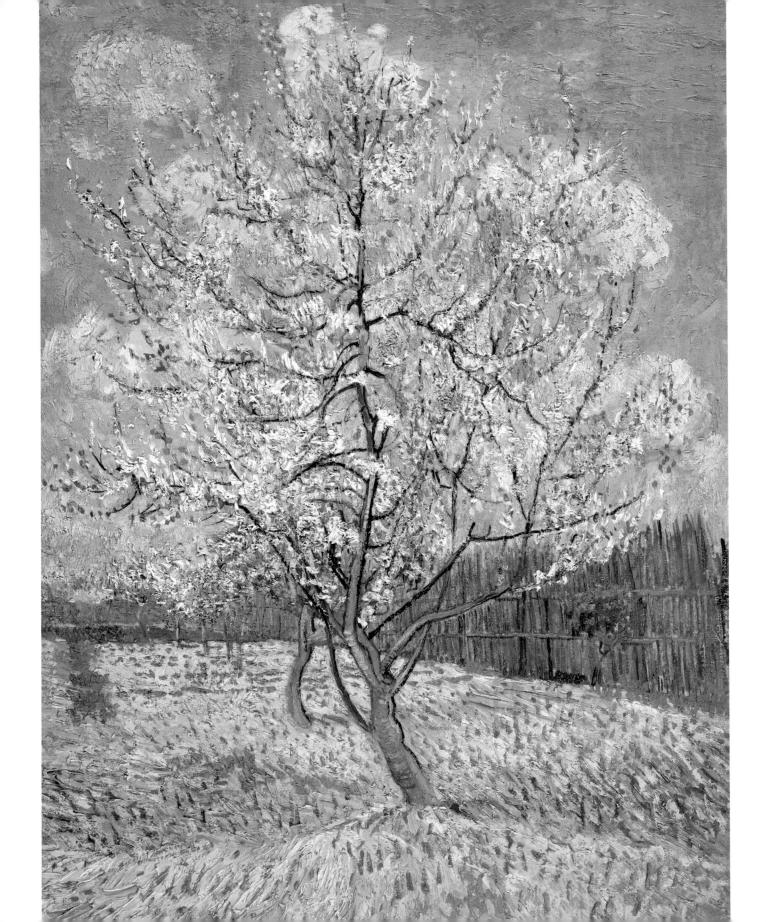

[CA. 13 APRIL, 1888]

477

I should tell you that I'm working on the two pictures I wanted to make copies of. The pink peach tree is giving me the most trouble.

You can see from the three squares on the other page that the three orchards go together more or less. I now also have a small pear tree in vertical format also placed between two horizontal canvases. That will make six canvases of orchards in blossom. Every day now I try to work on them a little more and give them a certain unity.

I still hope to do three more, forming a set, but as yet these are only at the stage of embryos or fetuses.

I'd really like to complete this set of nine canvases.

You see we could well think of this year's nine canvases as the groundwork for an eventual, much larger decorative scheme (consisting of size 25 and size 12 canvases), to be executed next year during the same season from exactly the same subjects.

Here is the other middle piece of the size 12 canvases.

The ground is violet; in the background there's a wall with straight poplars and a very blue sky. The small pear tree has a violet trunk and white blossom, and a large yellow butterfly on one of the clusters. On the left, in the corner, is a small garden with a yellow reed fence, green bushes, and a flowerbed. A small pink house. There, those are the details of the decorative scheme of orchards in blossom that I've been planning for you.

The only thing is that the last three canvases are still only in a draft form and should show a very large orchard bordered by with cypresses and with large pear and apple trees.

mon cher They, merce de ta lettre contenant les échantellons de toile Clerai bien - ause de recevoir - mous cela ne pres/e aney I mêtres de celle à 6 fr. our ce open est 4 grostules tous les autres tubes élaient dans les mimes proportions c'est forbien muis aus allention à cela -Li Tubes de blanc à 1 fr. mais le seste ne doct être qu'a mortie prix Je trouve son blen de Truste muavais Maintenant je te deran que je travaille out & tableaux Jesquels je voulan faire pecher lose me Jum des repetitions

477

errain girly & rec

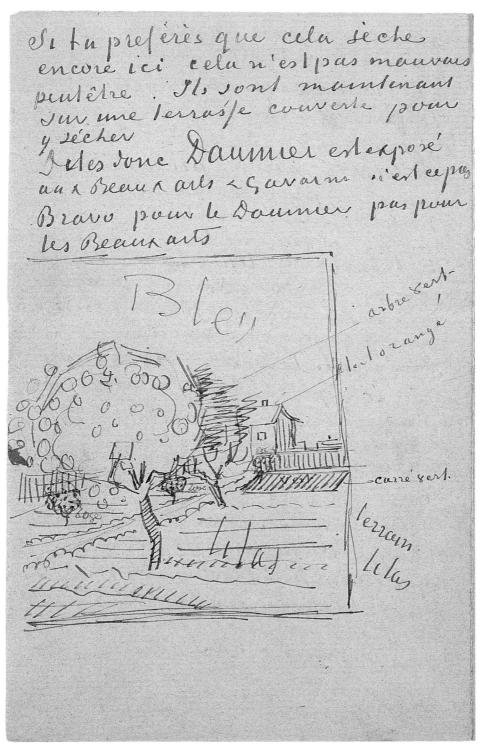

[CA. 21 APRIL, 1888]

478

Here is a sketch of an orchard that I'd planned specially for you for May 1.* It's absolutely simple and done at one go. A whirl of impasto with the faintest hint of yellow and lilac on the first white clump.

You'll probably be in Holland at that time, and you'll perhaps see the same trees in blossom that very day.

[APRIL 1888]

SISTER W3

At this moment I have six paintings in hand of fruit trees in blossom. And you would perhaps like the one I brought home today—it is a cultivated stretch of ground in an orchard, a rush fence, and two peach trees in full bloom. Pink against a sparkling blue sky with white clouds and in sunshine.

+ mon cher Theo, merci de ta lettre 470 d'aujourd'hui et du bellet de 100 fr. qu'elle contenail. Pour ce qu'est de la précédente contenant sofr je l'ai equilement reque et je le l'ai aussi écrit le jour avant ou deux Jours avant que je n'air envoyé les deux deslins Ces desfins soul fails avec un roseun faille comme Seraet une plume d'oie. Je comple en are une serie comme cela et j'espère faire mieux que les deux premuers c'est un procede que j'ai déju cherché en Kollande dans le lemps, mais là je n'avais Bus d'aus/ bons roseaux qu'ici Ar recu une lettre de koning de laquelle veuille le remercier. his volonhers je veux lui échanger les cleux des juis contre une étude de lui que la choiseras a garderas sans la collection. Jetur écrirar pour lui expliquel le procedé el lui enverras des roseaux lalle. pour qu'il puisse en faire ausse Maintenant c'était une impor fante nouvelle que celle de tonvoyage à Bruxelles.

478

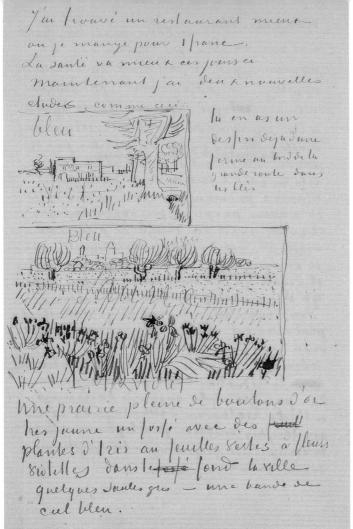

487

[12 MAY, 1888]

487

I've now done two new studies like this: you already have a drawing of one—a farm at the side of the main road among the wheat fields. A meadow full of very yellow buttercups, a ditch with irises with green leaves and purple blooms, the town in the background, a few gray willow trees, and a strip of blue sky.

If they don't cut the meadow, I'd like to do this study again, as the subject was truly beautiful and I had trouble finding the right composition.

A small town surrounded by countryside filled with yellow and purple flowers—you can imagine, very much a Japanese dream.

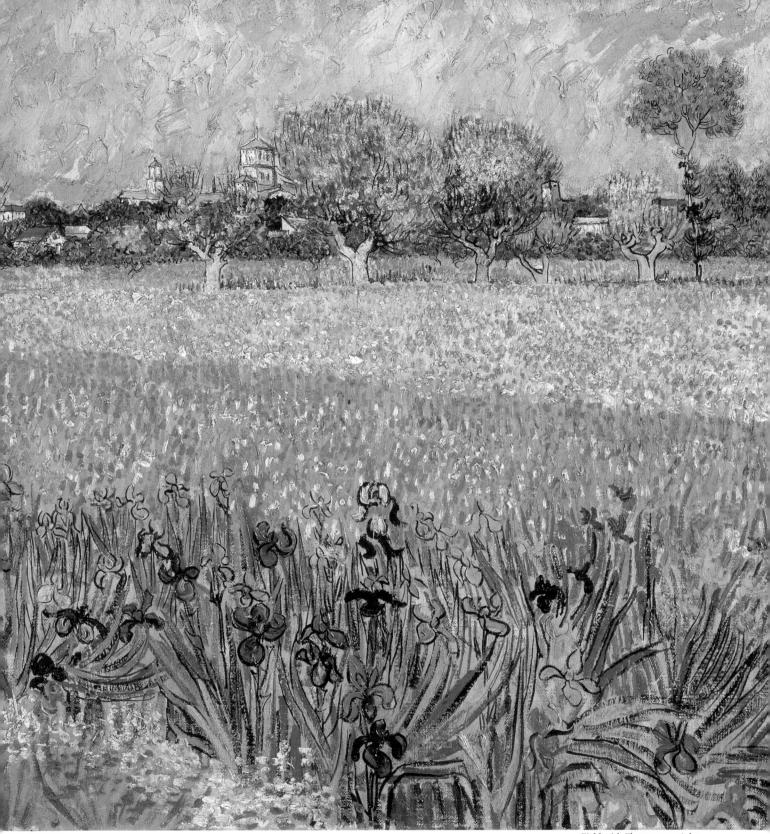

Field with Flowers near Arles

[14 MAY, 1888]

481

We are having a tremendous amount of wind and mistral here, at the moment three days out of four, though it's still sunny, but it makes it difficult to work outside.

I think there are some good opportunities here for portraits. Although the people are grossly ignorant about painting in general, in themselves and their way of being they are far more artistic than in the North. I've seen figures here that are certainly as fine as those by Goya and Velázquez. They know how to add a touch of pink to a black outfit, and have a knack of putting outfits together in white, yellow, pink, or even green and pink, or indeed blue and yellow, so that nothing needs to be changed from an artistic point of view. Seurat would find some very picturesque figures of men here, despite their modern clothing.

[CA. 15 MAY, 1888]

488

I've done two new studies, a bridge and the side of a main road. Many of the subjects here are, in character, exactly the same as in Holland; the difference is in the color. Wherever the sun beats down, there is this sulphur yellow.

You'll remember we saw a magnificent rose garden by Renoir. I imagined I'd find similar subjects here and,

indeed, when the orchards were in bloom that was the case. Now things have changed in appearance, and nature has become far harsher. But what greenness and what blue! I must say that the few landscapes by Cézanne that I know render this extremely well, and I regret not having seen more of them. The other day I saw a subject exactly like the beautiful Monticelli landscape with the poplar trees, which we saw at Reid's.

You would probably have to head towards Nice to find more gardens like those by Renoir. I've seen very few roses here, although there are some, including the large red roses known as *Rose de Provence*.

[CA. 20 MAY, 1888]

489

This week I've done two still lifes.

A blue enamel coffee pot, a cup (on the left) royal blue and gold, a pale blue-and-white-checked milk jug, a cup—on the right —white with blue and orange decoration on a gray-yellow earthenware dish, a blue slipware or majolica jug with red, green, and brown designs, and finally two oranges and three lemons; the table is covered with a blue cloth, the background is yellow-green—so six different blues and four or five yellows and shades of orange.

The other still life is the majolica jug with wild flowers.

[CA. 20 MAY, 1888]

BERNARD B5

I've done a still life with a blue enamel metal coffeepot, a royal blue cup and saucer, a checkered milk jug in pale cobalt and white, a cup with orange and blue patterns on a white background, a blue majolica jug with green, brown, and pink flowers and leaves. All this on a blue tablecloth, against a yellow background and with two oranges and three lemons among the crockery.

So it's a variation on blue, enlivened by a series of yellows ranging to orange.

Then I have another still life: lemons in a basket on a yellow background.

Then a view of Arles. All that can be seen of the town are a few red roofs and a tower, the rest is hidden by the foliage of the fig trees and far off in the background, with a narrow strip of blue sky above. The town is surrounded by vast meadows filled with countless buttercups—a sea of yellow; in the foreground the meadows are cut off by a ditch full of violet iris flowers. They were cutting the grass while I was painting so it's just a study and not the finished picture I was intending to make it. But what a subject! That sea of yellow with a band of violet irises and in the distance this charming little town with its pretty women! Then two studies of roadsides—done later—when the mistral was blowing hard.

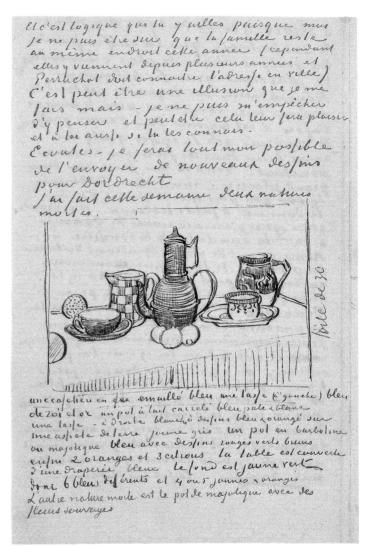

489, B5†

490†

Hill with Bushes

[26 MAY, 1888]

490

Today I sent you some more drawings, and I'm adding another two. These are views from a rocky hillside from which you can look towards the Crau (an area that produces an excellent wine), the town of Arles, and the Fontvieilles area. The contrast between the wild and romantic foreground and the horizontal lines of the broad, peaceful, distant perspectives, fading into the Alps range—made famous by the climbing exploits of Tartarin P.C.A. and the Club Alpin—is a truly picturesque one.

The two drawings I'm adding as an afterthought will give you an idea of the ruin that stands on top of the rocks.

What's always urgent is the need to draw—whether directly with the brush or using something else, such as a pen—one can never do enough.

I am now trying to exaggerate the essential and leave the ordinary deliberately vague.

[28 MAY, 1888]

492

I wish everyone could come down here to the South like me.

It's strange, one evening recently at Mont Majour I saw the sun setting red, its rays falling among the trunks and foliage of some pine trees growing among a pile of rocks, coloring the trunks and leaves a fiery orange, while other pine trees further off stood out in Prussian blue against a soft, cerulean blue—green sky. It was the same effect as in that Monet, and was superb. The white sand and the layers of white rocks under the trees were tinged with blues. What I'd like to do is the panorama for which you already have the first drawings. It has great breadth but doesn't fade into gray, remaining green to the very last horizon—which is blue, being the line of hills.

The Harvest

Fishing Boats on the Beach at Saintes-Maries-de-la-Mer

[CA. 4 JUNE, 1888]

499

At last I'm writing to you from Saintes-Maries on the shore of the Mediterranean. The Mediterranean has a color like that of mackerel, by which I mean it's always changing. You can't even tell if it's blue because a second later the changing light has taken on a pink or gray tinge.

I went for a walk by the sea one night along a deserted beach. It wasn't very cheery but neither was it sad—it was beautiful. The deep blue of the sky was dotted with clouds of a deeper blue than the essential blue of intense cobalt, with others of a brighter blue, like the blue whiteness of the Milky Way. In the blue depths stars sparkled brightly, greenish, yellow, white, pink, brighter still, more brilliant and more like precious stones than at home—or even in Paris—like opals, emeralds, lapis, rubies, and sapphires, one might say.

The sea was a very deep ultramarine—the shore, it seemed to me, a kind of violet and pale russet tone and on the dunes (which are about sixteen feet [five meters] high) Prussian blue bushes.

Seascape near Saintes-Maries-de-la-Mer

[5 JUNE, 1888]

500

Now that I've seen the sea here, I'm totally convinced of the importance of remaining here in the South and of the need to exaggerate color even more—Africa itself is not far away.

I wish you could spend some time here; you'd feel it like I do after a while: the way you see things changes, you view things with a more Japanese eye, and you get a different feel for color.

In fact, I'm convinced that staying here for some time is precisely what's needed for me to release my individuality.

Japanese artists draw quickly, very quickly, like lightning, because they are more finely attuned, their feeling simpler.

I've been here only a few months but—do you think that in Paris I could have done the drawing of the boats *in just one hour?* Not even using a perspective frame, because I did it without measuring, just giving free rein to my pen.

[21 JUNE, 1888]

501

I've had a week of stiff, intense work among the wheat fields in full sun; the result is some studies of wheat fields, landscapes, and—a sketch of a man sowing seed.

In a plowed field, a large field of violet clods of earth—climbing up toward the horizon a man in blue and white, sowing seed. On the horizon a field of short, ripe wheat. Above all this a yellow sky with a yellow sun.

You can tell simply from my catalog of colors that this is a composition in which color plays a very important role.

And this sketch, such as it is—a size 25 canvas—has been playing on my mind a lot, and I'm wondering if I shouldn't take it seriously and turn it into a tremendous painting. Dear Lord, how I'd like to do that! But I can't help wondering if I'll have the strength pull it off.

As it stands I'm putting the sketch to one side, scarcely daring to think about it. I've been longing to do a sower for so long, but things I've wanted for a long time don't always materialize. So I'm almost afraid of it. And yet, after Millet and Lhermitte what remains to be done is ... a sower in color and large format.

Changing the subject—at last I have a model—a Zouave—a boy with a small face, the neck of a bull, and the eye of a tiger. I began with one portrait and then another; the bust portrait I did of him was terribly harsh, in a blue uniform the color of enamel saucepans, trimmed with faded red-orange braid, with two lemon yellow stars on his chest, an ordinary blue and very hard to do.

I placed his deeply tanned, cat-like head with its maddercolored cap against a door painted green and the orange bricks of a wall. So it's a brutal combination of disparate tones, not easy to pull off.

The study I've made of it seems to me very hard, but all the same I'd still like to work at crude, even garish portraits like this. I'm learning from it and that more than anything is what I ask of my work. The second portrait will be a full length one, standing against a white wall.

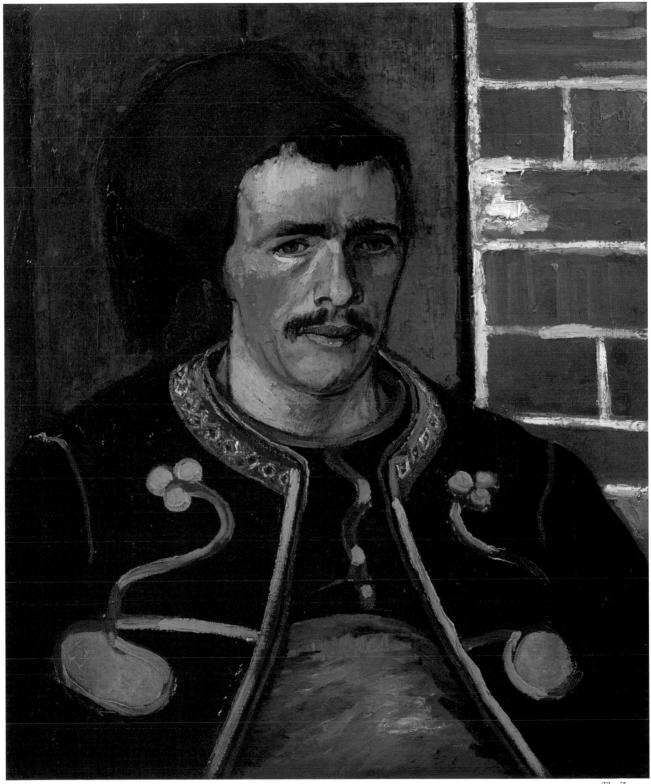

501† The Zouave

[6-11 JUNE, 1888]

BERNARD B6

A technical question. Tell me what you think in your next letter. I've decided blatantly to put the *black* and *white* as sold to us by paint merchants exactly as they are on to my palette and use them just like that. If—and note that here I'm talking about simplification of color in the Japanese style—if in a green garden with pink pathways I see a gentleman dressed in black, a justice of the peace by profession (the Arab Jew in Daudet's *Tartarin* calls this honorable functionary a zouge instead of a judge), reading *L'Intransigeant...* Above him and the gardens a simple cobalt sky.... Then why not paint said justice (or zouge) in simple bone black and the newspaper in simple raw white? Because the Japanese disregard reflected color, placing flat tints side by side, with simple lines and outlines to define movement and form.

On another train of thought, when one composes a subject with colors expressing, for instance, a yellow evening sky, the raw, hard white of a white wall against the sky can be expressed, if need be, in an unusual way using raw white softened by a neutral tone, because the sky itself colors it with a fine lilac tone. Or in this very simple landscape that is meant to show a cottage whitewashed all over (including the roof), standing on orange ground, naturally, because the southern sky and the blue Mediterranean produce an orange that increases in intensity as the range of blues becomes more heightened in tone, the black note of the door, the glass of the windows, the small cross on the rooftop create a simultaneous contrast between white and black that is as pleasing to the eye as the blue is with the orange.

To take a more amusing subject, let's imagine a woman in a black-and-white checked dress, in the same

simplified landscape with a blue sky and orange-colored soil—it would be a rather funny sight I imagine. But in Arles people do indeed often wear black-and-white check.

It just needs for black and white to be thought of as colors too, because in many cases they can be considered as such, the simultaneous contrast between them being as striking as that between green and red, for example.

And for that matter the Japanese make use of this. They express the pale, matte complexion of a young girl and the striking contrast of her black hair marvelously well by means of white paper and four strokes of the pen. Not to mention their black thorn bushes scattered with thousands of white flowers.

At last I've seen the Mediterranean, which you'll probably cross before I do. I spent a week at Saintes-Maries and to get there took a coach across the Camargue with its vineyards, heathlands, and fields as flat as those of Holland. In Saintes-Maries there were girls that reminded me of Cimabue and Giotto—slender, upright, slightly sad and mystical. On the flat sandy beach were small green, red, and blue boats of such pleasing form and color that they reminded me of flowers. It takes just one man to crew these boats, as they rarely go very far out to sea. They head off when there's no wind and return to land if there's too much.

What I was keen to know more about is the effect of a more intense blue in the sky. Fromentin and Gérôme see the soil of the South as colorless, and many other people see it this way too. Well of course, if you take some dry sand in your hand and if you look at it close up, or water too, or air looked at in this way, they are all colorless. No

blue without yellow or without orange; and if you use blue, then you should use yellow and orange too, isn't that right? But you'll be telling me that what I'm writing are simply platitudes.

[CA. 18 JUNE, 1888]

BERNARD B7

Here's a sketch of a sower: a large piece of land with plowed clods of earth, blatantly violet for the most part. A field of ripe wheat in a yellow ochre tone with a little carmine.

The sky chrome yellow, almost as bright as the sun itself, which is chrome yellow 1 with a little white, whereas the rest of the sky is a blend of chrome yellow 1 and 2. So very yellow indeed.

The sower's shirt is blue and his trousers white.

There are many echoes of yellow in the soil, neutral tones resulting from the mixing of violet and yellow; but I bothered hardly at all about the truth of the colors. I'd rather produce naïve images of the kind in old almanacs, those old country almanacs in which hail, snow, rain, and fine weather are represented in an entirely primitive manner, like that used so successfully by Anquetin in his Harvest. I must confess to you that I am actually quite fond of the countryside, having been brought up there snatches of memories, a longing for the infinite—of which the sower and the sheaf are symbols—still enchant me now as they did in the past. But when shall I get round to doing this picture of the starry sky that has been so much in my thoughts? Alas, alas! It is just as that excellent fellow Cyprien says in J. K. Huysmans' En Ménage [Living Together]: the finest pictures are those

you dream about while you are lying in bed smoking a pipe, but which you never actually paint.

But you have to try, no matter how incompetent you feel in the face of that unspeakable perfection, those glorious splendors of nature.

Here's another landscape. A sunset? Or a moonrise?

A summer sun in any case.

The town violet, the celestial body yellow, the sky blue-green. The wheat is all in tones of old gold, copper, greengold, red-gold, yellow-gold, bronze-yellow, green-red. A size 30 canvas, square. I painted it when the mistral was blowing hard, my easel fixed to the ground with iron pegs, a device I can recommend. You drive the legs of the easel into the ground, then alongside them fifty-centimeter long iron pegs. Then you tie it all together with ropes. And that way you can work in the wind.

What I wanted to say about white and black is this. Let's take the Sower. The picture is divided in two: one half—the upper part—is yellow, the lower part is violet. Now the white trousers relax the eye and distract it just at the moment when the simultaneous, excessive contrast of the yellow and violet begins to jar. That's what I wanted to say.

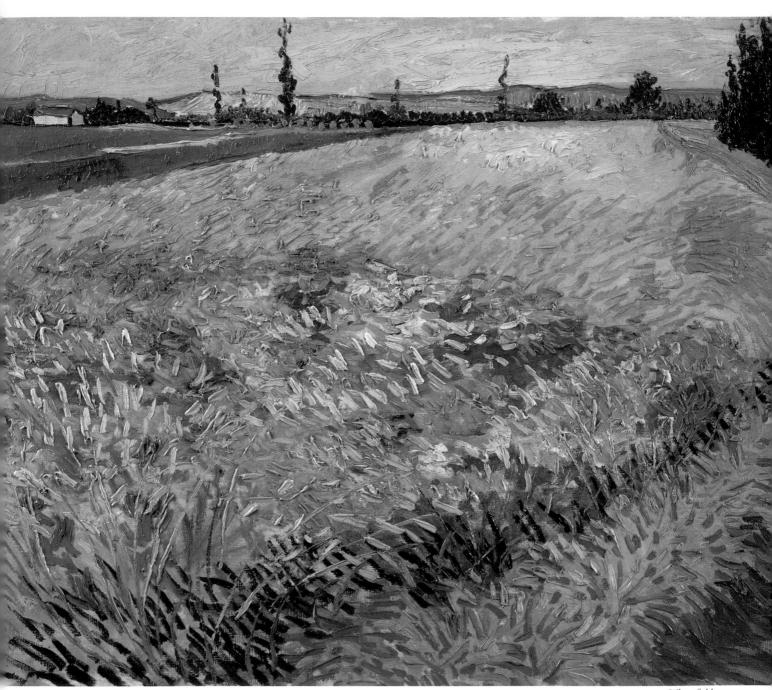

Wheatfield

[CA. 22 JUNE, 1888] SISTER W4

The color is actually very fine here. When the green is fresh, it is a rich green, such as we rarely see in the North, calm. When it is burnt and dusty, it does not look ugly, but then the landscape acquires golden tones of all kinds of colors, green-gold, yellow-gold, pink-gold, bronze- or copper-gold—in fact, from lemon yellow to the dull yellow color of, for instance, a heap of threshed grain. That with the blue—from the deepest royal blue in the water to that of forget-me-nots, cobalt, mainly bright clear blue—greenish blue and violet blue.

Of course, this orange is seductive—a sunburnt face looks orange. Also because there is so much yellow, violet makes an immediate impact; a rush fence or gray thatched roof or a cultivated field looks much more violet than it does in our part of the world. Also, as you already suspect, the people here are often beautiful. In a word, I believe that life here is rather more to be thankful for than it is in many other places.

Now that I am so busy writing about myself, I want to see whether I can write my own portrait into it. First of all, I put it that in my opinion one and the same person can provide material for very different portraits.

Here is my appraisal of a portrait I painted of myself in a mirror, and which Theo has.

A pinkish gray face with green eyes, ash-colored hair, wrinkles on the forehead, and round the mouth a very wooden and very red beard, rather unkempt and sad, but the lips are full, a blue smock of coarse linen, and a palette with lemon yellow, vermilion, Veronese green, cobalt blue, in fact all colors on the palette, but only whole colors, except the orange beard. The figure against a gray-white wall. You will tell me that this looks something like, perhaps, the face of—Death—in Van Eeden's book or something—fine, but anyway, it is that kind of figure—and it is not easy to paint yourself; in any case, it is different from a photograph. And you see, this is what impressionism is to me above all else: it is not banal, and you are searching for a more profound likeness than the one a photographer wants. Now today I look different in that I have neither hair nor beard any more, as both of these have been shaved off. Moreover, from a greenish gray-pink my face has become a grayorange, and I have a white coat instead of a blue one, and I am always dusty, always laden like a hedgehog with sticks, easel, canvas, and other equipment. Only the green eyes are still the same, but there is another color in the portrait, of course, a yellow straw hat, like an itinerant farm laborer, and a very black little pipe.

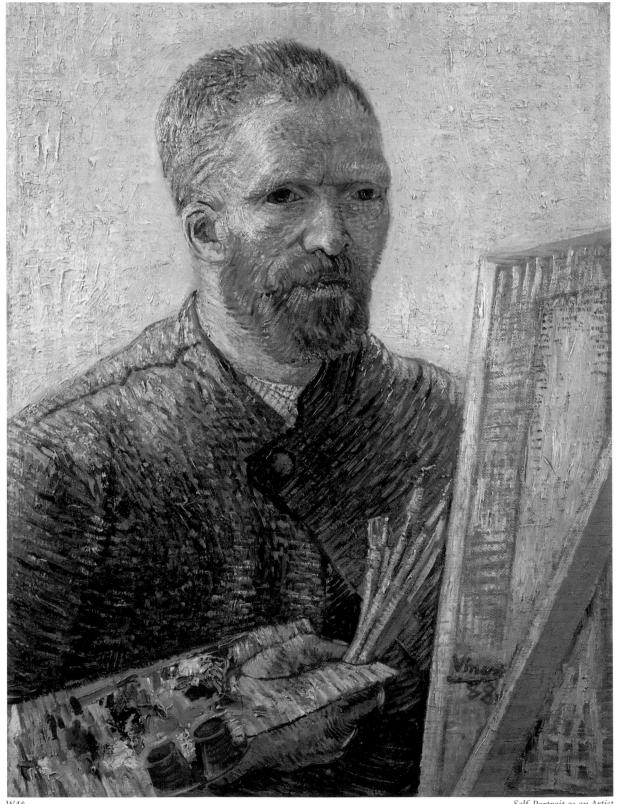

Self-Portrait as an Artist

[CA. 17 JUNE, JULY]

RUSSELL* 501A

For ever so long I have been wanting to write to you—but then the work has so taken me up. We have harvest time here at present and I am always in the fields.

The actual inhabitants of this country often remind me of the figures we see in Zola's work.

And Manet would like them as they are, and the city as it is. Bernard is still in Brittany and I believe he is working hard and doing well.

Gauguin is in Brittany too, but has again suffered of an attack of his liver complaint. I wished I were in the same place with him, or he were here with me.

My brother has an exhibition of 10 new pictures by Claude Monet—his latest works, for instance a landscape with red sunset and a group of dark fir trees by the seaside. The red sun casts an orange or blood red reflection on the blue green trees and the ground. I wished I could see them.

I believe my brother has also another picture by Gauguin which is as I heard say very fine, two negro women talking, it is one of those he did at Martinique. McKnight told me he had seen at Marseilles the picture by Monicelli, *Flowerpiece*.

I must hurry off this letter for I feel some more abstractions coming on and if I did not quickly fill up my paper I would again set to drawing and you would not have your letter.

I heard Rodin has a beautiful head at the salon.

I have been to the seaside for a week and very likely am going thither again soon. Flat shore sands—fine figures there like Cimabue—straight stylish.

Am working at a sower; the great field all violet and the sky & sun very yellow, it is a hard subject to treat.

[24 JUNE, 1888]

BERNARD B9

At times I've worked excessively fast. Is that a failing? I can't help it.

Isn't it intensity of thought rather than calmness of touch that we are seeking? And in impulsive working conditions such as these, out on site and of this nature, is a calm, well-ordered touch always possible? Dear Lord, it seems to me no more so than when on the attack in fencing.

^{*}John Russell (1858–1930), a fellow student from Van Gogh's days in Paris.

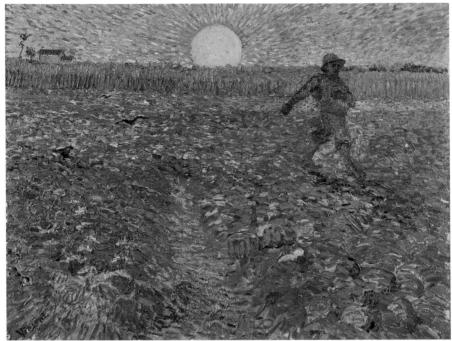

503† The Sower

[28 JUNE, 1888] 503

Yesterday and today I worked on the sower, which I've now redone completely. The sky is yellow and green, the ground violet and orange. I'm sure there's a picture of this kind to be painted of this marvelous subject, and I hope that one day it will be done, either by someone else or by me.

Millet's *The Sower* is a colorless *gray*, as indeed are Israëls' pictures.

Is it now possible to paint *The Sower* with color, with a simultaneous contrast of yellow and violet for example (like Delacroix's Apollo ceiling, *which is indeed yellow and purple*)—yes or no? *Yes*, of course it is. Well do it then! That's what old Martin says too: "The masterpiece is up to you." But you set about it and end up tumbling into a Monticellian metaphysics of color, a mess it's cursedly awkward to get out of with any credit.

The color is actually very fine here. When the green is I have a view of the Rhône—the iron bridge at Trinquetaille—in which the sky and the river are the color of absinthe, the embankments a shade of lilac, the figures leaning with their elbows on the parapet, blackish, the iron bridge an intense blue with a note of vivid orange and a note of intense Veronese green in the blue background. Yet another very unfinished effort, but where I'm searching for something more distressed and therefore more distressing.

[CA. 7 JULY, 1888]

504

I should warn you that everyone is going to think that I'm working too fast. But don't believe a word of it.

Isn't it emotion, sincerity of feeling for nature, that guides us, and if these emotions are sometimes so strong that one works without feeling that one is working, when there are times when each touch of paint leads to the

next and the relationship between them is like words in a speech or a letter, then one has to remember that it hasn't always been like this and that in the future there will also be difficult days, empty of inspiration.

So it's important to strike while the iron is hot and stack up the bars one has forged.

[EARLY JULY 1888]

507

Don't imagine that I'd remain in such a feverish state artificially; you have to understand that I'm in the midst of complicated planning, which produces a succession of paintings that are quickly executed but planned in advance over a long period of time. So if people say that my work is done too quickly, you can reply that they have looked at it too quickly. Besides, I am now in the process of touching up all my canvases a little before sending them to you. But during the harvest, work for me was no easier than that of the peasants who were actually bringing in the harvest. But I'm not complaining, far from it—it's precisely at times like these in my life as an artist, even though this may not be real life, that I feel almost as happy as I could be in any ideal, real life.

[5 JULY, 1888]

508

Yesterday at sunset I was on a stony heath where some very small, twisted oaks grow, in the distance a ruin on a hill and wheat in the valley. It was romantic in the extreme, like a Monticelli, the sun shining its bright yellow rays on the bushes and the ground, an absolute shower of gold. And all the lines were beautiful; the whole thing had a charming nobility. One wouldn't have

Pourtant j'ore espèrer qu'un jours l'aryent qu'un dépense reviendra en parlie el se j'avais d'avantage de l'argent, en depenserais d'avantage eneure pour chercher à faire des colorations Solei un moli nouveau. un coin de jardes des bustons en boule et un arbre rleurem et duns le fonct des touffesde lauriers roses. Et le gazon qu'on Viens de Jancher avec les longues trainées de poise que séche au sules Un polil coin de evel bles vers dum le haut

508

been in the least surprised suddenly to see knights and ladies returning from hawking or to hear the voice of some old Provençal troubadour. The land seemed violet, the distances blue.

Here's a new subject—a corner of a garden with round bushes and a weeping tree, and in the background clumps of oleander. And the grass, which has just been cut, with long trails of hay drying in the sun, and a small piece of blue-green sky at the top.

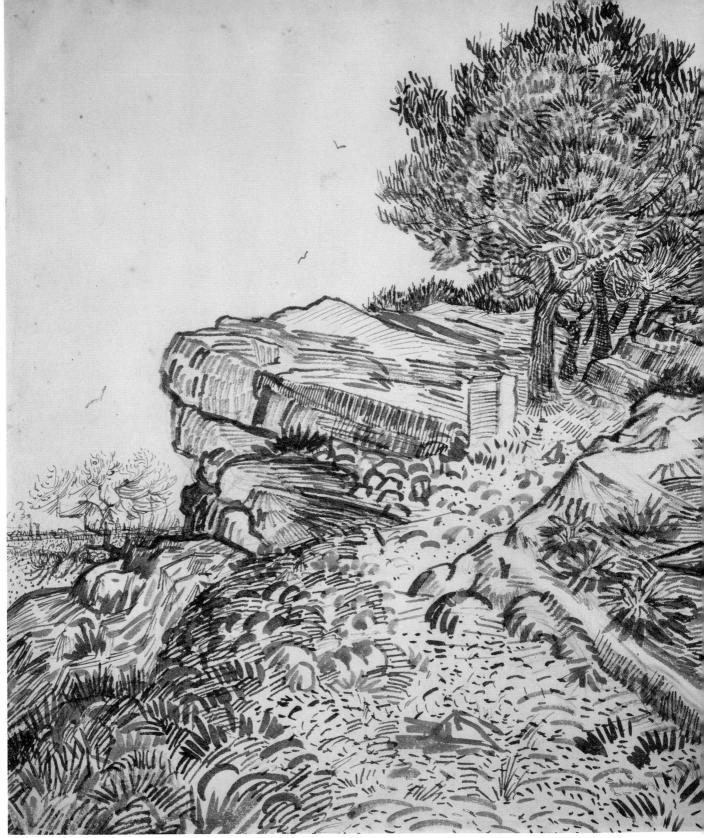

The Rock of Mont Majour

[CA. 13 JULY, 1888]

509

Not everyone would have the patience to allow themselves to be devoured by mosquitoes and to struggle against the infuriating perversity of this constant mistral, not to mention that I've spent whole days out of doors with just a little bread and milk, as I was too far away to keep going back into town.

I've already told you more than once how much the Camargue and the Crau—aside from the difference in color and clarity of the atmosphere—remind me of Holland back in Ruysdael's time. I think the two studies I've mentioned, the flat countryside covered with vines and fields of stubble, seen from above, will give you some idea.

For me these vast plains have an intense charm. Indeed, I've never felt any sense of weariness, despite circumstances that are essentially wearisome: the mistral and the mosquitoes. If a view can make you forget these little annoyances, it must have something about it. You'll see, however, that there is no particular *effect*: at first sight it's like a map, a strategic plan as far as execution is concerned. In fact, I was out walking there with a painter, and he said, "What a tedious thing to paint." Yet I've been to Mont Majour at least fifty times looking at this flat landscape—am I mistaken? I also went walking there with someone who was *not a painter*, and when I said to him, "You see, to me that is as beautiful and as infinite as the sea," he replied—and he's someone who knows the sea—"For myself, I *prefer* it to the sea because it's just as infinite and yet you feel that it's inhabited."

What a picture I could make of it if there weren't this confounded wind. That's the upsetting thing here, when you set up your easel somewhere. And that's also why my painted studies are not as finished as my drawings; the canvas is always shaking.

[15 JULY, 1888] BERNARD B10

I've done some big pen drawings. Two: one a vast stretch of flat countryside—a bird's eye view from the top of a hill—vineyards, fields of harvested wheat. All of it endlessly repeated, stretching out like the surface of the sea towards the horizon, bounded by the small hills of the Crau.

It doesn't look Japanese, and yet in fact it's the most Japanese thing that I've done; a microscopic figure of a plowman, a small train running through the wheat fields—that's the only life there is in it.

Listen, during the first few days I was there I was speaking with a painter friend of mine, who said: "What a tedious thing to paint." I said nothing, but I found it so magnificent that I didn't even have the strength to give the idiot a piece of my mind. I've been going back there again and again. And I've done two drawings of it—of this flat piece of countryside with nothing in it but ... infinity ... eternity.

And then, while I was drawing, a chap came along, not a painter but a soldier. I said to him, "Does it astonish you that I find this as beautiful as the sea?"

Now this was someone who knew the sea.

"No," he said, "it doesn't astonish me that you find it as beautiful as the sea; but myself I find it even more beautiful than the ocean because it's inhabited."

Which of these observers was more of an artist, the first or the second, the painter or the soldier? Personally, I prefer the soldier's eye, don't you agree?

> 509†, B10† La Crau Seen from Mont Majour

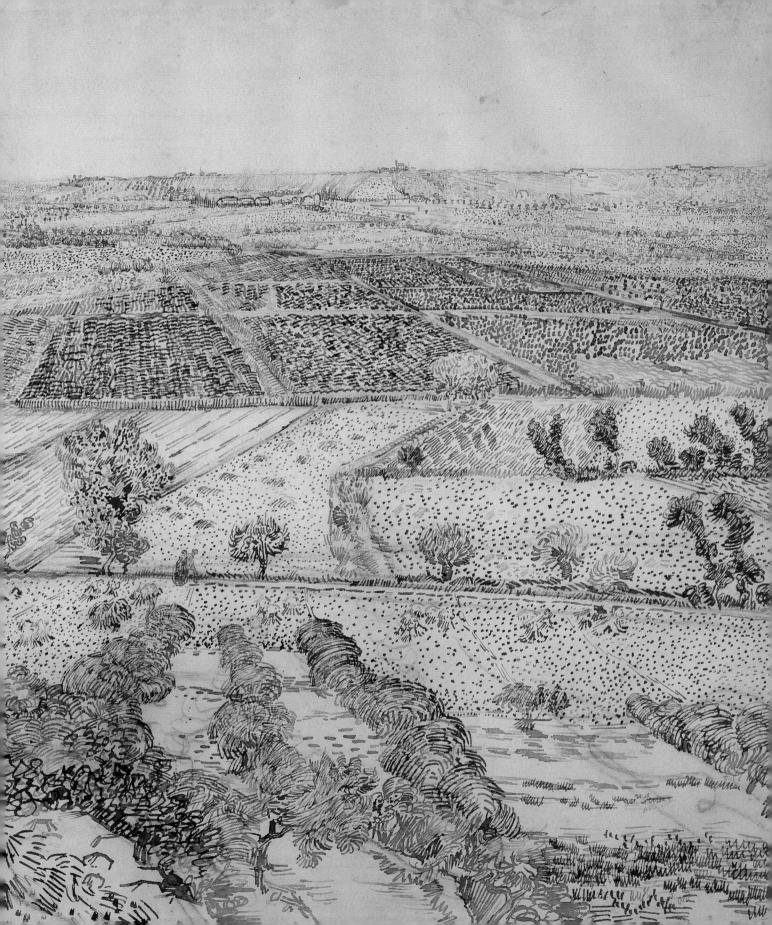

Ce que dois faceliles an Japonais de foure leurs veur es d'an deux des livour et des slacards c'est que lan peut waler les Rakemone; et non pas nossekuter pendes que s'ineracent par r'écaeller nous l'emplacement que de les faire a ccepter generalement carame constrents dis habitations and bourgeoises. Comme Anecement en Hallande. Amos la dans le mui cela feral rudemens been de voir des lableaux sur les mois blancs mus alter y voir, partout des grands medullous Julien culores des horreurs Es helus nous n'y changerous nen à cel étal de choses. Pourlant - les cafés. peut être plus land on les decerera. a brendal progress de main

moncher Theo Been merci de la lettre que ma fact been places arrevant bout juste an momentanjelais encore abruti par le soluit il la tension de mener une aspez grande loile / m un nouvera desfin d'un jurden plus de leurs , l'en avej vlement deux etudes Je does leurager une nouvelle communde de loclest de couleurs assez importante Veulement elle n'est point pressée Ce qu'à la requeur seroit prest à servet photos la luite va que j'ac un las dicharjis Dout j'au délactie les études et ou entre leng. I bancle blane el jaune cition s bande violelle Chande Orange'elvert blen et vertjaune à guache Pleurs rouges à droite

512

[CA. 19 JULY, 1888]

512

Many thanks for your letter, which gave me great pleasure, arriving just when I was still feeling exhausted by the sun and the strain of completing a rather large canvas.

I have a new drawing of a garden full of flowers, and also two painted studies of it.

You'll see from this sketch the subject of my new studies: there's one vertical and one horizontal canvas on the same subject, both size 30. I'm certain there's the subject for a painting in this and in other studies I've done. In truth, I really can't tell if I shall ever produce pictures that are calm and quietly executed, for I feel it will always be in fits and starts.

[31 JULY, 1888]

SISTER W5

I have a study, about a meter wide, of a garden. In the foreground are poppies and then a patch of bluebells. Then a patch of orange and yellow marigolds, then white and yellow flowers, and finally, in the background, pink and lilac, and then scabious, dark violet and red geraniums and sunflowers, a fig tree, and pink laurel and a grapevine. At the end black cypresses against low white houses with orange roofs—and a delicate greenish blue strip of sky. I know, of course, that not a single flower is drawn, that it is only licks of color, red, yellow, orange, green, blue, violet; but the impression of all these colors together is the same in painting as it is in nature. However, it may, I suppose, disappoint you, and seem ugly when you see it. You see that the theme is quite summery.

Uncle Cor has several times seen my work and thinks it frightful.

I am now working on a portrait of the postman with his dark blue and yellow uniform. A head like that of Socrates, almost no nose, a high forehead, bald crown, small gray eyes, highly colored full cheeks, a big pepperand-salt beard, large ears. The man is a well-known republican and socialist, speaks very well, and is very knowledgeable. His wife had a baby today, so he feels on top of the world and glows with satisfaction.

I would actually much rather paint something like this than flowers. But as you can do the one without dropping the other, I prefer to accept the opportunities as they offer themselves.

I hope I will also get to paint the infant born today. I also have a garden without flowers—grassland, recently mown, very green with the gray hay spread out in long rows. A weeping ash and some cedars and cypresses; the cedars yellowish and round, the cypresses tall and bluegreen. At the end oleander and a small corner of greenish blue sky. Blue shadows of the bushes on the grass.

Also a portrait bust of a Zouave in a blue uniform with red and yellow facings, sky blue sash, blood red cap with a red tassel. Sunburnt, short-clipped black hair—eyes leering like a cat, orange and green—a small head on a neck like a bull. The background is a hard green door and a few orange bricks from the wall and the white chalk.

[CA. 22, JULY, 1888]

513

Surely a canvas I've covered is worth more than a blank one. This, dear Lord, is all I have—my right to paint, my reason for painting—and believe me, my pretensions go no further.

And after all it has cost me: this dilapidated carcass and a brain addled from living as best I can and have had to because of my own philanthropy.

My concentration is becoming more intense, my touch more certain.

So I can almost dare to promise you that my painting will get better. Because that is all I have left.

[6 AUGUST, 1888]

518

Today I'm probably going to start work on the interior of the café where I'm lodging, in the evening by gaslight.

It's what's known here as a "night café" (they're quite common in these parts), one that stays open all night. "Night prowlers" can take refuge here when they don't have the money to pay for lodgings or are too drunk to be allowed in. All these things—family, homeland—are perhaps more attractive in the imaginations of people like us, who manage reasonably well without a homeland or a family, than they are in any reality. I always feel like a traveler, going somewhere, towards some destination.

If I sense that this somewhere, this destination, doesn't in fact exist, that seems to me quite reasonable and very likely true.

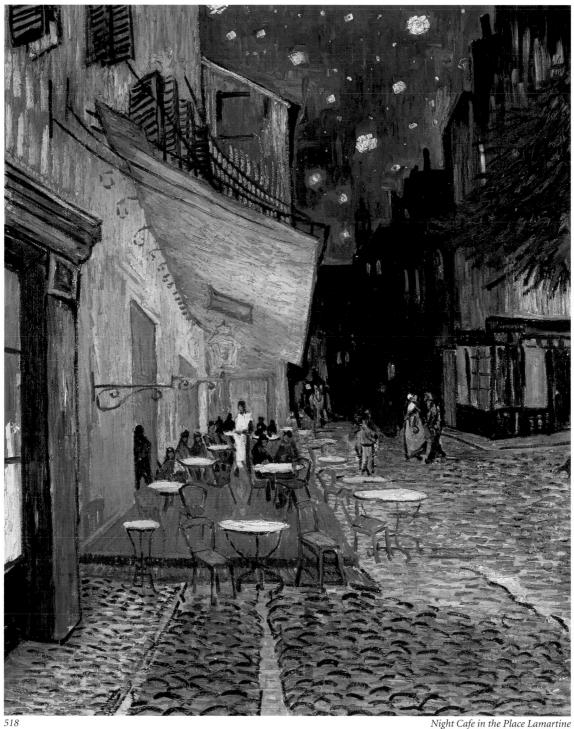

Night Cafe in the Place Lamartine

[8 AUGUST, 1888]

519

The little vertical cottage garden is, I believe, the best of the three large[drawings]. The one with the sunflowers is a little garden at some public baths, and the third, horizontal garden is one of which I've made painted studies as well.

Under the blue sky, the orange, yellow, and red splashes of the flowers take on a remarkable vividness, and in the limpid air there is something indefinably happier and warmer than in the North.

[*The Sower* and other drawings] are sketches made from painted studies. I think these are all good ideas, but the painted studies lack cleanness of touch. Another reason why I've felt the need to draw them.

This small vertical cottage garden I've done has the most superb colors when you see it in reality—the dahlias are a rich, dark purple, the double row of flowers is pink and green on one side and a shade of orange almost without green foliage on the other. In the middle, a dwarf white dahlia and a small pomegranate with blossom of the most striking orange-red and yellow-green fruit. The soil is gray; the tall, "Provence cane" reeds blue-green; the fig trees emerald; the sky blue; the houses white with green windows, red roofs, in full sun in the morning and in the evening completely immersed in the shadows cast by the fig trees and reeds.

Ah, these farm gardens with their large, handsome, red Provence roses, their vines, and their fig trees! It's truly poetic, and the bright, unending sunshine too, in spite of which the vegetation remains very green.

519†

Garden with Sunflowers

[9 AUGUST, 1888]

521

Not everything down here is bright. I saw a cowshed with four coffee-colored cows and a calf the same color; the shed was bluish white and hung with cobwebs, the cows very clean and very handsome, and a big, green curtain at the entrance to keep out the dust and flies.

Also gray, Velázquez gray!

It was all so tranquil—the café au lait and tobacco brown of the cows' hides and the soft gray—bluish white of the walls, with the green hanging and the sparkling green-yellow of the sunlit exterior making a striking contrast. So you see there are still things to do that are quite different from what I've already done.

I must get to work. I saw something else the other day that was also very tranquil and lovely: a young girl with a coffee—colored complexion—if I remember correctly—ash-blonde hair, gray eyes, a pale pink patterned bodice below which you could make out the small, firm shape of her breasts. This was against the emerald green of the fig trees. A true country girl with the real air of a virgin about her.

It's not impossible that I might get her to pose for me out of doors, and also her mother—a gardener's wife—skin the color of earth, dressed in dirty yellow and faded blue.

The girl's coffee-colored skin was darker than the pink of her bodice.

Her mother was stunning: her dirty yellow and faded blue figure standing out in full sunlight against a bright square of snow white and lemon-colored flowers. So you see, a true Vermeer of Delft. The south of France is not without its beauty.

[CA. 13 AUGUST, 1888]

522

Now we are having glorious, hot weather without wind, which suits me very well. The sun, the light that, for want of a better word, I can only describe as yellow—pale sulphur yellow, pale lemon gold. Yellow is such a beautiful color! And how much better I shall see the north.

Oh, how I keep wishing for the day when you too will see and feel the sun of the South.

As for studies, I have two of thistles on some waste ground, white thistles covered with fine dust from the road.

522† Thistles by the Roadside

Qu'est devenn le souvenir de mouve n'en ay and plus entenda parter par été porté à cruire que Tenteeg l'aurait del quelque chose pour faire savoir qu'un le refuserait ou autre misere. Naturellemen Je ne m'en Jerais pas de maurais sang dens ce cus le travaille dans des baleaux vu den hans Junquai les deux baleaux Jon Du violace l'eau est très verle un Trapeau Incolore oru mal Un ouvrier avec une brouelle decharge da sable. Jonaraus (un desfin. As la recu les trois andres des funda judin bu finira par ne plus les premore a la porte parcegne le format est trap grand Je crows que je n'aurai pus un bien ben modèle de Jemme, elle avait promis puis elle a à ce que prarait gayne des sous en

[CA. 14 AUGUST, 1888]

524

At the moment I'm working on a similar study, of boats seen from above from the quayside; the two boats are violet-pink, the water very green, no sky, a tricolor on one of the masts. A workman with a barrow is unloading sand. I have a drawing of it as well.

I'd begun signing the canvases, but I soon stopped because it seemed ridiculous. On one seascape there's a flamboyant red signature because I wanted a red note among the green.

AUGUST 1888

526

I have three canvases under way: first, three big flowers in a green vase, with a bright background, a size 15 canvas; second, three flowers, one gone to seed and the petals dropped and one in bud against a royal blue background, on a size 25 canvas; third, a dozen flowers and buds in a yellow vase (size 30 canvas). The last one is bright against a bright background, and I hope will be the best.

I have another study of dusty thistles under way, with a swarm of countless white and yellow butterflies.

[CA. 26 AUGUST, 1888]

527

Do you remember one day we saw a quite extraordinary Manet at the Hôtel Drouot—some large, pink peonies and their green leaves against a bright background? As fresh and as *flowery* as anything could be and yet painted in thick, solid impasto, and not at all like Jeannin.

That's what I'd call simplicity of technique. And I should tell you that these days I'm endeavoring to find a way of working with the brush without using stippling or anything else, just variety of stroke. One day you'll see what I mean.

524

[CA. 27 AUGUST, 1888]

528

The sunflowers are progressing; there's a new bunch of fourteen flowers on a yellow-green background, so exactly the same effect but larger format—a size 30 canvas—than the still life of quinces and lemons you already have, but in the sunflowers the painting is much simpler.*

[CA. 29 AUGUST, 1888]

529

I have plenty of ideas for my work, and if I continue diligently with figure painting I may well find even more.

But the fact is that sometimes I feel too weak to cope with the way things are and that one has to be cleverer, richer, and younger to be a success.

Fortunately for me, my heart is no longer set on any sort of triumph, and all I look for in painting is a way of getting through life.

[CA. 18 AUGUST, 1888]

BERNARD B15

Oh! The sun is so beautiful here in the middle of summer. It beats down on your head, and I've no doubt at all that it drives you crazy. But since I already am, I simply enjoy it.

I'm thinking of decorating my studio with half a dozen pictures of Sunflowers, a scheme in which raw or broken chrome yellows will burst forth against various backgrounds—blues from the palest Veronese green to royal blue—and framed with thin wooden strips painted in orange lead.

The kind of effect you get with stained-glass windows in Gothic churches.

*See page 243 for a later version of this composition.

[3 SEPTEMBER, 1888]

531

Sometimes, dear brother, I know so well what I want. I am quite able to do without God, both in my life and in my painting, but what I cannot do without, unwell as I am, is something greater than myself, which is my life, the power to create.

And if physically frustrated in this power, one seeks to create thoughts instead of children, one nevertheless remains part of humanity.

In a picture I'd like to say something comforting, in the same way as music. I'd like to paint men and women with a certain eternal quality, symbolized in the past by the halo, and that we now seek to convey through radiance itself, through the vibration of our coloring.

A portrait conceived in this way does not become an Ary Scheffer** because there's a blue sky in the background as in his painting of St. Augustine. Because Ary Scheffer is not very much of a colorist.

It would be more in keeping with what Delacroix attempted and achieved in his Tasso in Prison, and in so many other pictures—the representation of a *real man*. Indeed, portraits—portraits with the thoughts, the soul of the model—that's what I believe must happen.

 $^{^{\}star\star} \text{Ary Scheffer}$ (1795–1858), a Dutch-born painter in the French academic tradition.

[8 SEPTEMBER, 1888]

533

Precisely because I am always bowed under the problem of money with landlords, I made up my mind to take a positive approach. I had it out with the landlord, who after all is not a bad sort, and told him that to get my own back for having to pay him so much money for nothing, I would paint the whole of his filthy joint so as to get my money back. So, to the great joy of the landlord, the postman I've already painted, the visiting night prowlers, and myself, for three nights I stayed up painting, sleeping during the day.

I often think that night is more alive and more richly colored than day. As for getting back the money I've paid the landlord through my painting, I'm not too bothered as the picture is one of the ugliest I've done. It's equivalent to, though different from the *Potato Eaters*.

I've tried to express the terrible passions of humanity with red and green.

The room is blood red and dull yellow, with a green billiard table in the middle; there are four lemon yellow lamps casting an orange and green glow. Everywhere there's a struggle and a clash between the very different greens and reds—in the small figures of the sleeping good-for-nothings, in the sad and empty room in violet and blue. The blood red and the green-yellow of the billiard table, for example, contrast with the delicate little Louis XV green of the counter with its bunch of pink flowers.

And amid this furnace, the white clothes of the landlord, who is watching from a corner, become lemon yellow and pale, luminous green.

[9 SEPTEMBER, 1888]

534

In my picture of the night café I've tried to convey the sense that the café is a place where one goes to ruin, goes mad, commits crimes. I've tried to express the powers of darkness, in a way, in this dive of a bar, through contrasts of delicate pink, blood red, wine red, and soft Louis XV green and Veronese green, in contrast with hard greenyellows and blue-greens—all this amid an infernal furnace of pale sulphur.

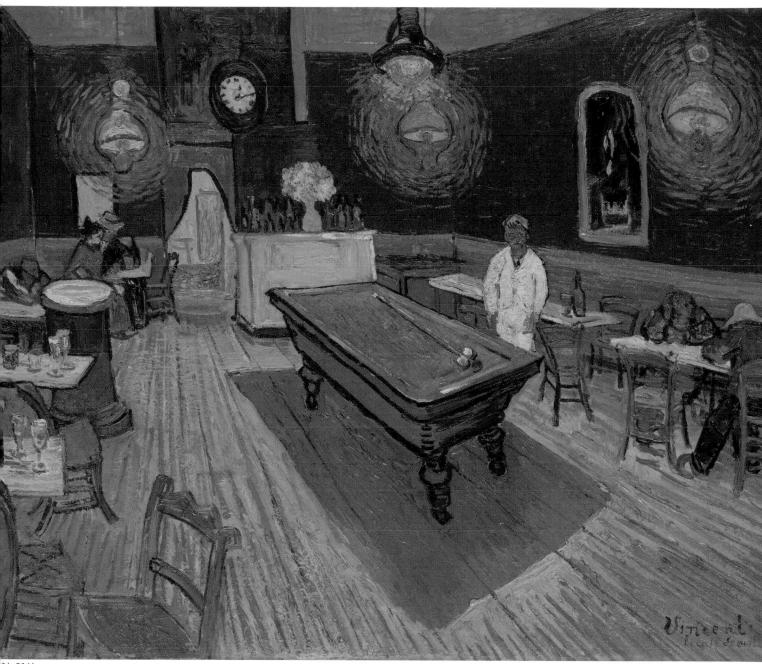

3†, 534†

Night Cafe

[17 SEPTEMBER, 1888]

537

I bought a mirror of a good enough quality to be able to work from my own image, for want of a model, because if I manage to paint the coloring of my own head—which is not without its difficulties—I'll be able to paint the heads of other good folk, both men and women.

I find the idea of painting night scenes and night effects on site and at night enormously interesting. This week I've done nothing but paint and sleep and have my meals. That means sessions of twelve hours, six hours, and so on, and then sleeping for twelve hours at a stretch, too.

[CA. 17 SEPTEMBER, 1888]

539

Because I've never had such an opportunity as here, nature being so *extraordinarily* beautiful. In each and every place the dome of the sky is a splendid blue, the sun has a pale sulphur radiance and it is as soft and charming as the combination of celestial blues and yellows in the paintings of Vermeer. I cannot paint as beautifully as that, but I find it so absorbing that I let myself go and forget all about rules.

It's true that in Impressionism I see the resurrection of Eugène Delacroix, but as interpretations are both so divergent and to an extent irreconcilable, it will not be Impressionism that will provide a doctrine to follow.

That's why I remain in the Impressionists, because it professes nothing and commits you to nothing, and being among friends I have no need to explain myself.

What's Seurat doing? I wouldn't dare show him the studies I've already sent, but the ones of sunflowers, inns, and gardens, I'd like him to see those. I often think about his method and yet I don't follow it at all, but he's an original colorist and the same is true of Signac, but to a different degree; this stippling they've invented is something new, and indeed I do like them a lot. But as for me—to be honest with you—I'm tending to go back to what I was trying to do before I went to Paris. I don't know if anyone before me has talked about suggestive color, but Delacroix and Monticelli*, though they didn't talk about it, practiced it.

When the mistral blows down here, the region is anything but pleasant, as the mistral really sets your nerves on edge. But how different, how very different, it is when there's a day without wind. How intense the colors are, how pure the air, what vibrant serenity.

^{*}Adolphe Monticelli (1824–1886), French painter.

[CA. 27 SEPTEMBER, 1888]

541

By seven o'clock this morning I was sitting in front of something rather unimpressive—a clipped, round bush of cedar or cypress standing among the grass. You're already familiar with this round bush as you already have a study of the garden. Also, enclosed is a sketch of my canvas, again a size 30 square.

The bush is green, with some bronze and other tones.

The grass is very, very green, a lemonish Veronese green, the sky very, very blue.

The row of bushes in the background are all oleanders and raving mad—these damned plants flower so abundantly that they may well catch a dose of locomotor ataxia. They are loaded with fresh blooms along with quantities of faded flowers; their foliage is also constantly renewing itself with vigorous and seemingly inexhaustible new shoots.

A funereal cypress, completely black, rises up above them, and some small, colored figures are strolling along a pink path.

541

[24 SEPTEMBER, 1888]

542

I'm now beginning to see better the beauty of the women here, and again and again I think of Monticelli.

Color plays an enormous role in the beauty of these local women; I don't mean that they aren't beautiful in terms of their figure, but that is not their greatest charm. This lies in the overall look of their clothing, which is colorful and worn with style, and in the tone of their flesh rather than in their figure. But it won't be easy to capture them in the way I'm beginning to see them. But what I am sure about is that by staying here I'm making progress. And to do a picture that is genuinely of the South, it's not enough simply to have a certain skill. It's looking at things for a long time that helps you develop and gives you a deeper understanding. I never thought that leaving Paris would make me find Monticelli and Delacroix so true. It's only now, after months and yet more months, that I'm beginning to realize that they imagined nothing. And I think that next year you'll see the same subjects again, the orchards, the harvest, but with different color and, above all, a new approach.

[24 SEPTEMBER, 1888]

SISTER W7

I enjoy enormously painting at night and on site. In the past one used to draw and then paint the picture the day after the drawing. But I find it suits me to paint the thing straight away. It's true, of course, that in the darkness I can mistake a blue for a green, a lilac-blue for a lilac-pink, because it's not easy to distinguish the exact quality of a tone. But it's the only way to get away from our conventional night paintings with their paltry, pallid, whitish light when just a candle on its own produces the richest yellows and oranges.

The more ugly, old, nasty, ill, and poor I become, the more I want to get my own back by producing vibrant, well-arranged, radiant color.

Jewelers too are old and ugly before they learn how to arrange precious stones well. And arranging colors in a picture so that the contrast between them makes them vibrate and so that each enhances the other is, in a way, similar to arranging jewels or—to designing costumes.

[3 OCTOBER, 1888]

54

The vines I've just painted are green, purple, and yellow with violet bunches of grapes and black and orange shoots.

On the horizon are some gray-blue willows, the press house with its red roof far, far away, and in the distance the lilac silhouette of the town.

In the vineyard are small figures of ladies with red parasols and other little figures of people working picking grapes, and their cart.

Above, a blue sky, and the foreground is gray sand. This is a pendant piece to the garden with the round bush and oleanders.

Day by day things grow richer still. And when the leaves start to fall—I don't know whether here that happens early in November as it does at home—when all the leaves on the trees are yellow, it will look amazing against the blue.

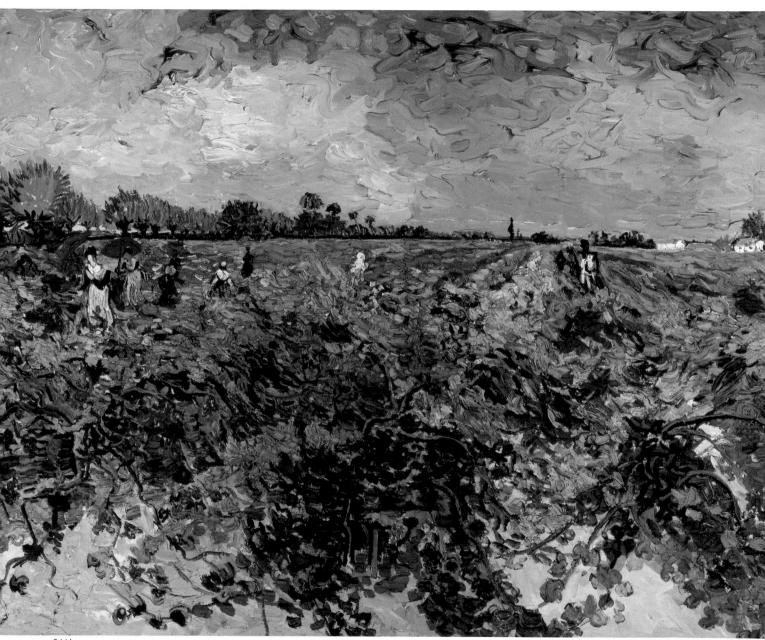

544† The Green Vineyard

[CA. 22 OCTOBER, 1888]

551

I have another size 30 canvas, *An Autumn Garden*—two bottle green, bottle-shaped cypresses, three small chestnut trees with tobacco brown and orange leaves. A small yew tree with pale lemon foliage and a violet trunk, two small bushes with blood red and scarlet-purple leaves.

A patch of sand, a patch of grass, a patch of blue sky.

And yet I'd vowed to myself not to work. But that's how it is every day—sometimes I just come upon things that are so beautiful I simply have to try and capture them.

The leaves are beginning to fall, the trees are turning yellow in front of your eyes—the yellow increasing every day.

It's at least as beautiful as the orchards in bloom.

[OCTOBER 1888]

BERNARD B20

I'm working on a big canvas of a ravine; the subject is very like the study with a yellow tree that you gave me: two exceptionally solid rock bases between which flows a thin stream, a third mountain closing off the ravine.

Such subjects certainly have a fine melancholy about them, and it's also enjoyable working out in wild spots like these where you have to bury your easel in among the stones so that the wind doesn't just blow the whole lot over.

[13 OCTOBER, 1888]

552

I've just painted this red and green carriage in the courtyard of the inn. See what you think. This quick sketch gives you an idea of the composition: a simple gray, sandy foreground; the background very simple too, pink and yellow walls with green shutters and a patch of blue sky. The two carriages are brightly colored, green and red, the wheels yellow, black, blue, and orange. Again a size 30 canvas. The carriages are painted in the style of Monticelli, with thickly applied paint. You once had a very fine Monet of four colored boats on a beach. Well, here it's carriages, but the composition is of the same kind.

Now imagine a huge, blue-green fir tree, with horizontal branches reaching out over a very green lawn and sand speckled with light and shade.

This very simple stretch of garden is enlivened by beds of orange lead geraniums in the distance, under the black branches.

A pair of lovers in the shade of the big tree; a size 30 canvas.

And then two more size 30 canvases: the Trinquetaille bridge and another bridge over the road where the railway passes.

In coloring this particular canvas is a little like a Bosboom.

The one of Trinquetaille bridge, with all those steps, is one I did on a gray morning; the stone, the asphalt, the paving are gray, the sky pale blue, some small colored figures, a sickly looking tree with yellow leaves. So two canvases in broken tones of gray and two brightly colored ones.

mon her theo, pen'avair tout a fait or especier audicibil ton nouveaux manchet de sofrancs closil jete remercie beaucoup.

I'ai bayecoup de frais et este me chagrene bien quidquive losoque de plus en plus jem'aperçois que la penduce est un melier que probablement est exerci par cles gens execestivement pauvres purquel coûte beaucoup d'argent de mais l'autonine continue encou à être d'un beau! que drois de pays que celle patrie cle Tarlarin. Ous jessus content cle mon sort, c'est pas un pays superbe est subtime ce n'est que du Daumier bien vevant. As ta chipa selu les Tarlarin ah re t'oublie pas. Te rappelles la claus Tarlarin la complaint, d'abvieillommbus delligence de Tarascont—celle ad mirable page—Eh bien je viens cle la pendre celle voilure rouge el verle dans la cour de l'amberge—Tayerle dans la

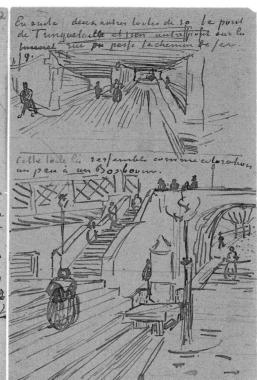

552

Enten le pont de Tronquetailer avac but es ces marele est une locke facte par une matinei grese les prerses l'esphalle les pures sont greses le cuel d'un bleu pale des jegur mes coloreis June. Donc deux loi les dans les lons gris etrompas et deux lodes hes colorees Pardonne ces bien mouveus croques Je sus assemme de pendre cedse dellegence de Tarascon el jevois que j'as pas la tèle a desfiner. Je m'envais duer et cesoir l'ecris envoite was elle marche un peu celle decoealin el jecrois que cela m'elargira ma manière de voir el de faire Cela sera mille jois critiquable bon maes entin pourva que j'arrive à y mettre de l'entrain. Mais va pour le pays elu bon Tarlarin je m'y amuse de plus en plus et cela va nous devenir comme une nouvelle palie. Tourlant jen vieble jas le Hollande juste les contrastes jours que j'y peux heaveroups Turet i l'houre je reprend catta lellre.

Cocroques Isalel ten Jourse la compositione: avant plan simple de sable quis fond auri. Très simple maracles roses et james avec fancties vertes combe celles Les deux voilures les colorées sentrouge Jame noir bleu orange Tockede 30 longours. Les voitures sont es prentes à la montreelle. Tu avans dans le lesseps un bien beau Claude mone! representant & barques colorees sur une plage. Ch bien c'est p ici des voilures mais la composition Suppose mainle un Sapur bleu Verl immenseelens des branches housouls Jus una polosse lee. veill et dusable lachelé de lumite (ecounde jardin polsemple est egay é par des parterses de garancieros mons Deux liques d'amourque se trouvent à l'ambre dagrandarbre lele de 10.

[16 OCTOBER, 1888]

554

At last I'm sending you a small sketch to give you at least an idea of the direction my work is taking. Because today I've gone back to it. My eyes are still weary, but a new idea came into my head, so here's a sketch of it. Again a size 30 canvas. This time it's simply my bedroom, but here it's the color that must make it what it is, bringing greater style to things through simplification and creating the feeling of *rest* or sleep in general. In fact, looking at this picture ought to bring a sense of repose to the brain or rather to the imagination.

The walls are pale violet. The floor tiles red. The wooden bed and chairs are a fresh, butter yellow, the sheet and the pillows a very light lemon green.

The bedcover is scarlet red. The window green.

The washstand orange, the basin blue.

The doors lilac.

And that's it—nothing more in this room with its closed shutters.

The solidity of the furniture should again express a sense of unwavering repose. The portraits on the wall and a mirror, a hand towel, and a few clothes.

The frame—as there is no white in the picture—will be white.

This is by way of revenge for the enforced rest I've been obliged to take.

I shall work on it again all day tomorrow, but you can see how simple the concept is. Shadow and cast shadows are done away with; it's colored in plain, flat tints like Japanese prints.

It will be a contrast with the Tarascon coach and the night café, for example.

554

[17 OCTOBER, 1888]

GAUGUIN B22

Again, as decoration, I've done a size 30 canvas of my bedroom, with the whitewood furniture you've seen before. I enjoyed enormously doing this plain interior, of a simplicity worthy of Seurat: flat tints but crudely brushed on in thick impasto, the walls pale lilac, the floor a broken, faded red, the chairs and bed chrome yellow, the pillows and sheet very pale lemon green, the bedcover blood red, the washstand orange, the basin blue, the window green. You see, by using all these very diverse tones I wanted to express a sense of absolute repose, and with no white at all in except for a small note in the mirror with its black frame (to get a fourth pair of complementary colors into it).

[17 OCTOBER, 1888]

555

This bedroom is something like that still life Parisian *Novels* with their yellow, pink, and green covers, if you remember. But I think the execution is more forceful and simpler.

No stippling, no hatching, nothing—only harmonious flat tints.

J'as been envie de l'ecrore une lettre expris que la pourras beur laire lice pour les expliquer encure une lois pourques je crois mos an mide pour l'avenur et le présent. Et pour du combien Je cross qu'on a rasson de voir dans le mouvement impres jourste une Tendunce vers les chuses grundes el non pas seulement une écule que se bornerait à laire des experiences oppliques. Amsi pour eux qui font alors de la pendine d'histoire on an moins l'ont faite dans le tempo s'el quoles been manues pendres d'histoire comme Delarchees Delort n'en a I il pas egalement des bons comme Eng Delacroes et mentonnier. Outin purque ele ecclemment j'as l'ententen. de ne pas peindre cen moins oluvant 3/0415 peul els mergroseras je en l'écrivant et à eux en meme lenges Car busans y ne celu m'intéres je as les l'instruence qu'alira l'impresses

[OCTOBER 1888]

556

Here's a rather rough sketch of my last canvas, a row of green cypresses against a pink sky with a pale lemon crescent moon. Wasteland in the foreground, sand, and a few thistles. A pair of lovers, the man pale blue with a yellow hat, the woman with a pink bodice, and a black skirt.

[7 OCTOBER, 1888]

But arriving there [at the night café] one night I came upon a little group—a pimp and a prostitute making up after a quarrel. The woman was acting haughty and hard to please, the man trying to coax her round. I set about painting it for you from memory on a small size 4 or 6 canvas.

I have ruthlessly destroyed one large canvas —Christ with the Angel at Gethsemane—and another of a poet with a starry sky, in spite of the color, which was correct, because I hadn't studied the form of them beforehand using a model, which is necessary in cases like these. If you don't like the study I'm sending you instead, try looking at it a little longer. I had a devil of a job doing it with the maddening mistral blowing (with the red and green study, too). Well, even if it's not as fluently painted as the Old Windmill, it's more subtle and more intimate. You'll see that none of this is in any way Impressionist; well, no matter. I do what I do surrendering myself to nature, without thinking of this or that. It goes without saying that if you'd prefer a different study in this package to the Men Unloading Sand, you can take it and erase the dedication if someone else wants it. But I think you'll come to like it once you've spent a little longer looking at it.

I can't work without a model. I'm not saying that I don't firmly turn my back on nature when transforming a study into a picture, arranging the color of it, enlarging it, simplifying it; but I'm so afraid of deviating from what's possible and true in terms of form.

Later, after another ten years of studies, maybe I will be able to; but to tell the truth I am so curious about what is possible and what really exists that I have little desire or courage to strive for the ideal that might result from my abstract studies.

Others may have more lucidity than I do when it comes to abstract studies, and you may certainly be among them, as well as Gauguin ... and perhaps I will be too when I'm old.

Meanwhile, it's nature that I feed on. I exaggerate, sometimes I make changes to the subject. Nevertheless, I don't invent the whole picture—on the contrary I find it ready made in nature but in need of unraveling.

[CA. 6 NOVEMBER, 1888]

559

Of course it's winter for us too here, though it continues to be very fine from time to time. But I don't find it disagreeable to try to work from my imagination, as it allows me to stay indoors. Working by the heat of a stove doesn't bother me, but the cold doesn't suit me, as you know. But I did mess up that piece I did of the garden at Nuenen, and I think that it takes practice to work from one's imagination. But I've done portraits of *an entire family*, the family of the postman whose head I had already done—the husband, the wife, the baby, the little boy, and their sixteen-year-old son, all of them very much types and very French although in the picture they may appear a bit Russian. Size 15 canvases.

I think you'd like the falling leaves I've done.

There are lilac poplar trunks cut off by the frame at the point where the leaves begin.

These tree trunks are like pillars running down the sides of an avenue with old, lilac-blue Roman tombs in rows to the right and left. The ground is covered with a thick carpet of orange and yellow fallen leaves. And like snowflakes, more continue to fall.

In the avenue are some small, black figures of lovers. At the top of the picture is a very green meadow and no sky, or almost none.

The second canvas is the same avenue, but with an old chap and a fat woman as round as a ball.

On Sunday, if you'd been with us, you'd have seen a red vineyard—completely red like red wine. In the distance it became yellow, and then a green sky with the sun, and the land after the rain violet and sparkling yellow here and there where it caught the reflection of the setting sun.

[Arles, second half of november] sister w9

I have just started painting a recollection of the garden at Etten to put in my bedroom—here's a sketch of it. The canvas is quite a large one. These are the colors: the younger of the two women out walking is wearing a green and orange plaid shawl and carrying a red parasol; the old woman has a shawl that is violet-blue, almost black. But a bunch of dahlias, some lemon yellow, others in a mixture of pinks and whites, creates an explosion of color on this somber figure. Behind them, some cedar or cypress shrubs in emerald green. Behind the cypresses one can see a plot of pale green and red cabbages edged by a border of small white flowers. The sandy path is raw orange, the foliage of the two beds of scarlet geraniums is very green. And in the middle ground there's a servant girl dressed in blue, who is arranging plants covered in a profusion of white, pink, yellow, and vermilion red flowers. There we are—I know that it's hardly a true likeness, but for me it renders the poetic character and style of the garden as I feel them. But let's suppose that these ladies out walking are you and Mother—even supposing that there is no resemblance at all, not even the crudest or most fatuous—the deliberate choice of color, the somber violet with the fierce lemon stains of the dahlias, suggests Mother's personality to me.

The figure in the orange and green check plaid standing out against the somber green of the cypresses, the contrast heightened still further by the red parasol, this figure makes me think of you as a character in a novel by Dickens, a kind of figurative presence.

I have also painted a Novel Reader, with rich, deep black hair, a green bodice, purplish red sleeves, and a black skirt; the background is entirely yellow, with bookshelves lined with books. She is holding a yellow book in her hands.

W9 "La liseuse."

[CA. 23 NOVEMBER, 1888]

56

Gauguin was telling me the other day that he had seen a very fine picture by Claude Monet of sunflowers in a large Japanese vase but—he prefers mine. I don't share his opinion—but I do believe that I'm improving.

If by the age of forty I've done a picture with figures like the flowers Gauguin was talking about, I will rank as an equal to anyone else in the art world. So, perseverance.

Meanwhile, I can also tell you that the last two studies I've done are rather odd.

Size 30 canvases, a wooden, rush-seated chair, entirely yellow, on red tiles against a wall (in daylight).

Then Gauguin's armchair in red and green, a night study, the wall and floor also red and green, on the chair two novels and a candle. On sailcloth in thick impasto.

[23 DECEMBER, 1888]

565

I think Gauguin had become rather disheartened with the good town of Arles, with the little yellow house where we work, and especially with me.

In fact, I think there are some serious problems still to be overcome here for both of us.

But these difficulties are inside ourselves rather than anywhere else.

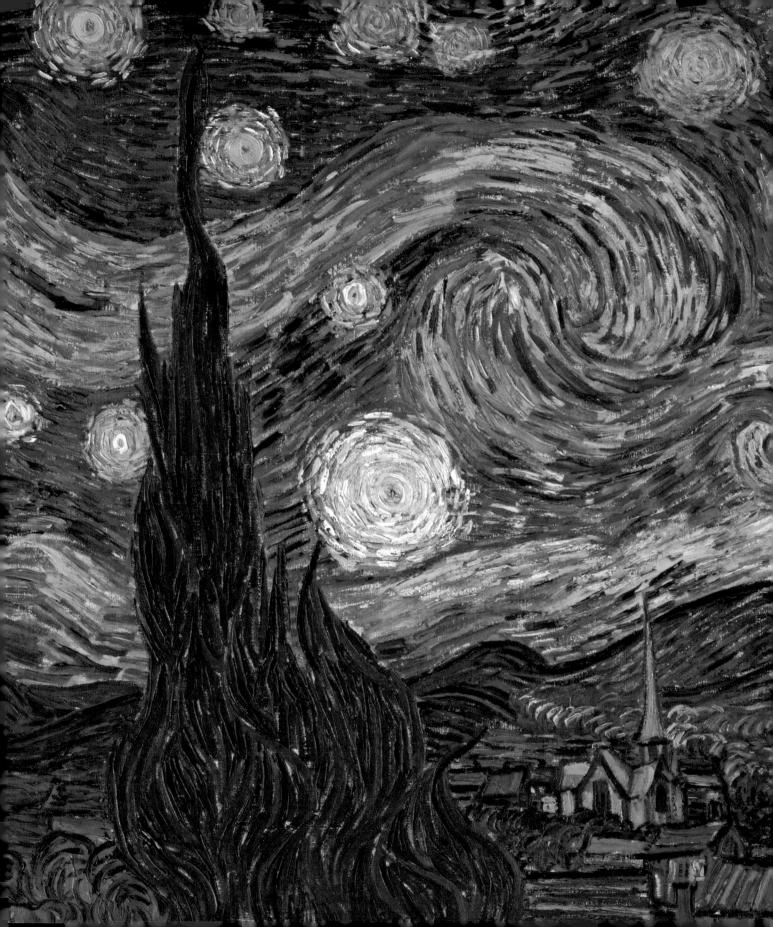

Part VI 1889

an Gogh recovered quickly from the infamous ear—cutting incident and left the hospital in January of 1889, although his neighbors petitioned to have him recommitted in February. These setbacks notwithstanding, he continued to work, producing several copies of a composition of summer sunflowers and a number of still-life paintings.

After a few more relapses, van Gogh decided to relocate to an asylum in nearby Saint-Rémy. Shortly after Theo's wedding in April (which Vincent did not attend), van Gogh was admitted as a patient in Saint-Paul-de-Mausole.

In Saint-Rémy, he adapted a slightly darker palette of earth tones, shifting away from the radiant yellows of his time in Arles. Simultaneously, his brushwork became more animated, and his paintings took on that surging quality that is uniquely van Gogh's.

Van Gogh found plenty of subject matter in the hospital grounds and the surrounding countryside. Despite the strains of living amongst genuinely insane patients, and another attack in July, van Gogh made some of his most famous paintings during this time, including *Starry Night* and his vibrant studies of cypress trees, wheat fields, and olive groves.

That fall, he started an ambitious series of paintings after prints by Millet as well as the works of Delacroix and Rembrandt. All these copies after his artistic idols contained a strong interpretive element that made them into highly original artworks in their own right. Indeed, van Gogh himself called them "translations." In September, his works were exhibited in a group show in Paris, to favorable reviews from both critics and his fellow artists.

Despite these promising signs, and despite many reassurances to Theo, he was preoccupied with morbid thoughts and nostalgia for the North. Still working "like one possessed," according to the faithful Theo's words, van Gogh suffered yet another attack in late December.

[1 JANUARY, 1889]

566

When I go out, I'll be able to get back to normal work, and soon the fine weather will be here and I shall start on the orchards in blossom again.

[17 JANUARY, 1889]

571

I've started work again and already have three studies done in the studio, plus the portrait of Dr. Rey,* which I gave him as a keepsake.

[JANUARY, 1889]

571A

At the moment I have in hand—or rather on my easel—a portrait of a woman. I have called it *La Berceuse*, or as we would say in Dutch (as in Van Eeden, you know, who wrote the book I asked you to read), at least in Van Eeden's Dutch, it would be called *Ons Wiegelied or Wiegster [Cradlesong or The Cradler]*. It is a woman dressed in green (olive green bust and pale Veronese green skirt). Her hair is all orange and plaited. The color of the face is done in chrome yellow with, of course, broken tones to give a natural look to it. The hands that hold the ropes to rock the cradle are the same color.

The lower background is vermilion (simply representing a floor of quarry tiles or flagstones). The wall is papered and, of course, I coordinated it with the other colors. This wallpaper is blue-green, with pink dahlias dotted with orange and ultramarine.

*Dr. Félix Rey treated Vincent after he cut his ear.

[23 JANUARY, 1889]

573

I have good and bad luck with my work, but not *simply* bad luck. If, for example, our Monticelli flower painting is worth 500 francs to a collector, and it is indeed worth that, I'd hazard to say that my sunflowers are worth 500 francs, too, to one of these Scotchmen or Americans.

To work up the heat to melt those golds and flower tones isn't something that just anyone can do; it takes all the energy and concentration a single individual can muster.

When I looked over my canvases after my illness, the one that seemed best to me was the bedroom.

[28 JANUARY, 1889]

574

During your visit I'm sure you must have noticed the two size 30 canvases of sunflowers in Gauguin's room. I've just put the finishing touches to copies of these that are absolutely identical.

Since it's still winter here, please just let me get on with my work; if it's the work of a madman, that's just too bad. There's nothing I can do about it.

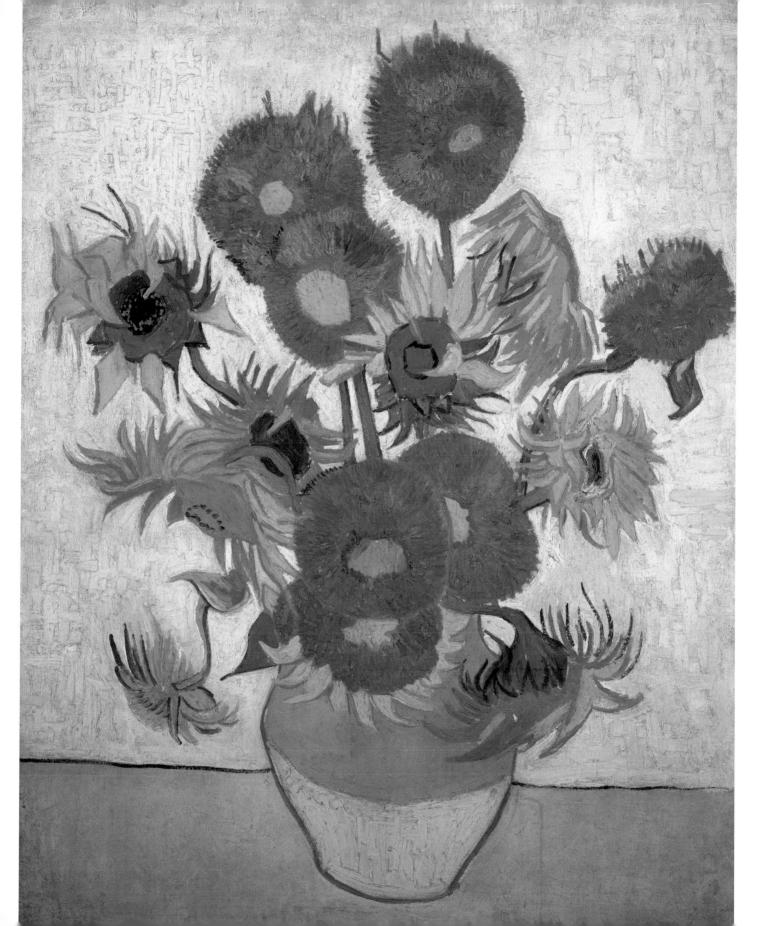

[CA. 10 APRIL, 1889]

SIGNAC* 583B

I'm well at the moment and am working at the asylum and in the surrounding area. In fact, I've just come back with two studies of orchards.

Here's a quick sketch of them—the larger one is of a poor stretch of green countryside with small farmhouses, the blue line of the Alps with a blue and white sky. The foreground, fields enclosed by reed fences with small peach trees in blossom—everything is small, the gardens, the fields, the orchards, the trees, even the mountains, as in certain Japanese landscapes, which is why the subject appealed to me. The other landscape is almost entirely green with a little lilac and gray-on a rainy day.

Orchards in Blossom, View of Arles

^{*}Paul Signac (1863–1935), an artist friend from Vincent's Paris Days.

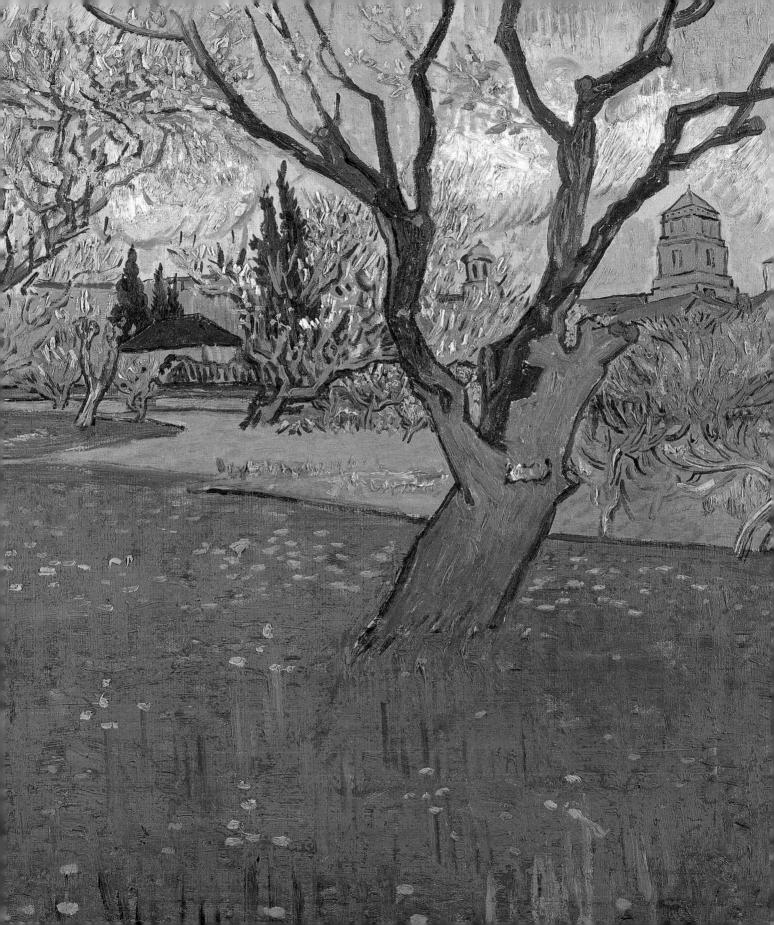

[28 APRIL, 1889]

587

If you could see the olive trees right now...! The foliage old silver and greenish silver against the blue. And the orange of the plowed soil. It's something quite different from what one imagines in the North—refined and distinguished!

It's like the pollarded willows of our Dutch meadows or the oak bushes among our dunes; in fact, the rustling of an olive grove has something very intimate about it, something immensely old.

It's too beautiful for me to dare to paint it or even imagine it.

The oleander—now, that speaks of love and is beautiful like the Lesbos by Puvis de Chavannes with its women on the seashore. But the olive tree is something different; if you want to compare it with something it would be with Delacroix.

[30 APRIL, 1889]

SISTER W11

I am, however, working and have just done two pictures of the asylum: one of a ward, a very long ward, with rows of beds with white curtains and figures of patients moving around. The walls, the large-beamed ceiling all in white, lilac-white or green-white. Here and there a window with a pink or light green curtain. The floor in red bricks. At the far end a door with a crucifix above it. It's very, very simple. Then, as a pendant to it, the inner courtyard. This is an arcaded gallery like those in Arab buildings, whitewashed. In front of the galleries, a very old garden with a pond in the middle and eight flowerbeds with forget-me-nots, Christmas roses, anemones, ranunculus, wallflowers, daisies, etc. And below the gallery, orange trees and oleanders. So it's a picture filled with flowers and spring greenery. But there are three mournful black tree trunks snaking through it, and in the foreground four large, dark bushes of box. Local people probably won't see much in it, yet it's always been my wish to paint for those who know little about the artistic side of a picture.

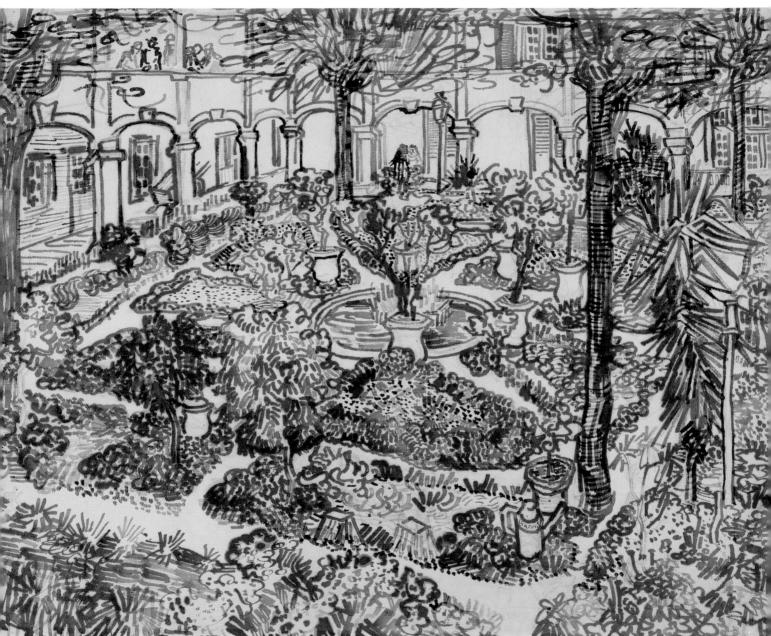

The Courtyard of the Hospital at Arles

592† Emperor Moth

[3 MAY, 1889]

590

Sometimes I regret not simply sticking with my Dutch palette of gray tones and turning out straightforward landscapes at Montmartre. And I've also been thinking about going back to drawing more with a reed pen, which, like last year's views of Montmajour, costs less and I find just as absorbing. Today I made just such a drawing, which became very black and rather melancholic for spring, but in any case, whatever happens to me and in whatever circumstances I may find myself, it's something that will keep me occupied for a long time and could even provide me with some kind of livelihood.

[MID-MAY 1889]

59

I keep thinking about the need to work, and I believe that I'll regain my full ability for work quite soon. But I often find work so absorbing that I can become very preoccupied and inept about sorting out the rest of my life.

[22 MAY, 1889]

592

Here's a new size 30 canvas, again rather ordinary, like the chromos of endless green bowers where lovers meet that are sold on cheap stalls.

Thick tree trunks covered in ivy, the ground covered in ivy, too, and periwinkle, a stone bench and a bush of pale roses in the cold shade. In the foreground some plants with white calyxes. It's in green, violet, and pink.

The problem—which unfortunately doesn't apply to the chromos sold on cheap stalls and at barrel organs—is putting some style into it.

Since I've been here, the abandoned garden with its large pines and tall, untidy grass beneath, interspersed with various weeds, has sufficed for my work, and I have not yet been outside it. However, the St. Rémy countryside is very beautiful and little by little I shall no doubt explore it.

Yesterday I drew a very large moth there, quite a rare one known as the death's head, with strikingly elegant coloring: black, gray, white tinged with carmine or shading vaguely towards olive green; it's very large. To paint it would have meant killing it, which was a pity with such a beautiful creature. I'll send you the drawing of it with some other drawings of plants.

Emperor Moth

Trees and Shrubs in the Garden of Saint-Paul's Hospital at Saint-Remy

Trees with Ivy in the Garden of Saint-Paul's Hospital at Saint Remy

Olive Tree in the Mountains

[CA. 9 JUNE, 1889]

594

What news do I have to tell you? Not a great deal. I'm working on two landscapes (size 30 canvases) of views of the hills; one is of the countryside I can see from the window of my bedroom.

In the foreground is a wheat field flattened and laid waste by a storm. A boundary wall and beyond it the gray foliage of some olive trees, some cottages, and the hills. At the top of the canvas is a large, white and gray cloud swimming in the azure sky.

It's a landscape of extreme simplicity—and also in coloring. It will make a pendant to that bedroom study that was damaged. When the object represented is, in terms of style, in absolute harmony and at one with the way it is represented, isn't that what gives a work of art its quality?

[16 JUNE, 1889]

SISTER W12

I've just finished a landscape of a grove of olive trees with gray foliage, a bit like that of willow trees, and the violet shadows they cast on the sunlit sand. Then another of a yellowing wheat field enclosed by brambles and green bushes. At the end of the field, a small pink house with a tall, gloomy cypress tree standing out against the distant bluish hills tinged with violet and against a forget-me-not blue sky streaked with pink, the pure tones of which contrast with the scorched ears of wheat, already heavy and in warm tones like the crust on bread.

I have yet another in which a wheat field on a hillside has been completely ravaged and laid flat by the pouring rain and streaming water of a cloudburst.

[17 OR 18 JUNE, 1889]

595

I now have a landscape with olive trees and also a new study of a starry sky.

Although I haven't seen the latest paintings by Gauguin or Bernard, I'm quite convinced that these two studies I've mentioned are similar in feeling.

When you've looked at these studies for some time, and that of the ivy too, you'll perhaps get a better idea than I could manage to put into words of the things that Gauguin, Bernard, and I have sometimes talked about and that have occupied our thoughts; it's not a question of returning to the romantic or to religious ideas—not at all. However, by taking from Delacroix more than may be apparent in terms of color and a drawing style that is spontaneous rather than imitatively precise, it's possible to express a countryside purer in nature than the suburbs and night clubs of Paris.

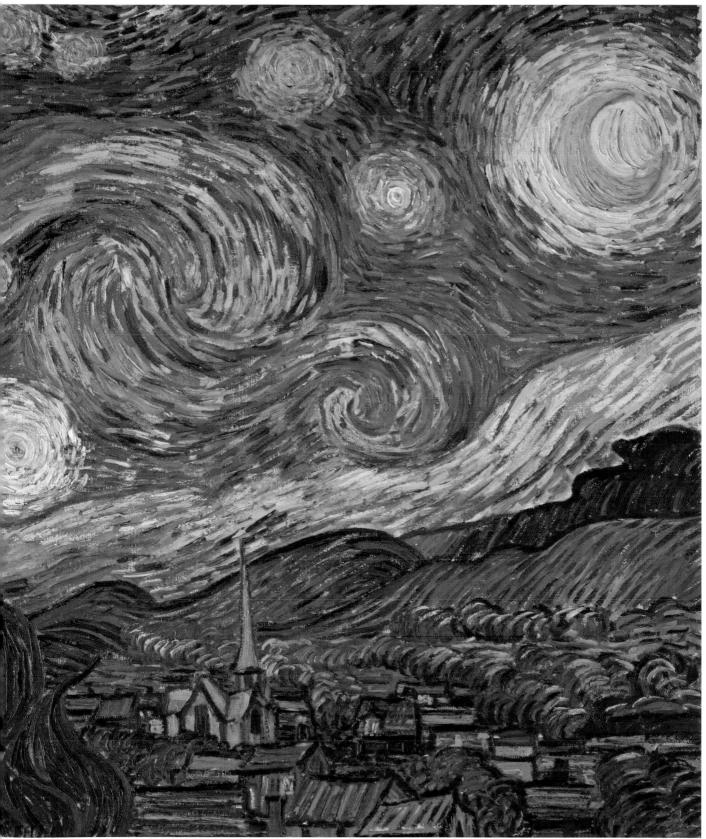

Starry Night

des consolations deurs la compagnie de sa temme ce que est très been vu mais entine pour mon propre usage il ne m'apprend absolument vien our le sens de la vie dans n'importe quel sens. De mon colé se pourrois le souver un peu blasé et m'étonner de ce qu'il are fait impremer de ces vous ce un tirre comme celu et qu'il vende cela à raison de fi 3.50. Enfin po je préfère alphonse l'un touvertre drois parceque c'est un peu plus vivant encon que coà. Il estruis que je suis peut être ingrat n'appréciant même pas l'ablé constantes et autres productions attéraires que cleuminent le voux règne des nais carnot. Il parciel que ce levre a fait grande impression sur no, bonnes souns quel m'en avait de moins parle' mais les bonnes pens mes et les horres cela l'ait deux. J'ai rela avec bien du plaisir Zacheg on la dà au mains le pous aux auteur lant entrevon qu'el que le une jous si b. la la que la vie aut un sens " quoi que en como dans la comenation que les choses de ce monde q'allocient, pas toujours au gré des plus sages l'ourmon je me sais que d'ésirer travailles ici ou alleurs me parad d'abort à peu près la même chire et étant ici y rester le plus simple Teulement des nouvelles à l'écrire cala manque cur les jours sont lous les meines des idées Je'n'en ar pas d'autres que de penser qu'un champ de blé ou un cyprie valent bren la peine de les regarder de pris et ausse de Juile

I'ar un champ de ble hes jaune et très clair pentetre la toute la jelus chance que j'aie tante Les apprès me preoccupent longours je vondrais en lans une chose comme les bolles des loursnes de parceque cela m'élonne et u'an ne les au peus encore fait comme je les vois C'est beau comme legnes et comme projections comme une obelonque eggs transco. Or le vert est d'une qualdé sidnlinguée C'est la tache noire dans un paysage ensolulle mais elle est une des nutes nu ves les jelus interespontes les plus défliciles à laprenjunte que ja jeuns se imagener or il faut les voir ici contre le bleu dans le Vous lave he nature ici comme partout el laut been y atte longlernys. ausi wante pas la note vrais et entine car la lumière dentacent cela: alors Perlarro en parlant his been dans letery, of je suis en core been loin de pouvour lance com me il disait qu'il le laudrait 1 a me perus noturellement plansin en m'em ayant las coulliers de c'est prostable beental mais las surlous la dedans comme la reux dans que cela l'erecute luj. ann, de tu préfères me l'envoyer en deux lois cela est bon austi () () [e crois que des deux locles de cyptes celle dont pe las le croques sera la methem les arbies y sont her grant celle Joint 1 - Join le croques sera la melleure. Les arbies y sont les grands et mas ; s t'avant plan l'es bes de vono, et 6 warfailles Derrecce des collènes Vivlette un cuel yert attore avec un cron fant le lune l'avant plan sur tout ent lies empate des loulles de ronces james à taftels paris Vertals verts. Je l'en en enactes destins avec deux autres des pros of an i'm encora lacks

[25 JUNE, 1889]

596

We've had some fine, warm days, and I've started work on some more paintings, so that now twelve of the thirty canvases are under way. Two studies of cypresses in that difficult shade of bottle green—I've worked the foregrounds in white lead impasto, which brings a firmness to the land.

There's no news to write about, as every day is the same; the only ideas I have are thinking that a wheat field or a cypress tree is really worth looking at closely, and that sort of thing.

I have a wheat field that is very yellow and very bright, perhaps the brightest canvas I have done.

The cypresses continue to occupy my thoughts; I'd like to do something with them like the paintings of the sunflowers, because I'm amazed that they haven't yet been done in the way that I see them.

They have a beauty of line and proportion like that of an Egyptian obelisk.

And the quality of the green is so distinguished.

It's the splash of *black* in a sunny landscape, but one of the most interesting black notes and one of the most difficult to capture precisely that I can imagine.

You have to see them here against the blue, *in* the blue, I should say. To paint nature here, as anywhere, you have to spend a lot of time in it.

I think that of the two canvases of cypresses, the one I've done a sketch of here will be the best. The trees are very tall and solid. The foreground very low with brambles and brushwood. Behind, some violet hills, a green and pink sky with a crescent moon. The foreground in particular is in thick impasto—clumps of brambles with touches of yellow, violet, and green.

Mountain Landscape Seen across the Walls

[2 JULY, 1889]

597

To give you an idea of what I'm doing, today I'm sending you a dozen drawings, all from canvases I'm working on.

The last one I started is the wheat field with a small reaper and a large sun. The canvas is entirely yellow apart from the wall and the background of violet-colored hills. Another canvas, which is almost identical in subject, is different in coloring, being grayish green with a white and blue sky.

I have a canvas of cypresses with some ears of wheat, poppies, and a blue sky that is like some gaudy Scottish plaid; the sky is painted in thick impasto like Monticelli's work and the wheat field with the sun, which shows the extreme heat, also thickly painted....

[EARLY JULY 1889]

598

From the rapid yellowing of the wheat you can see that the sun can sometimes have considerable strength, but the fields at home are immeasurably more beautifully cultivated, more evenly than here, where the rocky ground is in many places unsuitable for most things. Here there are very beautiful fields with olive trees, which are a silvery gray-green, like pollard willows. Then the blue skies don't bore me.

You never see buckwheat and rape here, and on the whole there is perhaps less variety than at home. And I would really so much like to paint a buckwheat field in flower, or oilseed in bloom, or flax, but very likely I will find the opportunity for that later in Normandy or Brittany. Then, too, you never see those mossy roofs on barns or cottages here, as we have them at home, and also no oak coppices, no spurry, and no beech hedges with their red-brown leaves and whitish old trunks crossing each other. Nor any real heather and no birches, which used to be so beautiful in Nuenen.

However, what is beautiful in the South are the vineyards, but they are in the plains or on the hillsides. I have seen them and actually sent Theo a painting, where a vineyard was entirely purple, bright red and yellow and green and violet, like the Virginia creeper in Holland. I am just as pleased to see a vineyard as a field of wheat. And then the hills full of thyme and other aromatic plants are very beautiful here, and because of the clear skies you can see so much further from the heights than at home.

Wheatfield and Cypresses

[6 JULY, 1889]

603

Anyway, while waiting I can't help dabbling about a bit with my pictures. I have one under way of a moonrise over the same field as the sketch in Gauguin's letter, but with ricks in place of the wheat. It's dull ochre yellow and violet. In any case, you'll see it before long. I'm also working on a new one with ivy.

Tree Trunks with Ivy

602, 604†

[3 OR 4 SEPTEMBER, 1889]

602

Yesterday I began working a little again—on something I can see from my window—a field of yellow stubble being plowed, the contrast between the violet of the plowed soil and the strips of yellow stubble, a background of hills.

[5 OR 6 SEPTEMBER, 1889]

604

So I'm working on two portraits of myself at the moment—for want of another model—as it's high time that I did a bit of figure work. One of them I began the first day I got up; I was thin and pale as a devil. It's dark, violet blue and the head is whitish with yellow hair, so it's a color study.

But after that I began a three-quarter length one on a light background.

And I'm also retouching this summer's studies—in fact, I'm working from morning till evening.

I am writing this letter bit by bit in the intervals when I feel weary of painting. Work is going quite well—I'm battling with a canvas I began a few days before becoming ill —a reaper; the study is all in yellow, terribly thickly painted, but the subject was fine and simple. I saw in this reaper—this vague figure struggling like the devil in the midst of the heat to reach the end of his task—I saw in him the image of death, in the sense that mankind could be seen as the wheat he is reaping. It is—if you like—the opposite of the sower that I tried before. But in this death there's nothing sad; it happens in broad daylight with the sun flooding everything with a fine, gold light.

At last—the reaper is finished; I think it will be one that you'll keep at home—it's an image of death as recounted in the great book of nature—but what I was seeking was an "almost smiling" quality. It's all in yellow, apart from a line of violet hills, a pale, fair yellow. I find it odd that I saw it like this from between the iron bars of a cell.

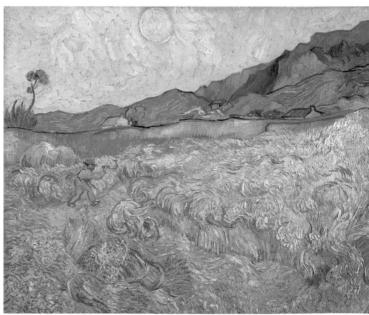

602, 604

Wheatfield with a Reaper

[7 OR 8 SEPTEMBER, 1889] 605

Yes, because I won't conceal from you that just as at present I eat my food with enthusiasm, a terrible desire has also come upon me to see my friends again and to see the countryside of the North once more.

Work is going very well; I'm discovering things for which I've searched in vain for years, and when I realize this I keep thinking of that saying of Delacroix's—you know the one—that he discovered painting only when he had no breath or teeth left.

In any case, please don't bother your head about me—work is going well, and I can't tell you how heartwarming it is at times to tell you that I am going to do this or that—wheat fields, etc. I've done a portrait of the ward attendant, and I have a copy for you. It makes a rather strange contrast with the portrait I did of myself with that vague, veiled gaze, as he has something military about him and small, black, lively eyes.

I made him a present of it, and I'll also paint his wife if she wants to sit. She is a washed-out kind of woman, an unhappy, resigned creature of little consequence and so insignificant that I have a great desire to paint this dusty blade of grass. I've chatted with her a few times when I was doing some olive trees behind their little house, and she told me that she didn't think I was ill—indeed you would say the same right now if you could see me working, my mind clear, my hand so sure that I've drawn Delacroix's *Pietà* without taking a single measurement, even though there are those four hands and arms in the foreground—gestures and postures that are not exactly easy or straightforward to do.

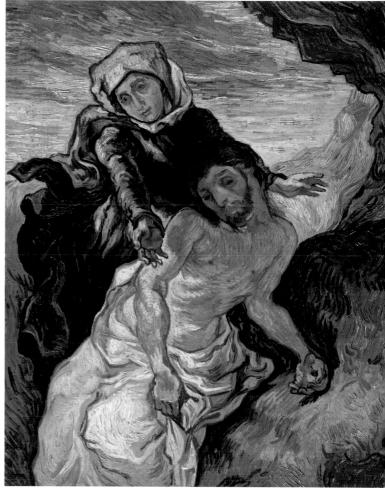

605† Pieta (after Delacroix)

[19 SEPTEMBER, 1889]

Today I'm sending you a portrait of myself; you'll need to look at it for some time—you'll see, I hope, that my face is much calmer, although my gaze is still vaguer than before, it seems to me. I have another that is an attempt I made when I was ill, but I think you'll like the other one better, and I've tried to keep it simple. You could show it to old Pissarro if you see him.

Many thanks for the parcel of canvases and paints. In return I'm sending you [some canvases.]

Personally I rather like the *Entrance to* a *Quarry* that I did when I felt this attack coming on, because, to my taste, the dark greens go well with the ochre tones; there's something sad in it, which is healthy and that's why it doesn't bore me. That's perhaps also true of the *Mountain*. People will tell me that mountains are not like that and that there are black outlines in it as thick as a finger. But in fact, I felt that this expressed the passage in Rod's book—one of the very few passages by him in which I found something good—about a remote area of dark mountains in which the blackish huts of goat herds could be seen and where sunflowers were in bloom.

The *Olive Trees* with a white cloud and background of mountains, and also the *Moonrise* and the *Night Study* are exaggerations in terms of arrangement and the lines are twisted like those in very old wood. The olive trees are truer to nature, as in the other study, and I've tried to express the time of day when you see green rose chafers and cicadas flying about in the heat.

The other canvases—the *Reaper*, etc, are not dry.

And now during the bad weather I shall make plenty of copies because I really ought to do more figure work. It's studying figures that teaches you to grasp the essential and to simplify.

All in all, I can only find a little of value in the Wheat Field, the Mountain, the Orchard, the Olive Trees with the blue hills, the portrait, and the Entrance to a Quarry; the rest says nothing to me because it lacks individual purpose and emotion in the lines. Where the lines are close together and purposeful, that's where it begins to be a picture, even if it's exaggerated. That's a little how Bernard and Gauguin feel—they don't ask for the exact shape of a tree, but they do insist on knowing whether the form is round or square—and, my goodness, they're right, exasperated as they are by some people's inane photographic perfection. They don't ask for the exact tone of the mountains, but they will say: "In God's name, were the mountains blue, then slap on some blue and don't start telling me that it was a blue a bit like this or that, it was blue wasn't it? Good—make them blue and that will do!"

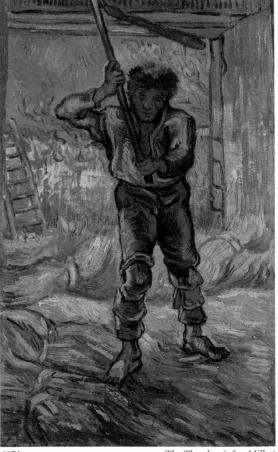

266

The Thresher (after Millet)

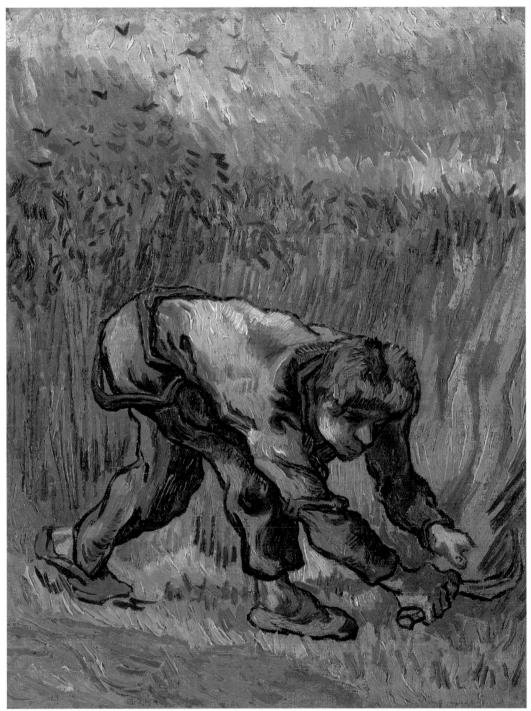

607† The Reaper (after Millet)

607†

The Sheaf-Binder (after Millet)

[28 SEPTEMBER, 1889]

608

Soon I'll send you some smaller canvases with the four or five studies I wanted you to give our mother and sister. These studies are drying at the moment; they're size 10 and 12 canvases, smaller copies of the *Wheat Field, Cypresses, Olive Trees, Reaper*, and *Bedroom* and a small portrait of myself.

That will make a good start for them, and I think that it will give you as well as me some pleasure to ensure that our sister has a small collection of pictures. I shall make some small-format copies of the best canvases for them, and I'd also like them to have the *Red [Vineyard]* and *Green Vineyard*, the pink *Chestnut Trees*, and the *Night Study* that you exhibited.

The olive trees are full of character, and I'm struggling to capture this.

They are silver at times, then blue, then greenish, bronze, fading to white above the soil, which goes from yellow, pink, violet, and orange, to dull, red ocher.

But it's very difficult, very difficult indeed. But that suits me, and working entirely in gold and silver appeals to me. And one day I may perhaps do a personal impression in these colors, like *the sunflowers* are for yellows. If only I'd had some this autumn! But this partial freedom often prevents me from doing what I feel capable of. You'll tell me to be patient, and patience is indeed required.

[5 OCTOBER, 1889]

609

I should tell you that we are having some superb autumn days and I'm making the most of them. I've done a few studies, including a mulberry tree, completely yellow on stony ground, standing out against the blue of the sky.

[CA. 8 OCTOBER, 1889]

610

I've just brought back a canvas I've been working on for some time, again of the same field as the Reaper. At present there are clods of earth and a background of arid land and then the rocks of the Alps. A scrap of bluegreen sky with a small white and violet cloud. In the foreground a thistle and some dry grasses. A peasant dragging along a bundle of straw in the center. Again this is a rough study and instead of being almost entirely yellow, has become a canvas that's almost completely violet. Broken violets and neutral tones. But I'm writing this because I think that it will complement the Reaper and will make clearer what it's about. Because the Reaper looks as if it were done at random, but this one will give it balance. As soon as it's dry, I'll send it to you with the copy of the Bedroom. I beg you, please, if anyone sees these studies, show them together because of the contrast between their complementary colors.

Also, this week I've done the *Entrance to a Quarry*, which has something Japanese about it; you'll remember there are some Japanese drawings of rocks with grass and small trees growing among them here and there. There are moments now and then when nature is superb, with glorious autumn effects, green skies contrasting with yellow, orange and green vegetation, the earth in every tone of violet, the scorched grass among which the rain has brought a final flourish to certain plants, which have come back to life and produced small violet, pink, blue, and yellow flowers. Things one feels quite melancholic about not being able to express.

And the skies—like our skies in the North, but the colors of the sunsets and sunrises more varied and purer. Like in a Jules Dupré or a Ziem.

I also have two views of the gardens and the asylum in which this place looks very attractive. I've tried to reconstruct it as it might have been, simplifying and accentuating the proud, unchanging nature of the pine trees and the clumps of cedar against the blue.

I've copied that *Woman with a Child Sitting by a Hearth* by Madame Dumont Breton, almost entirely in violet. I shall definitely continue making copies; it will give me a collection of my own, and once it's a sufficiently big and reasonably complete I shall give the whole lot to a school.

[CA. 20-22 OCTOBER, 1889]

612

The countryside is very beautiful here in the autumn, with yellow leaves. I am only sorry that there aren't more vineyards here; I have started to paint one, but it is a few hours away. It so happens that a large field turns entirely purple and red, like the Virginia creeper at home, and next to it a square of yellow, and a little further on a patch that is still green. All this under a magnificent blue sky, with lilac rocks in the far distance.

Last year I had a better opportunity to paint that than now. I would have liked to have added something like it to what I am sending you, but I will owe you that until next year.

From the portrait of myself that I enclose, you will see that although I have seen Paris, London, and so many other large cities, and that for many years, I still look more or less like a peasant from Zundert, for instance Toon or Piet Prins, and I sometimes imagine that this is how I also feel and think, only peasants are of more use in the world. Only when people have everything else do they acquire a feeling for, a need for, paintings, books, and so on. So in my own estimation, I count myself definitely below the peasants.

Still, I plod along with my canvases as they do in their fields.

At the moment I am working on a portrait of one of the patients here. It is odd that when you have spent some time with them and have got used to them, you no longer think of them as mad.

612†

Portrait of a Patient in Saint-Paul Hospital

[CA. 2 NOVEMBER, 1889]

613

You've brought me great pleasure sending me those Millets; I'm working on them with zeal. Never seeing any real art had made me slack, but this has reawakened me. I've finished Women Sewing by Lamplight and am working on The Diggers and the man putting on his jacket, size 30 canvases, and a smaller version of The Sower. Women Sewing by Lamplight is in a range of violets and soft lilacs with pale lemon lamplight, the glow of the fire orange, and the man in red ochre. You'll see; it seems to me that painting from Millet's drawings is more like translating them into another language than copying them.

613† Night (after Millet)

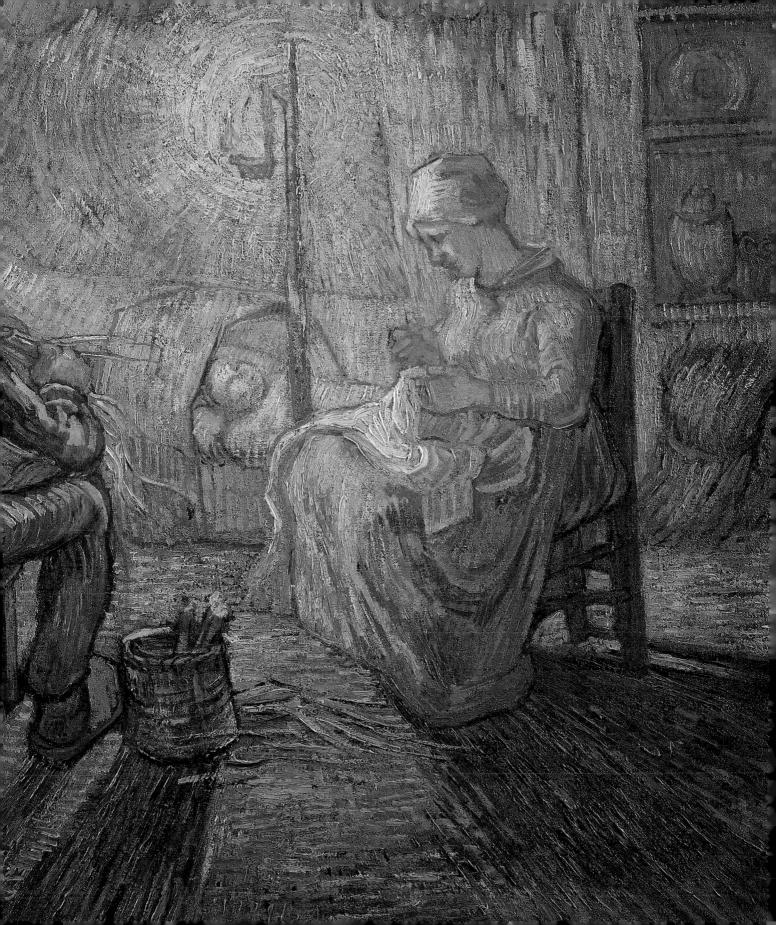

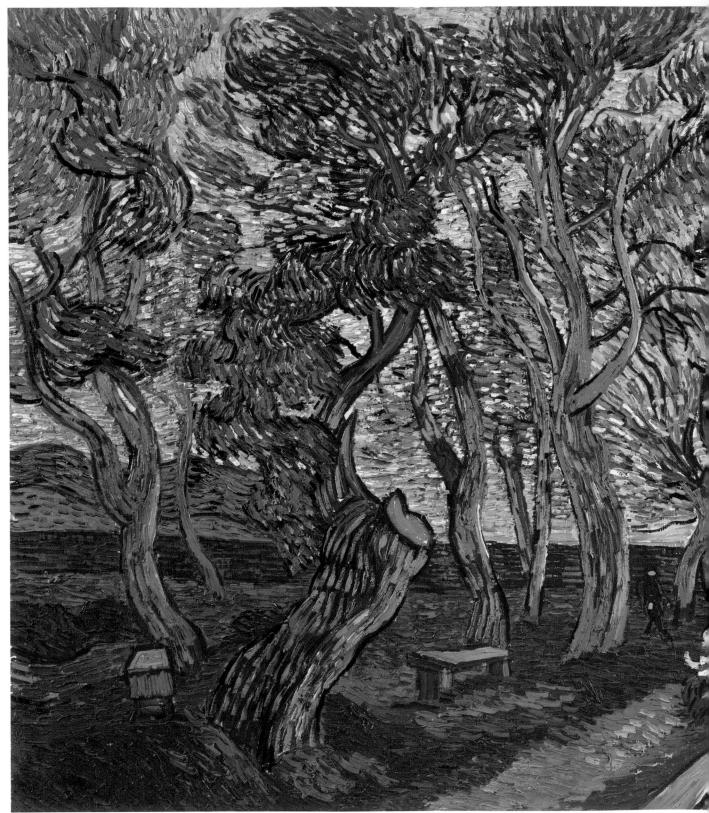

The Garden of Saint-Paul Hospital

[CA. 20 NOVEMBER, 1889]

BERNARD B21

Here's a description of a canvas I have in front of me at the moment. A view of the gardens at the asylum I'm staying in: on the right, a gray terrace, a wall of the building. A few denuded rose bushes; on the left, the ochre-red of the garden soil, the ground scorched by the sun, covered in fallen pine needles. This edge of the garden is planted with tall pine trees with ochre-red trunks and branches and green foliage made dull by mixing in black. These tall trees stand out against an evening sky streaked with violet on a yellow background, the yellow turning to pink higher up, and to green. A wall—again ochre-red—closes off the view with only a violet and ochre-yellow hill rising above it. The first tree is an enormous trunk struck by lightning and sawn down. One side branch, however, soars upwards into the sky and drops back down in an avalanche of dark green needles. This dark giant—like some proud but ravaged being contrasts, when considered in the nature of a living being, with the pale smile of the last withering rose on the bush in front of it. Under the trees, vacant stone benches, gloomy box, the sky reflected—yellow—in a puddle after the rain. A ray of sunlight, the last glimmer of day, lifts the somber ochre almost to orange. Small black figures wander about among the tree trunks.

You'll appreciate that this combination of ochre-red, green made dull with gray, and black lines defining the contours—that all this produces something of that feeling of anguish known as "black-red" often experienced by my companions in misfortune. And for that matter, the subject of a mighty tree struck by lightning and the sickly, green-pink smile of the last flower of autumn serve to confirm this idea.

Another canvas shows the sun rising over a field of young wheat: receding lines, furrows rising high up the canvas towards a wall and a line of lilac hills. The field is violet and yellow green. The white sun is surrounded by a large, yellow halo. Here, in contrast with the other canvas, I've tried to express a sense of calm, a great feeling of peace.

[CA. 21 NOVEMBER, 1889]

615

These days, when it's been bright and cold but with a fine, clear sun, I've been out morning and evening poking around in the orchards and have produced five size 30 canvases that, with the three studies of olive trees you have, constitutes at least an assault on the problem. Olive trees are changeable, like our willows and pollarded trees in the North. As you know, willows are very picturesque despite perhaps seeming monotonous; they are what gives the countryside its character. Here olive trees and cypresses have exactly the same importance as the willow has back home. What I've done is a rather hard and crude realism when compared to their more abstract qualities, but it will give a rustic note and a feel for the region.

615† Olive Trees on a Hillside

[CA. 15 NOVEMBER, 1889]

617

The countryside is very beautiful here in the autumn, I'm working on a picture at the moment: women gathering olives, which might be suitable, I think. These are the colors: the ground is violet and in the distance yellow ochre; the olive trees have bronze trunks and green-gray foliage; the sky is entirely pink and there are three small, pink figures too. All of it in a very restrained range of color.

It's a canvas I've been working on from memory from a study of the same size done on site, because I want something distant, like a vague memory softened by time. There are only two pink and green notes, which harmonize with one another, neutralize each other, and also form a contrast. I shall probably do two or three copies, as it is, after all, the product of half a dozen studies of olive trees.

I'm going to work outside again for a while; the mistral is blowing. Around sunset it usually quiets down a little and then there are some superb effects, with skies of pale lemon and desolate pine trees standing silhouetted against them like exquisite black lace. Sometimes the sky is red, sometimes an extremely delicate neutral tone, or again pale lemon, but neutralized by a delicate lilac.

1889

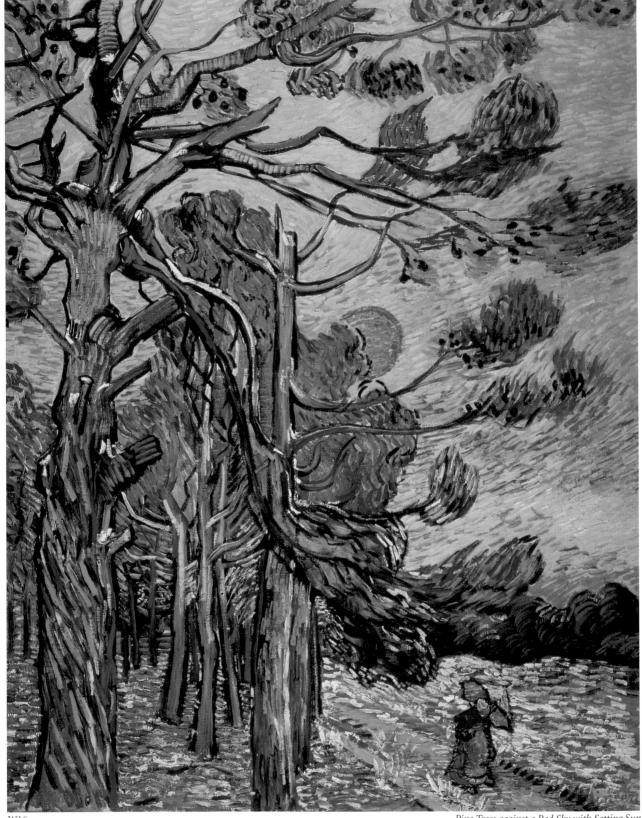

Pine Trees against a Red Sky with Setting Sun

[CA. 10 DECEMBER, 1889]

SISTER W16

The countryside is very beautiful here in the autumn, I have twelve large canvases under way, mainly olive groves, including one with the sky entirely pink, another with a green and orange sky, and a third with a big, yellow sun.

And then some tall, battered pines against a red sky at sunset.

When I was writing this letter I got up to put a few brushstrokes on a canvas I'm working on—in fact, it's the one with the battered pine trees against a red, orange, and yellow sky—yesterday it was very fresh—the tones pure and bright—well, I don't know what came into my head while I was writing and looking at the canvas, but I told myself that it wasn't right. So I took a color that appeared on the palette, a dirty, matte white that you get by mixing white, green, and a little carmine. And I plastered this green tone all over the sky, and at a distance it does indeed soften the tones by breaking them up; and yet it would seem as if one was spoiling the canvas and making it dirty. Isn't this exactly what misfortune and illness do to us and to our health, and are we not better off like this, with the fate that destiny ordains, than serene and in good health by the lights of our own vague ideas and desires of possible happiness?

I cannot tell.

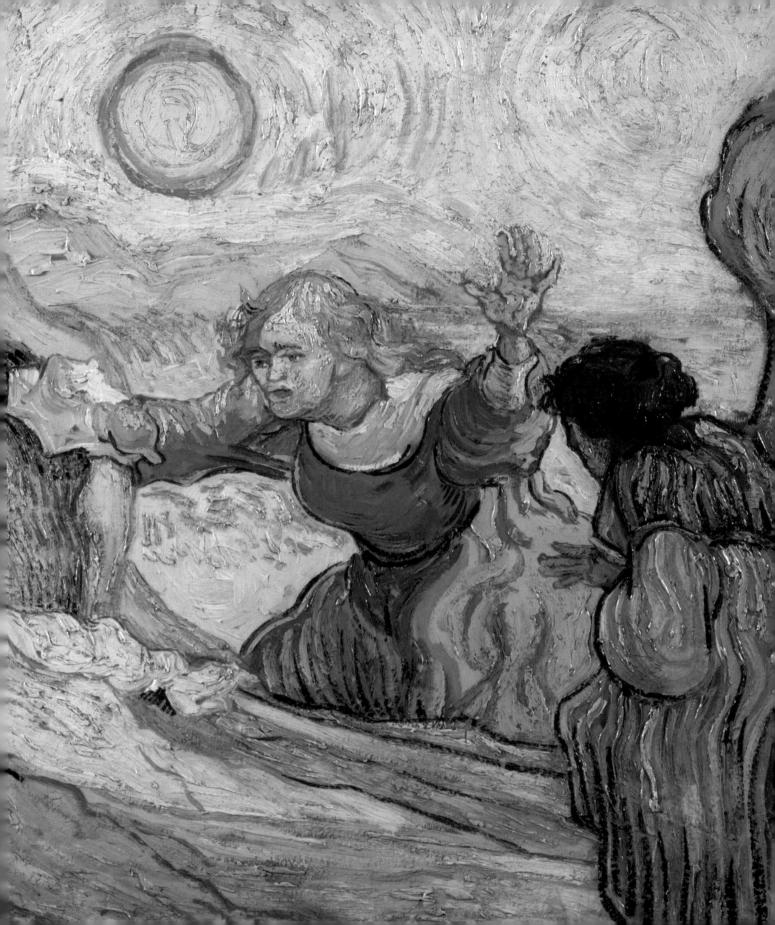

Part VII 1890

and again in January of 1890, van Gogh continued to work during that winter. He also exhibited more paintings in a group exhibition in Brussels, to even greater critical acclaim. One of them was even purchased, the only sale of van Gogh's work during his lifetime.

In late January, Theo's wife gave birth to a son whom they named Vincent. The proud new uncle immediately set to work on a composition of blossoming almond branches for his namesake. But in the midst of this joy, Vincent suffered yet another attack in late February, from which he did not recover until late April.

In late May, Vincent moved yet again, this time to the northern town of Auvers. On his way there, he stopped in nearby Paris to meet his sister-in-law and nephew. In Auvers, he placed himself in the care of Dr. Paul Gachet, a homeopathic physician who had studied nervous disorders in artists.

Van Gogh developed a close friendship with Gachet, an amateur artist himself. Despite several more attacks, van Gogh seemed to respond well to his care. His commitment to nurturing his art remained firm, as evidenced by several compositions in a new, wider format.

During his seventy days in Auvers, van Gogh painted some seventy canvases, an astonishing outpouring of creative energy. In contrast to the bright colors and rich tones of his southern palette, cooler blues and violets dominate the Auvers landscapes. At the same time, his portraits reveal more daring uses of color. Throughout this period of urgent activity, his brushstroke techniques continued on their exuberantly kinesthetic trajectory.

Van Gogh's last letter to his brother betrayed little more than his usual melancholia and even contained his standard request for more supplies. But on July 27, while painting in a wheat field, he shot himself in the chest. Theo rushed to his side, only to witness his brother's death two days later. Vincent van Gogh was thirty-seven years old. Heartbroken, Theo collapsed later that year and died in Holland the following January.

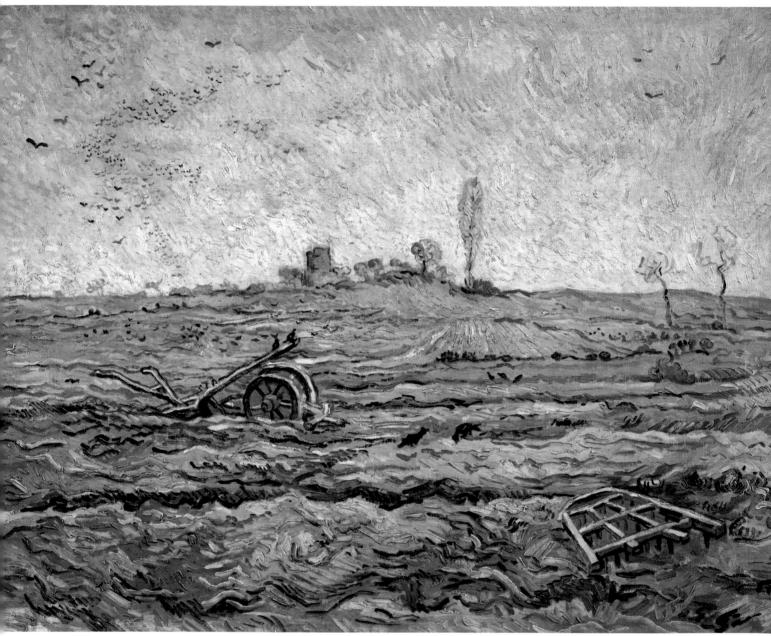

623†

Snow-Covered Field with a Harrow (after Millet)

JANUARY 1890

622

Soon, when the weather isn't too cold, I'll have a chance to go outside, and then I'd really like to try to finish the work I started here.

To give an idea of Provence it's essential to do some more paintings of cypress trees and the mountains.

The Ravine and another painting of the mountains with a road in the foreground are typical of the area.

And particularly the *Ravine*, which I still have here as it's not yet dry. Also the view of the gardens with the pine trees. I've spent a long time studying the character of the pine trees, cypresses, etc., in the pure air of this place—lines that don't change and are found at every step.

[CA. 12–15 JANUARY, 1890]

623

The more I think about, it the more I feel justified in trying to reproduce some of Millet's pieces that he himself did not have time to paint in oil. And then again, working either from his drawings or his wood engravings is not purely and simply copying.

It's more like translating his black and white chiaroscuro impressions into another language—the language of color. I've just finished three more *Hours of the Day* after the wood engravings by Lavieille. It took me a long time and a great deal of trouble. And, as you know, this summer I'd already done *Agricultural Work*. I haven't sent those copies—though you'll see them one day—because they were even more tentative efforts than these ones, but all the same they've been very useful to me for the *Hours of the Day*. Who knows, later I may perhaps be able to make them into lithographs.

These last three [copies of *Hours of the Day*] will take another month to dry, but once you have them you'll see that they've been done out of a very deep and sincere admiration for Millet. And whether they are later criticized or scorned as copies, the fact remains that their justification lies in trying to make Millet's work more accessible to the great general public.

This week I'm going to start work on a field under snow and on Millet's *First Steps*, in the same format as the others. There will then be a series of six canvases, and I can assure you that I've put a great deal of thought into working out the colors for the last three *Hours of the Day*.

[CA. 20 FEBRUARY, 1890]

MOTHER 627

For days I have been meaning to answer your letter, but I did not get around to writing, because I was painting from morning to night and so the time passed. I imagine that you, like me, will be thinking of Jo and Theo a lot; how pleased I was when the message came that everything had gone well; it was a very good thing Wil stayed on. I would have liked it much better if he had called his boy after Pa, of whom I have been thinking so often these days, than after me, but still, as that is the way it is, I have started straight away to do a painting for him to hang in their bedroom: large branches of white almond blossom against a blue sky.

APRIL 1890

628

Work was going well—you'll see that the last canvas of branches in blossom was perhaps the best and most patiently worked one I'd done, painted calmly and with greater certainty of touch. Then the next day I was completely wiped out. It's difficult to understand things like that, but that, alas, is how things are.

[30 APRIL, 1890]

629

I fell ill at the time I was doing the almond blossom. If I'd been able to continue working, you can tell from it that I would have done more trees in blossom. Now the blossom on the trees is almost over, I really have no luck.

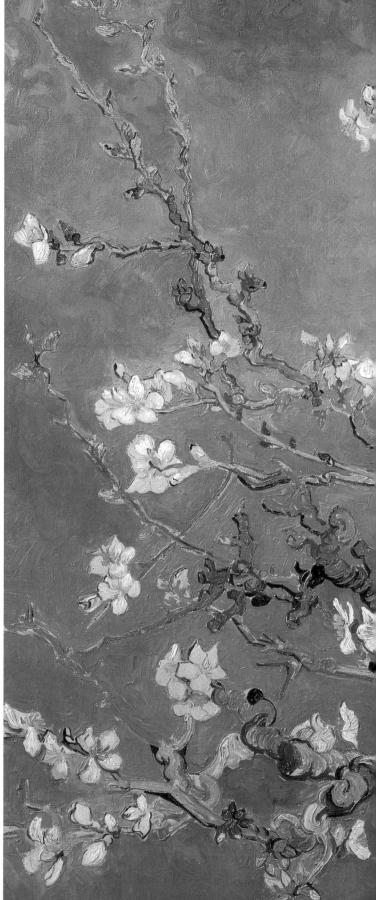

627†, 628†, 629† Almond Blossom

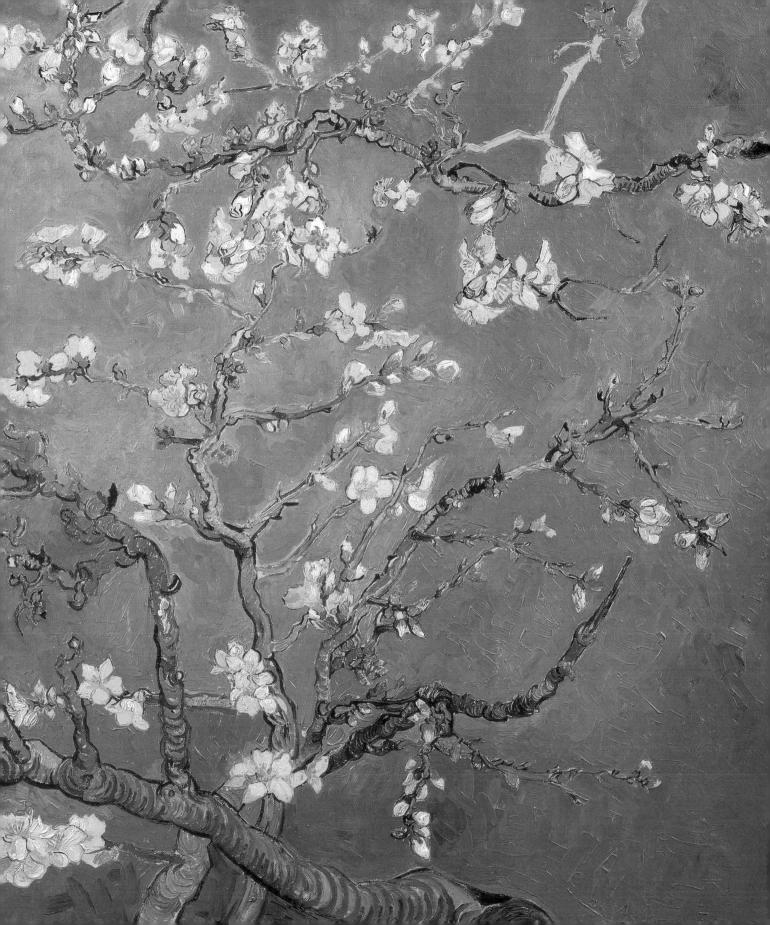

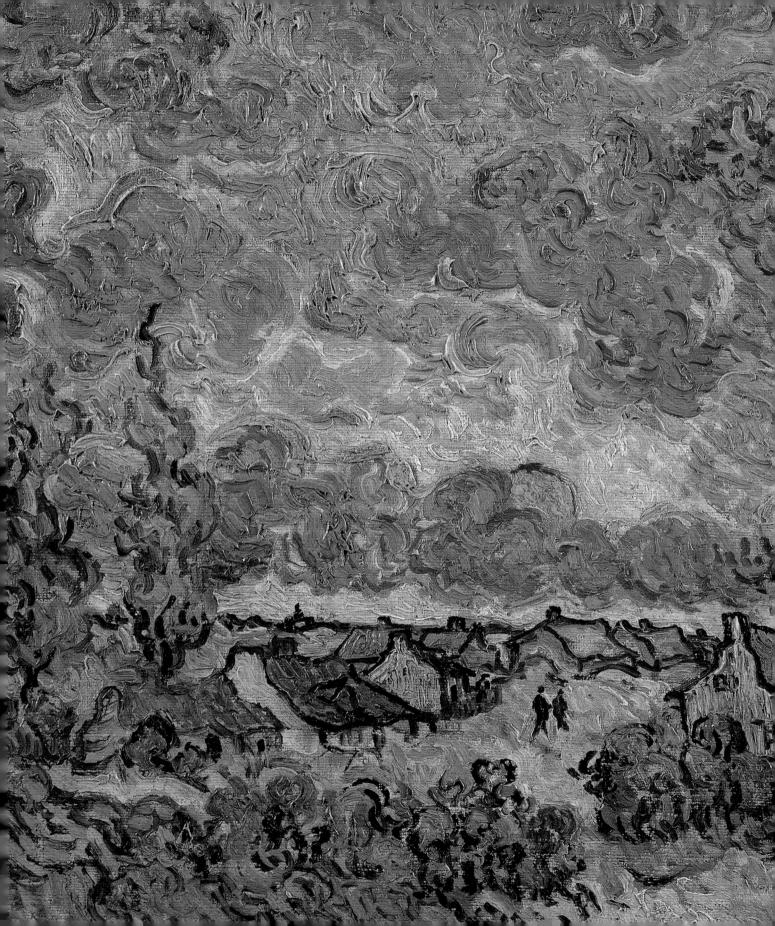

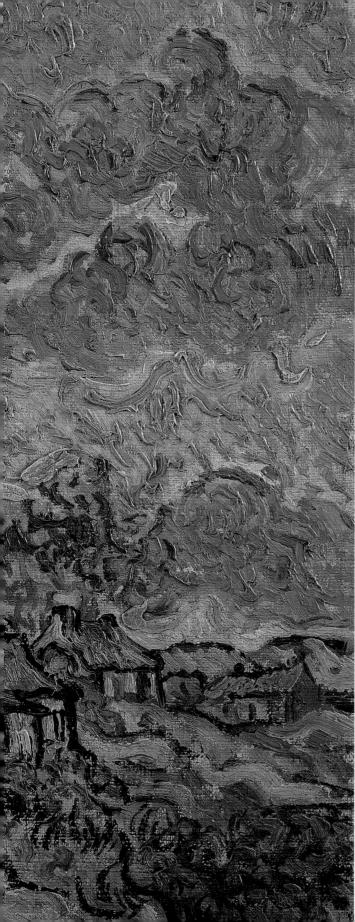

[30 APRIL, 1890]

MOTHER AND SISTER 629A

For the last few days I have been working on a painting of a green field in full sun, with yellow dandelions. And while I was most seriously ill, I still painted, including a souvenir of Brabant, cottages with moss-covered roofs and beech hedges, on an autumn evening with a stormy sky, the sun setting red in russet clouds. Also a turnip field with women picking the foliage in the snow.

629A† Reminiscence of the North

many in evice gue morn aplands as me many many per pas for land se chappin due gueller many per pas for land se chappin due peter but year comme celle gue la chappin due peter but year la for for craire l'aplants sacriface la for for for craire l'aplants sacriface la for for for craire l'aplants sacriface la for for sacriface and la for for craire and and segment and all do sapprossibilité man auns i on a en finitered du de de sacriface and formant par a ficher de past of 2 autre on season formant par a ficher de past of 2 autre mor many parant est loud a changer manche been de changement me for ou le for he have al marche been du par a loud a louds de l'autre franche dans le pare dont d'a consequent me for ou l'action for la la la loud a louds de l'autre franche dans le pare dont d'a consequent me l'aplace de l'autre franche dans le par dont d'a par l'appropriet l'alle l'alle l'appropriet l'

[4 MAY, 1890]

631

Work is going well, I've done two canvases of the fresh grass in the gardens, one of which is extremely simple—here's a quick sketch of it.

The trunk of the pine in violet-pink and the grass with white flowers and dandelions, a small rose tree and more tree trunks in the background at the very top of the canvas.

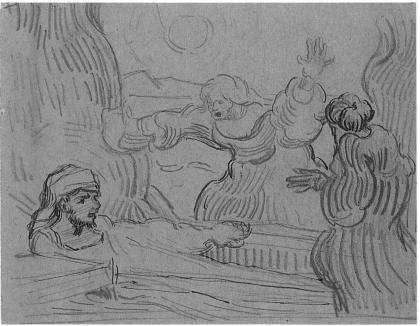

632

631

[3 MAY, 1890]

632

The etchings you sent me are truly beautiful. Opposite I've scribbled a sketch of a painting I've done of three figures who are in the background of the etching of Lazarus: the dead man and his two sisters. The cave and the corpse are violet-yellow-white. The woman removing the handkerchief from the face of the man who has come back to life has a green dress and orange-colored hair, the other woman has black hair and a gown of green and pink stripes. Behind is a countryside of blue hills and a rising yellow sun.

The combination of colors will work in the same way as the chiaroscuro effect of the etching.

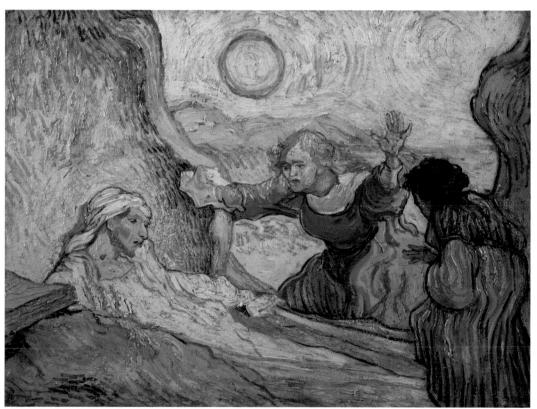

632†

The Raising of Lazarus (after Rembrant)

[11 OR 12 MAY, 1890]

633

I'm working on a canvas of roses on a bright green background and two other canvases of large bunches of violet irises, one against a pink background in which the combination of greens, pinks, and violets creates an harmonious and gentle effect. By contrast, the other violet flowers (ranging to carmine and pure Prussian blue) stand out against a striking lemon yellow background with more yellow tones in the vase and the surface on which it stands, creating an effect of fantastic, ill-assorted complementary colors, the contrast of which is mutually enhancing.

[21 MAY, 1890]

THEO AND JO 636

I now have a study of old thatched roofs with a field of peas in flower in the foreground and some wheat, and with hills in the background—a study I think you'll like. And I can already tell that coming to the South has done me good, helping me to see the North better.

It's as I imagined—I see more violet tones wherever they are. Auvers is decidedly very beautiful.

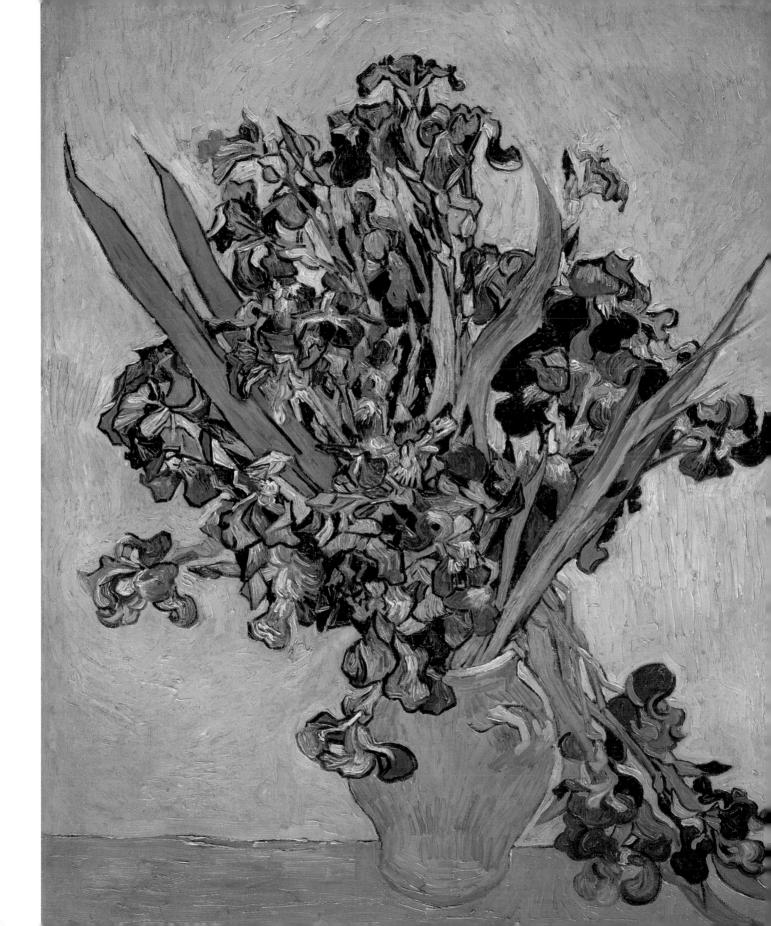

[25 MAY, 1890] THEO AND JO 637

I have a drawing of an old vineyard from which I intend to do a size 30 canvas; also a study of pink chestnut trees and one of white chestnuts. But, if circumstances allow, I hope to get on with some figure work. Pictures come into my mind in a vague way, and it will take time to get them clear, but it will come little by little.

[25 MAY, 1890] Isaäcson* 614A

In the South I've tried to paint some olive groves. I'm sure you're familiar with existing pictures of olive trees. It seems likely to me that there must be some among the work of Monet and Renoir. But apart from this—and though I imagine some must exist, I haven't seen any—apart from this very little has been done with olive trees.

But probably the day is not far away when people will paint olive trees in many different ways, just as they have painted Dutch willows and pollarded willows and just as they have painted the apple trees of Normandy since Daubigny and César de Cocq. The effect of daylight and the sky means that there are endless subjects to be found in olive trees. For myself, I've looked for contrasting

effects in the foliage, which changes with the tones of the sky. At times, when the tree bears its pale blossoms and big blue flies, emerald fruit beetles and cicadas in great numbers fly about, everything is immersed in pure blue. Then, as the bronzer foliage takes on more mature tones, the sky is radiant and streaked with green and orange, and then again, further into autumn, the leaves take on violet tones something like the color of a ripe fig, and this violet effect manifests itself most fully in the contrast with the large, whitening sun within its pale halo of light lemon. Sometimes, too, after a shower I've seen the whole sky pink and light orange, which gave an exquisite value and coloring to the silvery gray-greens. And among all this there were women, also pink, who were gathering the fruit.

These canvases, together with a few studies of flowers, are everything that I've done since we last corresponded. The flowers are an avalanche of roses against a green background and a very large bunch of violet-colored irises against a yellow background and against a pink background.

^{*}Joseph Jacob Isaäcson (1859–1942), a Dutch painter and critic who wrote a positive review of Vincent's work.

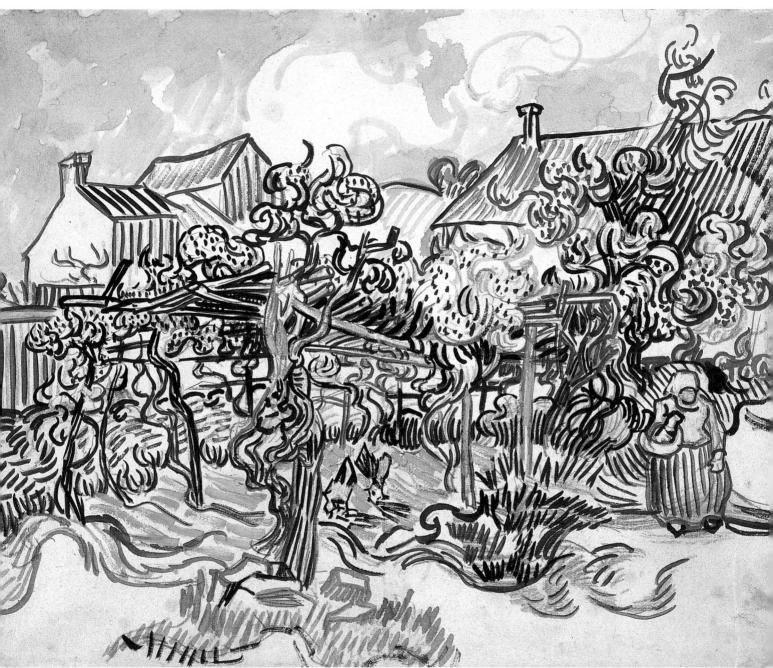

637† Old Vineyard with Peasant Woman

[3 JUNE, 1890]

638

I'm working on his [Dr. Gachet's] portrait—a head with a white cap, very fair, very light, the hands also in light flesh tints, a blue tailcoat and a cobalt blue background, leaning on a red table on which there's a yellow book and a foxglove with purple flowers. It's in the same vein as the self-portrait that I did when I left to come here.

Dr. Gachet is absolutely fanatical about having this portrait and wants me to do one for him, if I can, exactly like it, which is what I'd like to do, too. Also he has now come to understand the last portrait of the woman from Arles, of which you have a version in pink; he keeps going back to these two portraits when he comes here to see the studies and accepts them as they are, entirely as they are.

Dr. Gachet says that he thinks it very unlikely that it [the illness] will return and that everything is going very well.

[CA. 12 JUNE, 1890] SISTER W23

I've done a portrait of Dr. Gachet with a melancholic expression that may well seem like a grimace to those who may look at the canvas. And yet that's what should be painted because, by comparing this with the calmness of older portraits, one realizes how much expression and passion there is in the faces of today, like a kind of expectation, or a certain vintage quality. Sad yet gentle, but clear and intelligent—that's how many portraits ought to be painted.

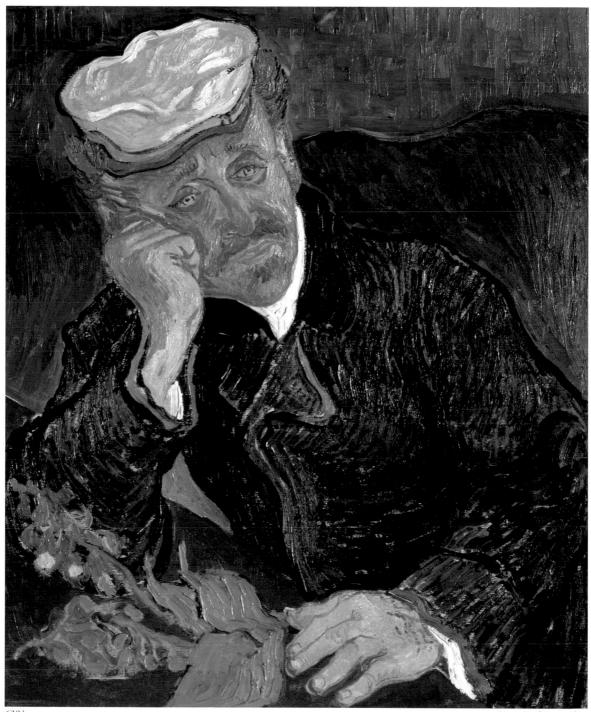

638† Portrait of Dr. Gachet

devand bus sur unitable de jaiden eouge des tornais jaunes est une fleur de dugidale pourpre sombre mon pertrait à mai est prisqu'aussi, armi on ais le bleur est un bleu fin dei missi est le videment est libas dair. Le pertrait d'alleiement est d'unitable est un bleu fin dei missi est le videment est libas dair. Le pertrait d'alleiement est d'un lois de chair incolore est moste les que ca cacauptes à l'ordomplus le telement mois le lond dans l'experiteurs est est au nouve l'une l'able verte aux des les tours verts. Mos dans l'experiteur est est au nouve le l'experiteur en le donné le la mousellere d'une vert d'est d'autourieure le crossère et l'ent vert d'est d'autourieure le crossère et l'ent vert d'est d'ent publishere le constitue et le course de chair anne le l'ent l'est d'ent prime en l'ent l'est prime en l'ent l'est prime en l'ent l'ent prime en l'ent l'ent l'ent prime en l'ent l'ent l'ent prime en l'ent l'ent

[CA. 5 JUNE, 1890]

W 2 2

I have a large picture of the village church. The building has an effect of violet hues against a sky of simple deep blue, pure cobalt. The stained glass windows appear as ultramarine blots, the roof violet and partly orange. In the foreground some green plants are in bloom, and sand with the pink glow of sun on it. Again, it is almost the same as the studies from Nuenen of the old tower and cemetery, but probably the color is now more expressive and sumptuous.

What excites me most—far, far more than any other part of my craft—is portraiture, modern portraiture.

I pursue it through color and am certainly not alone in pursuing it this way. I should like—as you can see I'm a long way from claiming that I shall be able do all this, but that is my aim—I should like to paint portraits that, a century later to the people living then, will seem like apparitions. So I'm not seeking to achieve this through photograph likeness but through the expression of emotions, using our modern knowledge and taste for color as a means of expression and elevation of character. Hence, the portrait of Dr. Gachet shows a face the color of overheated brick, scorched by the sun, with red hair, a white cap surrounded by a background landscape of blue hills; and his clothes are ultramarine blue—this brings out the face and makes it paler despite its brick color. His hands, the hands of an obstetrician, are paler than the face.

In front of him on a red garden table are some yellow novels and a dark purple foxglove. My self-portrait is very similar: the blue is the fine blue of the South and the clothing bright lilac. The portrait of the woman from Arles has a neutral, matte flesh tone, the eyes calm and very simple, the clothes black, the background pink, and she is leaning with her elbows on a green table with green books. But in the version Theo has the clothes are pink, the background white-yellow, and the front of her open bodice is muslin of a white turning to green. Amid all these light colors, the hair, eyelashes, and eyes are the only spots of black.

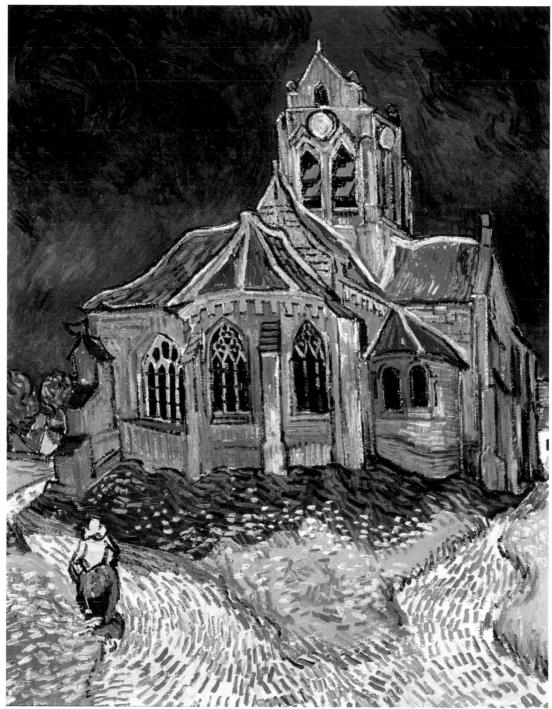

The Church at Auvers

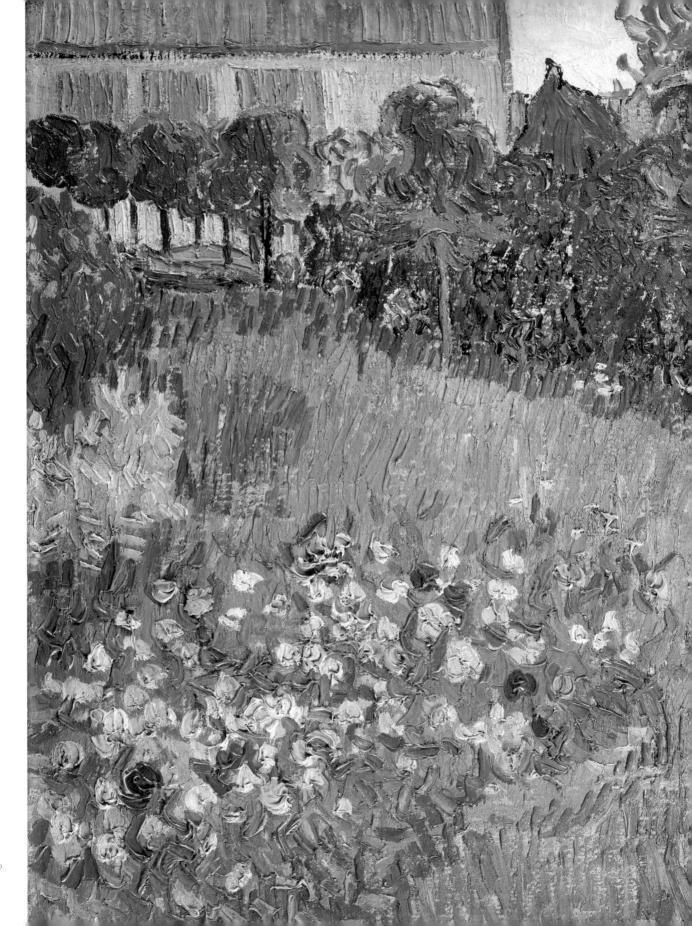

JUNE 17, 1890

642

I've just finished a landscape of a grove of olive trees At the moment I have two studies under way: one a bunch of wild plants—thistles, ears of wheat, and various different leaves. One almost red, another very green, and a third ranging towards yellow.

The second study, a white house among the vegetation, with a star in the night sky, an orange-colored light at the window, black vegetation, and a note of somber pink. That's all for the moment. I have an idea for doing a larger canvas of Daubigny's house* and garden, of which I already have a small study.

^{*}Charles-Francois Daubigny (1817–1878), a French painter whose house in Auvers was still occupied by his widow.

643† Ears of Wheat

JUNE 1890 GAUGUIN 643

I still have a cypress tree with a star from down there, a last attempt—a night sky with a lackluster moon, a slender crescent barely emerging from the opaque shadow cast by the earth—a star of exaggerated brightness if you like, shining soft pink and green in an ultramarine sky with clouds scurrying across. At the bottom a road lined with tall yellow canes, behind them the blue foothills of the Alps, an old inn with windows illuminated orange, and a very tall cypress tree, very straight and very somber.

On the road a yellow carriage drawn by a white horse and two figures out late walking. Very romantic, if you like, but also very typical of Provence.

Here's an idea you might like—I'm trying to do some studies of wheat like this—though I can't draw it—nothing but blue-green stems of wheat, leaves like long green ribbons shot with pink, ears of wheat yellowing slightly, edged with the pale pink of dusty flowers—a pink bindweed at the bottom winding around a stem.

After this, I would like to paint some portraits on a very bright yet tranquil background. Greens of different quality, but of the same value, so that they form one green whole, the vibration of which reminds you of the gentle rustling of wheat as it sways in the breeze; as a color scheme, it's far from easy.

302

Avez vous auste vu les obssess? Maintenant p'us un portrat du De Gachet à caprespour navier de notre temps de vous vouly quelque chore comme vous desce de votrecheist au javour des obveurs pas distuni à être comprime mois enfin là jusque la je vous suis et mon fire soiset been cette nuance.

un deman e par e um aborde un deman e par e la companio some à perse la companio some à perse la companio some à perse la companio some a perse la companio some en la lanca une contra projetir apogra de la lara un contra de la constant de la companio con la constant de la companio con la companio con la companio con la companio de la companio del la companio de la companio del la companio de la companio del la companio de la companio del la

some only man austi pacri, it la file la lite d'action a a greverar à l'eau fort. cette la et d'autres souven pagrager et moly, souvenir, de s'ouvene alors se me ferar une fete per de vous en donner un lout un résume un peu voula et éludie. Mon per del que dayet que fait le léhographies et apres monticelle à trouve trem la léte d'acterierme an guerton

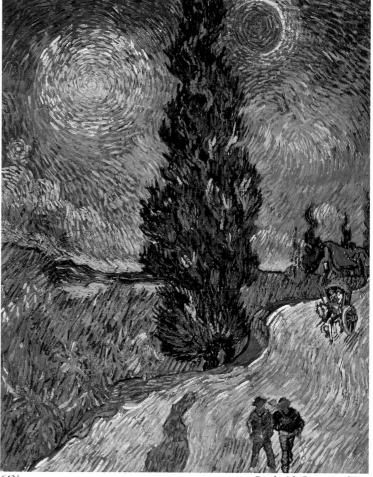

Road with Cypress and Star

643

[24 JUNE, 1890]

644

The canvases from there have now arrived; the irises have dried well, and I like to think that you'll find something in them; there are also some more roses, a wheat field, a small canvas with mountains, and a cypress tree with a star.

This week I've done a portrait of a young girl of sixteen or about that, in blue against a blue background, the daughter of the people I'm lodging with. I gave this portrait to her, but I've done a version for you, a size 15 canvas.

Also, I have a canvas one meter long by only fifty centimeters high of wheat fields and a matching pendant of a forest interior with the lilac trunks of poplar trees and below them grass with flowers in pink, yellow, white and various greens. It's an evening study—two pear trees completely black against a yellowing sky with wheat, and in the violet background the château enclosed by the dark vegetation.

644†

Landscape with the Chateau of Auvers at Sunset

[28 JUNE, 1890]

645

Yesterday and the day before I painted a portrait of Mademoiselle Gachet, which I hope you'll soon see; the dress is pink, the wall in the background green with orange spots, the carpet red with green spots, and the piano dark violet; it's one meter high and fifty centimeters wide.

It's a figure I enjoyed painting—but difficult to do. He has promised to have her pose again with a small organ. I'll do one for you—I've noticed that this canvas goes very well with another horizontal one of wheat, as one is vertical and pink and the other is pale green and yellow-green that are complementary to the pink; but we're still a long way from people understanding the curious relationships that exist between one piece of nature and another and that are mutually explanatory and mutually enhancing.

But there are those who certainly do feel it, and that's already something. And one good thing is that with the combinations of pretty, light-colored clothing people wear, if one could get people passing by to pose and do their portraits, it would be just as attractive as any period in the past.

[2 JULY, 1890]

Theo and jo 646

Here are three sketches—one of a peasant woman with a big yellow hat and a bow of sky blue ribbon, her face very red, a deep blue blouse with orange spots, and a background of ears of wheat.

It's a size 30 canvas, but it's a bit rough, I'm afraid.

Then there's the horizontal landscape with fields, a subject like one of Michel's, but the coloring is soft green, yellow, and blue-green.

Then a forest interior with violet poplar trunks that run perpendicularly through the landscape like columns; the depths of the forest are blue and under the tall trunks is a flowery meadow of white, pink, yellow, and green, with tall grasses turning russet, and flowers.

646

645† Marguerite Gachet at the Piano

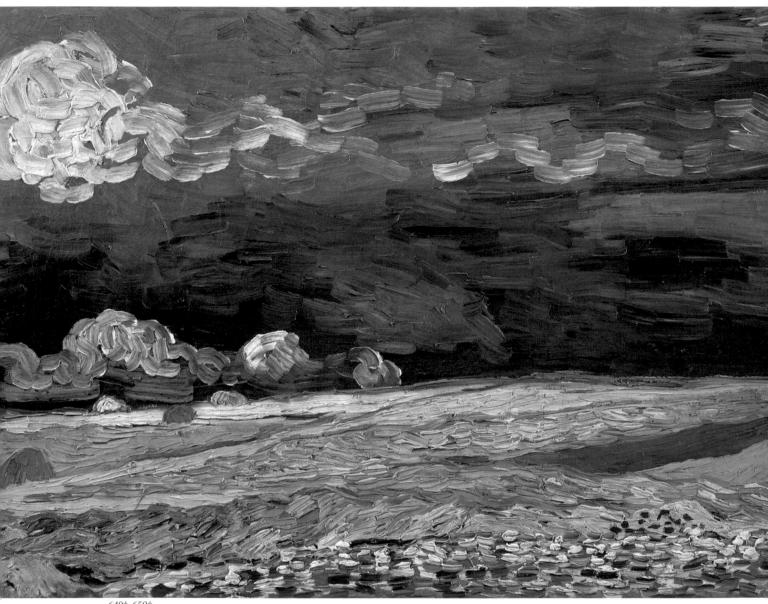

649†, 650†

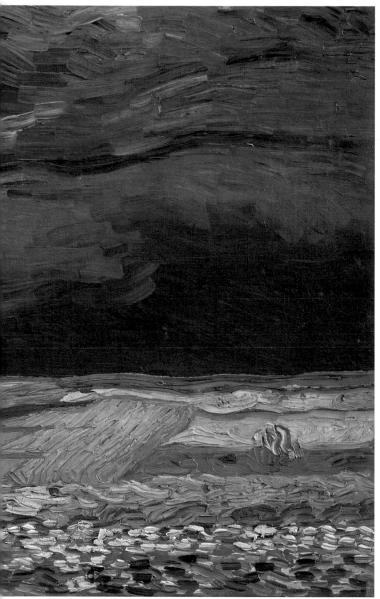

Wheat Field under Thunderclouds

[CA. 10 JULY, 1890]

BROTHER AND SISTER 649

So—once back here I set to work again—though the brush was almost slipping from my fingers, but I knew what I wanted to do, and I've painted three more large canvases since then.

They are of vast expanses of wheat under stormy skies, and I had little trouble in conveying the sense of sadness and extreme solitude. You'll see that shortly, I hope—as I hope to bring them to you in Paris as soon as possible, because I somehow believe that these canvases will tell you what I can't put into words, what I find healthy and invigorating about the countryside.

The third canvas is Daubigny's garden, a picture I've been thinking about ever since I came here.

JULY 1890

BROTHER AND SISTER 650

I myself have been completely absorbed by that endless plain with fields of wheat against the hills, as vast as a sea, delicate yellow, delicate soft green, the delicate purple of a turned-over and weeded piece of ground, speckled regularly with the green of flowering potato plants, all this under a sky of delicate blue, white, pink, and violet hues.

I am altogether in a mood of almost too great composure, in a mood to paint this.

[23 JULY 1890]

651

Perhaps you'd like to look at this sketch of Daubigny's garden—it's one of my most deliberate canvases. I'm also enclosing a sketch of old stubble fields and sketches of two size 30 canvases of vast stretches of wheat after the rain.

Daubigny's garden, the foreground green and pink grass. On the left a green and lilac bush and a low shrub with whitish leaves. In the center a bed of roses, on the right a wicket gate, a wall, and above the wall a hazel tree with violet foliage. Then a hedge of lilacs, a row of rounded, yellow linden trees, the house itself in the background, pink with bluish roof tiles. A bench and three chairs, a black figure with a yellow hat, and in the foreground, a black cat. The sky pale green.

Daybigay's Garden with Black Cat

651

651

[24 JULY 1890]*

652

And to be honest, it is only through our pictures that we can speak. And yet, dear brother, there's still what I've always told you and I'll say it once again with all the seriousness that the efforts of a mind diligently set on seeking to do as well as it possibly can is capable of expressing—I tell you again that I shall always consider you to be other than a mere dealer in Corots, that through me you have your part to play in the actual production of certain canvases, which even in the midst of this disaster retain their calm.

For that's where we are, and that is all or at least the main thing I have to tell you at this moment of relative crisis. At a moment when things are very fraught among those dealing in pictures by artists both living and dead.

As for my own work, I risk my life for it and my sanity is half shot away because of it—fine—but you're not one of those dealers in men as far as I know, and you can choose the side you're on, it seems to me, and act with genuine humanity, but what's to be done?

^{*}This letter was an unfinished draft of letter 251. It was found on Vincent's body when he died on 27 July.

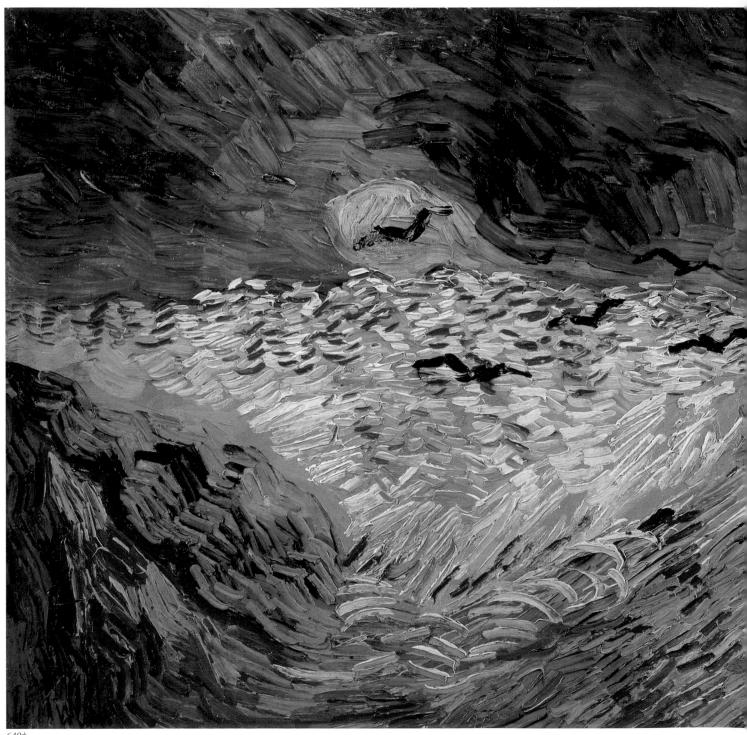

649†

Wheat Field with Crows

BIBLIOGRAPHY

Alley, Ronald. Catalogue of the Tate Gallery's Collection of Modern Art Other than Works by British Artists. London, 1981.

Baer, Ann. A Catalogue of Marées Gesellschaft and Ganymed Press Facsimiles. London, 1994.

Bailey, Martin. "KGB's Secret Store of Looted Old Masters." *The Observer* (London), September 20, 1992.

Bargue, Charles. Exercices au fusain, pour préparer à l'étude de l'Académie d'après nature. Paris. 1871.

Barnett, Vivian Endicott. *The Guggenheim Museum, Justin K. Thannhauser Collection*. New York: Solomon R. Guggenheim Museum, 1978.

Bernard, Émile. "Vincent van Gogh." *Leshommes d'aujourd'hui* 8, no. 390 (1891). Published in translation in Stein 1986, pp. 282–85.

Bernard, Émile. "Vincent van Gogh." *La plume*, September 1, 1891. Published in translation in Stein 1986, p. 282.

Blanc, Charles. Grammaire des arts du dessin: Architecture, sculpture, peinture. Paris, 1867.

Bremmer, H. P. ed. Beeldende Kunst 5 (1917-18), vol. 2.

Bremmer, H. P. ed. Beeldende Kunst 11 (1923-24), vol. 4.

Bremmer, H. P. ed. Beeldende Kunst 13 (1926), vols. 8, 11.

Bremmer, H. P. Catalogus van de schilderijen verzameling van Mevr. H. Kröller-Müller. The Hague, [1917].

Bremmer, H. P. ed. Moderne kunstwerken: Schilderijen, teekeningen en beeldhouwwerken 2 (1904), vol. 10.

Bremmer, H. P. ed. Moderne kunstwerken: Schilderijen, teekeningen en beeldhouwwerken 8 (1910), vol. 11.

Bremmer, H. P. Vincent van Gogh: Inleidende beschouwingen. Amsterdam,

Bremmer, H. P. Vincent van Gogh: Reproducties naar zijn werken in de verzameling van Mevrouw H. Kröller-Müller. The Hague, 1919.

Bremmer, H. P. Verzameling van Mevrouw H. Kröller-Müller, The Hague. 2 vols. The Hague, 1921–28.

"Brieven en Platten van Vincent van Gogh." *Van nu en straks*, no. 3 (1893). Contributions by Henry van de Velde, Richard N. Roland-Holst, Jan Toorop, Johan Thorn Prikker, et al.

Bromig-Kolleritz von Novisancz, Katharina. "Die Selbstbildnisse Vincent van Goghs: Versuch einer kunsthistorischen Erfassung der Darstellungen." Ph.D. dissertation, Garmisch. Munich, 1954.

Carroy, Christian. "Een panoramalandschap van Van Gogh." Bulletin van het Rijksmuseum 10, no. 4 (1962), pp. 139–42.

Cassagne, Armand. Abécédaire du dessin/Abecedary of Drawing. Ser. 7 of Le dessin pour tous: Cahiers d'exercices élémentaires et progressifs. Paris and London, [186–?].

Cassagne, Armand. Guide de l'alphabet du dessin ou l'art d'apprendre et d'enseigner les principles rationnels du dessin d'après nature. Paris, 1880.

Cassagne, Armand. Guide pratique pout les différents genres de dessin:

Dessin à la mine de plomb;—au crayon noir dit Conté;—à la sanguine;—au fusain;—à la plume;—au lavis;—à la sépia; à la plume, relevé de couleur. Paris, 1873.

Cassagne, Armand. Traité d'aquarelle Paris, 1875.

Cassagne, Armand. Traité pratique de perspective. Paris, 1879.

Catalogus Schilderijen van, teekeningen en beelden in het Stedelijk Museum bijeengebracht door de "Vereeniging tot het Vormen van eene Openbare Verzameling van Hedendaagsche Kunst" te Amsterdam. Amsterdam, 1914.

Chetham, Charles. *The Role of Vincent van Gogh's Copies in the Development of His Art*. New York and London, 1976.

Cohen-Gosschalk, Johan. "Vincent van Gogh." Zeitschrift für bildende Kunst 43, no. 9 (1908), pp. 225–35.

Cooper, Douglas. *Drawings and Water-colours* [by Vincent van Gogh]: *A Selection of 32 Plates in Colour*. With an essay by Hugo Hofmannsthal. New York, 1955.

Cooper, Douglas. "The Yellow House". In *Van Gogh in Perspective*, edited by Bogomila Welsh-Ovcharov, pp. 149–55. Englewood Cliffs, N.J., 1974.

Daloze, Marcel. "La découverte de l'oeuvre et de la personalité de Van Gogh en Belgique (1890–1914). "Doctoral dissertation, Université de Liège, 1982.

Davis, Bruce. *Master Drawings in the Los Angeles County Museum of Art*. Los Angeles: Los Angeles County Museum of Art, 1997.

De Brouwer, Tor. De oude toren en Van Gogh in Nuenen. Venlo, 2000.

De la Faille, J.–B. *L'oeuvre de Vincent van Gogh: Catalogue raisonne.* 4 vols. Paris and Brussels, 1928.

De la Faille, J.–B. *The Works of Vincent van Gogh: His Paintings and Drawings*. Rev. ed. Amsterdam, 1970.

De la Faille, J.-B. *Vincent van Gogh: The Complete Works on Paper. Catalogue Raisonné.* 2. vols. Reprint of De la Faille 1928, vol. 3 and a rev. suppl. ed of the portion of 1970 concerning works on paper. San Francisco, 1992.

Dijk Wout, J. and Meent W. van der Sluis. De Drentse tijd van Vincent van Gogh: Een onderbelichte periode nader onderzocht. Groningen, 2001.

Dorn, Ronald. "Als Zeichner unter Malern: Vincent van Gogh in Den Haag, 1881–1883." In John Sillevis et al., *Die Haager Schule: Meisterwerke der holländischen Malerei des 19. Jahrhunderts aus Haags Gemeentemuseum*, pp. 58–80. Exh. cat. Mannheim: Kunsthalle Mannheim, 1987.

Dorn, Ronald. "Refiler à Saintes-Maries?": Pickvance and Hulsker Revisited." Van Gogh Museum Journal 1997–98, pp. 15–25.

Dorn, Ronald. "Vincent van Gogh Soir d'été, 1888." In Van Gogh, Van Doesburg, de Chirico, Picasso, Guston, Weiner, Mangold, Richter: Texte zu Werken im Kunstmuseum Winterthur, edited by Dieter Schwarz, pp. 11–41. Düsseldorf and Winterthur, 1999.

Douwes, Willem F. Vincent van Gogh. Amsterdam, [1930].

Drawings by Vincent van Gogh in teh Kröller-Müller Museum. Otterlo, 2006. Forthcoming.

Du Quesne-Van Gogh, E. H. Persönliche Erinnerungen an Vincent van Gogh. 2nd ed. Munich, 1911.

Elderfield, John. The Modern Drawing: 100 Works on Paper from the Museum of Modern Art. New York, 1983.

Elgar, Frank. Van Gogh. Paris, 1958.

Erpel, Fritz. Van Gogh: The Self-Portraits Oxford, 1964.

Feilchenfeldt, Walter. with a catalogue of the drawings complied by Han Veenenbos. Vincent van Gogh and Paul Cassirer, Berlin: The Reception of Van Gogh in Germany from 1901 to 1914. Cahier Vincent, no.2. Zwolle, 1988.

Fels, Florent. Vincent van Gogh. Paris, 1928.

Findhammer, Joost. "Wat is er over van het landschap ten tijde van Van Gogh?" De Drijehornickels 11, no. 1 (April 2002), pp. 17–24.

Francis. "Exposition Van Gogh chez Le Barc de Boutteville." *La vie moderne*, April 24, 1892. Published in translation in Stein 1986, p.294.

Gans, L. "Twee onbekende tekeningen uit Van Gogh's Hollandse Periode." *Museumjournaal* 7, no 2. (July 1961), pp. 33–34.

Gauguin, Paul. "Vincent van Gogh." Kunst und Kunstler 8 (1910), p.581.

Gaunt, William. "Van Gogh: The Man in His Time." *Artnews Annual* 19 (1950), pp. 51–64.

Hagen, Oskar. Vincent van Gogh: Faksimiles nach Zeichnungen und Aquarellen. Munich, 1919.

Hansen, Dorothee. "Outside Arles: Harvest in Provence, 1888". In Bremen 2002–3, pp.110–33.

Havelaar, Just. Vincent van Gogh. Amsterdam, [1915].

Heenk, Elizabeth Nicoline. "Vincent van Gogh's Drawings: An Analysis of Their Production and Uses". 2 vols. Ph.D. dissertation, Courtauld Institute of Art, University of London, 1995.

Heenk, Liesbeth. "Revealing Van Gogh: An Examination of His Papers". *Paper Conservator* 18 (1994), pp. 30–39.

Hulsker, Jan. The Complete Van Gogh: Paintings, Drawings, Sketches. New York, 1980.

Hulsker, Jan. "The Houses Where Van Gogh Lived in The Hague". Vincent: Bulletin of the Rijksmuseum Vincent van Gogh 1, no.1 (1970), pp.2–13

Hulsker, Jan. *The New Complete Van Gogh: Paintings, Drawings, Sketches.* Rev. ed. Amsterdam and Philadelphia, 1996.

Hulsker, Jan. "The Poet's Garden". Vincent: Bulletin of the Rijksmuseum Vincent van Gogh 3, no. 1 (1974), pp.22–32.

Hulsker, Jan. "Van Gogh's First and Only Commission as an Artist". Vincent: Bulletin of the Rijksmuseum Vincent van Gogh 4, no. 4 (1976), pp.5–19.

Hulsker, Jan. Vincent van Gogh: A Guide to His Work and Letters. Amsterdam, 1993.

Joosten, E.J. "Gezicht uit het hospitaal Saint Paul". Verslag van de Vereniging Rembrandt 1970, pp. 31–32.

Joosten, J.M. "Deel 5: Het vervolg van de besprekingen van de Amsterdamse keuze-tentoonstelling van vroege tekeningen bij de kunsthandel Oldenzeel te Rotterdam en de Van Gogh tentoonstelling in het Panorama-gebouw te Amsterdam." *Museumjournaal* 15, no. 2 (1970), pp. 100–103.

Kerstens, C. Piet Kaufmann: Van Gogh's Model. d?Hûskes, no. 19. Etten-Leur. 1990.

Knapp, Fritz. Vincent van Gogh. Bielefeld and Leipzig, 1930.

Ködera, Tsukasa, "Van Gogh's Utopian Japonisme." In van Rappard-Boon, Van Gulik, and Van Bremen-lto 1991, pp. 11–45.

Ködera, Tsukasa. Vincent van Gogh: Christianity versus Nature. Oculi, vol. 3. Amsterdam and Philadelphia, 1990.

Ködera, Tsukasa, ed.; Yvette Rosenberg, ed. for English. *The Mythology of Vincent van Gogh.* Tokyo, 1993.

Komanecky, Michael K. "Vue d'Ales (View of Arles)". In Selection V: French Watercolors and Drawings from the Museum's Collection, ca. 1800–1910, pp. 83–87. Exh. cat. Providence: Museum of Art, Rhode Island School of Design, 1975.

Konheim Kramer, Linda, Karyn Zieve and Sarah Faunce. French Nineteenth-Century Drawings and Watercolors at the Brooklyn Museum. New York, 1993.

Kress, Annelise. "Vincent van Gogh's 'Reality". Vincent: Bulletin of the Rijksmuseum Vincent van Gogh 2, no. 4 (1973), pp. 8–21.

Kruel, Andreas ed. and Anne Röver-kann. A Catalogue of the Works of Art from the Collection of the Kunsthalle Bremen Lost during Evacuation in the Second World War. 2nd ed. Bremen, 1997.

Larsson, Håkan. Flames from the South: On the Introduction of Vincent van Gogh to Sweden. Eslöv, 1996.

Leprohon, Pierre. Vincent van Gogh. Paris, 1972.

Lettres de Vincent van Gogh à Émile Bernard publiées par Ambroise Vollard. Paris, 1911.

Leurs, Stan and Edo Tralbaut, Mark. "De verdwenen kerk van Nuenen. Door Vincent van Gogh levend gebleven in de herinnering". *Brabantia*, February 1, 1957, pp. 29–68.

Leymarie, Jean. VanGogh. Paris, 1951.

Leymarie, Jean. Qui était Van Gogh? Geneva, 1968.

Lugt, Fritz. Les marques de collections de dessins et d'estampes....Amsterdam, 1921. Supplément. The Hague, 1956.

Luijten, Hans. "Rummaging among My Woodcuts': Van Gogh and the Graphic Arts." In *Vincent's Choice: The Musée Imaginaire of Van Gogh*, edited by Chris Stolwijk et al., pp. 110–12. Exh. cat. Amsterdam: Van Gogh Museum, 2003.

Martin, Kurt. Die Tschudi-Spende: Hugo von Tschudi zum Gedächtnis, 7. Februar 1851–26 November 1911. Munich, 1962.

Mauclair, Camille [Séverin Faust]. "Galerie Le Barc de Boutteville". *La revue indépendante* 23 (April 1892). Quoted in translation in Stein 1986, pp. 294, 303.

Meier-Graefe, Julius. Vincent van Gogh. 3rd ed. Munich, 1910.

Meier-Graefe, Julius. Vincent. 2 vols. Munich, 1921.

Meier-Graefe, Julius. Vincent van Gogh der Zeichner. Berlin, 1928.

Meier-Graefe, Julius. Vincent van Gogh: Faksimiles nach Aquarellen und Zeichnungen. Munich, 1928.

Millard, Charles W. "A Chronology for Van Gogh's Drawings of 1888." Master Drawings 12, no. 2 (Summer 1974), pp. 156–65.

Mothe, Alain. Commentary to Les 70 jours de Van Gogh à Auvers: Essai d'éphéméride dans le décor de l'époque (20 mai-30 juillet 1890), d?après les lettres, documents, souvenirs et déductions, Auvers-sur-Oise, by Paul Gachet. Paris, 1994.

Mothe, Alain. Vincent van Gogh à Auverssur-Oise. Paris, 1987.

Murray, Ann. "'Strange and Subtle Perspective...ä: Van Gogh, The Hague School, and the Dutch Landscape Tradition". *Art History 3*, no. 4 (December 1980), pp. 410–24.

Museum of Fine Arts, Boston. Illustrated Handbook. Boston, 1976.

Nijland, J. Hidde. Vincent van Gogh: 100 teekening van uit de verzameling Hidde Nijland in het Museum te Dordrecht. Amsterdam: W. Versluys, 1905. Published in conjunction with Dordrecht 1905.

Novotny, Fritz. "Van Gogh's teekeningen van het Straatje te Saintes-Maries". Maandblad voor beeldende Kunsten, December 1936, pp.370–80.

Novotny, Fritz. "Reflections on a Drawing by Van Gogh: *Tile Factory Near Arles*". Translated by Marguerite Kay. *Art Bulletin* 35 (March 1953), pp. 35–43.

Op de Coul, Martha. "The Entrance to the 'Bank van Leening' (Pawnshop)". Vincent: Bulletin of the Rijksmuseum Vincent van Gogh 4, no.2 (1975), pp. 28–30.

Op de Coul, Martha. "De toegang tot de 'Bank van Leening' in Den Haag, getekend door Vincent van Gogh". *Oud Holland* 90, no. 1 (1976), pp. 65-68

Op de Coul, Martha. "Een mannenfiguur in 1882 door Vincent van Gogh getekend". Oud Holland 97, no.3 (1983), pp. 196–200.

Op de Coul, Martha. "In Search of Van Gogh's Nuenen Studio: The Oldenzeel Exhibitions of 1903". *Van Gogh Museum Journal* 2002, pp. 104–19.

Passantino, Erika D, ed. *The Phillips Collection: A Summary Catalogue*. Washington, 1985.

Pataky, Dénes. Master Drawings from the Collection of the Budapest Museum of Fine Arts: 19th and 20th Centuries. New York, 1959.

Paul, Barbara. Hugo von Tschudi und die moderne französische Kunst im Deutschen kaiserreich. Mainz am Rhein, 1993.

Pfister, Kurt. Van Gogh. Potsdam, 1922.

Pickvance, Ronald. "Vincent van Gogh: La Maison de Vincent à Arles." Offprint of Impressionist and Modern Art, lot 52. Sale cat. London: Christie's, June 24, 2003.

Pickvance, Ronald Van Gogh in Arles. New york, 1984.

Pickvance, Ronald Van Gogh in Saint-Rémy and Auvers. New york, 1986.

Pierre, Richard. "Vincent van Gogh's Montmartre." Jong Holland 4, no. 1 (1988), pp. 16–21.

Pion, Léonce, with Irène Pion-Leblanc. Catalogue du Musée des Beaux-Arts de Tournai. Tournai, 1971.

Plasschaert Albert. Vincent van Gogh. The Hague, 1898. Published in conjunction with The Hague 1898.

Pollock, Griselda. "Vincent van Gogh and Dutch Art: A Study of the Development of Van Gogh's Notion of Modern Art with Special Reference to the Critical and Artistic Revival of Seventeenth Century Dutch Art in Holland and France in the Nineteenth Century." 2 vols. Ph.D. dissertation, Courtauld Institute of Art, London University, 1980.

Pollock Griselda. "Stark Encounters: Modern Life and Urban Work in Van Gogh's Drawings of The Hague, 1881–3." *Art History* 6, no. 3 (1983), pp. 330–58.

Proust, Antonin. Édouard Manet: Souvenirs. Paris, 1913.

Rosenblum, Robert. Modern Painting and the Northern Romantic Tradition: Friedrich to Rothko. New York, 1975.

Roskill, Mark W. "Van Gogh's Blue Cart and His Creative Process." *Oud Holland* 81, no. 1 (1966), pp. 3–19.

Roskill, Mark. Van Gogh, Gauguin, and the Impressionist Circle. Greenwich, Conn., 1970.

Roskill, Mark W. "Van Gogh's Exchanges of Work with Émile Bernard in 1888." *Oud Holland* 86, no. 2–3 (1971), pp. 142–79.

Salzmann, Siegfried ed. *Dokumentation der durch Auslagerung im 2. Weltkridg vermißtern kunstwerke der kunsthalle Bremen.* Bremen, 1991. In German and Russian.

Saunier, Charles. "Vincent van Gogh." L'endehors, April 24, 1892. Published in translation in Stein 1986, pp. 303–5.

Schwarz, Heinrich. "An Unnoticed Drawing by Vincent van Gogh." *Museum Notes, Museum of Art, Rhode Island School of Design, Providence* 4, no. 4 (April 1946), pp. 2–3.

Silverman, Debora. Van Gogh and Gauguin: The Search for Sacred Art. New York, 2000.

Silverman, Debora. "Framing Art and Sacred Realism: Van Gogh's Ways of Seeing Arles." Van Gogh Museum Journal 2001, pp. 45–62.

Soth, Lauren. "Van Gogh's Images of Women Sewing." Zeitschrift fur Kunstgeschichte 57, no. 1 (1994), pp. 105–10.

Stein, Susan Alyson. "Passage du Puits-Bertin, Clichy." In Signac, 1863–1935, by Marina Ferretti-Bocquillon et al., pp. 118–19. Exh. cat. New York: The Metropolitan Museum of Art, 2001.

Stein, Susan Alyson, ed. Van Gogh: A Retrospective. New York, 1986.

Stein, Susan Alyson. "Van Gogh and Millet." In *Treasures from The Metropolitan Museum of Art: French Art from the Middle Ages to the Twentieth Century*, pp. 39–44. Exh. cat. Yokohama: Yokohama Museum of Art, 1989.

Stolwijk, Chris and Han Veenenbos. Account Book of Theo van Gogh and Jo van Gogh-Bonger. Cahier Vincent, no. 8. Amsterdam and Leiden, 2002.

Styles Wylie, Anne. "An Investigation of the Vocabulary of Line in Vincent van Gogh's Expression of space." *Oud Holland* 85, no. 4 (1970), pp. 210–35.

Tellegen-Hoogendoorn, Annet. "Geen panoramalandschap bij Van Gogh." *Bulletin van het Rjiksmuseum* 12, no. 2 (1964), pp. 57–61.

Tellegen-Hoogendoorn, Annet. "Van Gogh en Montmajour." *Bulletin Museum Boijmans-Van Beuningen* 18, no. 1(1967), pp. 16–33.

Thannhauser, Henry: "Van Gogh and John Russell: Some Unknown Letters and Drawings." *Burlington Magazine* 73, no. 426 (September 1938), pp. 95–104

The Paintings of Vincent van Gogh in the Collection of the Kröller-Müller Museum. Catlogue by Jos ten Berge et al.; edited by Toos van Kooten and Mieke Rijnders. Otterlo, 2003.

Thomson, Richard "Van Gogh in Paris: The Fortifications Drawings of 1887." *Jong Holland* 3, no. 3 (1987), pp. 14–25.

Tralbaut, Marc Edo. Van Gogh: Eine Bildbiographie. Munich, 1958.

Tralbaut Edo, Marc. Van Gogh, le mal aimé. Lausanne, 1969.

Tralbaut, Marc Edo. Vincent van Gogh in Drenthe. Assen, 1959.

Van Crimpen, Han. "Landschap in Drente, met kanaal en zeilboot, Vincent van Gogh, 1853–1890." *Vereniging Rembrandt. Jaarverslag 1986*, pp. 70–71.

Van Crimpen, Han. "New Acquisition." Van Gogh Bulletin 2, no. 2 (1987), unpaged.

Van den Eerenbeemt, Herman. "Vincent van Gogh." *Opgang* 4, no. 162 (1924), pp. 265, 268–82.

Van der Wolk, Johannes. The Seven Sketchbooks of Vincent van Gogh: A Facsimile Edition. Translated by Claudia Swan. New York, 1987.

Van Gelder, J.G. *De aardappeleters van Vincent van Gogh*. Amsterdam and Antwerp, 1949.

Van Gelder, J.G. "Vincent van Gogh (1853–1890): Gezicht op een industriewijk te Paris." *Openbaar Kunstbezit* 2 (1958).

Van Gogh, Vincent. Brieven aan zijn broeder; uitgegeven en toegelicht door zijn schoozuster. Preface and notes by Jo van Gogh-Bonger. 3 vols. Amsterdam, 1914. German ed.: Vincent van Gogh. Briefe an seinen Bruder; zusammengestelt von seiner Schwägerin, J. van Gogh-Bonger. Translated by Leo Klein-Diepold. Berlin, 1914.

The Complete Letters of Vincent van Gogh with Reproductions of All the Drawings in the Correspondence. Introduction by Vincent W. van Gogh. 3 vols. Greenwich, Conn., 1958.

 $\label{eq:continuous} De\ brieven\ van\ Vincent\ van\ Gogh.\ Edited\ by\ Han\ van\ Crimpen\ and\ Monique\ Berends\ Albert.\ 4\ vols.\ The\ Hague,\ 1990.$

Van Heugten, Sjraar. Vincent van Gogh Drawings. Vol. 1, The Early Years, 1880–1883. Amsterdam: Van Gogh Museum, 1996. Published in conjunction with Amsterdam 1996.

Van Heugten, Sjraar. Vincent van Gogh Drawings. Vol. 2, Nuenen, 1883–1885. Amsterdam: Van Gogh Museum, 1997. Published in conjunction with Amsterdam 1997.

Van Heugten, Sjraar. "Working in Black and White and Colour: Van

Gogh's Regard for Tonality and Technique". In *Vincent's Choice: The Musée Imaginaire of Van Gogh*, edited by Chris Stolwijk et al., pp. 123–32. Exh. cat. Amsterdam: Van Gogh Museum, 2003.

Van Meurs, Jan Gerritt Willem. *Isographieën systeem W. van Meurs.* Volledige ge^allus-treerde catalogus. Amsterdam, [1910].

Van Rapprad-Boon, Charlotte, Willem van Gulik, and Keiko van Bremenlto. Catalogue of the Van Gogh Museum?s Collection of Japanese Prints. Introduction by Tsukasa Ködera. Amsterdam, 1991.

Van Tilborgh, Louis. *The Potato Eaters by Vincent van Gogh / De Aardappeleters van Vincent van Gogh*. Contributions by Dieuwertje Dekkers et al. Cahier Vincent, no. 5. Zwolle, 1993.

Van Uitert, Evert and Michael Hoyle, eds. *The Rijksmuseum Vincent van Gogh*. Amsterdam, 1987.

Vanbeselaere, Walther. De Hollandsche periode (1880–1885) in het werk van Vincent van Gogh (1853–1890). Amsterdam, [1937].

Vellekoop, Marije and Sjraar van Heugten. Vincent van Gogh Drawings,. Vol. 3, Antwerp and Paris, 1885–1888. Amsterdam: Van Gogh Museum, 2001. Published in conjunction with Amsterdam 2001–2.

Vellekoop, Marije and Roelie Zwikker. Vincent van Gogh Drawings. Vol. 4, Arles Saint Rémy and Auvers-sur-Oise, 1888–1890. Amsterdam: Van Gogh Museum, 2006. Forthcoming.

Vincent van Gogh. Catalogue of 276 Works in the Collection of the Rijksmuseum Kröller-Müller, Otterlo, [Otterlo, 1974.]

Vincent van Gogh: A Detailed Catalogue of the Paintings and Drawings by Vincent van Gogh in the Collection of the Kröller-Müller National Museum. 4th ed. Otterlo. 1980.

Visser, W. J. A. "Vincent van Gogh en 's-Gravenhage." Geschiedkundige Vereniging Die Haghe. Jaarboek 1973, pp. 1–125.

Vogelsang, W. "Tentoonstelling Vincent van Gogh." Onze Kunst 4, 2nd semester (1905), pp. 59–68.

Wadley, Nicholas. Impressionist and Post-impressionist Drawing. London, 1991.

Wadley, Nicholas. The Drawings of Van Gogh. London, 1969.

Waldstein, Agnes, comp. Museum Folkwang. Vol. 1, Moderne Kunst, Malerei, Plastik, Grafik. Essen, 1929.

Walker, John A. "Van Gogh's Drawing of La Crau from Mont Majour." *Master Drawings* 20 (Winter 1982), pp. 380–85.

Weisbach, Werner. Vincent van Gogh: Kunst und Schicksal. 2 vols. Basel, 1949-51

Wilson, Carol and Catherine Young. "Deux tableaux de Vincent van Gogh identifiés à Auvers-sur-Oise." *Vivre en Val-iOise*, no. 34 (November 1995), pp. 62–65.

Zemel, Carol. "The 'spook' in the Machine: Van Gogh's Pictures of Weavers in Brabant." *Art Bulletin* 67, 110. 1 (1985), pp. 123–37.

Zemel, Carol. "Sorrowing Women, Rescuing Men: Van Gogh's Images of Women and Family." *Art History* 10, no. 3 (1987), pp. 351–68.

INDEX

Bold indicates illustrations.

abstraction, 237
Agricultural Work (after Millet), 285
Almond Blossom, 283, 286, 286-287
anatomy, 19, 40, 130
Anatomy for Artists (Marshall), 19, 130
Antwerp, Netherlands, 113, 156, 160, 161
Antwerp Academy, 113, 162, 167
Arles, France, 177, 178, 191, 239, 244-245
Arles Museum, 178
asylums, 241, 246, 247, 270
Au Charbonnage (At the Coal Merchants), 14
Autumn Garden, 230
Auvers, France, 283, 292
Avenue of Poplars, 120
Avenue with Poplars in Autumn, 131

Balzac, Honoré, 167 Basket of Potatoes, 153 bats, 155 Bedroom, 232-233, 234-235, 270 bedrooms, 232, 232-233, 234, 234-235, 242 Berceuse, La, 242 Bernard, Émile, 113, 254, 177, 207, 266 birches, 122-123 bird's nests, 152 boats, 62, 196-197, 222, 222 bog oak, 100 Boulevard de Clichy, 168 Breton, Jules, 133 Bridge in the Rain (after Hiroshige), 171 bridges, 180, 180-181, 230, 231 Brochart, Julien, 118

cafés, 216, 217, 224, 225, 237 Camargue, France, 211 Canal, 8 carriages, 230, 231 Cézanne, Paul, 190 chairs, 239 Chestnut Trees, 270 Christ with the Angel at Gethsemane, 237 churches, 13, 119, 298, 299 Coalmine in the Borinage, 15 coalmines, 15 composition, 62, 83, 88 Congregation Leaving the Reformed Church in Nuenen, 119 Constant, Benjamin, 150 Corot, Jean-Baptiste-Camille, 138, 144 cottages, 149, 149 Couples in the Voyer d'Argenson Park, 172-173 Courbet, Gustave, 150 cradles, 45, 80 Crau, France, 211 cypresses, 227, 236, 236, 240, 256, 257, 259, 260, 260-261, 285, 303

Daubigny, Charles-François, 144, 294, 301
Daubigny's Garden, 300-301, 309, 310
Daubigny's Garden with a Black Cat, 310
Daumier, Honoré, 118
De Cocq, César, 294
De Goncourt, Edmond de, 167
De Ruijterkade in Amsterdam, The, 154
Dekkerduin, Nehterlands, 85
Delacroix, Eugène, 144, 167, 223, 226, 228, 241,

246, 254, 265 Delaroclie, Paul, 118 Dernier Jour de la Creation, Le (Last Day of Creation, The)(Brion), 110 Devant les Tisons (In Front of the Fire), 20, 20 Diggers, The (after Millet), 272 Discus Thrower, The, 166 Donkey Cart, 25 donkeys, 25 drawings and sketches, 11, 13, 14, 22, 23, 24, 25, 26, 28, 31, 32, 33, 34, 43, 45, 46, 47, 52, 53, 54, 60, 63, 73, 74, 76, 78, 79, 82-83, 87, 89, 90, 91, 97, 100, 102, 103, 104, 105, 107, 112, 114-115, 127, 129, 134, 135, 145, 185, 186, 188, 191, 209, 214, 222, 231, 236, 239, 256, 290, 298, 303, 306, 310, 311 Drenthe, Netherlands, 98, 99, 110 Dupré, Jules, 96, 100

Ears of Wheat, 302 École des Beaux-Arts, 19 Eglise de Gréville, L' (Millet), 110 Emperor Moth, 248, 249 En Route, 20, 20 Entrance to a Quarry, 266, 270 Entrance to the Pawn Bank, The Hague, The, 30, 38-39 Exercises au Fusain (Barques), 22, 40 Exterior of a Restaurant, 174-175

Farmhouse with Peat-Stacks, 109
Field with Flowers near Arles, 188-189
Figures in a Park, 168
First Steps (after Millet), 285
Fishing Boats on the Beach at Saintes-Maries-de-la-Mer, 196-197
flowers, 174, 176, 188, 188-189, 218, 218, 222, 243, 293, 294
Flying Fox, 155
Four Peasants at a Meal, 141

Gachet, Marguerite, 306, 306, 307 Gachet, Paul, 283, 296, 296, 297, 298 garbage dumps, 86, 87 Garden of Saint-Paul Hospital, The, 274-275 Garden with Sunflowers, 219 gardens, 121, 123, 124, 209, 215, 218, 219, 230, 238, 250, 251, 274-275, 290, 300-301 Gasworks, 36 Gauguin, Paul, 177, 207, 239, 254, 266, 302 Gérôme, Jean Léon, 202 Girl Kneeling by a Cradle, 80 Gogh, Cornelius van, 14 Gogh, Theo van, 9, 113, 168, 187, 241, 283 Gogh, Vincent van, artistic training, 31, 49, 113, 150, 162, 164, 167; death of father, 113, 136; ear mutilation, 177, 241; family relationships, 31, 32, 49, 75, 91, 111, 113, 116, 167, 173, 177, 238, 270, 286; fraternal love, 9, 17, 113, 311; institutionalizations, 271, 241, 275; mental health and illnesses, 31, 44, 75, 79, 95, 164, 167, 173, 177, 208, 209, 215, 223, 228, 232, 241, 242, 244, 257, 264, 265, 275, 281, 283, 286, 289, 296, 309, 311; on adversity, 16, 81; on art, 44, 45, 61, 79, 95, 106, 113, 124, 126, 130, 139, 150-151, 155, 177, 203, 208, 216, 239, 253, 283, 294, 298, 306, 311; on color, 28, 29, 46, 47, 48, 49, 51, 54, 55, 56, 58-59, 64, 94, 126, 128,

130, 133, 138, 140, 144, 154, 155, 156, 161, 162, 174, 177, 183, 190, 200, 202, 208, 228, 248, 294, 298, 302; on copies, 265, 270, 272, 285, on drawing, 18, 19, 20, 22, 26, 29, 44, 48, 49, 50, 62, 64, 72, 77, 81, 118, 138, 193, 248; on life drawing, 40, 61, 62, 126, 139, 162; on life and death, 94-95, 106, 173, 225, 248, 264, 281; on models and posing, 21, 25, 35, 36, 40, 42-43, 44, 81, 113, 128, 156, 174, 200, 237; on painting, 29, 40, 42, 51, 52, 55, 56, 59, 77, 130, 156, 162, 183, 222, 241, 294, 311; on the art market and selling, 48-49, 106, 152, 155, 161, 242, 283, 311; on watercolors, 28, 34, 46, 49, 77; on work and need for money, 14-15, 19, 20, 42, 44, 45, 46, 47, 51, 64, 72, 77, 79, 81, 95, 130, 207, 208-209, 220, 224, 241, 248, 264, 283, 290, 309; personal relationships, 31, 49, 75, 113, 173; piety and religion, 9, 13; reviews of work, 241, 283; suicide and death, 283, 311

Goupil & Co, 118 graveyards, 97, 97 Great Lady, The, 41 Green Vineyards, The, 228, 229, 270

Harvest, The, 194-195 haycocks, 55 Head of a Man (Possibly Theo Van Gogh), 168 Head of a Peasant Woman with White Cap, 132 Head of a Woman, 133 Head of a Woman, 158 Head of a Woman, 161 Head of a Woman with White Cap, 157 Head of an Old Man, 158 Heathland in Drenthe at Dusk, 98 heathland, 98, 99 Hill of Montmartre with Stone Quarry, 168 Hill with Bushes, 192-193 Hood, Tom, 40 Hoogeveen, Netherlands, 96 Hoornik, Clasina (Sien), 32, 75 horses, 61, 86 Hours of the Day (after Millet), 285 human figures, 20, 21, 22, 23, 25, 29, 30, 32, 33, 34, 35, 38, 41, 43, 59, 62, 63, 65, 67, 72, 73, 74, 76, 77, 78, 79, 80, 81, 82, 82-83, 84-85, 85, 87, 89, 90, 91, 96, 99, 100, 101, 102, 103, 104, 105, 112, 114, 119, 127, 129, 132, 133, 134, 135, 141, 145, 150-151, 161, 239, 264, 265, 266 huts, 96

Impressionism and Impressionists, 113, 138, 205, 226 infants, 69, 215 Irises, 293 irises, 292, 293, 294, 304 Isaäcson, Joseph Jacob, 294 Israëls, Jozef, 144, 208 ivy, 251, 262-263

Kaufman, Piet, 21, 22 Kingfisher, The, 121

laborers, 9, 21, 22, 27, 82, 82-83, 104, 140 Landscape with the Chateau of Auvers at Sunset, 304, 304-305 landscapes, 8, 9, 11, 12, 14, 27, 36, 36, 37, 46, 46, 47, 47, 48, 52, 68, 69, 91, 98, 106, 107, 108109, 110-111, 149, 168, 169, 172, 175, 176, 178, 179, 181, 182, 184, 185, 192-193, 194-195, 210-211, 212-213, 244-245, 247, 253, 258-259, 260-261, 262-263, 264, 274-275, 276-277, 278-279, 288-289, 304-305, 310, 311 Langlois Bridge, The, 180-181 Le Crau Seen from Mont Majour, 212-213 Lhermitte, Léon Augustin, 150, 200 light, 61, 68, 79, 86, 141, 144 looms, 115, 116, 117 lottery, 64

Man Breaking up the Soil, 81 Man in Village Inn, 80 Manet, Edouard, 207, 222 Marguerite Gachet at the Piano, 307 Marshall, John, 19, 130 Mauve, Anton, 22, 28, 29, 32, 34, 86 Mediterranean Sea, 198, 202 Men Unloading Sand, 237 Michelangelo, 151 Millet, Jean-Francois, 9, 18, 96, 110, 118, 141, 151, 167, 200, 241, 272, 285 miners, 18, 70-71 Miners in the Snow: Winter, 70-71 mistral, 177, 178, 190, 203, 211, 226, 237, 279 Monet, Claude, 207, 239 Mont Majour, France, 211 Monticelli, Adolphe, 226, 228, 242 Montmartre, Paris, 168, 170 Moonrise, 266 moths, 248, 248, 249 Mountain Landscape Seen across the Walls, 258-

National Lottery Office, 64 nature, 9, 22, 26, 47, 48, 49, 52, 68, 87, 93, 94, 152, 155, 226, 237, 254, 257, 270 night, 183, 198, 224, 228, 240, 254-255 Night Café, 225 Night Café in the Place Lamartine, 217 Night Study, 266, 270

Old Vineyard with Peasant Woman, 295 Old Windmill, 237 oleanders, 209, 227, 227, 246 Olive Grove, 278-279 Olive Tree in the Mountains, 252-253, 266 olive trees, 246, 252-253, 270, 276, 276-277, 294 Olive Trees on a Hillside, 276-277 Orchard in Blossom, 183 orchards, 179, 183, 184, 185, 186, 244 Orchards in Blossom, View of Arles, 244-245

Paris, France, 113, 168, 169, 170
Path in Montmartre, 170
Peasant Woman Binding Sheaves (after Millet), 268
Peasant Woman Digging, 150
Peasant Woman Lifting Potatoes, 150
peasants, 132, 133, 133, 136, 138, 139, 140-141, 141, 150, 150, 151
peat moors, 99, 100, 100
Pietà (after Delacroix), 265
Pine Trees against a Red Sky with Setting Sun, 280

pines, 280, 281 Pink Orchard, The, 179 Pink Peach Tree, The, 184 Pissarro, Camille, 266 Plaster Figure of a Female, 165 Poor and Money, The, 66-67 poplars, 121, 130 Portrait of a Patient in Saint-Paul Hospital, 271 Portrait of a Woman, 163 portraits, 132, 133, 133, 148, 149, 156, 157, 158, 159, 161, 162, 163, 169, 190, 200, 215, 271, 297, 298, 304, 306; self, 168, 205, 207, 226, 238, 264, 265, 266, 271, 296, 298 postman, 215 Potato Eaters, The, 113, 138, 139, 140, 141, 142-143, 144, 174 potatoes, 52, 61, 88, 89, 90, 91, 91, 102, 151 prints, Japanese, 156, 177, 180, 183 Public Sale of Crosses from Nuenen Cemetery, 146-147

ravines, 230
reader, 239
Reaper, The (after Millet), 267
reapers, 264
Red [Vineyard], 270
Rembrandt, 241
Reminiscence of the North, 288-289
Renoir, Auguste, 190
Rey, Félix, 241
Rijksmuseum, Netherlands, 113
Road with Cypress and Star, 303

Rock of Mont Majour, 210-211

Rodin, Auguste, 207

roses, 190, 292, 294

Raising of Lazarus (after Rembrandt), 282, 290,

Raffaelli, Jean-Fançois, 150

291, 291

Ravine, The, 285

Russell, John, 207

Saintes-Maries-del-la Mer, France, 196-197, 198, 198-199, 202

Saint-Paul-de-Mausole, 241, 250, 251, 274-275

Saint-Rémy, France, 241, 248

Sand Pit at Dekker's Dune Near The Hague, 84-

Scheffer, Ari, 223 Scheveningen, Netherlands, 56, 57, 58, 62, 91, 93

Scheveningen Woman Knitting, 29 sea and seascapes, 53, 55, 56, 57, 58, 63, 69, 93, 154, 177, 196-197, 197-198, 200 Seascape Near Saintes-Maries-de-la-Mer, 198-199 seasons, 56, 61, 62, 68, 69, 77, 80, 81, 110, 128,

Self-Portrait as an Artist, 207 Self-Portrait with Felt Hat, 168 Seurat, Georges, 113, 224 Sheaf-Binder (after Millet), 269 Signac, Paul, 224, 244 Sketch of a Peasant Family at Table, 139

130, 178, 180, 220, 222, 237, 270

Section of a reason running at table, 139 Snow-Covered Field with a Harrow (after Millet), 284 Source, La (Breton), 133 Sower, The, 208, 218, 218 Sower, The (Millet), 18, 177, 208 Sower, The (after Millet), 272 sowers, 200, 203, 207, 208 Starry Night, 177, 203, 240, 241, 254-255 stars, 198, 240, 254-255, 303° still lifes, 136, 152, 152, 153, 190, 191, 191 storms, 56 Streatham Common (London), 10 Sunflowers, 242 sunflowers, 219, 223, 239, 242 sunsets, 77, 128

Tersteeg, Hermanns Gijsbertus, 18, 34, 42, 43, thistles, 220, 221, 222 Thistles by the Roadside, 221 Thresher, The (after Millet), 266 Toulouse-Lautrec, Henri de, 113 Tree Trunks with Ivv. 262-263 trees, 22, 24, 47, 48, 49, 50, 61, 120, 121, 122-123, 124, 125, 130, 177, 179, 182, 183, 184, 185, 187, 236, 236, 238, 250, 251, 252-253, 262-263, 276-277, 278-279, 281 Trees and Shrubs in the Garden of Saint-Paul's Hospital at Saint-Remy, 250 Trees with Ivy in the Garden of Saint-Paul's Hospital at Saint-Remy, 251 Two Peasant Women Working in the Fields, 136 Two Peasants Planting Potatoes, 138 Two Women in the Peat-Field, with a Wheelbarrow, 101

Veronese, Paolo, 144
View of Het Steen, 160
View of Paris with the Hotel de Ville and the
Tour-Saint-Jacques, 169
View of Royal Road, Ramsgate, 12
View of Scheveningen, 36
View of the Beach at Scheveningen, 58
View of the Sea at Scheveningen, 57
vineyards, 228, 238, 260, 295

Weaver, 117 Weaver at His Loom, 117 Weaver Facing Left, 116 Weaver with Baby, 116 weavers and weaving, 112, 113, 114-115, 115, 116-117, 116-117, 126, 127, 140 wheat fields, 110, 128, 200, 204, 257, 259, 260-261, 264, 302, 308-309, 309, 312-313 Wheat Field under Thunderclouds, 308-309 Wheat Field with a Reaper, 264 Wheat Field with Crows, 312-313 Wheatffield, 204 Wheatfields and Cypresses, 260-261, 266, 270 windmills, 14 Winter Garden, 121 Woman Walking with Stick, 35 Woman with a Child Sitting by a Hearth (after Breton), 271 Woman Sewing by Lamplight (after Millet), 272 women, 202, 228, 265 woods and woodlands, 56, 58, 60, 61

Zola, Émile, 167, 207 Zouave, The, 201, 215 Zouaves, 177, 200 Zweeloo, Netherlands, 110

ART CREDITS

Amsterdam, Van Gogh Museum (Vincent van Gogh Foundation) pp. 8, 10, 11, 12, 13, 14, 15, 20, 21, 22, 23, 24, 25, 25, 26, 28, 29, 30, 31, 32, 33, 34, 36, 37, 38-39, 41, 43, 45, 46, 47, 50, 52, 53, 54, 57, 58, 60, 63, 65, 66-67, 68, 69, 70-71, 73, 74, 76, 78, 79, 80, 81, 82-83, 84-85, 87, 89, 90, 91, 92, 97, 98, 100, 101, 102, 103, 104, 105, 107, 108-109, 112, 114-115, 116, 117, 119, 120, 121, 122-123, 124, 125, 127, 129, 131, 132, 133, 134, 135, 136, 137, 138, 139, 141, 142-143, 145, 146-147, 148, 149, 150, 151, 152, 153, 154, 155, 157, 158, 159, 160, 161, 163, 165, 166, 168, 169, 170, 171, 172-173, 174-175, 176, 179, 180-181, 182, 183, 184, 185, 186, 187, 188, 189, 191, 192-193, 194-195, 196-197, 198-199, 201, 204, 206, 209, 210-211, 212-213, 214, 219, 221, 222, 227, 231, 232-233, 234-235, 236, 239, 243, 244-245, 247, 248, 249, 250, 251, 252, 253, 256, 258, 260-161, 262-263, 264, 265, 266, 267, 268, 269, 271, 272-273, 274-275, 276-277, 278-279, 282, 284, 286-287, 288-289, 290, 291, 293, 295, 296, 297, 298-299, 300, 301, 302-303, 304, 305, 306-307, 308, 309, 310-311

Coll. Kröller-Müller Museum, Otterlo pp. 208, 217, 229, 280

Réunion des Musées Nationaux/Art Resource, NY pp. 297,299

The Museum of Modern Art/Licensed by SCALA/Art Resource, NY pp. 240, 254-255

Yale University Art Gallery p. 225